THE NOTEBOOK OF
WILLIAM BLAKE

THE NOTEBOOK OF WILLIAM BLAKE

A PHOTOGRAPHIC AND TYPOGRAPHIC FACSIMILE

Edited by

DAVID V. ERDMAN

with the assistance of

DONALD K. MOORE

REVISED EDITION

READEX BOOKS

A DIVISION OF READEX MICROPRINT CORPORATION

1977

Library of Congress Cataloging in Publication Data

Blake, William, 1757–1827.
 The notebook of William Blake.

 Includes indexes.
 1. Blake, William, 1757–1827—Manuscripts—Facsimiles.
I. Erdman, David V. II. Moore, Donald K. III. Title.
PR4142.A5 1977 821'.7 77-2397
ISBN 0-918414-00-8 paper
ISBN 0-918414-01-6 cloth

Printed in the United States of America.

TO

GEOFFREY AND MARGARET KEYNES

PREFACE

SINCE the publication by Sir Geoffrey Keynes in 1935 of a facsimile edition of Blake's Notebook (sometimes called the Rossetti Manuscript, from having been the property of the two Rossettis), its physical appearance has been familiar to scholars, and in more recent years the texts of the poems and prose in it have been available in two kinds of variorum transcript—self-contained or with an apparatus criticus—in Sir Geoffrey's editions of Blake's works and in my own. Justification for a new facsimile lies in improved photography, which makes visible sketches and lines of text scarcely seen before, and in an improved and more sophisticated typographical transcript, which 'translates' the texts with all their erasures, cancellations, mendings, and palimpsest writing so faithfully, even in arrangement on the page, that almost no external apparatus is required.

In the present edition we have been successful, I believe, in achieving a typographical facsimile of each page which, thanks to the professionalism of Mr. Moore at the composing machine, explains itself in juxtaposition to a photographic reproduction of that page without resort to brackets and superscript symbols with keys and footnotes. A few visibly distinct styles and sizes of type sort out the ink and pencil colours and the stages of manuscript revision for the reasonably attentive reader. Page notes explain the system and, when necessary, discuss the sequences. Only a few longer notes have been supplied (in Appendix I) for the most difficult or elaborate cases, since other auxiliary help may be found in the apparatus of the standard editions.

A few of the readings correct or supplement those in texts earlier than my 1972 revised edition, and the numbers under the emblems are here first adequately deciphered. But in textual matters the one bold venture of the present work is a reconstruction of the sequence of Blake's use of the Notebook and a numbering of the 'Poems and Prose in Order of Inscription' (Table II).

The real excitement offered by this facsimile—thanks to the photographers' skill and patience— will be found in its recovery of important details in the pencil drawings and of some whole drawings hitherto unknown. These were invisible or indecipherably faint in the earlier facsimile; some are so faint in the manuscript itself as to escape the eye of any but a patient and optically well-equipped scrutinizer in optimum daylight. Aesthetically a photographic facsimile dedicated to full documentary recovery must fall short of perfect uniformity of appearance. Infra-red photography brings faint or erased pencil to maximum visibility, but the balance of ink and pencil, and their tones, varies from page to page. High-contrast prints have been more effective for some pages, normally balanced prints for others. Inevitably, with such eclectic photography the plates must vary in the degree to which they reproduce the texture of the paper, heavy writing that shows through from the reverse side, or lines and pictures rubbed off on facing pages.

Infra-red photographs have been used for the reproduction of Notebook pages 1, 7, 8, 9, 10, 11, 12, 13, 15, 16, 17, 19, 20, 21, 26, 28, 29, 30, 31, 32, 33, 35, 36, 37, 39, 41, 45, 47, 48, 49, 50, 51, 54, 55, 56, 57, 59, 60, 61, 64, 66, 68, 69, 70, 71, 72, 73, 74, 75, 76, 77, 81, 82, 86, 87, 88, 89, 90, 92, 93, 94, 95, 96, 97, 98, 99, 100, 101, 102, 105, 110, 111, 112, 114, 116.

Because the drawings have been the least accessible part of the contents of the Notebook and are

almost free of previous commentary, no ingenuity has been spared to make them comprehensively available and to provide the scholar with as much of the evidence as can be defined, tabulated, or diagrammed. Not that it is the purpose of this edition to explicate with any amplitude. Numerous miscellaneous drawings have been described and listed as simply as possible. The interesting but often extremely sketchy Milton and Shakespeare illustrations have been dealt with mostly in the page notes and in a briefly annotated list, with conjectural identifications noted as such but not defended at any great length.

The fifty-odd emblem drawings, with and without legends, are a different matter, however. Simply to recover the drawings, legends, and numberings, helpful as that might be, would scarcely have made their reality available to the reader. Nothing short of reconstruction of the several series of emblems called for by Blake's numbering and renumbering could have opened the door to his intent or accomplishment here. There are some gaps in each series of numbers and some irrecoverable erasures of sketches, but it is pleasant to have managed to reconstruct, if imperfectly, a thrice-varied gallery of symbolic images, with legends, which constitutes a graphic prophetic work that can now be studied and appreciated in itself or as the matrix out of which Blake refined the seventeen final emblems of *The Gates of Paradise*. This reclamation has necessitated, despite some feats of compression, a fairly long presentation and some complicated tables and a diagram through which one will need to work one's way carefully to reach the reconstructed series and *The Gates*.

This book has been many years in preparation, and my obligations to librarians, photographers, typographers, editors, and scholars and friends and relatives has been immense. For help in designing the transcription format I am indebted to C. Freeman Keith of the Stinehour Press and to Donald K. Moore of the State University of New York, who undertook the gruelling translation of design into camera-ready pages. To the fact that Mr. Moore during the course of this assistance has become an expert critical scholar I owe some of the improvements in textual analysis, particularly of the 'Infant Sorrow' revisions. Most of the tracings in Appendix II were made by my daughter Heidi Lichterman; the crude ones are my own.

The Blake scholars John E. Grant, Michael J. Tolley, Irene H. Chayes, Harold Bloom, Martha W. England, Irene Tayler, Morton Paley, and Paul Miner have been critically and materially helpful. G. E. Bentley, Jr. helped by giving close scrutiny to my bibliographical demonstration of the sequence of pages and contributed points in evidence. Early and sustaining encouragement has come from Sir Geoffrey Keynes and Northrop Frye, patient critical advice from my wife Virginia and daughter Wendy. For corrective and stimulating discussion, particularly of the emblem readings, I am obliged to my colleague Rose A. Zimbardo and my students Terry Bases, Ronny Brucker, Tom Dargan, Isabel Davis, Dalene Stowe, and Marlene Deverell-Van Meter.

T. C. Skeat, Keeper of Manuscripts at the British Museum, and his staff have co-operated over several years in the preparatory work for this facsimile, expressing particular concern that it should represent the most meaningful replica of this fragile and decaying manuscript. Messrs. Pearce and Smythe of the British Museum Photographic Service have been responsive and patient. John Peckham and James Barnett of Meriden Gravure generously prepared sample plates at an early stage of the planning, as did William Weatherby of John Weatherhill, Tokyo. Undaunted by delays, demands, complications have been the staff of the Clarendon Press, Oxford.

I am grateful for many kinds of assistance from colleagues at the New York Public Library,

especially William Coakley and Marilan Lund, Genevieve Oswald, Elizabeth Roth, and Lola Szladits; from Gert Schiff of New York University; and from Martin Butlin of the Tate Gallery.

The Notebook is reproduced with the permission of the Trustees of the British Museum, as are the drawings and engravings for Figs. 34, 39, 41, and 42. The manuscript fragment of *The Everlasting Gospel* (Appendix III) is reproduced by permission of The Philip H. & A. S. W. Rosenbach Foundation; Fig. 39 by permission of the Arents Collection, the New York Public Library; Figs. 31–3 by permission of Harvard College Library; Figs. 30 and 35 by permission of the Tate Gallery. Research was assisted by grants in aid from the Bollingen Foundation and the American Council of Learned Societies.

September 1971

PREFACE TO THE REVISED EDITION

REVIEWERS were generous in their praise of the first edition; their welcoming of this facsimile as 'an essential guide'—'both stimulating and useful' and even 'something of a landmark'— lulled my critical faculties, so that when the opportunity of a reissue arose my first inclination was merely to correct the manifest errors and occasional misprints, to put a proper note of identification near the finely sketched portrait of Blake's wife Catherine on Notebook page 82 (Geoffrey Keynes having pointed out that the sketch had been copied by Frederick Shields for the 1880 Gilchrist *Life* and there identified), and, with the necessary rearrangement of adjacent items, to correct the mistaken dating of Poem 78 in the Table on pages 56–8 and in the explanation on page 71. I intended also to cite briefly, in the note to page 27, a clear solution to the puzzle of Emblem 10 which was proposed by Robert N. Essick in his review in *Blake Newsletter* 32 (Spring 1975) pp. 132–6.

When I sat down to check through the reviews for specific criticisms and suggestions, however, I was gradually drawn into a sober reappraisal of my 'readings' of two of the emblem designs, one being that of the figure resting on a cloud in a star-studded sky used by Blake in his strategic 'Introduction' to *Songs of Experience*. 'On pages 73 and N57, the figure in Emblem 36 must surely be identified not as the future Bard but as the future Earth', declared Jean H. Hagstrum in his review in *Philological Quarterly* 53 (Fall 1974) 643–5. 'Her position resembles that of a clear but unmistakable Blakean icon . . . the position of Earth, of the Clod of Clay or Nature in *Thel*, of the sleeping girl in *America*, and of *Vala* in *The Four Zoas*.' Long uncertain about this figure, I had defined it as 'the alerted Soul on her cloud' as late as the galley-proof stage of the first edition, then persuaded myself that it was, after all, 'the Bard on his scroll'. Sir Geoffrey Keynes had once agreed that it was the Bard but in his recent facsimile edition of the *Songs* (1967) had come round to seeing it as 'Earth . . . a female figure reclining on a couch borne on a cloud among a night of stars'. What finally convinced me were two pages of close argument for the Earth/Soul interpretation in a copy John E. Grant sent me of his review scheduled for publication in the Autumn 1977 issue of *Modern Philology*. It is with relief and pleasure that I now belatedly join such a 'strong' company of scholars as Keynes, Grant, and Hagstrum.

John Grant's review also questions my reading of Emblem 13, page 31, as did Robert Essick's. Where I saw a gowned 'Saviour' descending through a doorway, they see a gowned woman ascending. The sketch is quite vague; what convinces me in this case is the early wash drawing, kindly supplied by Essick, of what is clearly a variant of the same scene (Fig. 43). William Rossetti had been substantially correct with his caption, 'The Soul entering Eternity. Exhibits a maiden entering a door, guarded by two spiritual women' (Gilchrist *Life*, 1863, II, 248 no. 92). Another variant is Blake's design for Young's *Night Thoughts* (*NT* 510), in which the woman entering 'at the door of Heaven' is welcomed by a bearded man who pushes the door open and represents 'humble Love'. (Another version, emblem size, is a slight sketch of a figure entering a door, inscribed 'Frontispiece' above the drawing and 'It is Deep Midnight' below it. Since this sketch is drawn on the verso of Blake's title page 'For Children The Gates of HELL', the probability is, Martin Butlin suggests, that this and some of the other unpublished Notebook emblems were at one time intended for a separate *Gates of Hell* series.) As for Emblem 10, which I can now see as a variant of *A Breach in a City the Morning after the Battle* (1794) or *War* (1805), Essick has kindly sent me an annotated tracing which helps to identify the edges of the broken wall, the three corpses before and within the break, a small figure seen in the distance through the break and walking to the left, and an eagle perched on the wall. I would hardly say that 'the eagle's beak and left wing are particularly clear in the emblem', since I see only the neck, not the beak, but I do agree that 'this arrangement at least seems more likely than Erdman's "lightning strikes the neck of a woman whose slippered leg is extended at left"'. As comparison with the variant versions makes evident, what I saw as cloud and lightning are a clump of trees and the outlines of the eagle. What looks like a giant leg proves to be the space between the edges of the broken wall and a fallen body.

Revising the account of Emblem 10, which I had called 'War', required little more than a refining of connotations. But my erroneous accounts of Emblems 13 and 36 had far-reaching effects. While I was wrestling with the necessary revisions *passim*, and discussing them on the telephone with John Grant, he gently urged me to examine and reconsider the sex of the figure I had identified as Satan in the picture on pages 110–11. The prominent rounded breasts ought perhaps to suggest Eve—or Satan's daughter and paramour, Sin. (But then Christ in the same picture looks rather like that Bard—I mean 'lapsed Soul'—in Emblem 36, hair and gown: some suggestion of an androgynous Human Form Divine?)

Three females I had mistaken for males! I could take some comfort from recalling the first part of Blake's letter to the *Monthly Magazine* in 1806 in which he protested the criticism of a painting by Fuseli. The critic had mistaken a boy in Count Ugolino's arms for a girl. 'Whether a boy or girl', Blake wrote, 'signifies not.' Then he added: 'but the critic must be a fool . . . who does not know a boy from a girl'. Small comfort. I have omitted the first 'who': 'a fool who has not read Dante': Blake *knew*, from reading Dante, that the child was a boy. I had thought I *knew*, from reading Blake, that those figures were male. By this time a simple patching here and there and a note of errors would not do. I have now revised the descriptions of these three Emblems completely, put in a query about Eve or Sin, and revised my accounts of the sequences of emblems in Blake's various numberings. The changed readings of the three emblem pictures fortunately

make no drastic change in the sequences of variation between images of fear and images of hope which constitute the dynamics of the series. Emblem 10 comes into sharper focus as death and mourning after battle, with permissable allusions to the English Civil War and the American War, while 'the drift of hollow states' suggests contemporary prophecy. Emblem 13, whether representing Christ coming through a doorway toward us or a Soul going toward heaven, is an emblem of hope. And Emblem 36, whether the Bard watching for Earth to respond to 'the Word' or the Earth awake to 'the Word' but not yet arising, is critically ambivalent. It can make a positive thrust in the thematic series of the Notebook emblems; in the context of the 'Introduction' poem and its sequel 'Earth's Answer' it may lead the viewer and reader into a lapsed condition that puts the dawn of a future age far off. The fit of text to picture, however, is a compelling reality: it is the Earth *as globe* to whom 'the starry floor', prominent in the picture, is given; the 'watry shore' is given as boundary to the earth *as land* (the 'slumberous mass'), and it is from that prison that her chained spirit answers in the second poem ('Earth's Answer').

Four emblem pictures which I have added at John Grant's suggestion, on pages 98–9, afford further possibilities—which I leave others to explore—for the reconstruction of Blake's numbered series of emblems. Figures 44 and 45 are sketches on a small sheet of paper which Grant calls to my attention as bearing alongside their captions revised and thrice revised numbers that seem to fit gaps in Table V (p. 64) of emblems in numbered series. In Fig. 44 a snaky-haired woman surrounded by tropical vegetation is coming out of a splitting gown or perhaps a vegetable sheath. In Fig. 45 a bee-winged girl hovers with folded arms under an archway, or possibly the branch of a tree. These drawings are not much like those in the Notebook, but the possibility that they may have been considered for the Notebook series cannot be ruled out.

Figures 46 and 47 are less ambiguous and in a different category. Both were added to blank verso pages, within the areas framed by the plate printed on the rectos, in copy C of *For Children: The Gates of Paradise*, a copy which Blake's old friend George Cumberland apparently purchased after his death. These added emblems, a flower-woman to match the fire-man of the emblem it faces, and a printer at work following 'Death's Door', show Blake still the relentless emblem-maker. Perhaps they are restorations of earlier rejected designs; the first, Fig. 46, bears a kind of sibling relation to Fig. 45. But I have no ingenious speculations ready, nor has John Grant, who led me to these surprises.

Thanks, then, to Professors Essick, Grant, and Hagstrum, this new edition contains significant improvements that have involved minor revisions throughout, even in the index. And although I have found no way to make direct use of '"Blake's Gothicised Imagination" and the History of England', David Bindman's essay in *William Blake*, 1973 (the Keynes *Festschrift* edited by Morton Paley and Michael Phillips), my brief discussion of the historical sketches and of the list of topics from English history on page 116 would benefit from the wider context supplied by Bindman's survey 'of Blake's interpretation of the whole panorama of English history from its mythological origins to the apocalyptic future'.

Jean H. Hagstrum is to be thanked for a most interesting textual correction of 'Public Address' sections 63 and 29 (N 20 and N 62). What has always been read as 'Poco Pen' and 'Poco Pend', but never made sense of, can now be confidently given as 'Poco Piu' and 'Poco Piud'. Hagstrum

observed that *n* was a misreading of *u*, and Geoffrey Keynes noted that what looks like *e* (though loopless) is indistinguishable from an undotted *i* (of which the text affords frequent examples) and that Blake would have had no qualms about making such a participle as 'Piu'd'. The recovered expression, Italian for 'a little more', is just the phrase that the sense requires in these passages, in which Blake is attacking the slang of the 'Cunning Sures' (N 40); compare his scorn of their 'je ne sais quoi' in Poem 124 (N 41). The only other error of transcription noted, and corrected, is 'Accusation' corrected to 'Accusations' in Appendix page 95.

For permission to reproduce the drawing for Fig. 43 I wish to thank the Liverpool Public Libraries, the drawings for Figs. 44–5 the Library of Congress, Rosenwald Collection. For various favors I am again obliged to several of the colleagues named in the first Preface; also to Anthony Rosati of the Alverthorpe Gallery. I am particularly grateful to Albert and William Boni, of Readex Books, and to Robert Wise of the Wickersham Press, for the opportunity to make this work more accurate as well as more available.

DAVID V. ERDMAN

Crane Neck Point
January 1977

CONTENTS

ABBREVIATIONS AND SHORT TITLES

1. The following abbreviations are employed for Blake's works:

EG	*The Everlasting .Gospel*
GP	*The Gates of Paradise* (*For Children* or *For the Sexes*)
H	Harvard College Library pencil drawings—copies by D. G. Rossetti
J	*Jerusalem*
MHH	*The Marriage of Heaven and Hell*
Msc	Miscellaneous prose
N	The Notebook
NT	*Night Thoughts* illustrations (by number of drawing)
PA	*Public Address* (in *N*)
VDA	*Visions of the Daughters of Albion*
VLJ	*Vision of the Last Judgment* (in *N*)

2. Drawings are referred to by *N* page and a letter indicating position on page; e.g. the third drawing on *N* 17 is designated 17c.

3. Blake's text is cited from *The Poetry and Prose*, ed. David V. Erdman, abbreviated E, with page number, e.g. E777.

4. The following abbreviations are used for frequently cited references:

Bentley, *Records*	G. E. Bentley, Jr., *Blake Records*, 1969
BNYPL	*Bulletin of The New York Public Library*
BVFD	*Blake's Visionary Forms Dramatic*, ed. David V. Erdman and John E. Grant, 1971
Keynes, *Bible*	Sir Geoffrey Keynes, ed., *William Blake's Illustrations to the Bible*, 1957
Keynes, *Drawings*	Sir Geoffrey Keynes, ed., *Drawings of William Blake: 92 Pencil Studies*, 1970
Keynes, *Gates*	Sir Geoffrey Keynes, ed., *The Gates of Paradise*, 3 vols., 1970
PL	*Paradise Lost*, by John Milton
Schiff	Gert Schiff, *Johann Heinrich Füsslis Milton-Galerie*, 1963
'Terrible Blake'	David V. Erdman, ' "Terrible Blake in his Pride"; An Essay on The Everlasting Gospel', pp. 331–56 in *From Sensibility to Romanticism*, ed. F. W. Hilles and H. Bloom, 1965

1

INTRODUCTION

IN February 1787 Robert Blake died and his older brother and fellow artist William inherited the not very large notebook reproduced and transcribed here. In it Robert had drawn some sketches of great moments in British history—John Milton's *History of England* being evidently well known to both brothers—from the days of the ancient Druid philosophers and 'ministers of state' to the time of Gothic churches and armed knights. He may have sketched some of the scattered profiles and details of lips and other bodily parts. And he filled one page with a fine wash drawing of Oberon and Titania at a fairy dance. (For a list of Notebook drawings attributed to Robert Blake, see Table IA; for miscellaneous profiles and details, IB and IC.)

William Blake kept the Notebook near at hand all his life, filling it over the years with emblems and portraits, with sketches large and small, with lyrics and epigrams and drafts of essays on the state of art and artists and on his own exhibitions, with memoranda of 'Despair', of 'the Word Golden', of instruction in how 'To Woodcut on Copper'. In some pages he drew anatomical or nude sketches of a hand, a leg, a traveller's buttocks; in other pages he experimented with almost geometrical drawings of the human form cramped into shapes of letters of the alphabet—fearfully symmetrical and perhaps preparatory to his severely ironic designs in the *Book of Urizen* and its sequels. Quite early he made a series of sketches for illustrations of *Paradise Lost*. At various times he used the Notebook for trial designs or details for his illuminated prophecies, for the *Songs of Experience*, for some of his colour prints, for *Jerusalem*, for the recently discovered Arlington Court painting. (See Table I, B to G.) As the book filled up, Blake crowded his writing around the pictures and sometimes on top of them, sometimes first erasing the drawings. When he erased a poem on page 50 he wrote another in its place. In 1818 or later he squeezed most of *The Everlasting Gospel* into remaining spaces on eleven pages and finally sewed on to the end of the book a salvaged fold of paper containing part of that poem as well as a draft of his Chaucer prospectus.

When William Blake died, in 1827, his wife Catherine gave this book of sketches to an artist, William Palmer, brother of Blake's closer friend Samuel Palmer. It was next acquired by the poet and artist Dante Gabriel Rossetti, who had it bound in half calf with a partial and imperfect transcript of some of the poems—headed 'All that is of any worth in the book'—inserted at the back. The binder's leaves (end papers) front and back were left blank, but on the verso of the front fly-leaf (folio i) Rossetti left this note in pencil, now partly erased:

I purchased this original M.S. of Palmer, an attendant in the Antique Gallery at the British Museum, on the 30*th* April, 1847. Palmer knew Blake personally, and it was from the artist's wife that he had the present

M.S. which he sold me for 10.[s.] Among the sketches, there are one or two profiles of Blake himself. [Here three and a half lines are erased, with only these traces discernible:]

 Illustrated div ? . . . ation is by Robt. Blake but with neither his brother's ease and vigour nor his ?heavenly spirit.

 D.G.C.R.

I *think* that Rossetti was committing himself to the observation that Blake illustrated his works divinely, with ease and vigour and heavenly spirit. The erasure was made, perhaps not from any inclination to withdraw this critical commitment but simply to remove the conjectural attribution of some of the drawings to Robert Blake.[1]

 At Rossetti's death in 1882 the Notebook passed quickly through two auctions and reached the New York dealers Dodd, Mead, who sold it for £154 or $825 (with a two-volume 1880 Gilchrist thrown in) to William Augustus White of Brooklyn, who completed this inscription below Rossetti's:

Dodd Mead & Co	W. A. White
With 2 Vols 8vo	Brooklyn
RE x/ /	26 Jany '87
154 x/-/	$825-.

At Mr. White's death the book passed to his daughter, Mrs. Frances White Emerson of Cambridge, Massachusetts, who permitted Sir Geoffrey Keynes and the Nonesuch Press to reproduce it in 1935 in collotype facsimile—from photographs that were good except for the very faint representation of the drawings and poems that were in pencil. Later Mrs. Emerson had the volume rebound, with interleaves, in levant morocco, and in 1957 she donated it to the British Museum, where it is catalogued as Add. MS. 49460.[2] Before it went home to London, it was exhibited at the Morgan Library in New York City—the occasion of my own first acquaintance with the Notebook itself.

DESCRIPTION OF THE MANUSCRIPT

 The Notebook, not counting Rossetti's fly-leaves, consists of fifty-eight leaves measuring $19 \cdot 6 \times 15 \cdot 7$ cm. with an appendage of two leaves of different and smaller paper added to the end of the book not earlier than 1818. The original book, which will chiefly concern us, appears to be a standard stationer's commodity of the 1780s cut from laid paper sewed in gatherings of twelve leaves, probably originally covered in somewhat heavier paper. Of the gatherings that comprise the extant book of 116 pages only three are complete, as we shall see. There is no watermark in the paper, but top and bottom segments of a countermark, which has not been identified, occur at the inner centre edges of the leaves, each of which is now mounted separately. The distribution of these countermark segments, one clue

[1] The erasure was not necessarily made by Rossetti. The idea, at any rate, disappeared, and in 1949 Geoffrey Keynes could, when assigning to Robert Blake the Notebook drawings now firmly accepted as his, declare that 'This association with Robert Blake had not been noticed until I drew attention to it in the introduction to the Nonesuch facsimile of the *Notebook*.' *Blake Studies* (London, 1949) 14.

[2] Documents of provenance and some testimonials respecting William Palmer are now designated Add. MS. 49460*. Among these f. 10, dated 9 Jan. 1928, marks its transfer to the collection of Mrs. Emerson and its valuation at $40,000. For a more detailed account of the history of the Notebook and of Rossetti's and Keynes's transcriptions of its poetry, see chapter 2, 'Blake's Notebook', in Keynes, *Blake Studies*.

to the original collation of pages, is tabulated below. The horizontal chain lines of the laid paper are varying distances apart: 2·6, 2·6, 2·5, 2·7, 2·6, 2·7, 2·6 cm.—to take as a sample the leaf containing pages 87–8 measured from top to bottom.

A small slip of paper containing a sketch for the second page of the *Europe* Preludium was pasted on to page 8[10]; it has chain lines 2·6 cm. apart, but it also contains a segment of a large watermark that is sufficient evidence that the slip was not cut from a missing page of this book. The probability that some pages did disappear, subsequent to Blake's writing on them, however, is discussed in the next section.

The leaf containing pages 71–2 has the top outside corner cut away. Possibly William Michael Rossetti, who shared his brother's interest in the Notebook, and had given him the money to buy it, was responsible for this excision of about 7·5 × 11·8 cm. In a letter of 27 November 1864 to Horace Scudder in America he offered to 'snip out' a bit of Blake's Manuscript book 'just as a specimen of writing'. There was evidently no poetry on the segment snipped out of this leaf, only a paragraph of Blake's notes on a *Vision of the Last Judgment* which would not have been considered by the Rossettis as of any worth.[1]

Pages 117–20, the appendage that cannot have been made earlier than 1818, consists of an odd bit of paper salvaged from an unsewn sheet that had been printed for one of the Hayley *Ballads* which Blake illustrated in 1802. The treasure on it was section i of *The Everlasting Gospel*.[2] Another surviving fragment of the poem, now in the library of the Rosenbach Foundation and here reproduced as Appendix III, contains stitch marks that show it to have been bound at one time into some book, but not into this one.

CORRECTING AND VERIFYING THE PAGINATION

Early in my study of the Notebook I noticed that a large brown spot of something spilled (possibly aqua fortis; ink would not have been so penetrating) could be seen, dwindling in size progressively, in the leaves containing pages 1 to 4 and 15 to 20.[3] The leaves containing pages 5 to 14 lacked this spot completely and must have been in a different location originally. And indeed it could be seen that when the ink of the poem on page 4 was still wet the book had been shut and the ink had blotted on to the facing page, not 5 but 15.[4]

To find out where the misfitted pages ought to be and to check on the arrangement and pagination of all the pages in the Notebook, I made a close examination of all facing pages (and pages potentially facing) for similar evidence of propinquity and order. What I found through the rest of the book confirmed the familiar sequence, though not quite at every juncture. Spots from spilled liquid that seem

[1] The letter to Scudder is now in the Harvard College Library. The missing segment may still turn up in some autograph collection.

[2] Since Rossetti did not include this section in his transcript of 'All that is of any worth', he cannot be supposed responsible for its binding into the book. So Blake must have done the sewing—a matter of importance as evidence that he considered section i an uncancelled part of the poem. He would hardly have salvaged this scrap of paper for its other contents, a draft of his Chaucer prospectus which had already been revised and printed.

[3] The page numbers used in this section are those pencilled by a cataloguer, presumably in the twentieth century, in the top outer corners and accepted as standard in all references to *N* before my 1965 edition of *The Poetry and Prose*, where a revised order was suggested.

[4] The use of infra-red photography for most of these pages in the present facsimile somewhat mutes the evidence of the brown spots, though they show darkly enough in the standard photography used for pages 4 (new number 14) and 18.

to *confirm* the present order are not very strong evidence, since they can have been caused at a time later than Blake's use. In the tally that follows, such spots are designated 'sp'; but actually they are few. Better evidence, commonly present, is the offprinting of fresh ink (here designated 'i') or the continuation of text from one page to another ('t') or the continuation of lines of a drawing ('d') or—not quite such certain evidence—pencil rubbing from one page to another ('pr'). Included under 'i' are small spots that match on facing pages and appear to be spatterings of ink from a scratchy pen. Other evidence harder to define but often present in confirmation of these indications may be described as congruities of penmanship, of ink, of design, and congruities in the use of the space available on facing pages.

In the opening pages the new sequence 1,2,3,4,15,16,17,18,19,20, which is signalled by the large brown spot mentioned above, is confirmed by other indicators thus: 2,3[i,t]; 4,15[i]; 16,17[i] (small ink spots); 18,19[t]. The confirmation for 18,19 is not impressive; there is much writing on both pages, but the ink must have dried before the book was closed; without the brown spot we would lack strong evidence of juxtaposition. The sequence 7,8,1,2 is established by the fact of a missing chip of paper from the top inner margin.[1] The sequence 9,10,13,14,11,12 is established by ink spots linking 10,13 and 14,11. The other displaced leaf, containing pages 5,6, bears no clear evidence of fitting against any of the ends of the confirmed sequences here or, to anticipate, anywhere else in the Notebook. We must put the problem aside for the moment.

Following the long sequence ending with page 20, a link to 21 is established by matching ink spots, but between 22 and 23 the evidence is inconclusive; the few matching spots may be coincidental, and we must treat this as a potential break in the sequence. From 23 to 62, juxtapositions are established thus: 24,25[i]; 26,27[i]; 28,29[i]; 30,31[i]; 32,33[i]; 34,35[i]; 36,37[i] (for example, 'Compliment' at the top of page 37 makes a recognizable blot above 'Created' on page 36); 38,39[i]; 40,41[i]; 42,43[i]; 44,45[i]; 46,47[i,t]; 48,49[i]; 50,51[i]; 52,53[i,t]; 54,55[i]; 56,57[i,t]; 58,59[i]; 60,61[i]. Here is a possible gap, for I find nothing that links 62 and 63 physically; the prose (of 'Public Address') does continue, but only between paragraphs.

Demonstrable linkage resumes thus: 64,65[i]; 66,67[i]; 68,69[i,t]; and then another possible gap occurs. Two lines of wet ink have left strong blottings on 70—but the facing portion of 71 has been cut away. There is evident linkage in 72,73[i]; 74,75[i,pr]; 76,77[t]; there is not in 78,79; there is in 80,81[t]; also in 82,83[i,t]; probably in 84,85[t] (where text continues, though with a paragraph break); in 86,87[i]; 88,89[i,t]; 90,91[i,t]; 92,93[i,t]; 94,95,[sp,t,pr]; 96,97[sp,t]; 98,99[i,pr]; 100,101[i,t]; inconclusively in 102,103[i]; clearly in 104,105[i]; 106,107[i]; 108,109[i,t]; 110,111[d,i]; 112,113[i]; 114,115[i]. The rubbing of 116 (not against 117) indicates that for long it was the back of the book. Pages 117–20 are, of course, an added fragment of paper; the contiguity of 118,119 is confirmed by wet ink offprinting. The fact that no spots or off-printing link pages 116 and 117 confirms the deduction (from the nature of the contents) that the supplementary sheet was added to the Notebook after being written on.

The handwriting is William Blake's throughout, except for the word 'Frank' on page 116.

To sum up this survey, after the sequence of 7,8,1–4,15–22, the pagination represents the demonstrable contiguities except for a certain break at 116 and possible or probable breaks after pages 22, 62, 70, 78, 84, and 102. The actual sequence of pages 9–14 was 9,10,13,14,11,12. No location is established for this sequence or for pages 5,6.

[1] Called to my attention by G. E. Bentley, Jr.

That these disarranged pages were all near each other and near the front of the book is suggested by the fact that they ended up so, as well as by their content and the impossibility of finding satisfactory locations for them elsewhere in the book. Pencil or ink and wash drawings attributed to Robert Blake occur on the recto pages 5, 7, 9, 13, 11, and on the verso page 8, and nowhere else in the Notebook. By moving photographs about I have tried each of these in each of the possible breaks in sequence indicated above and have found no physical evidence of linkage nor even any plausible fit (in terms of characteristic use of adjacent spaces, textual or pictorial sequences, or general physical appearances). Several incongruities would be perpetrated by any insertion of these early pages at later locations. One oddity would be the interruption of an otherwise continuous series of emblem drawings in the centre of each recto page from 15 through to 101. Insertion after 102 would avoid this disjunction but would create a very odd interruption, by matter facing right side up, among the texts of songs written the other way round (starting from the back of the book and working forward) and among the Milton drawings which fill verso pages sideways. Another difficulty involved in this or any hypothetical insertion of the pages in question into one or more of the possible breaks noted is that we would have to assume that, even though the Notebook was otherwise blank throughout when Robert Blake used it, he crowded his larger drawings into an odd section or sections in the middle. All the probabilities being considered, it is virtually certain that the pages in question belong near each other at the front of the book, where they have apparently always been except for some minor disarrangement.

Let us now consider the watermark evidence. The leaves of this blank book were of course originally bound in gatherings (of twelve, we shall discover), but in rebinding they have been separated into individually mounted leaves no longer physically conjugate. There are two sides to any leaf, however, easily distinguishable in this sort of laid paper. The side facing the mould when the paper was manufactured will be indented with the lines of the mould and chain; the side that faced the felt which pressed it against the mould will be smoother. A normal gathering of twelve leaves will reveal itself in that the first six leaves will lie with the mould side of each leaf as recto and the felt side as verso (or vice versa) and the second half with the surfaces reversed, thus: mf mf mf mf mf mf : fm fm fm fm fm fm.[1]

This is how the pages of Blake's Notebook have lain since the twentieth-century rebinding—or since the numbering of pages, which predates the binding:

pages 1–16: fm fm mf mf fm mf mf fm (an impossible scramble)
pages 17–36: mf mf mf mf fm fm fm fm fm fm (a broken gathering: 4 : 6)
pages 37–60: mf mf mf mf mf mf fm fm fm fm fm fm (a gathering of 12)
pages 61–84: mf mf mf mf mf mf fm fm fm fm fm fm (a gathering of 12)
pages 85–108: mf mf mf mf mf mf fm fm fm fm fm fm (a gathering of 12)
pages 109–16: mf mf mf mf (an odd four leaves, not a gathering of four, which would lie mf mf fm fm or vice versa).[2]

[1] I am grateful to Mr. Howard Nixon, formerly of the British Museum staff, for suggesting this method of analysis. A confirmation of this tally of leaves is obtained from a tally of the incidence of the top and bottom segments of the countermark. Of the two kinds of segments of the monogram that I have designated A and B (in Appendix IV), segment A appears in all leaves in which the felt side is the recto page (fm) and segment B in the others (mf).

[2] Professor Bentley points out that the watermark evidence alone would equally well show a leaf pattern of irregular gatherings from pages 1 to 24, followed by gatherings of 12 beginning at pages 25, 59, 73, and 97—the last lacking two leaves. But the evidence of juxtapositions fails to support this pattern.

The basic structure, then, was gatherings of twelve.[1] At least four leaves are missing at the end of the book; our previous evidence of contiguity forces us to deduce that these did not directly precede 109 or 111 or 113 or 115.[2] No pages are missing between 37 and 108, where we have full gatherings; so we may rest our minds about possible gaps after 62, 70, 78, 84 (unless we imagine a whole gathering lost here), and 102. Apparently two leaves are lacking from the broken gathering preceding these—from its first half, pages 17–24, presumably from the gap noted between 22 and 23, for no gap in use is found at the beginning or end of the sequence nor elsewhere within it.

Theoretically, the two leaves might have been removed before Blake's use of the book, but since there are numerous spotty ink mendings and changes on both pages (22 and 23), there must have been an intervening leaf or leaves to receive the usual blots and spots that would otherwise be present in each of these as a facing page. The likelihood is that two leaves are gone that contained further satiric verses, two recto emblem drawings, and perhaps some paragraphs of the fragmentary *Public Address*. (An explanation that resolves otherwise conflicting indications of the date of Poem 157 on page 22 is offered below.)[3]

As for the scrambled opening pages, we know that 7,8,1–4 should immediately precede 15 (whence the sequence does not break till after 22). And we have concluded that the unlocated leaf 5,6, and the three contiguous leaves containing 9,10,13,14,11,12 belong ahead of that sequence. Among these, no leaf shows (as 116 at the other end of the book does) the wear of having been an outside leaf a long time, but page 5 (with the Klopstock verses in pencil on top of pencil drawings) shows perhaps as much wear as erasure and probably lost its bottom lines, later retraced, from the moisture of handling. Pages 7 and 9, on the contrary, are quite clean. I assume that an original opening leaf is gone but that 5,6 held that position for some time. (While in the wrong order, page '1', which must now be 11, got a bit of wear but nothing like the wear of 116 at the other end.)

The quite certain juxtaposition of 10 and 13, constituting a felt-mould:mould-felt opposition, forces us to infer that our first eight leaves (pages 1 to 16) must be the remains of *two* gatherings, the first of which need not have begun as full size. Allowing the argument for 5 as the first page among these remnants, we then have the arrangement: mf fm mf mf mf fm fm fm (5,6,9,10, 13,14,11,12,7, 8,1,2,3,4,15,16). In the present edition these pages have been renumbered accordingly, with the older page numbers given in parentheses.

Any number of missing pairs of leaves can be conjectured from this initial folio followed by a gathering of six. They could not, if lost after Blake's use of the pages which his pen now links by ink blottings, have been removed from any position after the centre fold of the gathering of six (i.e. after page 8), but that is just where a gathering of twelve could have lost half its leaves from broken stitching. On the other hand, one can entertain the conjecture that when William Blake inherited this Notebook he cleared out a number of untidy leaves, retaining only the more perfect of Robert Blake's Druid drawings. (The black smudging on page 6 may appear to have come from the heavily inked wash drawing on page 9, which our rearrangement brings next to it, but the shape of the smudging is

[1] I can make nothing of the statement on page vi of the facsimile edition of 1935, to the effect that the book 'consists of 58 leaves . . . paginated consecutively 1–116 . . . made up of one gathering of 10 leaves, and four gatherings of 16 and 18 leaves alternately'—which would total 78, not 58.

[2] Unless leaves were removed or rearranged before Blake's use of the Notebook—but consider the evidence of pages 22 and 23, cited in the next paragraph.

[3] See page note.

wrong for that: a drawing of similar blackness but different design must have been removed.) And the ink spots on pages 5, 11, 7, and 8 imply lost facing pages written in ink.

BLAKE'S USE OF THE NOTEBOOK

The central sketch on page 75 seems to go back at least to the year of Robert's death. The pairs of lips on pages 21 and 33 may be early sequels to the somewhat cruder sketches of lips on pages 3, 4, and 20 of 'Robert Blake's Book 1777' (now in the Henry E. Huntington Library). Some of the scattered heads and profiles may also have been drawn quite early, some perhaps by Robert.

Among Robert's drawings at the front of the book, William for years drew or wrote nothing of his own. His memorandum of personal despair in June 1793 was entered first, on page 10. The Klopstock poem was written toward the end of the century, on page 5. In 1802 the sketches for illustrating William Hayley's 'Elephant' ballad were made on page 6, followed perhaps soon by the lines on Johanna Southcott (Poem 63). The poems on pages 14, 12, and 7 belong to 1803 or later. And then in 1810 the 'Public Address' essay, begun in later pages, was allowed to overflow here (page 1). (To shift to the revised pagination, which will be used consistently henceforth, we have been speaking in this paragraph of pages 4, 1, 2, 6, 8, 9, 11.)

With the restoration of the page misnumbered 4 to its proper position as page 14, we can see that the original writing on it, the words 'Ideas of Good & Evil', constitute a title for the series of emblems beginning on page 15. The inscription is in pencil, i.e. tentative, but the words are written large and are laid out as for a title-page. And the emblems that follow, some sixty-four drawings centred in every recto page to 101 and spreading on to several verso pages, are truly a series, as we shall see. The earliest emblem drawing to which a date can be assigned (1787) is on page 75; it is not in an emblem frame and may have been drawn before the other emblems had been drawn or even conceived; when Blake was fitting it into the series, however, he thought of an alternative (or supportive) series title, of visions of hope and fear.

Before the autumn of 1792, at the latest, the emblems had reached the end of the book (page 101 and a trial drawing on 107) and Blake had begun from that end, with the Notebook turned the other way round, to copy in and create in draft Poems 3 to 57, including most of the poems from which he would select his *Songs of Experience*.[1] A terminal date for this inscribing—not of course for revision—is supplied by Poem 58, the climax of which is the Austrian jailing of La Fayette, an item of news that reached London on 25 October 1792 and must have elicited this kind of chiding, prophetic response fairly promptly. It was news that would spread fast, and I cannot see Blake brooding over it any length of time before this outburst in the Notebook.[2]

In January 1793 he added his last emblem (on page 40, a verso page) and chose a title for the series, *For Children: The Gates of Paradise*, both the title and the last emblem being contrarious responses to a political print by James Gillray which mocked revolutionary visions of 'The Straight Gate . . . to the Patriot's Paradise' by means of a graphic parody of John Bunyan's vision of a Celestial City

[1] For convenience of reference I have assigned numbers to all the poems in *N* (see Table II) according to their relative order of inscription. The emblems have also been assigned numbers (see Table IV), but according to their sequence in the book from front to back.

[2] A beginning date of 1791 or later, for the inscribing of the Songs, is suggested by the fact that Poem 8, on page 114, was written to replace 'A Divine Image', engraved in 1791 (or just possibly late 1790), as indicated by conventional serifs on the *g*s.

beyond the Slough of Despond.[1] This choice of title released for use elsewhere the idea of contrary visions, already implied in the ironic title of *The Marriage of Heaven and Hell* and suggested in Poem 55, a jesting 'Motto to the Songs of Innocence & of Experience'. In the title-page which Blake finally etched for the *Songs* he defined them as showing 'Contrary States of the Human Soul'.

Since several of the notebook Songs of Experience are fair copies, it is evident that Blake did not write the whole collection during the fairly brief time, a few months in 1792, during which he was entering and developing them in the Notebook. But the emblems, begun by 1787, given a title in 1788, not complete until early 1793, do seem to have accumulated and developed in character and quality in the Notebook. Meanings and designs engendered in the emblem series influenced and were influenced by the text and illuminations of *The Marriage of Heaven and Hell*, *Visions of the Daughters of Albion*, *America a Prophecy*, and *Europe a Prophecy* (see Table IH), all in gestation in 1790–3. Some of the emblem pictures ended up as illustrations in *Songs of Experience*—which probably means that they were sketched for the emblem series before the second set of Songs was far along. And one emblem (34) is suggestively related to two late designs for *Songs of Innocence*, dated 1789.[2] We know that at least three Songs of Innocence (in the manuscript *Island in the Moon*) were written by 1784; hence that the Innocence songs took five years to accumulate; and that the Experience songs took another three or four. My suggestion is that the emblems began in the Notebook four or five years before 1792; that the initial title, 'Ideas of Good & Evil', belongs to 1787 or early 1788 and assumes the conception, if not the sketching, of a series of some kind.

Gillray, with his conveniently dated caricature prints, frequent stimulators of the 'very contrary' Blake, helps again at the front of the emblem series. On page 14, some time after he had inscribed the 'Ideas' title there, Blake sketched a homely bedroom scene which seems to have been inspired by Gillray's parody *The Morning after Marriage or A scene on the Continent*, of 5 April 1788, deriving in idea more than design from Hogarth's *Marriage à la Mode*, second episode. Gillray was laughing at the secret marriage of the Prince of Wales and Mrs. Fitzherbert and suggesting the entrance of Hogarthian boredom (all centering in the Prince). Poor Mrs. Fitzherbert is drawing on her stockings to leave the great fine bed and resume a routine existence. A maid is bringing breakfast.

Blake's drawing has long been 'supposed to represent Blake and his wife together'.[3] The poem beneath it (which I deduce to be Poem 1 in the book) implies a sort of carpenter's approach to the first night of marriage; if it were not for the Gillray evidence (which is stronger, I think, than the evidence for autobiography) it might be plausibly given the date of the actual Blake marriage, 1782. But if these bedfellows are the Blakes, the theme must be the contrast of their working lives to the luxury and boredom of royal secrecy. At the left where Gillray shows the door ajar and a maid bringing a tray, Blake draws a plain dressing-table with mirror tilted. In the Blakes' simple life the table is bare, not strewn as the Prince's with last night's decanter and wine glasses; the bed is curtainless and untumbled; and it is the young husband who gets up and pulls on stockings and shoes to meet the day. Wife, with a simpler mob cap than Mrs. Fitzherbert's, stays in bed for another doze.[4]

[1] See discussion of Emblem 20, below; the Gillray print is reproduced in Appendix II (Fig. 38). See also my *Blake: Prophet Against Empire* (1969 edition), pp. 202–3 and figs. 6 and 7. For other instances of Gillray's influence, see my 'William Blake's Debt to James Gillray', *Art Quarterly*, xii (1949), 165–70.

[2] See Table IG. The only drawings related to *Songs of Innocence* seem to be 76a, 55b, and, possibly, 15h.

[3] Keynes, *Blake Studies*, 15.

[4] The Gillray print is reproduced below, Fig. 37, Appendix II. Blake's drawing echoes its lines, details, and of course

Assuming that this sort of response to a topical print is apt to be rapid, we should date the drawing not long after early April 1788 and the emblem series title, 'Ideas of Good & Evil', which the drawing of the domestic scene partly obscures but visually and thematically complements, earlier in 1788 or in the previous year. Further evidence, both of date and of thematic matrices, may be inferred from the group, on pages 13 to 17, of preliminary and final drawings of a striding pilgrim, among which appear the first proper emblems in the book. These, Emblems 1 and 2 complete with legends and framing lines, introduce as central figure the traveller who 'hasteth in the Evening' and is 'glad to find the Grave'. Since his form is evolved here (on pages 13 and 16), this traveller probably predates the tiny variant etched for Pl. 7 of *All Religions Are One* (*c*. 1788). And since his hat and staff are rather similar to those of the travelling Christian in Thomas Stothard's designs for Bunyan made at this time, plates 'Publish'd' in March and July 1788, and in 1789 and 1791, for an edition of *Pilgrim's Progress* printed for J. Mathews, No. 18, Strand, and others in 1792—even to the shift from staff to crutch when heading, respectively, for the Wicket Gate or the Grave (Stothard's second plate, Blake's Emblem 46)—it is not improper to wonder whether Blake helped his recent collaborator with some of these designs.[1] Finally, from the probability that Blake was influenced—in such details as the serpent round the traveller's leg on page 13—by J. Wynne's *Choice Emblems . . . For . . . Youth* (1772), it is reasonable to suppose that Blake early had in mind a series of emblems 'for Children'.[2]

Still earlier use of the Notebook, perhaps by both Robert and William, may be represented by the profile drawings or some of the simpler outlines of faces listed in Table IB. The two very crude faces on page 14, for instance, were apparently present before the 'Ideas' title. In the last page of *An Island in the Moon* (1784) profiles of William and Robert Blake are jestingly and competitively drawn. The rather large profiles of William Blake in the Notebook (self-portraits 66a and 67a)[3] seem too middle-aged for the 1780s, but drawings 19a and 21a suggest one of the 'Island' profiles, the one which I take

theme; it does not seem to owe anything directly to Hogarth's much earlier print (1745). The particulars Blake mocks are Gillray's.

I find that some people suppose that it is Mrs. Blake who sits up putting on long stockings, but this I think is an anachronistic response: in the Gillray picture we see long stockings on both man and wife. The shoes of the rising figure seem, for that era, a man's, the mob cap on the figure staying in bed a woman's. (But the uncertainty does not affect the question of derivation.)

[1] We can be sure at least that he *saw* them, though the engraving had been given not to himself but to Joseph Strutt. The eight large plates, with titles, are variously dated as published 'by J. Thane, Rupert Street, Hay Market'. Of these, *The Alarm* (1 March 1788), and *The Reception* (1 March 1789)—reproduced below, Fig. 39, Appendix II—show the staff and hat; the crutch appears in *Christian directed to the Wicket Gate* (opposite p. 2), one of the small pictures, undated and probably not published separately. It should be noted that the mother and children, depicted, e.g. in *The Alarm*, are akin to the group we meet in the emblems and in *N*16a, who later become Jerusalem and her children. 'Apollyon' is bat-winged like Blake's Spectre, but with joints badly drawn, in *The Victory* (25 Nov. 1789) and the small engraving opposite page 79.

[2] *Choice Emblems, Natural, Historical, Fabulous, Moral and Divine. For the improvement and pastime of YOUTH.* London for George Riley, 1772. [John Huddleston Wynne.] Note the fivefold choices in the title. Wynne's No. 24 'Of the Use of Self-Denial' (see Fig. 41, Appendix II) shows a 'snake in the grass' coiled round the left leg of a traveller (as in 13a) who turned from his path to find shade: the 'chearful traveller' moves in the manner and direction of Blake's in 15g (Emblem 1). Wynne's No. 27 'Of Vain Pursuits' (Fig. 42, Appendix II) is a standard emblem of a youth chasing a butterfly but is graphically close to 19b (Emblem 4). Daphne taking root in No. 35 'Of Chastity' is graphically like 36b (Emblem 17). The frontispiece, a woman instructing the children in the cultivation of 'the Human Plant' and in the importance of tree to vine, is a useful approach to the educational symbolism in the frontispiece to *Songs of Innocence*. Only the 1772 plates bear such close resemblances to Blake's designs—including an emblem of 'Silence' (No. 2) as a naked man in front of two pyramids that may have inspired the design of *MHH* 21.—Correction: No. 27 was re-engraved but the others were not; the copy lacking No. 2 was defective. (Information supplied by Judith Wardle.)

[3] Drawings are here designated by *N* page and a letter indicating location on the page. The marriage bed drawing is 14c, because the profile drawings above it are 14a, b.

to be Robert,[1] and drawing 82a, a carefully drawn front face that suggests (vaguely: the extant por-
traits vary widely) a portrait of Henry Fuseli in the 1780s, could be fairly early. Some of the drawings
of anatomical details seem early: attention to the traveller's anus in 16c, h, and 13a suggests the spirit
of Quid and Suction in *An Island*.

A clearer indication of an early date is the close resemblance of drawing 75e—of a man, woman, and
child or children embracing or clutching each other—to a separate drawing that must have been made
before Flaxman left England in the autumn of 1787. Flaxman in Italy five years later made a sketch
'from Memory of three Drawings of Blake', and one of them is a fairly straight rendition of the
separate drawing.[2]

The absence of any working drawings for *Songs of Innocence*, except for the title-page and 'The
Voice of the Ancient Bard'[3]—probably the latest parts of the work—can easily be accounted for by
supposing that Blake had done most of his sketching for the *Songs of Innocence* before 1788 and that
the date 1789 etched on the title-page is bona fide. But there is another absence that is more puzzling.

THE HISTORY OF ENGLAND

In Blake's Prospectus of 10 October 1793 he advertises 'The History of England, a small book of
Engravings' at the price of 'The Gates of Paradise', likewise designated 'small'. On page 116 of the
Notebook is a list of twenty topics, revised to twenty-four, logically comprising just such a series.
No such book of history prints has ever been seen, but we can assume that all copies were lost. It is
more difficult to account for the fact that none of Blake's drawings in the Notebook seems to corre-
spond to any title in the Notebook list (p. 116), except for a few of the emblem pictures that could easily
be called 'Famine', 'Plague', 'Fire', possibly 'War'.

One explanation is that many of the subjects listed had already been designed and painted and some
even engraved, in large sizes, before the time of the Notebook; smaller versions made from these for
the advertised booklet would bypass the Notebook. Early paintings include *The Landing of Brutus*
and *The Landing of Caesar* (both recently exhibited at Princeton University Library), *Edward at*

[1] On the back page of the MS. of *An Island in the Moon* (see reproduction in *BNYPL* 73 (1969) facing p. 454 and note p. 463)
is a profile of Robert above a profile of William. Robert is crowned by laurel leaves which a goat is eating; his face is deleted
by an ink smear and a 'line of beauty' across lips and cheek. William's profile is deleted by pen strokes almost exactly like those
deleting the profile (of Robert?) in 19a. My guess is that in both cases both brothers were engaged in the making and effacement
of profiles in teasing affection. William drew Robert's face in 19a; Robert, with careful veiling strokes, deleted it. Then William
drew a larger version in 21a, with the same outline of eye, nose, and mouth but with lengthened and cleft chin, a fine beard,
higher forehead, bushier hair; Robert responded by tampering (somebody did, hardly the original artist) with the lines of the hair
at the back of the head, adding eyes and a mouth around a lock that resembles a hooked nose, to suggest a grotesque
counterface.

More than thirty years later Blake drew in John Varley's sketchbook of 1819 sketches of a similar head for a character in
Shakespeare's *King John* inscribed 'Faulconberg the Bastard' Martin Butlin (ed.), *The Blake-Varley Sketchbook of 1819*, 1969,
vol. 1, Pl. 9 and vol. 2, pp. 23–5). It may be pure coincidence that Blake's 1819 drawings approximated to the features and cut
of beard of the Notebook profiles, or Blake may have known that he was casting his brother Robert in the 'Faulconberg' role.

[2] Flaxman's sketch is reproduced in Bentley, *Records*, Pl. 6. The picture of Blake's he was recalling from memory is the pencil
drawing (or some close variant of it) reproduced as Pl. 38 in Keynes, *Drawings*, and there in error assigned a date *c.* 1805. Blake's
drawing and Flaxman's copy of it contain two standing figures at the left which do not appear in the small emblem, *N* 75e, but
the family group of the emblem is closely similar.

Keynes's date is based on the thematic similarity to the third plate in Blake's illustrations to Blair's *Grave*, but there (Pl. XI
in S. Foster Damon's reprint) the embracing couple stand upright, unencumbered by children. The conjecture of so late a date has
no force against the Flaxman evidence.

[3] See Table IG, where a possible relation is noted between 15h and a detail in 'On Anothers Sorrow'.

Calais (at Yale), *The Penance of Jane Shore* (often reproduced), and possibly the lost painting of *The Ancient Britons according to Caesar* which Blake developed into an exhibition piece in 1809. The latter topic is number 5 in the list on page 116, considered for the series frontispiece; the others are numbers 2, 7, 13, and 15.

Another explanation may be that some of the subjects had been designed and sketched by Robert Blake—and that some of these *are* in the Notebook. The first, fourth, fifth, and sixth drawings in Table IA may be pertinent. Drawing 7a–b, if not exactly suiting the action of topic 3, 'Corineus throws Gogmagog the Giant into the sea', may represent Trojan Brutus (the crowned king at top right) assigning the kingdom of Cornwall to his comrade Corineus (top left) whose lust to subdue giants (see Milton's *History of England* for all this) was satisfied in his great contention with Gogmagog (the fallen giant form at the bottom). The drawing on page 1, containing some of the persons in Robert Blake's water-colour of a Druid assembly, can qualify for topic 6, 'The Druids'. And so can 9a–e, sketches of other Druids from (or for) the same painting. The Notebook list does not seem to call for anything like the ceremonial and apparently historical crowning depicted in 10b–g, but perhaps I misinterpret the drawing, or the list.

Among the Notebook emblems, by William, three of those noted above could relate to topics 12(a), 16, and 17, and Emblem 10 may conceivably have something to do with topic 8, 'Boadicea inspiring the Britons against the Romans', or its unnumbered sequel, 'Women fleeing from War'. Blake excluded these four emblems from his final selection for *The Gates of Paradise*, one of the two small books of engravings advertised; he may have included them in the other, *The History of England*.

BLAKE'S MILTON GALLERY

The foregoing speculations, if correct, would account for as many as eleven of the topics in Blake's list, six by reference to drawings in the Notebook. The hazards of such guesswork, however, are revealed by the case of drawing 26a, the only one of the larger Notebook drawings (not counting those by Robert) which is unmistakably illustrative of English history. I put off mentioning it because even though it can be traced precisely to Milton's account of the first Roman invasion of Britain, under Julius Caesar, it is not quite right for the list. It illustrates Milton's account of the leaping ashore of a warrior of the tenth legion with the legion's eagle standard; even the elephant in or alongside the small galley, though surely out of place (not to mention the curious error or pun of his 'trumpeting' by holding a military trumpet in his trunk), can be traced to Milton, a few pages further on.[1] Yet Blake's probably earlier water-colour of 'The Landing of Julius Caesar' (topic 7 in the list) represents a quite different scene, the social occasion of the exchange of hostages after the Britons admitted defeat. The list will accommodate only one of these; both qualify for the title; possibly neither was chosen for *The History of England*.

A much more comprehensible series of Milton illustrations, including some of the largest and most striking drawings in the Notebook, is the group of nine designs for *Paradise Lost* and one for *Lycidas* with two, perhaps three, for *Macbeth* that crowd the verso pages from 86 to 114 and were there before

[1] For lists of the pictures mentioned in this section, see Table I and respective page notes. As for the elephant with the Romans invading Britain in 26a, it has an impressive future in *NT* 508. There, to illustrate Young's reference to Satan's passing from Rome to Britain, Blake depicts a shield-and-spear-bearing legionary, falling in Phaeton fashion as in *MHH* 5, with the elephant falling beside him.

the poems. (See Table I**F**.) 'As far as they are decipherable', wrote F. W. Bateson in 1957, 'these sketches appear to be illustrations of scenes in or suggested by *Paradise Lost*, and they can no doubt be connected with Joseph Johnson's abortive scheme for a magnificent illustrated Milton by Henry Fuseli that Blake was to engrave and Cowper the poet to edit. The drawings . . . may perhaps be dated 1790–1.'[1] Fuseli went on to paint his own Milton Gallery, and Blake, in a more modest way, at least sketched his. But only a few of his later Milton illustrations derive at all directly from these Notebook drawings. As a series unique in emphasis and selection these drawings have never really been seen, let alone studied. One of the purposes of the present volume will be satisfied by their photographic recovery and their listing and identification.

Between 1788 and 1793, then, Blake was using the Notebook for various overlapping projects. Both the emblem series and the Songs of Experience reached a sorting out and fruition, and perhaps a History of England series did too. Work on all the illuminated prophecies from *The Marriage* to *Europe* was current and interfertile. Death's door was used in the *Gates* but in *America* too; Ugolino in *Gates* and *Marriage*; Oothoon and the eagle in *America* and *Visions of the Daughters of Albion*. Then there are the curiously diagrammatic human forms of 74b–j and 75ab and 64a, possibly preceding, possibly derived and abstracted from, some of the other pictures. Pages wholly given to small pictures may have been started early and filled up late, e.g. 15, 74, 75.[2] And finally, drawn beside and apparently after the emblems on pages 15–17 but not long after, there is the series of seven sequential sketches of a human flying monster bearing a human body in its mouth, the sketches increasingly inhuman, which eventuated in nothing recognizably similar in Blake's finished work. One feels that the sketches of this man-eater must have been put near the traveller as symptoms of the approach of death, and perhaps they served their purpose as marginalia to the emblems—if not also a further one in the work of Fuseli.[3]

USE AFTER THE *SONGS* AND *GATES*

Thus by 1793 we reach almost the end of Blake's use of the Notebook for series of designs, for all but a few isolated sketches of work in progress. Poetry too almost ceases for nearly a decade after 'Fayette Fayette' (Poem 58)—though ultimately to mount to a total of 161 poems. Three or four of the colour prints of 1795 were developed from earlier Notebook sketches—'Pity', 'Nebuchadnezzar', 'Elohim creating Adam', 'Hecate' perhaps—but the developing was not done in the Notebook. Graphically it was not drawn upon again until 1799, when one of the emblems helped for 'Malevolence'; at about this time page 1 received the pencilled conjuration of Klopstock by 'terrible Blake'. In 1802 a design for Hayley's first Ballad, 'The Elephant', was sketched and perfected, in 2ab and 92a, and three trial sketches were made for the second Ballad, 'The Eagle', in 73a–c, with the bird in

[1] F. W. Bateson, ed., *Selected Poems of William Blake* (London, 1957), p. 105. For details in a broader context, see my *Blake: Prophet Against Empire*, 406–7 [2nd edition 437–9].

[2] Irene Chayes notes that 74g closely resembles one of Fuseli's 'Silence' figures of *c*. 1800, in Paul Ganz, *The Drawings of Henry Fuseli* (London, 1949), Pl. 65, and that 74j looks like an engraving dated 1818 by William Ottley published in his *The Italian School of Design* (1823), after a bas-relief by Donatello.

[3] These sketches may have suggested or been suggested by Fuseli's illustration for the reference to Scylla in *PL* II. 1019, the heads on the necks of Fuseli's Scylla resembling especially sketches 17 a, b; yet Blake's subject cannot have been Scylla, for his heads are on flying human bodies. Fuseli's Milton Gallery painting (Schiff, Pl. 23) dates *c*. 1794–6.

three different flying positions with mother and child on its back.[1] Two more designs complete the graphic tale: one drawing for *Jerusalem* (plate 46[32], developed in 80a from 16f),[2] and one (70b) for the Arlington Court painting, before 1810. (See Table IG.)

Poetry resumed with the Johanna Southcott poem (63), perhaps not long after October 1802, and with Poems 64–9 on page 8 around the Grey Monk poem (66) of about August 1803. The next few poems may have followed in 1804; Poem 73 literally dates itself near Blake's forty-ninth birthday in 1806; the numerous satiric verses (see Table II) run from late 1807 to 1811 and 1812, with the heaviest concentration in 1809. In 1818 (or later) the tidal impulses of *The Everlasting Gospel* flooded in.

Prose meanwhile, first finding a niche for memoranda on page 4, developed in random jottings and explosions in 1809 and later—addressed to the public who *ought* to be attending Blake's Exhibition (which began later than announced in 1809 and was kept open through most of 1810).[3] Modern editors have fitted these dicta into a loose essay that we entitle *Public Address* (taking the phrase from page 56); Table III shows their not always sequential distribution from page 11 to page 67, apparently all in 1810. On page 65 Blake tried a title featuring his Chaucer panorama; on page 70 he tried a different title (for the year 1810) featuring a large painting of the Last Judgment. This subject inspired him to write a rather more focused series of paragraphs on pages 68 to 95 which we call *Vision of the Last Judgment*. But after he had written most if not all of this essay he turned back to the *Public Address*. The additions on pages 71, 76, 68 (perhaps), and 86 we can see are later than the 'Vision' passages on those pages. Some of the additions to 'Public Address' segments on preceding pages may also have been written this late, but we cannot tell. The two essays are, in part, variant and overlapping fragmentary drafts for one or two pamphlet essays that Blake never shaped for publication. Few had come to buy the *Descriptive Catalogue*.

Some of the satiric and mocking Notebook verses are physically a part of the *Public Address* (Poems 132–6), and many others may be so, morally and even chronologically. It used to be assumed that the satiric poems 'are all to be assigned to the years 1808–11, when he was feeling annoyed and humiliated by his failure to obtain recognition through the exhibition of his pictures and his "Canterbury Pilgrims" '.[4] But 1807–12 seems a more likely span for Poems 77–158. Some may be closer to 1804, some to 1818. The physical evidence puts at least Poems 160 and 161 after *The Everlasting Gospel*.

[1] A large pencil sketch of this subject (Fig. 34, Appendix II), once boxed with the *NT* water-colours in the British Museum but not related to them, shows the details of mother, child, and eagle more clearly. This 'moment' of the ballad is not illustrated in Blake's final engravings, but the three persons can be identified from the scene of their arrival at the eagle's eyrie, engraved as frontispiece for 'Ballad the Second . . . Published July 1. 1802' and often reproduced (e.g. Bentley, *Records*, Pl. 16).

[2] In *J* 46[32] Jerusalem and her three children confront Vala, and one of the children soars up to point out the true path. The rounds and ovals at bottom right in 80a correspond to nothing in the final etching; yet they may correspond to the stones ('ruins of the Temple') mentioned in the text (*J* 45[21]). The final etching replaces ruins with two unruined but opposed and darkening temples, of Babylon at the left and Jerusalem at the right. Thus the drawing seems closer to the actual text than the final etching.

[3] See Bentley, *Records*, 219. [4] Keynes, *Blake Studies*, 16.

2

EMBLEMS OF FEAR AND HOPE

BLAKE'S engraved emblem series *The Gates of Paradise*, issued in 1793 'For Children' in seventeen plates with a title-page, revised 'For the Sexes' in 1818 with amplified legends and an illustrated paper of 'Keys to the Gates', is one of his best-known works and least fathomed—puzzling and simple for children, complicatedly enigmatic for adults. That all seventeen emblems derive from drawings in the Notebook, that with them there are over forty other emblem drawings, some with legends, are facts not unfamiliar to scholars but apparently of little use to them. Comfort is taken in the impression that 'none of equal value' were left in the Notebook.

Actually there are three respects in which the Notebook emblems have not really been available for study. Many of the drawings are difficult to make out, some impossible, and good photographs were not to be had. Some of the legends and most of the numbers under the drawings had not been deciphered.[1] The present edition should go far to remedy these matters. But simply to supply better reproductions and careful descriptions of the drawings and a full transcript of the legends and numbers would leave the emblems unavailable in a third respect, that is, as a series or several series, a work of fifty-odd emblems in several variant arrangements, which preceded and precipitated into another work, *The Gates of Paradise*, two-thirds smaller and of a different structure and character.

If Blake wrote the number '5' under four different emblems, as he seems to have done over the period of months, perhaps years, during which he was trying all arrangements, how are we to deduce which was his first choice, which his last, or what he meant to do about the others when he had made that last choice? There is a good deal of evidence for making such deductions, but much of it defies reduction to simple presentation. It would take a long book to write out the step-by-step pacings of the summertime of concentration I have given to the sifting of clues and indications which have led me to the conclusions charted in Table V, which traces the paths of all the emblems through four Notebook series and thence into *The Gates*. There remain lacunae, of missing numbers and missing emblems or both, but the tabulation is sufficiently certain and sufficiently extensive to give fairly full reconstructions of Blake's first numbered series of emblems and his last and of the successive re-arrangements in between. Yet this table alone hardly makes the information available in any tangible form. In the pages that follow I attempt to acquaint the patient reader with the emblems and the enigmas in them and with something like their magnetic fields. When we look for the effect of arrangements and rearrangements of series of emblems, the question at each juncture is, What is now the

[1] The imperfect report of emblems and emblem numbers in Keynes, *Gates*, i. 41–6, hardly suggests the possibility of the present reconstruction of the series. Five numbered emblems are reported as unnumbered, five as bearing indecipherable numbers; seven sets of numbers are erroneously reported, ten incompletely; four numbered emblems are not even listed. Yet my own review, in *English Language Notes*, vii, Supplement (1969), 22–3, was premature and not free of inaccuracies.

effect of this enigma on that enigma when Blake puts them in direct juxtaposition—or moves them apart? It can be ironic, reinforcing, contrastive, disjunctive, enriching, reductive. A changed position in a chain of emblems can affect the legend of a given emblem (the verbal part of its enigma) as well. The communicative possibilities of fifty emblems in a row differ from those of seventeen; both reach to infinity.

What 'Children' and 'the Sexes' find in these series will depend on many things; yet there can be valid and invalid readings. Any talk about the emblems requires a common denominator of validity, and I have tried to hold to readily verifiable or descriptive interpretations and to indicate patterns and salient motifs without closing any doors. Our interest in these drawings increases as we discover that some of the graphic images of the *Songs of Experience* were developed in them, the sickbed scenes progressing to the deathbed or mortuary scene that became the mortal half of the *Songs* title-page, for example. But it is more to the immediate purpose to keep in mind the major irony of the ultimate emblem series, *The Gates of Paradise*, that our access to what Blake called the sports or fires or 'realities of intellect', that is, to life, is through acceptance of death as corporeally inescapable, hence not worth fearing. In the full Notebook series of emblems reminders of every conceivable manner of dying meet us at every turn as if to eliminate the illusion that we should worry about any kind of death but mental.

THE EMBLEMS BEFORE NUMBERING

The first emblem series we have is the fullest but the least structured; it is simply the sequence of emblems as they occur in the Notebook from page 15 to page 101. We might try to make something of what evidence there is of their order of composition; we might take the recto emblems first, then those on verso pages, and we might attempt to refine such evidence into a tentative chronology. Yet it is wiser to assume that the sequence in which Blake placed them is the best guide to his intent. Until he resorted to other sequences by giving them numbers, their only signified order is that of occurrence. And in our first survey of this sequence it will do no harm to include all the small oblong drawings in the centres of pages.[1] That he failed to number some of them may not mean that he did not originally consider them emblems. On the other hand, even the most unlikely *looking* drawings, if given numbers in the usual position, must be included. Emblems that we know were not in the Notebook before the first numbering are listed and described, but their late arrival is noted. All the emblems are listed in Table IV with the information about their numbering, and with short captions for ready reference. And for convenience all the emblems have been assigned first numbers indicating their order of occurrence, page after page, in the Notebook. But all drawings, including emblem drawings when desirable, are cited by page and location on the page. Thus, the drawing 15g is Emblem 1; 40a is Emblem 20.

Title (p. 14). 'Ideas/of/Good & Evil'

This title, on the page facing Emblem 1, is partly hidden by the marriage picture added beneath it; yet the drawing serves as a frame and support of the words and obscures only the start of the word

[1] They run roughly to three sizes: (*a*) less than 2 in. wide by $2\frac{1}{2}$ to $2\frac{7}{8}$ in. high, (*b*) $2\frac{1}{2}$ in. wide by $2\frac{3}{4}$ in. high, and (*c*) $2\frac{1}{4}$ by 3 in.; but I have found no meaningful grouping of these. A few drawings are larger which are numbered as emblems and must be included.

'Good', perhaps accidentally, perhaps with ironic intent. The suggestion of a *marriage* of contrary ideas, a marriage of 'Good & Evil', affords guidance to a peruser of the emblems.

(Outside the Notebook, for his series published in 1793, Blake hit upon the title 'For Children: The Gates of Paradise' as a proper guide to pictures of various swift or slow paths and doors to Death. Was it just a bit earlier, perhaps, that he designed on an emblem-sized slip of paper—when he was making *The Marriage of Heaven and Hell*, perhaps—a title-page that reads: 'For Children/ The Gates of HELL'?)[1]

Emblem 1 (p. 15). 'Thus the traveller hasteth in/the Evening'

The traveller strides to the right (but westward if it is 'Evening'; his shadow suggests strong sunlight in mid afternoon) alongside a forest. He wears a brimmed hat (repeated in Emblem 2 and echoed in 4) and a tail coat and uses a staff (seen again in 2 and perhaps in 24). His destination is revealed in the next emblem. (A preliminary sketch of his striding legs is on page 13; see page note. For hints from Bunyan and from Wynne's emblems, see above, p. 9.)

(Used as *GP* 4, with the same legend—minus 'Thus'—and with this 'Key' in 1818: 'Thro evening shades I haste away/To close the Labours of my Day'. In the engraving the forest is larger, but the outlines of man and shadow are unchanged.)[2]

Emblem 2 (p. 17). 'Are glad when they can find/the grave' [Job 3:22]

The clothed traveller steps into Death's doorway, gesturing bravely in the face of a conventional bony, skull-faced Death (whose cowl we shall see again in Emblem 24).

The drawings on page 16, between Emblems 1 and 2, show the traveller readying his hand for this gesture. If it is a defiance of death, it is likewise a glad greeting to wife and children, already in the doorway. Nevertheless on all three pages, 15, 16, 17, visions of man-eating men haunt the scene.

Emblem 3 (p. 18). Below a machicolated tower a damsel on her knees implores a mounted, helmeted knight. (Keynes, *Gates*, i. 41, thinks there may be 'a child in her arms', but the dark patch in the drawing is no larger than clasped hands: see tracing, Fig. 1, Appendix II.) Will he listen and turn back? We must invent our own story.

The knight is a kind of traveller; otherwise scene and theme have changed, as they do again abruptly with the next emblem.

Emblem 4 (p. 19). 'Ah luckless babe born under cruel star
 And in dead parents baleful ashes bred
 That little weenest now what sorrows are
 Left thee for portion of thy livelihed
 Spenser' [*Faerie Queene*, II. ii. 2]

The legend (all written over an erased earlier inscription) can apply to each: the unweening boy (his hat an image of the traveller's), the human butterfly he has struck, the one who is escaping—and the reader. Emblematically the two female infants can represent the mortal and the immortal; the

[1] Reproduced in Keynes, *Gates*, i. 41.

[2] Spots of glue that held tracing paper show that Blake made a tracing of this emblem from *N*. The identity of outline in the final engraving shows that he used the tracing, turned back to front to avoid reversal of direction in printing.

encounter can be one between Cupid and Psyche.[1] But when the motif reappears in *Night Thoughts* 182 and 441 we are shown that an alteration in the gesture of the pursuer from grasping to greeting can open a Moment to Eternity.

(Used as *GP* 7, with slight changes; legend, in 1793, 'Alas!', amplified in 1818 to 'What are these? Alas! The Female Martyr/Is She also the Divine Image', and given this Key: 'One Dies Alas! the Living & Dead/One is slain & One is fled'.)

(Page 20 contains a small drawing not counted here among the emblems. On a verso page and hence not necessarily a part of the original series, it appears to be a picture of much later date than the series—because of its design and because of its symbolism; both are close to the late Job illustrations, not to the single early Job pictures. The symbolism of gesture seems more highly symmetrical and 'coded' than in the emblems of 1793 and earlier.)

Emblem 5 (p. 21). 'Every thing that grows
 Holds in perfection but a little
 moment Shakespeare' [Sonnet 15]

In the large blossom of an anemone, Adonis' flower,[2] reclines a boy who looks up at a flowery-haired girl whose arms stretch wide and whose hands are like anthers (perhaps: that would mix the genders of stamen and pistil, but the possibility, in Blake's loves-of-the-plants, is not to be ruled out). Miss Raine impetuously describes the two as in an embrace; they will be so in the *next* moment—for which see the title-page of *Thel*. For the moment after that, when Adonis-Cupid turns into a worm, see, alas, the illustration of 'The Sick Rose'. (My 'alas' is meant to emphasize the interaction of this and the preceding emblem: in the next we are shifted to domestic love.)

It may be possible to recognize nuances tying this flower-bedded couple to the *Morning after Marriage* couple emerging from the domestic sheets of page 14. Is there insouciance in the elbow-resting of the male, the arm-stretching of the female, or ennui? Gillray's male (Hogarth's female) is deeply bored. The Emblem 5 'moment' can thus also bear interpretation as the moment *after* 'perfection'. A point to notice is the *enigmatic* perfection of the emblem itself.

Emblem 6 (p. 22). At the right a young man kneels at the feet of a maid who looks down at his imploring hands. (Compare Emblem 3.) Perhaps she weeps. It must be her father, at the left, who walks away with hand to head. (See Figs. 2 and 3, Appendix II, p. 77.)

This begins a domestic narrative that reappears in Emblem 8, with a symbolic emblem between. (But two emblems, on two recto pages, may be missing here, if two leaves after page 22 were removed, as seems likely.)

Emblem 7 (p. 23). A bird is outside and a small boy inside a birdcage hanging from a bough. Alas! The boy's hands cover his face. There is a suggestion of the sorrows promised the luckless *boy* of Emblem 4. (That the figure in the cage is a boy is confirmed by Emblem 50.) The ornamental corners

[1] Keynes notes that the motto is from a stanza of *The Faerie Queene* which bewails 'the state of men', beginning in woe and ending in misery, and that it is applicable to the whole series of emblems.

[2] Kathleen Raine, *Blake and Tradition* (1968), i. 107, calls this flower 'indeterminate—not, certainly, an anemone', yet compares it to the flower in the title-page of *Thel*, which on pp. 104–5 she demonstrates clearly to be the pasqueflower, *Anemone pulsatilla*. The leaves clinch the identification in *Thel*; the blossom in *N* is like the blossom there, though no leaves are shown.

imply an expensive cage, perhaps a golden one.[1] There is also a suggestion of a cupid caged *away from matrimony*, in the context of Emblems 6 and 8—though the closeness of Emblem 6 may be accidental (see above) and Emblem 8 may be an afterthought.

In *Night Thoughts* 490 such caging signifies repression of 'Imagination's airy Wing' and locking up of the Senses. Behind these emblems is the tradition represented in the picture engraved for Francis Quarles's *Emblemes* (1635), Book 5, Emblem X ('Bring my soule out of Prison that I may praise thy Name'); see Fig. 40, Appendix II. There the caged soul is seen in human form, the soul released in that of a bird; for Blake the bird signifies the potential, but the released spirit is a fully human form, naked even of wings (see Emblem 50).

Emblem 8 (p. 24). (Not in the first numbering.)[2] Three standing figures, among trees, recall the three of Emblem 6. The father, now grey-haired, with outstretched arm orders away the young lovers (dressed as if for a wedding?). The girl looks back; the boy turns away as the father had done. (The branch of a tree behind the father's arm can be mistaken for a rod in his hand; Keynes, *Gates*, i. 42, disregarding the modern clothing, sees 'the expulsion of Adam and Eve from the Garden of Eden by an angel with a sword'.)

Emblem 9 (p. 25). Plague or the Black Death has seized three women, one supported by a young man, one by an old woman, at the doorsteps (an ironic Death's door) of a Palladian town house.

(Three of these figures, the young couple and the frantic woman in the centre, reappear in *Europe* 7, beside a solid oak door in a brick wall, in the street with a sad bellman.)

Emblem 10 (p. 27). Death after battle. The English Civil War is suggested by the 'hollow states' in the legend from Milton's 'To Sr Henry Vane the younger'. The drawing is faint, but variant versions, from 1784 to 1805, two called *A Breach in a City* (see next emblem) and one called *War*, clarify the details. A fallen warrior is mourned by a standing woman and man; an eagle perches on the left side of the broken wall; in the background a lone figure searches the battlefield. (See tracing, Fig. 5, Appendix II.)

Emblem 11 (p. 29). A gowned female hovers, her hands expressing concern, over a fallen male. War (Emblem 10) thus separates the soul and body of perfection (Emblem 5)? A narrative sequel to Emblems 6 and 8?

The man's posture is perhaps of sleep, not death (though symbolically, of course, this would always be an implication). A very similar separate drawing (Keynes, *Drawings*, Pl. 40) gives the fallen man a crown of leaves, identifying him as a poet, a lyre under his right hand, and a tambourine at his side (possibly intended by the not very round loop at the man's side in the emblem). Compare also the women and fallen warriors in *A Breach in a City the morning after a battle* (1784) and in the frontispiece and title-page of *America*; also *MHH* 14.[3] For a contrary vision, see the lost traveller under the hill and under a bat-like Satan in the 1818 tailpiece of *GP*.

[1] On the golden cage and all Blake's cupids and psyches, see Irene Chayes, 'The Presence of Cupid and Psyche' in *BVFD*.

[2] Possibly Emblem 8 was not present in *N* (it is on a verso page) until Blake's second numbering, when it was numbered 18 to replace Emblem 51; yet since its immediate sequel is Emblem 11 in that and later numberings, and since Table V shows a blank in the position above Emblem 11 in the first numbering, it may have been drawn while Blake was still working out his first series and may have been intended for that position (number 23).

[3] *MHH* 14 was entitled 'The Body of Hector' on the fly-leaf (no longer extant) of Copy A, probably by George Cumberland, its first owner.

Emblem 12 (p. 30). 'A fairy vision of some gay
creatures of the element who
in the colours of the rainbow live
Milton' [*Comus*, 298–300]

Four weightless fairies dance at all angles in an open circle, against a white cloud. This 'vision' that is human and unambiguously 'of hope' heralds the next emblem.

These dancers reappear in the *VDA* title-page, at the bottom of the rainbow; at its top the sorcerer of Emblem 52; below them the running naked woman of Emblem 47. In *NT* 520 the dancers, as mortal joys, are shown being drenched in rain from the sorcerer's cloud. (Compare the water-colour *Oberon, Titania and Puck with Fairies*; also *NT* 205.)

Emblem 13 (p. 31). A Soul entering death's door: a gowned female, seen from behind, arrives on a cloud at a squared doorway and greets two figures (angels perhaps) with gestures that complement the traveler's in Emblem 2. Will that be God's head, in the center?

Earlier (I believe) and later variants clarify the sketchy details. In the earlier (Fig. 43, p. 97) the angels look like women, the central circle is a shining (spiritual) sun.

Emblem 14 (p. 33). Beneath curtains that slant like rain lie two ailing parents; beside the bed we see a coffin, at the right, and a mother kissing her newborn child, at the left.

Emblem 15 (p. 34). (Not in the first numbering.) 'My son My son' [2 Samuel 18:33]

The rebellion of youth against age brings in a new topic. We may note that King David, like the father in Emblem 6, turns away with hand to head; that his dismissing hand is like the father's in Emblem 8. His son Absalom, striding westward like the traveller, turns back in violence. There is a sense of the sudden reversal life may take.[1]

(Used as *GP* 8, with the legend punctuated 'My Son! my Son!' The 1818 Key reads: 'In Vain-glory hatcht & nurst/By double Spectres Self Accurst/My Son! my Son! thou treatest me/but as I have instructed thee'. The direction is reversed, the son's weapon is a dart or javelin, and the father's outstretched right hand grasps a huge sword—of which only the hilt is discernible in the Notebook emblem. Keynes adduces the relevance of *PL* II. 728–30, assuming it is the mother (not shown) who cries 'my Son!')

Emblem 16 (p. 35). Christ, borne on a cloud, with children at each hand—a vision of tender care frequent in *Songs of Innocence*.

After the emblems of Plague and War (9–11) we have been cheered by three visions of Peace, the rainbow dancers and the Saviour of Emblems 12, 13, 16. Even the coffin of Emblem 14, in this context—and ignoring the later emblem, 15—is ambiguously the grave of age and the cradle of infancy.

Emblem 17 (p. 36). 'As Daphne was root bound
Milton' [*Comus*, 660–1]

[1] J. E. Grant notes a possible source in Vasari's fresco *The Mutilation of Uranus by Cronos*, in the Palazzo Vecchio, Florence, reproduced in *Larousse Encyclopedia of Mythology*, Intro. Robert Graves, London, 1959, p. 90.

This vegetable metamorphosis of human form is the fate imposed by wand-waving Comus upon the lady who would run (like the female martyrs of Emblem 4) as Daphne did who 'fled Apollo'. To be thus transfixed in response to energy (compare the councillors 'art-bound' in *America* b 14) is a kind of dying; in this state 'Half-life, half-death join', according to the text similarly illustrated in *NT* 257.[1]

Emblem 18 (p. 37). Another curtained sickbed, with the whole family (of five) pyramided above the victim; yet this time there is no coffin, and the sick person, a girl, has a book to read.[2]

Emblem 19 (p. 39). A child's sickbed, close to the floor, with kneeling mother and weeping sibling; but hope arrives in the form of a doll or dolls carried by a man who walks in the open door. His turban and swirling cloak suggest Persia or India.

Emblem 20 (p. 40). (Later than the numbered emblems.) A young man has begun climbing a ladder that reaches a crescent moon; two stand watching. The curve of the earth, as drawn behind the ladder, shrinks the distance by an act of artistic vision. (Cf. Fig. 38, Appendix II, p. 90.)

(Used as *GP* 9 with the legend 'I want! I want!' and the Key, in 1818: 'On the shadows of the Moon/Climbing thro Nights highest noon'. In engraving, the direction of the ladder has been reversed but the moon is kept a waxing crescent. The climber is given the traveller's hat, and he looks over towards the two watchers, dressed as man and woman, who embrace each other. The woman points or waves toward him. The message of this climbing can hardly be futility. *NT* 130 gives a nearer view.)

Emblem 21 (p. 41). Parents embracing maiden and youth at a Gothic door, a composite vision of hope and life; a prodigal's return welcome and a happy new beginning for all the rejecting parents and unhappy girls and boys of preceding emblems. Crossed tree trunks, a *Songs of Innocence* motif, repeat the embrace.

(It will be noticed that these domestic emblems are not highly organized as symbols but rather invite interpretation as illustrations of a narrative. Yet even these serve as apperception tests, like the aphorisms of Lavater to which Blake in 1789 responded with open heart. One viewer can fear What May Happen Next, another be full of hope.)

Emblem 22 (p. 42). A bearded man, leaning dramatically on his crutch, is lecturing a spider—not (*pace* Keynes) trying to 'catch a butterfly hovering just beyond'. (The creature has many legs, no wings, and hangs by a thread.) Is it death's spider? Is a bare stage intended?

Comparison to *NT* 26 is suggestive. There a similar old man reaches toward a butterfly. It is flying upward, and the man is lunging—a contrast to the horizontal stasis of the emblem. And the lunging man's hand is, symbolically, trying to 'catch' the butterfly (i.e. impose death upon it) by measuring it as a span (reducing the infinite potential of its flight to mortal span). The man in Emblem 22 is neither lunging nor 'spanning'.[3]

[1] This emblem-sized drawing (36b) seems earlier than the more finished and frame-less version (12a). Both are on verso pages, however, and unnumbered; perhaps neither was intended for the emblem series.

[2] Compare the Book carried by Christian in Bunyan's dream, e.g. in Blake's second illustration for *Pilgrim's Progress*.

[3] Possibly the creature in Emblem 22 *is* meant for a butterfly; if so, the action (not identical to *NT* 26 but a horizontal preliminary to it) would be an aged parallel to the girl-hunting of Emblem 4. On spanning, see note 2, next page.

Emblem 23 (p. 43). Death has turned the sick in bed to statues; this bare, stiff, and squared picture is the climax of the sickbed, deathbed emblems, and grief is turning the children stiff also.[1] Contrast the prosperous, tiptoe rejoicing of Emblem 21.

(Used in the lower, 'Experience' half of the title-page for *Songs of Experience*, direction reversed. In the upper, 'Songs' half, Blake will add visions of hope.)

Emblem 24 (p. 45). 'I have said to corruption thou art
 my father. to the worm thou art
 my mother & my Sister
 Job' [17:4]

The parents and children of Emblem 23 have said this, and stiffened in their fear, but we are ready to see with clearer eyes the human form of natural death. The cowled skeletal Death of Emblem 2 has here taken on flesh; the worm, coming out of the earth beside three human heads, spirals loosely (like vine around elm) around the sitting figure—behind whom death's door is not of squared stone and hewn wood but a natural cavity beneath trees or roots. A staff *belongs* in her right hand since there is one in the engraving and also in the earlier water-colour (reproduced in Keynes, *Gates*, i. 39); it is barely perceptible in the drawing.

We have come to one of Blake's perfect enigmas. This sibyl will let the traveller see himself, his hopes and fears. And in that sense Keynes is metaphorically right to allow himself to see an 'androgynous figure' here representing the traveller 'dead . . . his staff still in his hand, enveloped in his winding sheet', even though Keynes himself notes that the earlier water-colour drawing is 'clearly that of a woman, having long hair with ringlets escaping from the hood over her head'. The staff can be read as an emblem of mortal dependency, variants being the traveller's staff (Emblems 1 and 2), the old man's crutch (Emblem 22), and the weapons of father and son in Emblem 15.

(Used as *GP* 16, with legend reduced to 'I have said to the Worm, Thou/art my mother & my sister'; expanded in the 1818 Key to: 'Thou'rt my Mother from the Womb/Wife Sister Daughter to the Tomb/Weaving to Dreams the Sexual strife/And weeping over the Web of Life'. Dramatic shifts of meaning will be noted in Blake's shifting of the position of this emblem in his different numberings.[2]

Emblem 25 (p. 46). 'Murder'

An assassin enters the deathbed scene of Emblem 14, with curtains and coffin, to hasten things. His shield indicates a warrior; his backward glance a hireling who looks offstage to some master for direction—or a sneaking villain apprehensive of apprehension. A similar hireling murderer, with shield, appears in *NT* 481.

Emblem 26 (p. 47). Four naked figures, with hands held free, show that upward flight is possible. They seem just barely to avoid collisions; they are humans, not fairies and not necessarily gay (though

[1] Keynes, *Gates*, i. 43, sees in the emblem only 'the body of their father lying on a bier', but both parents are visible in *N* as well as in the final plate.

[2] See below. This sibyl appears in *America* 14, where her worm, become a serpent, takes a phallic position; she has become a partisan instructor of superstitiously pious youth, and her message to a young man is the mere span of life, indicated by the gesture of her right hand: it measures him for a grave. A source or analogue has been noted in the second compartment of the Portland vase (engraved by Blake for Darwin's *Botanic Garden* in 1791, reproduced in Raine, i. 131). There a woman with a serpent in her lap welcomes a dead traveller who has entered the columned door of Hades.

the gesture of the one on the left is that of 'Joy' in H1 q). Coming after Emblem 25, are they souls released by Murder?

The bodies are difficult to distinguish. The tallest is in the centre facing us, and we see his knees and legs beneath a more curved and soaring figure whose head hides his jaw. Both have their arms outstretched (and redrawn once or twice); with a slight veering they could embrace. The other two, much smaller figures, one facing us with arms up and together, the other facing away with arms up and palms spread, repeat in their body angles the respectively stiff and curved bendings of the other two. We may be expected to see the larger two as man and woman, the smaller as boy and girl; a family of free individuals, none regarding the others.

Emblem 27 (p. 48). This small version of Nebuchadnezzar is of emblem size, and a curious variant of the one on page 44 destined for *MHH* 24. A horizontal traveller beneath trunks of trees.

Emblem 28 (p. 49). Here is the original Murder story: Abel outstretched, Cain clutching his head; a moment later he will travel fast (as in *The Body of Abel found by Adam and Eve, with Cain Fleeing*; cf. Keynes, *Drawings*, Pl. 47).[1]

Emblem 29 (p. 50). Self-murder: a naked man, teetering in his travel, points the dagger toward himself. Yet he turns his whole face up to heaven. This is both ironic and enigmatic. Self-slaughterers do not soar to heaven, according to the code cited in the legend of Emblem 61; yet up is the direction of Christian hope and imaginative restoration. The emblem can represent the conquering of the mortal Self. Cowper is the example later given in Poem 130, added beneath the picture (and subsequently erased, with the probable erasure of the emblem's legend and numberings).

(A diagram sketch of this gesture is labelled 'Suicide' in H1 g [Fig. 32, Appendix II], and a metaphorical variant occurs in *NT* 411.)

Emblem 30 (p. 51). Five fairies dance in a closed circle, to the music of a serpent-trumpet blown by a sixth sitting on the bending stem of a flower, under a crescent moon that is uncertainly waning or waxing. This imitation of Judgement Day could welcome the self-murderer either way, whether conquering or conquered by despair. (Reversed, the serpent-trumpeter appears in *VDA* sitting merrily on the *V* of 'Visions' in Pl. 1.)

Emblem 31 (p. 52). (Later than the numbered emblems.) 'Aged Ignorance'

Sedentary age with the shears of Atropos will clip the wings of the hastening traveller and transform his rising to a setting sun. (A variation on the traditional emblem of Time clipping the wings of Love.)

(Used as *GP* 11, with legend 'Aged Ignorance', an additional line in 1818, 'Perceptive Organs closed. their Objects close', and the Key: 'Holy & cold I clipd the Wings/Of all Sublunary Things'.)

Emblem 32 (p. 53). A figure soaring from right to left with lowered arms—perhaps; there is an ink smudge on top of the erased drawing.

[1] A variant of the Cain story is the brief cryptic account of Lamech in Genesis 4: 23–4. Blake's colour print *Lamech and his two Wives* (1795) (Keynes, *Bible*, Pl. 17a) draws upon Emblem 28 for the position of hands clutching head.

Emblem 33 (p. 54). The ageing traveller on crutches has eager eyesight and face; he accepts the confident guidance of youth.

(Used in 'London', *Songs of Experience*.)

Emblem 34 (p. 55). A child kneeling at the lap of a woman (nurse or mother) seated in a chair, within a cloister. The message, even in this slight sketch, is clearly of hope. Note the balance of girl and woman with the boy and man of Emblem 33.

(For the title-page of *Songs of Innocence* the woman will move her chair to the orchard, and the child, a girl, will be shown reading the book of life, assisted by a boy. Later we are shown children learning at a woman's lap in *NT* 6 and 290 or learning at Christ's lap, without need of book, in *NT* 376 and 527–8.)

Emblem 35 (p. 56). On an abrupt cliff above jagged rocks a girl with long braids is poised, held by someone's firm grasp on her left ankle. A suicide attempt—or the terrified flight of youthful ignorance? Erased, alongside the clutching hand, is a heavy sword directed at her vitals by another firmly grasping person—or the same one? (Compare *NT* 224, 258; also 196.)

Emblem 36 (p. 57). A naked figure, looking leftward, half reclines on a divan-like scroll among clouds and stars, the face in profile, hair apparently short. The scroll that forms both couch and arm-rest resembles the scroll in *NT* 5 which forms a similarly reclining poet's writing-desk and couch, in one. It is thus tempting to identify this figure as 'the Bard' who is hailed in the 'Introduction' of *Songs of Experience*, a poem illustrated by this design with little change except reversal of direction. (Keynes once held this view; I argued it in a note in *BVFD*, in the first edition of this book, and in *The Illuminated Blake*.) Yet the etched figure is, in many copies, clearly female, with a long strand of streaming hair (lightly indicated even in the drawing; obscured by a large spherical halo in copy Z) and with thicker hips than, e.g., those of Blake's self-portraits in *Milton*. (The sphere is a proper halo for earth; in copy V the curling end of her scroll-cloud is given a spherical shape). Dawn is suggested in the text and sometimes by colouring. I have come to agree with Sir Geoffrey and Professors Grant and Hagstrum that the drawing anticipates the female defined in the 'Introduction' poem as 'the lapsed Soul' and metaphorically equated to a female 'Earth' and the rising 'morn', Her half reclining, half turning symbolizes a dawning response to the Bard's appeal to 'Arise' and 'Turn away no more'. Between Emblems 35 and 37, emblems of death sought and help sought, this emblem suggests pause and reversal from death to life, fear to hope.

Emblem 37 (p. 58). Death by drowning, desperately resisted. All we see is a hand stretched above the waves.

(As *GP* 10 this figure, given a head and an oddly bloated or apple-shaped belly, bears the legend 'Help! Help!' and the Key: 'In Times Ocean falling drownd'.)

Emblem 38 (p. 59). Death in life: the Ugolino family in a prison vault with no key, where they are to starve to death.

(In the engraving, *GP* 12, the suggestion of a window in the door is muted; the legend reads 'Does thy God O Priest take such vengeance as this?' and the Key: 'And in depths of my Dungeons/Closed

the Father & the Sons'. 'Ugolino', observes Keynes, *Gates*, i. 18, 'has become the symbol of spiritual starvation.')[1]

Emblem 39 (p. 60). The woman halted in flight, like the girl on the cliff edge in Emblem 35 but on firmer ground, might be crying Help but has her lips tight. The dark man clasping her has his face buried in her neck. Is this what the 'perfection' of Emblem 5 'grows' to?

Emblem 40 (p. 61). 'What we hope we see'

If we have sought out the positive in the preceding emblems, we already have the idea. This vision picture controverts all the sickbed/deathbed scenes but is particularly directed at Emblem 23, where the young were looking at the body without thinking of the soul. Also note that the hands of these direction-reversing mourners are as tense with excitement as the hand of the traveller laughing at Death in Emblem 2.

(In *GP* 13 the sketched ovals behind the woman's shoulder emerge as children's faces; the legend is 'Fear & Hope are—Vision'; the Key reads: 'But when once I did descry/The Immortal Man that cannot Die'.)

Emblem 41 (p. 63). 'I found him beneath a tree in the Garden'

As Emblem 40 contradicts 23, so this disputes the legend of 24. If infants are 'found', it is anyone's guess where they have come from—or will go to. Only in despair did Job learn to 'call' the grave his mother; clearly 'mother' is an adoptive fiction. (The legend was written only after the two numbers, and after their erasure.)

(In *GP* 1 the legend omits the phrase 'in the Garden'; the Key is so elaborate as almost to replace emblem with poem:

> My Eternal Man set in Repose
> The Female from his darkness rose
> And She found me beneath a Tree
> A Mandrake & in her Veil hid me
> Serpent Reasoning us entice
> Of Good & Evil: Virtue & Vice

—yet the initial 'Ideas of Good & Evil', now less enigmatic than doctrinally ironic, still can be considered central.)

The elderly heads in the ground beside the sibyl of Emblem 24 are, by this plucking of forked-radish 'Mandrakes', exposed as mere cyclic perpetuation of the same Eternity-denying wives' tale. (For a contrary version, see *NT* 4.)

Emblem 42 (p. 65). Infant boy wooes big girl by tugging at her arm—which, from her end of the arm, is signalling Begone. Drawn in wash as a sort of companion to the mandrake emblem, this explodes another romantic fiction, that Love is an angel who comes to a lovesick maiden among the tall shrubs, disguised as a naked little boy. (For the ironies that evolve, see 'The Angel', a Song of Experience perhaps suggested by and ultimately illustrated by this drawing.)

[1] For the English 'Transformation of Dante's Ugolino' before Blake, see the article under that title by Frances A. Yates, *Journal of the Warburg and Courtauld Institute*, xiv (1951), 113.

In the context of the Notebook emblems, we see a clothed girl repeating the half-reclining posture of the naked boy in the blossom of Emblem 5, having attained the ennui of the Morning after Marriage even before courtship. Yet in an inverted way, for she stares too exclusively at the earth.

(On page 66 a large drawing, not the shape of an emblem and not numbered as one, seems to repeat the motif of Emblem 42, but with two figures, on a cloud, who both appear to be men. The person reclining appears to be reading a book, or writing. The other, not a boy but an adult, is kneeling almost astride him and looking up with arms outstretched in excitement. His fingers, spread like the excited fingers we have seen earlier, are nudging the downward-gazing figure to look up and share his vision; what *that* is, by coincidence or joke, is a large left profile of William Blake! In some sense this curious cloud-borne picture is a link between the half-reclining figures of Emblems 5 and 42 and the alert figure of Emblem 36—compare also *NT* 34, 477, and 531.)

Emblem 43 (p. 67). Two adults, very sketchily drawn, are walking away from the cloister of Emblem 34.

Emblem 44 (p. 68). 'What is Man that thou shouldst
 magnify him & that thou shouldst set
 thine heart upon him

 Job' [7:17]

A cancelling line is drawn through all but the first three words, probably not before the numbering. 'Frontispiece' is written above, probably only after the first numbering.

('What is Man!' constitutes the 1793 legend of this emblem as *GP* i; in 1818 a couplet is added, 'The Suns Light when he unfolds it/Depends on the Organ that beholds it', and the Key reads: 'The Catterpiller on the Leaf/Reminds thee of thy Mothers Grief'.)

The legend of 1818 conveys an idea about perception implicit in the original emblem, that man's perceptive imagination can see the magnificence of man's genius. The caterpillar gobbling a spinach-like leaf and the human chrysalis lying in state on a beautifully scalloped leaf-shell hint at two possibilities for the eye that beholds these emblems. A brighter enigma within this enigma is open to everyone who knows about butterflies. From the 'worm' we might never guess the magnificent potential, but the baby's face on the sphinx-like chrysalis reminds us to dream of rainbow wings. Simply, the mortal worm using a leaf for food indicates one way of perceiving life; the immortal infant on his scrolled couch, another.[1]

Emblem 45 (p. 69). (Not in the first numbering.)
 'At length for hatching ripe he breaks
 the shell
 Dryden' [*Palamon and Arcite*, III. 1069][2]

The promised metamorphosis is imaged here: wings on the infant human, the shell breaking. The awkward cupid of Emblem 42 comes better equipped this time. The breaking of the shell prefigures the breaking of coffins and tombs, Ugolino's and the others', a universal gaol delivery.

[1] In *NT* 17 we are shown a hybrid, the human grown old but still a worm.
[2] Keynes, *Gates*, i. 14, suggests reading the whole passage from Dryden's version of Chaucer's *Knight's Tale* for a Boethian perspective on *GP*.

(Used as *GP* 6, with legend unchanged. The Key reads:

> I rent the Veil where the Dead dwell
> When weary Man enters his Cave
> He meets his Saviour in the Grave
> Some find a Female Garment there
> And some a Male woven with care
> Lest the Sexual Garments sweet
> Should grow a devouring Winding sheet

This recapitulates in words the images of emblems that have shown the veil or cowl of Death (2 and 24), travellers entering artificial and natural caves, weary (recall all the sickrooms), meeting the Saviour (13 and 16), and entering sexual garments without care enough to distinguish growth to perfection from growth to stasis or to tell wedding clothes from cerements. Many of these emblems had been eliminated, of course, long before the verses were written; the verses of 1818 reintroduce, as it were, the multeity of the original Notebook series of emblems before they were rarefied into the engraved seventeen of *GP*.

Emblem 46 (p. 71). 'Deaths door'

Age on crutches enters a squared stone doorway, his garment drawn inward by a strong wind. Is this stone wall the eggshell, the door its breaking? Is the hatching of Emblem 45 the *next* stage, i.e. is this where the confident child of Emblem 33 leads trusting Age? Is he to go in the same direction as the bearded soul of Emblem 40, namely Up?[1]

This is the central 'What next?' emblem. Blake found it so powerful that he designed another windy doorway for the frontispiece of *Jerusalem*, replacing the lintel with a Gothic arch and the aged traveller with the youthful one of Emblem 2 and his staff with a globe of fire.

(Used as *GP* 15, with the same legend. The Key reads: 'The Door of Death I open found/And the Worm Weaving in the Ground'—but this line about the worm applies to *GP* 16, Emblem 24, not placed near Death's door until the engraving of *GP*.)

Emblem 47 (p. 72, partly cut away). We come at once to storm-tossed waters, with a naked woman running along the wave crests, illuminated by a sun half risen (or setting) on the leftward horizon. Is the figure whose legs appear behind her rising in hope or descending in menace? The legs may be those of the conjuror of Emblem 52, who is far above this girl, Oothoon, when both appear on the title-page of *VDA*. Or they may be a simpler human form of Urizen as bombing plane—the image is accurate—roaring close above her there. The sun must be rising if it holds the same message as the rainbow that replaces it in *VDA*.

(*NT* 81 shows a similar running girl—'Sense', who 'runs Savage thro' the wilderness of Joy', about to be 'smother'd by the Pall' of Reason.)

Emblem 48 (p. 73). 'Yet can I not perswade
 me. thou art dead
 Milton' ['On the Death of a Fair Infant', V. 29]

[1] An object faintly sketched just inside the door may be an abandoned skull or head, but it is not used in *GP* 15. In the 'Death's Door' variant in Blake's Blair a roll of bedding is visible.

Though born in the Garden, the infant is coffined in this bare, stiffly draped room. The stiff-bodied mother cannot persuade herself of death (a hopeful reluctance); yet her found infant is lost as long as she looks downward so grimly, even in pity and sorrow. (Compare the still stiffer mother and infant of 74c, humanized in the 'Holy Thursday' of *Songs of Experience*.)[1]

Emblem 49 (p. 75). 'A vision of fear
 A vision of hope'
(The first line erased.)

These two lines of legend apply uncertainly to the drawings on page 75 (see page note); the drawing chosen and numbered as an emblem is clearly 75e, but perhaps only the second line was felt to apply to it. A man and woman embrace in a huddle (of forgiveness? of reunion?) above a child, anxious-faced, who pulls or pushes the man's right arm. (Keynes, *Gates*, i. 45, sees him 'trying to push the woman away'.) If we view this as the moment fulfilling the joyous expectation of the Commins *Elegy* frontispiece of 1786 (reproduced in Keynes's *Blake Studies*, Pl. 15) we see a returned traveller welcomed by son and wife, their hope fulfilled. In so rough a sketch, facial expressions are the least reliable clues, large body gestures the most. The more finished version of *c.* 1787 (*Drawings*, Pl. 40) establishes this as a vision of hope's fulfilment; a close variant in *NT* 413 shows the lunging figure, as in Commins, to be the man; and another line of development culminates in the more orthodox vision of 'The Meeting of a Family in Heaven', Blake's third design for Blair's *Grave*.

The idea in the inscription, visions of hope and fear, will work better as a series title than the initial 'Ideas of Good & Evil'; see especially the later legends of Emblem 40.

Emblem 50 (p. 77). Good tidings for all the caged and rejected or neglected cupids, including the parent-crowded boy of Emblem 49. The cage door, shut since Emblem 7, is opened at last; the bird is gone, or the boy has become the bird, needing no wings. His flight is directed vigorously toward us, and he recalls the Puck-like boy of Fuseli's Milton Gallery No. 31, *The Friar's Lanthorn*. What he is up to could be a matter for fear as well as hope. Yet he springs through the air like the resurgent child in the tempera *Nativity*. (Compare the Quarles emblem, Fig. 40, Appendix II.)

Emblem 51 (p. 79). A deathbed or bier abruptly confronts us, surrounded by stiffened mourners, adult and child. (See page note.)

Emblem 52 (p. 81). A shaggy-haired naked man with tense crossed legs is on a pillow of cloud from which rain is slanting. He is conjuring with his hands, perhaps to stop but probably to urge on the rain. On the title-page of *VDA* he is less enigmatically, nay unmistakably, supporting the dark side of the storm and almost untouched by the rainbow counterforce. In a separate drawing (Fig. 31, Appendix II), his title is 'The Evil Demon'. His positive contrary is the conjuror in red in the Arlington Court painting, deriving originally from John the Baptist in the frontispiece of *All Religions Are One*.

[1] The marginal drawings (73a–c) of a mother clinging to her infant as it is airborne by an eagle must have been made for Hayley's ballad of 1802; Blake's turning to this Notebook page to make his sketches implies a thematic relevance.

Emblem 53 (p. 83). 'Sweet rose fair flower untimely pluckd soon faded
Pluckd in the bud & faded in the Spring
Shakespeare' [Pseudo-Shakespearian *Passionate Pilgrim*, X. 1–2]

A rich or royal mother, in a throne-like chair, holds a dead infant in her lap. Not unpersuaded of its death, as the poor mother of Emblem 48, but grief-shaken. Yet her hands suggest that she may be calculating while grieving. (Compare the rich mother in *Europe* 6 watching the pot and 'preparing', according to George Cumberland's inscription, 'to dress the child'—a gruesome pun; yet cf. *NT* 28.) The motto harks back to the fading flower legend of Emblem 5.

Emblem 54 (p. 84). Another place to die is on the road on a dark night. Under an uncertain moon (waning or waxing?) a fat man and a lean, bundled in clothing, the lean man carrying a stick or weapon, walk past a fallen man. (The motif, not this drawing, may be related to the good Samaritan sequence in *NT* II and to the hypocrites' walking upon Caiaphas in Dante illustration 44.)

Emblem 55 (p. 85). 'Whose changeless brow
Neer smiles nor frowns
Donne' [*The Progress of the Soul*, st. 4]

Destiny or 'Fate' (so identified in a separate drawing—see Fig. 30, Appendix II—and in *NT* 473) is a bearded impassive man with his legs folded close. His belt may be fastened behind him; his hands and feet are bound by a large chain that loops around a mountain behind him. On the mountain's brow a rakish cloud spins. This emblem is a grim and extremely non-committal way of saying that frowns or smiles depend on the vision that beholds them.

Emblem 56 (p. 87). A boy chasing a flying figure with his hat; a variant or early sketch for Emblem 4. Like a tennis player at his utmost reach, the boy stretches far forward; the flying girl, if it is to be she, is but a wavy cross in the top left corner. (For similar lungers in different contexts, however, see *NT* 46 and 140.)

Emblem 57 (p. 89). Falling children, perhaps because 'It is a land of poverty', if we may take a cue from the use of these images in 'Holy Thursday'. (See page note.)

Emblem 58 (p. 91). 'Forthwith upright he rears from off the pool
His mighty stature
Milton' [*PL* I. 221–2]

(Cancelling line through the first two words.)

Here man attains full youthful vigour and stature; here in a flower of flames 'rears' the naked male who reclined in the flower of perfection in Emblem 5. (It is perhaps no accident that the reclining figure of Satan on page 90, from which Emblem 58 derives, matches the posture of Emblem 5.)[1] Yet naked energy is a warrior; his shield recalls the 'Murder' emblem (25), his spear (only the spot of glue makes it look like a torch) recalls the weapon of Absalom (15). His rising combines the hatching of Cupid, the escape of the caged Puck, and some of the dancing of the fairies; as a vision of hope this

[1] It should be noted that the Satan of the Milton drawings in *N*, drawn *c.* 1790, would have corresponded, sympathetically, to the Devil of *MHH*. Satan had become a different symbolic character by the time Blake painted his other *PL* illustrations. Blake's 1818 revisions of 'Fire' as scaled and blind are adjustments to the later symbolism.

is the unclothed human form of the rising spirit of Emblem 40. Or perhaps he is not rising but plunging forward like Puck; at some stage Blake deleted the words 'Forthwith upright'.

(Used as *GP* 5, where he is first called 'Fire' and first grouped as an elemental or Zoa figure. See discussion below. A second line in the 1818 legend, 'That end in endless Strife', refers back to the 'Cloudy Doubts & Reasoning Cares' of *GP* 4, the Urizenic against which the Orcan rears. The Key reads 'Blind in Fire with shield & spear,' for in 1818 the youth is shown with blind eyes, as well as scales. The next six lines of the 'Keys' survey the progressive import of the first five emblems as presented in 1818. Around this 'Fire' emblem the 1818 *Gates* revolve and evolve into a very different work from the *Gates* of 1793. But we must here focus on the Notebook emblem, even before the deletion of 'upright'.)

Emblem 59 (p. 93). 'Rest Rest perturbed Spirit
Shakespeare' [*Hamlet* I. v. 182]

A titan cramped in a cave or grave of rock has the muscles to struggle for more room—but is using his arms partly to clutch his anxious head. An abrupt contraction from the bold open furnace of Emblem 58. Yet he is more active than the figure labelled 'Despair' in H1 l (Fig. 32, Appendix II).[1]

(As *GP* 3 this emblem is inscribed 'Earth', with the addition in 1818, 'He struggles into Life'. The Key reads: 'Struggling thro Earths Melancholy'. All these seem implicit in the original drawing and motto. The perturbed spirit of Hamlet's father had just been addressed as 'A worthy pioner' who could 'work i' the earth like a mole'. Yet not originally implicit is the import of the legend 'Earth': that our man is the spirit of that element. Possibly this concept only evolved after the female Earth spirit of Emblem 36 had been removed from the series, to be used in the *Experience* 'Introduction'.)

Emblem 60 (p. 94). (Not in the early numbering.)
'Thou hast set thy heart as the
heart of God—

Ezekiel' [28: 6]

Pressing his forehead with clenched hands and peering—at us in 94b, slightly to our left in 94a, sharply to our right in *GP* 4—a feckless naked man seems weighed upon by his cloud throne, even though, like the turning Earth, he is among the stars. The legend is from Ezekiel's warning to the King of Tyre (whom he identifies as the 'covering cherub') for pride in riches and reason. The drawing derives from the Macbeth of 98a, who has set his heart in opposition to Pity.

(Used as *GP* 4, with the legend 'Air' and a second line in 1818, 'On Cloudy Doubts & Reasoning Cares'. The Key reads: 'Naked in Air in Shame & Fear'.)

Blake was accumulating emblems (58, 59, 61 on pages 91, 93, 95) which he may have considered potentially a group of elements, fire, earth, water. Adding this emblem (on a verso page, between the earth and water pictures) made four; yet he did not give this or any of the four an elemental

[1] Figs. 32 and 33 represent the recto and verso of a sheet ($7\frac{15}{16} \times 12\frac{1}{8}$ in. inside matting) inscribed 'Blake' in the hand of W. M. Rossetti, from whose collection it passed to the Harvard College Library (catalogued fMS typ 98 *42M–353). I have designated the drawings a to r and a to n, counting across and then down the sheet. (See headnote, p. 51 below.)

legend until he rearranged and engraved them in the *Gates* of 1793. Emblems 60 and 61 were not available for the first numbering, i.e. had not yet been drawn.

Emblem 61 (p. 95). (Not in the first numbering.)

> 'O that the Everlasting had not fixd
> His canon gainst Self slaughter
> Shakespeare' [*Hamlet* I. ii. 131–2]

This hesitant suicide, startled at what he sees below him—evidently his reflection in a body of water—is not going to destroy himself by taking a plunge but by the Narcissism of immobility. His stomach muscles are up tight; he will sit on this rock under this barren tree until he attains the 'changeless' lifelessness of 'Fate' in Emblem 55.

The original legends of Emblems 59 and 61 (both preceding Emblem 60) suggest that they were conceived together. They focus on moral psychology, not elemental components. (For a simple version of 61 see 'Doubt', H1 a, Fig. 32, Appendix II.)

(Used as *GP* 2 with the legend 'Water', supplemented in 1818 with 'Thou waterest him with Tears'. The Key reads: 'Doubt Self Jealous Watry folly'. Rain is added in the engraved emblem.)

Emblem 62 (p. 97). A lurking assassin clutches a knife (or pistol?) in his right hand; in his left perhaps a cloth, against the weapon. (Yet of the two similar figures in H2 [Fig. 33] it is difficult to say whether this is closer to 'Cruelty' or to mere 'Mischief'.) He sits beneath a large tree and is concealed by shrubbery; behind that is a row of buildings, the first with a tile roof, the second with gable and windows, the third a sort of multiple tower; or perhaps all are one compound. Malevolence breeds an assassin even in a city park, i.e. it is easy (and yet a form of mental death) to become discouraged about civilization.

Emblem 63 (p. 99). (Little but the number is visible; the drawing was erased before being written over in 1792. This indicates a numbering done before the inscription of the poems.)

Emblem 64 (p. 101). (Not in the first numbering.)

> 'Begone & trouble me
> no more'
> [Adage usually applied to 'care']

A man pushes away a woman, who holds her hands to her face. But he is not the old man (bearded) of Emblem 8; the two are more probably of the same age. Something like a string of bells or flowers is wound around the man's left leg. Is he a jester? The legend was familiar as a command to 'dull Care'.[1] This emblem as a finis page (drawn first at the end of the series and returned to that position by the second numbering, as we shall see) may have been intended as a final merry dismissal of all the head-clutching, downward looking, weeping responses that might still linger in stubbornly pessimistic minds despite fifty or sixty tempting or teasing enigmas.

[1] 'Begone, dull Care, and trouble me no more!' must have been a familiar version, though I happen to find it in a Gillray cartoon of later date (1801). A more drab version, 'Begone, old Care, and I prithee begone from me', was common, deriving from John Playford's *Musical Companion* of 1672. Line 6 of Martial's epigram 6, book xi, translates 'Ye pallid cares, far hence away'.

(On page 107, not in the page centre as all the emblems are, is a small drawing that somewhat resembles the sibyl of Emblem 24 but is squatting like the Fate of Emblem 55; not an emblem itself, it may predate them.)

SOME OBSERVATIONS ON THE UNNUMBERED SERIES

Clearly the emblems as they occur in the Notebook do not constitute a tightly ordered series. The abrupt mirth of the final emblem, if I read it right, offers rather an arbitrary halt than a strong closing cadence. When Blake did specify new sequences, his first choice for a concluding emblem was number 10, a breach after the battle; his second was the simple sketch of parent and child that finally went into the title-page of *Songs of Innocence*; his third was the curt 'Begone' of Emblem 64 again. As long as his aim was a series of as many as fifty pictures, he evidently intended neither a solemn conclusion nor a mounting tension. Yet before we go on to the series he achieved by numbering, let us consider the symmetries and asymmetry of the original collection. (In the enumeration that follows I exclude the emblems that were not in the Notebook until after the first numbering; I include early ones that were never numbered.)

Despite some clustering, main themes and motifs are fairly evenly distributed throughout the sixty-odd emblems. Nearly a third of the pictures indicate ways of dying: murder, Emblems 4, 25, 28, probably 35, 54, 62; war, 10, 11; plague, 9; drowning, 37; starvation in prison, 38; suicide, 29, 61, perhaps 35; unspecified sickness, 14, 18, 19, 23, 25, 40, 51, perhaps starvation, 48, 53, 57. Most frequent are the sickbed or deathbed scenes. Nearly as frequent is the motif of the grave (as doorway, 2, 9, 13, 46, 50; cave mouth, 24; prison, 38; cage, 7, 50; coffin, 14, 25, 51; tomb, 23, 51; earth, 24), with some clustering between 7 and 14 and at 23–5, though the traveller's goal, Death's door itself, is held off till 46. The traveller motif, ending at 46 (with a happy epilogue in 49, perhaps), occurs otherwise only in the first three emblems (if we count the mounted knight), in Emblem 27 (Nebuchadnezzar crawling), 33 (age, on crutches, led by a child), and perhaps 54 (man fallen by the wayside), but the range is wide. Travelling is what the body does, but the spirit can rise up, soar, fly; this occurs in Emblems 4, 13, 26, 40, 50, 56 (all upward), in 11 horizontally (soul hovering above body but not rising as in 13 and 40) and 32, in 16 (children and Saviour) and 36 cloud-supported, in 58 ambivalently: the youthful Satan has risen (as Albion rose) but stands on a flaming platform, his spear thrust down toward us and calling on us: the match and contrast with the welcome of 13 is instructive. The motif of gay dancing (fairies or naked humans) appears in 12, 16 (to include the children around Christ), 26, 30, and perhaps 47 (not very gay). The theme of birth, unless we count the flowering of Emblem 5 and the infant at the deathbed in 14, is concentrated in 41, 44, 45 (hatching), with the overtone of another kind of hatching in 46, Death's door; yet metaphors of birth can be found in the opened cage of 50 and the rising or struggling human forms of 58 and 59. The motif of soul and body, implicit in 7 (caged body, flying bird-soul) and in 11, is dramatized in the pivotal emblem 40.

Sexual love and strife are expressed in Emblems 4, 5, 6, 11, 21, 39, 42, 56, and perhaps in 3 and 64; implied in Daphne's rooting in 17. And an interweaving theme of parents and children embracing and confronting carries through Emblems 6, 8, 9, 14, 15, 16, 19, 21, 23, 24, 33, 34, 38, 41, 48, 51, 53, 64.

The validity of our conceiving of the whole series as a single picture gallery, however gradually assembled, is supported by the appearance of meaningful small groupings or juxtapositions throughout; it is further confirmed by the distribution of obviously matching pairs: the boy caged in Emblem 7,

released in 50; the bearded heads in the earth in Emblem 24 matched by the mandrake babes plucked from the earth in 40; the insertion of the motif of 'trouble me no more' (Emblem 64) in the early addition of a serious version of dismissal as Emblem 8.

This summary of the emblems before numbering is intended chiefly as preparation for a study of the effects Blake achieved by the new arrangements his numbers indicate. But I must first try to explain how, from the numbers, it has been possible to reconstruct a first and subsequent series.

BLAKE'S NUMBERING OF THE EMBLEMS

(Table IV, still helpful as a quick guide to the emblems and their locations, will need to be consulted for their several numberings. It is Table V, however, which displays the progression of the whole group—with rejections and replacements—from first numbering to final arrangement in *GP*.)

Some time before Blake got to page 99 with transcripts and new texts of Songs of Experience (working from the back end of the Notebook), he had begun numbering the emblems, for the emblem on page 99 bears the cancelled number '5'. He may not have completed his numbering and renumbering until after all the songs were entered, however, since although Emblem 64 was on page 101 before the songs on that page, no songs were written over it, and its numbering (26, then 50) can have been done at any time. Fifty-three of the emblems have discernible numbers, and the highest of these is 53 (on Emblem 10, page 27), but there are some gaps in the series. Six of the emblems seem to have received their first numbers (indicated in Table V by the use of bold face for each emblem in its first numbered position) only after the trial and rejection of six other numbers (each marked by // at the point of rejection). The first series of fifty-three is thus short by six (lacking numbers 30, 31, 33, 36, 38, 52), while the final series of fifty lacks four (numbers 20, 22, 41, 49). Two late additions, Emblems 20 and 31, lack numbers presumably because they were sketched in the Notebook in direct preparation for their use in *The Gates*, when Blake had already lost interest in the longer series. As for the shortage of six first numbers, two are accounted for by the probability that two numbered emblems were lost when two leaves disappeared after page 22 (as conjectured above), and four by the reasonable supposition that four of the unnumbered emblems had numbers at one time, if only in the artist's head. One of these must have been Emblem 29, for glue spots indicate that it was among Blake's semi-final choices. The surface of the paper below the emblem where it would have been numbered was removed by erasure when Poem 130 was erased. Though no other emblem pages show similar signs of erasure, Emblem 12 must have just missed getting numbered, for it was given a motto from Milton, a sure sign of emblemhood. And the same can be said for Emblem 17. I have failed in attempts to place any of these three in the existing gaps, however, finding no clues in adjacent emblems that might aid in conjectural restoration. (But see Figs. 44–5, p. 98 below.)

For the first numbering, nevertheless, we have now a reconstructed continuum of twenty-nine emblems before the gaps begin and another continuum of thirteen further on. Much can be learned from examining these sequences—and then from following the shifts and new juxtapositions of the second, third, and fourth renumberings, of which conveniently long continua have also been reconstructed. Patient study of these four rearrangements can prepare us for an appreciation of the final drastic selecting and slight further rearranging that produced the engraved series of seventeen emblems that constitute the 1793 *Gates of Paradise*.

THE FIRST NUMBERED SERIES (I)

The most striking effect of Blake's first numbering of the Notebook emblems (given in Table V, column I) is that the whole cauldron has been stirred. Yet the stirring has left several of the original juxtapositions together, a confirmation that the original sequence before numbering was not wholly fortuitous. Within pairs or small sequences, Emblems 1,2; 21,23 (dropping unnumbered 22—perhaps unintentionally, for there is a gap); 41,42; 46,48,49; 51,52; 55,57,58 (56 dropping to 6) remain close together and in the same relative positions. But Emblem 1 (the traveller) has been moved to position 42, Emblem 48 (poor woman with dead child) to position 15; and so on. The boy and girl in the perfect anemone (Emblem 5) and the boy clutching the fleeing girl (Emblem 39) remain far apart (at 3 and 27). But the boy who is in the birdcage in Emblem 7 and free in Emblem 50 is now caged at position 7 but free almost at once at 9 (the intervening number 8 being given to the cloud-borne —and now freeing—Soul of Emblem 36; compare the Quarles emblem in Fig. 38, Appendix II).

Whereas the thematic progress of the original series began with and was defined by the hastening traveller, seen in an apparently simple moment of everyday existence, the first numbered series begins with an arresting conundrum, the double enigma of the caterpillar and cocoon (Emblem 44 numbered '1')—which contains at the same time two encouraging clues to progress, the child's face and the implied butterfly. For opener the caterpillar on the leaf was an excellent choice, and Blake held to it through all succeeding arrangements.

For his second picture Blake would now have Emblem 59, the perturbed, struggling titan in his cocoon of earth. With the chrysalis infant and this seed or flower-bulb of man in earth, we are starting the traveller's journey at early morning instead of afternoon. And at position 3 comes Emblem 5, the moment of 'perfection' in the growing blossom—dividing even in that moment into sexes. (At position 4 Blake probably meant to have Emblem 14, the sickbed that shows the extremes of coffin and nursing infant; placed here it would develop the dualism of the caterpillar and perfection emblems.) Then Emblem 63, the erased sketch, whatever it was. Then the hat-wielding boy (in the Emblem 56 version)—perhaps replaced at once with the version of Emblem 4, the 'luckless' and flying girls chased by the wanton boy, a sex sequel offering a swift leap from marriage flower (Emblem 5) to murder. Next, Emblem 7 in position 7, coming with swift visible justice: a small boy the size of the slain girl is shut in a cage—a birdcage with implications for the girl that flew free (and with whom we may associate the blackbird in this emblem, if we choose).

At this point, the eighth picture, the alerted Soul on her cloud is introduced (Emblem 36), implying perhaps salvation by the Imagination; and lo! in the ninth (Emblem 50) the cage is opened and the bird flown or become Puck. The three emblems together, 7, 8, and 9, analyse the three elements of the traditional illustration of Quarles's Emblem X (Fig. 38): the human form in a birdcage; the cage unlocked by a spirit from Heaven (compare Quarles's winged, haloed angel-cupid, textually identified as Christ, with the Earth Soul of Emblem 36, haloed in some copies of *Songs of Experience*); the human spirit flying free—seen as a bird by Quarles, as the naked human boy by Blake. We see, looking back, that the chrysalis babe can get out of the cocoon swiftly. Yet his adventures have only begun. In position 10 the more cheerful sickbed appears, of Emblem 18 (did Puck have something to do with this?) in which the invalid interrupts her reading to welcome the whole family. (But if she has borne a child, where is it?) Abruptly Emblem 28 (numbered 11) shows Abel dead, Cain preparing to flee!

Before we can catch breath or fall into melancholy, however, Emblem 16 appears, the Saviour taking children by the hand, forgiving all siblings.

At this point Blake considers us ready for Emblems 24 and 46 (at positions 13 and 14), the sibyl and Death's door, the enigmatic natural and the ironic civilized visions of the grave. How almost right this is we can see from Table V. Although in the second numbering Blake moves the sibyl to the front of the series and the old man to position 35, in *The Gates of Paradise* he brings them together again, at the very end of the sequence—though in reverse order, ending with the more enigmatic and prophetic of the two: 46, 24.

What happens next in the first numbering is that after Death's door seven of the emblems that followed it in the unnumbered sequence are numbered to follow it, with a few omissions and insertions, thus: positions 14 to 22 are assigned to Emblems 46, 48 (omitting 47, Oothoon running on the waves, and going at once to the mother and dead child), 49 (the 'vision of hope' as a family reunion), 6 (from early in the book, the courtship scene with the father turning away), 51 (another deathbed), 52 (the conjuror making rain), 55 (Fate, of 'changeless brow')—this omits 53, the rich mother and dead babe, moved toward the end of the series, and 54, the night scene, not numbered—then 57 (the fallen, starving children of poverty) and 58 (upright Satan). (Presumably 56 disappeared or was absorbed into 4.)

This is an effective tidying. The sequence 48,49,6,51 keeps the scene domestic and indoors: dead child, father-finding child, courted or seduced child, family funeral. After the funeral the conjunction of the conjuror and emotionless destiny[1] compounds enigma—one mental jump being: make your own rain; God rains on the just and the unjust; flash to the fallen children: this is a land of poverty. Satan rearing from the fiery pool (Emblem 58 at position 22) is a logical sequel; a 1790 interpretation: energy as Saviour *and* child.

No number 23 can be found, but Emblem 11 (female hovering over male) is numbered 24, and since in the second numbering Blake uses Emblems 8 and 11 together, it is possible that he meant to use them as a pair in positions 23 and 24. The effect would interweave the Miltonic and the domestic, moving from the original courtship sequel, aged father expelling daughter and son from the garden (Emblem 8), to Eve as soul hovering over fallen Adam as body (Emblem 11). This would support Keynes's view that the figures in Emblem 8, despite elegant clothing, are Adam and Eve. Yet Emblem 11 may signify, if the symbolic details of the cognate larger drawing are to be inferred, the sleep of a bard.

Next, in positions 25 and 26, are two intrusive emblems which I fail to see as inevitable or even very useful here: the lurking assassin (Emblem 62)—but perhaps he is only mischievous?—and the doll being brought to the sickroom (Emblem 19). At 27 follows Emblem 39, that contrary of the 'perfection' scene, male clutching female, which now seems Adam turned Satan seizing Eve as Oothoon. We might suppose that the hovering spirit of the girl (Emblem 11) came too near and the boy's sleeping body leaped up as butterfly-chaser again. There follows the scene full of soaring naked humans, to inspire us (Emblem 26, at position 28), and then Emblem 40, the deathbed demonstration that 'What we hope we see'.

[1] The chained man of Emblem 55 (and in the 'Fate' drawing) matches the description in Blake's *The French Revolution* of the 'strong man' in the den of the Bastille 'nam'd Destiny' (lines 43–6). The hopeful irony lies in our sensing that revolution is about to free such prisoners from the 'image of despair' that emasculates their own strength.

The Table has gaps between numbers 30 and 38, showing only Emblem 9 at position 32 (the Plague) and 3 and 13 at 34 and 35 (damsel and mounted knight; Soul arriving at the gate of Paradise), then Emblem 21, the happy church-door scene, at position 37. But a strong sequence of thirteen emblems starts off with Emblem 23, numbered 39, the vision of fear made out of the deathbed of Emblem 40. On the heels of this worship of dead parents (Emblem 23) we see (and hear) the closed circle of fairies (Emblem 30) dancing to the serpent-trumpet of their Satan (for the trumpeter sits in his flower-stem the way Satan stands in his flame flower). But this modulates to the quiet picture of two standing in the cloister of Innocence (Emblem 43 at position 41). Thus from 39 to 41 the fairy magic that turns sweetly from Experience to Innocence, from funeral mourning to educational preparation, shows the right course for 'everything that grows'. This is the place where Blake chooses, in his first numbering, to put Emblems 1 and 2, the traveller and his glad discovery of the grave—which we may for a moment equate with the school of Innocence. Then quickly we are shown extremely fearful graves (as if we may now be presumed strong enough to face them?): Emblem 38, Ugolino and family immured in stone, and Emblem 37, the signal for help from a watery tomb—death by starving and death by drinking too much grief.

Notice that the gallery is now organized into cadenced groups: Experience to Innocence in three steps; traveller through grave to bathos, in four. A new series of three is created by the bringing in of Emblem 47 (Oothoon on the waves) to follow 41 and 42 (Oothoon finding a mandrake child and then Oothoon staring at the ground and holding at arm's length the uncouth wingless Cupid!). This brings us from drowning in the waves to running on top of them in three emblems. But dare we regard the woman in each of these as Oothoon-Thel? Yes, if we consider the parallel between her plucking of marigolds (in human-cupid form) in the *VDA* 'Argument' (28a) and the mandrake-plucking. Yes, if we consider that her gesture (in Emblem 42) toward the clumsy angel-boy declares, from an opposite perspective, that he has been as helpless at love-making as Theotormon. We are not surprised in the next picture to see her hurrying across the sea. In the larger context of the whole emblem series, this sequence nicely blends the motifs of dysphoria between the sexes and the strife of parents and children, the particulars for the latter being the mother's treating the infant boy like a garden vegetable and then like an intrusive nuisance—for in Emblem 42 she refuses to 'see' him at all. And this development leads perfectly into the succeeding pair, Emblem 53 (the rich mother appalled, histrionically, at the dead child in her lap) and 34 (the reading-ready child kneeling to engage in education at the mother's knee—the *Innocence* title-page).

That takes us through position 50 and makes a good place to stop. But the first numbering goes on, with a 51 (for Emblem 32, an obscure figure—because later erased—soaring horizontally or downward) and no number 52 but a 53 (for Emblem 10, a breach in the wall the morning after a battle). It was not uncharacteristic of Blake to open out to such a theme in three steps; yet the erasure of these two emblems, after their numbering as 51 and 53, may signify a decision to end the series with number 50, where all later numberings halt.

BLAKE'S SECOND NUMBERING (II)

How soon did Blake decide to rearrange this gallery? We cannot know; possibly the next morning. Dissatisfaction would have supplied only half the incentive, invention and curiosity the other half.

Keeping the caterpillar emblem, and perhaps now first naming it 'Frontispiece', he chose this time to bring up his heaviest guns to follow it, one, two: Emblem 55, the changeless brow, man chained to sedentary immobility, and Emblem 24, the sibylline message of natural death in the earth. Confronted so closely with these two dark riddles, readers might have difficulty seeing the hope, the promise of change, in those sleeping bearded heads in the sibyl's earth: that men are roots that rest a season, that the grave is a womb—although the hints in the Frontispiece are broad. So the probable mood is receptivity to Emblem 61, introduced in position 3, the subsident suicide ready to weep for ever on Fate's rock. Blake issues a stern warning in this emblem's legend, that the spirit truly 'Everlasting' has fixed a limit here 'gainst Self slaughter'. And then he brings forward from position 22 to 4 his naked Energy rearing amidst fires and unconsumed (Emblem 58): with a message Blake would later define as a mental fight to annihilate Self(hood).

The strategy of this opening is to entice and lull with enigmas and then arouse by sympathy. Emblems 5 and 63 are both now abandoned for ever, the blossom of the scarlet anemone (with the Satanic fire now brought forward, the blossom is not needed for colour) and the erased sketch which, apparently, Blake positively rejected. From the fire the series now goes to the sickbed of Emblem 14, then to the boy chasing girl-butterflies (Emblem 7), the sequence in positions 6 through 10—and perhaps through 12—remaining as before. (Table V shows Emblem 28, which was at position 11, moving down to 27 in this second series; perhaps in Blake's mind it lingered long enough to be still counted in position 11, or perhaps one of the 'lost' emblems came in here.—Emblem 28 is Cain appalled at the death of Abel.) Position 13 is vacant this time, and a new arrangement fills positions 14 to 19. As we have seen, the sibyl has moved front; Death's door moves far back; Emblem 21 (age and youth rejoicing at the church door) takes position 14, followed, practically as before, by Emblem 23, youth weeping over stone-cold age, upon which now follows the armed confrontation of youth and age ('My son My son', Emblem 15). Attention is then shifted to the domestic narrative: disapproved courtship (Emblem 6) followed immediately by the father's expulsion of the young lovers (Emblem 8). The closeness of this narrative sequence to 'My son My son' amplifies the paradigm. If we note that the expelled lovers are not holding hands but turning different ways, we will be prepared for the separation in Emblem 11 next, girl hovering over fallen boy: this can happen to a rebellious son.

Here the main gaps occur this time, between positions 19 and 26. Emblem 57 (falling children) remains at 21; Emblem 10 (war?) moves from the end to 24. At position 26 Emblem 64 makes its first appearance, 'Begone', followed unjestingly by fratricide (Cain and Abel, Emblem 28) and rape (a construction we are led to put on Emblem 39 in this context). Imprisonment follows (Ugolino, Emblem 38), and then, alas, a gap—which the Cowper suicide emblem (29) would fit nicely—and then the benign and forgiving Emblem 40, of corrected vision (escape; conversion of the family; the ascent and upward pointing of the human soul). This holds only for a moment, followed by Malevolence, the lurker of Emblem 62. After another gap, intriguing for the thought that leaps it, we see the knight and lady of Emblem 3 (for the last time), the testing of chivalry. What it leads to this time is not 13 (the youthful Soul finding heaven's door) but 46 (age entering into it). (Though, of course, these emblems are but contrary visions of the same hope.)

As before, what we find beyond the door is a dead child and a wondering mother, Emblem 48, joined this time by its elegant variant, 53, dead child and consternated rich mother. It is now high

time for the parental reunion over the stirring child (Emblem 49), the full condition for life in death's doorway. The reunion is suitably followed now by Emblems 1 and 2, in which the traveller strides toward the sun and is glad to find the mausoleum door to be a garden Gate. Blake is now satisfied; he will make no further rearrangements in this part of his continuum.

After the gap at position 41, he brings together Emblems 30 and 32, the fairy dancers with serpent-trumpet and the soaring human. After another gap (which Emblem 39, boy clutching girl, will fill, in the next numbering), the arrangement for positions 45 to 48 is unchanged (drowning, finding beneath a tree, rejecting, running across water), and, though nothing is marked for 49, number 50 continues as Emblem 34 (mother and kneeling child), the transition to the title-page of *Innocence*—now the last number and a quiet conclusion to a fifty-picture series.

THE THIRD AND FOURTH ARRANGEMENTS (SECOND AND THIRD RENUMBERINGS) (III, IV)

Blake's next rearrangement by numbering is almost as extensive as his first, though with fewer sweeping changes. This third arrangement establishes the final Notebook series, leaving only some slight if crucial further changes which, for convenience of analysis, are here described as constituting a fourth arrangement though they represent rather a final polishing than a distinctly separate plan. Still, the third and fourth series need to be discussed together.

By now Blake is almost content with his opening sequence, but he makes some subtle adjustments in it—and effects two strong new impressions. The sibyl (Emblem 24) is moved *between* the caterpillar (44) and rock-bound Fate (55). And Emblem 59, the titan struggling in the earth (apparently left out of the second arrangement), is brought to follow. In 55 we see man chained outside the earth-mountain, a passive Promethean; in 59 we see him chained inside the mountain, perturbed enough to attempt pushing his way out. Emblem 61 (the suicidal Tantalus), coming next, shows man outside the rock and unchained except by his own short-circuiting vision; he sees where he is, not where he can go. Shifting perspective at this point, Blake introduces for the first time his infant, winged urchin (Emblem 45) who is 'for hatching ripe' and knows how to break a shell, followed by his pubescent form, rearing fully armed in fire (Emblem 58). We can see that the invention of this hatching cupid emblem has wrought many changes—more than can be explored in a mere survey.

Perhaps at once, Blake went on to his fourth arrangement of this opening section. He moved the hatching putto to come *after* rising Satan. Satan, as we may not at first realize, is still inside the mortal shell—or, to say it differently, this arrangement puts him inside, though armed for or bent on hatching. And a new persona (Emblem 60, numbered '5' to follow 61 and precede 45, Satan) is introduced: a brooding spirit, with knees and elbows interlocked and locked hands bracing his forehead, who has set himself in the sky as king and god but is still almost as self-enclosed as the Narcissus of 61. In this final arrangement, Emblems 59, 61, 60, 58 in positions 3 to 6 all precede the hatching; leading to it they form a progression from inside the earth, to its outside, to the sky (studded with stars), to erupting fire, with a progression of gestures from uncertain struggle, to alarmed stasis, to contraction of limbs, to expansive rearing. (Blake now has four elements collected, and he has assembled them inside the human skull-shell, but he does not yet direct our attention to this group as such.)

Following the hatching cupid, Blake first tries Emblem 7, the boy in the birdcage, but finally puts the boy as hunter of flying girls (Emblem 4) ahead of that. And now the boy in the cage is followed immediately by the boy out of it (Emblem 50), a jack-in-the-box effect, since the cloud-borne Earth or Soul, who was between these emblems, now moves further down the series; yet Blake likes and keeps both birdcage emblems thus, until, predictably, he eliminates them both when choosing the engraved *Gates*.

In arrangements III and IV all the first ten emblems are more or less fantastic and obviously figurative. The domestic narrative mode begins at position 11 with Emblem 14, the mother and newborn child beside sickbed and coffin (earlier numbered 4, then 5). It continues with the family funeral of Emblem 51 (moved up to position 12), then Christ walking with children in the sky (Emblem 16 at 13), and another, more realistic sickroom with a touch of the exotic, the turbaned father or wise man bringing a doll (Emblem 19 at 14). Cain and Abel (biblical-realistic) were finally to come next, at position 15, but the sickroom with doll was then moved down, vacating position 14 (or filling it, rather, with one of the 'lost' emblems). The next sequence, positions 16 to 21 (with gaps at the same places), was unchanged for a while—'My son' and so on. Position 23 was given to Emblem 28 (Cain and Abel), but when that was moved to position 15 (see above), the spot was given to Emblem 9, death by plague. Emblem 10 (battlefield death) logically followed, and one, then two, sickroom scenes (Emblem 18, then Emblem 19 to precede it). The movements from III to IV are few enough to be followed easily in Table V.

For positions 27 to 32 Blake assembled a new grouping, retained in the final sequence (IV). It begins with a pair of opposites that he always kept together, Emblems 21 and 23, the parents and young couple at church door—and in the burial field. Emblem 26, with soaring naked humans, then shows the upward possibilities (are these a group representation of Satan uprearing but not armed?), only to let us plunge into the prison-grave with Ugolino and children (Emblem 38 at 30), to be reassured again by a recognition (Emblem 40 at 31) that what we ought to be able to see is 'What we hope'. In all the numbered series this emblem occupies the same crucial, pivotal position beyond the halfway mark. But I have the impression that its function in the revised grouping is to assist in shaking off some of the narrative progressions that had become attached to emblems regrouped here and to make symbolic progressions more insistent.

Blake's next change is the introduction of Emblem 52, the conjuror, between hope (Emblem 40) and the assassin in ambush (Emblem 62); his next is the dropping of Emblem 3, the chivalry test that came next in the second arrangement, in favour of Emblem 36, the turning Soul in the starry night. (Death's door then follows as before, with no further change down to position 43). This sequence gives us much more to ponder than when the vision of hope gave way at once to the assassin and Death's door, the dead infant, and the rest. A conjuror is harder to categorize than an assassin, especially with the listening Earth (36) following soon after. (In his final sequence, IV, Blake replaces the assassin with the drowning man of Emblem 37, who is a victim possibly of the rainfall induced by the conjuror, but possibly also of his own too fearful guess at what that rain signified.)

There is no cause to regret the removal of the chivalry emblem, which had not seemed to absorb much of the surrounding symbolism. Contrarily, Emblem 36 in the enrichening context has grown apace. Most valuably this emblem has at last been given a visual and moral contrary in the new emblem (60) at position 5, the watchful, anxious King of Tyre. That Urizenic worrier or Covering

Cherub is a youthful variant of the 'selfish father' of 'Earth's Answer', the poem which follows 'Introduction' but is pitched at ground level rather than above the stars. Both the King of Tyre and Earth or the Soul herself are set, or have set themselves, proudly or patiently, in the heavens. In the Notebook drawings (57a and 94b) each has about the same amount of cloud and a sketchy suggestion of two or three stars. In their final published forms, in the *Songs of Experience* and *Gates of Paradise* respectively, both face the future but at opposite poles of the starry floor—the Earth having the Pleiades and Orion of the constellations of winter; her contrary, 'Air', having (to hazard a guess about Blake's clustered stars) the Crow, the Lion, the Sickle, and the Wolf of the summer sky. The legend declares that the airborne King has set his 'heart as the heart of God', and his face suggests that he can only fear for the future. The Earth or Soul may, in contrast, be presumed to be sustained on her scroll by the voice of God, the 'Holy Word' mediated by 'the voice of the Bard'. As the day breaks she will arise and open the garden Paradise of 'Free love' (I am quoting both poems). A consequence of her now occupying in the emblem series a position immediately preceding Death's door (Emblem 46 at 35) is that she serves as watchman and guide. Prepared by her awakened presence, we are glad, when we see the aged traveller entering (in Emblem 46), to see that crippled age as well as winged infancy can step through into the garden.

In the remainder of the fifty emblems, with a gap still at position 49, only some small changes occur from II to III/IV. Emblem 39 (boy grasping girl), which looked like rape in the second numbering—coming as it did between Cain and Abel and Ugolino—now follows Emblem 32 (the obscure soarer) and leads to Emblem 41 (the gathering of infants as mandrake roots), an arrangement open to the construction that a rather fierce sexual embrace must actually precede the plucking of the children that Eve-Oothoon imagines she merely 'found in the garden'. That would explain why she is staring at the earth in Emblem 42 (Where *do* they come from?) and is perhaps simply indifferent to the overtures of young Cain (is it?)—i.e. from her ignorance about the source of seed. (This is at most an aspect, a nuance, of the main theme iterated earlier.)

And now Emblem 34, the child and instructing nurse, occupying position 50 in I and II, is abandoned as closing scene. The other cloister picture, Emblem 43, is moved down to position 47 to follow Emblem 42 (it is striking how closely this rearrangement recovers the original order before numbering). Next comes Emblem 47, at position 48, Oothoon running along the waves, beside a sunrise, surely a marvellous and prophetic extension of cloistral Innocence to the far waters of freedom. Perhaps the next emblem (maddening that there is a gap at position 49!) should illustrate Oothoon's 'finis' cry, 'Wait Sisters Tho all is Lost' (the words added in the Small Book of Designs—E662). And surely in this context the new number 50, 'Begone [dull care] & trouble me no more', is a saucy valediction from the artist himself, breaking through the too ponderous morality of his immortality play. He would soon put aside all but a choice seventeen of these carefully sifted conjurings.

THE GLUE SPOTS

One last stage, after the last numbering but before the final selection of emblems to be engraved for *The Gates of Paradise*, is partially indicated by the evidence of glue spots on nineteen of the Notebook drawings. I take it that Blake's troubling to make tracings of these emblems meant that he was satisfied with their outlines and ready to transfer them to copper, or to some intermediate clean sheet of

paper. Eleven of the nineteen do end up among the chosen seventeen *GP* emblems, the other six of the chosen having gone through modifications in drawing before their final engraving, evidently because the Notebook versions were thought less satisfactory graphically than iconically. Presumably the seven drawings traced but not chosen were eliminated only in the last testing.

One of these, Emblem 29, the suicide with dagger, is the one that must have had numbers under it before the erasure of the Cowper poem—a conjecture that the glue spots strengthen. Another is the second traveller emblem (2) of a man glad to find the grave. These two threshold emblems have much that relates them to each other and may have been rejected as a pair. Another more obviously inseparable pair, eliminated after tracings had been made, are the birdcage emblems (7 and 50); another, the two women with dead infants (48 and 53). These inseparable pairs, one feels, lost out from their own attenuation, requiring two pictures for one vision. The seventh emblem that was traced but eliminated was Emblem 42, maiden rejecting naked boy, put to other use in 'The Angel'.

THE SELECTING OF *THE GATES*

In the preceding pages I hope to have assembled enough information and thumb-nail characterization of the Notebook emblems to make them available for study individually and in series. Their paramount interest for many people, however, will be as the matrix from which the perfect emblems of the *Gates* were quarried. I have held this consideration often in mind but will take no more space here than seems necessary to define briefly the nature of the final inclusions and arrangement. (In Table V the course of each *GP* emblem through the various numbered series is indicated by a heavy line.)

After the 'Frontispiece' of caterpillar and chrysalis, long settled upon, Blake now adds a simple title-page (Pl. ii) illuminated by one of his simplest page-turners, a forward-soaring figure between the words 'For Children' and 'The', with a slight scroll of garment and the merest suggestion of a rising sun beneath. (All the Notebook fairy dancers, as well as the floating, loose-garmented Saviour, leave no other trace.) The effect of a light and buoyant opening is greatly assisted by the shift of the sibyl and her dark cave (Emblem 24) to the end of the series—and the dismissal altogether of frownless, unsmiling Fate (Emblem 55). Now chosen for position number 1 is the mandrake-picking (Emblem 41), one of the wash-drawn emblems now separated from its companion, 42, which is diverted to lyric purposes in illumination of 'The Angel' in *Songs of Experience*.[1]

A digression not uninstructive about the emblems themselves would be an analysis of that poem to see how Blake's lyric imagination worked upon the motifs that converged upon this emblem in series. In 'The Angel' the poet gives us the teased but rejecting female as one unriddling her own posture: 'what can it mean?' and experiencing angelic protection, a male counterpart of the maternal; discovering pity and timidity (a kind of 'fear'), and the perverse success of arming, the grey hairs of time's revenges.

Placing the mandrake-gathering so near the Frontispiece not only establishes a tone verging on whimsy but produces the immediate optical surprise of revealing that the human-faced radishes 'found' in the earth are simply variants of the human-faced chrysalis of the Frontispiece. *Gates* 2 to

[1] Blake also removed Emblem 36 from his contracted series, for use in the *Experience* 'Introduction', and thereby made room for the masculine 'Earth' of Emblem 59, one of the four elements and not to be confused with the woman in space who is the Bard's vision of the whole Earth and Soul as bride and Copia.

7 are only slightly changed versions of the emblems assembled for these positions by the Notebook numbering; yet a single transposition that puts Emblem 61 (now 'Water', with rainfall added) ahead of 59 ('Earth') makes a striking difference. It lightens the graphic transition from 'I found him beneath a Tree', the 'Water' emblem being engraved in thin lines, even its tree, while 'Earth' is dark and heavy to indicate stone and dirt. And it severs the thread of narrative suggestion. If 'Earth' were number 2 we would incline to see the potentially upward-thrusting roundish titan in it as a root or bulb in the mandrake garden. (*The Gates* legend omits the words 'in the garden'; indeed all the new legends are very brief—in 1818 Blake will let them expatiate—and many are deliberately non-narrative.) Now we are compelled to see the emblems of Water, Earth, Air, Fire as personifications of elements of a or the universe, and secondarily as states of man. In Plate 6, the hatching, we see one human form (infant, winged) and must simultaneously accept him as a fifth mutant state of man or as One Man who must be the four elements combined: the eggshell exhibits itself as the universal cave or mundane shell that contained the four elements. The next emblem (as already arranged), the girl-chasing boy, returns us from the universal perspective to the flat world of grass and trees; in the new context we know this as the fantastic everyday world of the mandrake children (*GP* 1).

The other emblems used in *The Gates* are brought together from widely separated positions in the last numbered series (IV), except for Emblems 38 and 40 (Ugolino and Vision), a pair that began close together and became inseparable after the second numbering. Thus all the juxtapositions after *GP* 7 are, with this exception, newly contrived. Emblem 15 ('My son! My son!') is brought in as *GP* 8, and a new emblem (20: a ladder to the moon) is engraved as *GP* 9, forming a five-emblem sequence of active youth in various perspectives: rising, armed youth seen as 'Fire' (*GP* 5); a hatching, eager infant seen as Cupid (6); a striding, potentially travelling youth misusing his hat as a net to hunt flying females (7); an armed son threatening an armed father, seen as a confrontation of rebel and king (in the engraving the father is placed on a vast stone throne, a history painter's setting); and a youthful traveller keeping his hat on and mounting toward the moon in defiance of the step-counting diagrams of Reason.

Presumably children reading these cartoons are now sufficiently braced to view bravely the three dark plates that follow: a fall from ladder to ocean ('Help! Help!'); the fatal shearing by 'Aged Ignorance' of the wings of adolescent Cupid—who will quickly discover he can fly without them (*GP* 11, the second new emblem, unnumbered Emblem 31); and the sealing up in prison tomb by priestly 'vengeance' (*GP* 12). (Blake's legend under the Ugolino prison picture reminds us that while emblematizing this scene he has not forgotten its historical reference.)

The ensuing deathbed picture (Emblem 40 as *GP* 13) will have its previously tested effect. Its new legend, 'Fear & Hope are—Vision', combines the earlier legend of this emblem with the legend of Emblem 49.

The next two plates (Emblems 1 and 46 as *GP* 14 and 15) show the traveller hastening at once into Death's door—though aging abruptly in the process. This simplifies the idea expressed imperfectly in Blake's original Emblems 1 and 2 and resumed or, in the numbered series, foreshadowed in 46. The dropping of 2 and the putting of 46 in its place was a long-delayed but 'inevitable' improvement. The choice of Emblem 24 to follow and thereby to conclude the gallery, as Plate 16, gives its worm-embraced sibyl a new function. In Blake's first numbering (I) he had put the sibyl and Death's door together—but far from the end of the series and in an order the opposite of that of the final

sequence. Then (II–IV) he had chosen this emblem of natural human death (Emblem 24), of the elemental grave of earth and cave, as an invitation at the beginning of the series, welcoming the reader to enter and explore the 'land unknown' described in Plate 6 of *The Book of Thel*. Moving it to stand as 'Finis' transforms it into an invitation to Paradise, a farewell to the reading 'Children' who must, by now, have found wings.

Blake's compression of an emblem series of sixty or fifty into a series of seventeen is comparable in effect to his reduction of the nine stanzas of Poém 17 to the two of 'Infant Sorrow', but the process of selection is like that which reduces the sixty-seven trial lines of Poem 58 into the twelve lines of 'Fayette'. With the condensing, the room for and the effect of narrative sequences may be decreased; yet the interaction of pictures increases. In so compact a gallery, all the emblems are near each other, and they serve in series as a cable that can carry several sequential messages at once—even while each separate picture, with its motto, can continue to function as a unique moment of vision, a complete apperception exercise in itself. Roughly, the relation between the fifty-emblem series and the seventeen-emblem *Gates* is like that between the text of Bunyan's *Pilgrim's Progress* and Blake's twenty-eight illustrations of that work—or a selection that eliminated the ten least symbolic illustrations.

In the final selection, the original seventeen ways of dying are represented by only two emblems directly, drowning and starving (in prison), though by several incidentally: suicidal impulses in 'Water', 'Earth', and 'Air'; murder in 'Alas!' and in 'My Son!' (so that a separate Assassin picture is not needed). All the sickbeds and deathbeds are compacted into the bedside demonstration that fear and hope are vision—which also takes care of the soul-body theme. The eleven varieties of graves and coffins must now be represented by the two concluding emblems and Ugolino's prison, with peripheral suggestions in the cocoon of the Frontispiece; yet note also that one of the messages of 'I found him beneath a tree' and the heads in the ground in *GP* 16 is that the notion that man comes from the earth and must return to it is a fantastic wives' tale.

Now all the male-female and parent-child themes and all the scenes of larger domestic groups are represented—in extravagant variety—by the childish boy and girls of *GP* 7, the son-father and father-son confrontations of 8 and 11, the prison and deathbed scenes, and of course the garden scene of the mother who wishes childbirth were like picking radishes. But even the many solitary figures in the final *Gates* imply others who are absent.

SAMPLE READING OF A SINGLE THEME

As an example of a theme that is explicit in one or two emblems of *The Gates of Paradise* but is communicated by all the rest or is lurking to be read in them, let us consider the traveller theme originally presented in Emblem 1, now apparently postponed to Plate 14. Once we have looked through the series and charged our imagination with the vision given by the picture and legend of that emblem of the traveller's stride, direction, haste, hat, and staff, we are ready to discover that the Frontispiece, asking 'What is Man!', is hinting that man is to rise from chrysalid sleep as a flying creature. The soaring angel on the title-page directs 'Children' to haste onward. The Eve of Plate 1, in a backward fashion, is burdening her journey with apple-shaped babies' faces: but the infants are getting an apron ride. The human figures in Water, Earth (only potentially moving?), and Air represent non-

travelling—though Air is looking to see where to go, having already 'set' himself *up*. 'Fire' is ready to pave Hell's highway, and the ripe cupid (note this well) looks brightly forward and upward from his broken shell. In Plate 7 the boy is striding but not properly travelling; idly competitive with other human forms (female), he attempts to halt their flight, not realizing that he could join it; we may hope he will learn what his hat is for. Plate 8 shows youth growing taller but striding backward, and age forgetting all about journeys. A king, he is acting in his bodily gestures remarkably like the imagined 'angel queen' of Emblem 42.

Plate 9, the new emblem of the ladder that reaches a waxing moon (the night's light, not yet the sun of morn), makes a crucial contribution to the theme. It shows that Desire's best journey is *up* and can be very steep. In the engraving Blake has put the traveller's hat on the ladder-climber, who sees that he is leaving an embracing couple on the ground (who, however, are turning aside from each other). It is necessary in this pessimistic age to stress the climber's identity with the traveller, for many commentators begin to fail at this point and become Edmund Burkes. It is to be understood that the traveller's getting to the Moon, if not the whole business of life, is an important and a possible stage.

Plate 10 shows a traveller crying for 'Help'. (Bunyan's pilgrim, having tumbled into the Slough of Despond because he was pursued by Fear, is rescued by a man named Help—as shown in Blake's sixth Bunyan water-colour.) The cry will surely bring his rescue. Plate 11 permits us to see the point of no return (Atropos, whose shears are wielded by 'Aged Ignorance') as an approach to the rising sun: the winged youth has a vigorous stride like the traveller's; the wings, emblems of potential flight, will not be needed for true human soaring; their shedding repeats at a higher stage the preliminary shedding of the eggshell. (The comparable plate in *Jerusalem* is Pl. 97, in which a traveller is hurrying beyond where hat and staff are needed.)

The travel information of Plates 12 and 13 (Ugolino and the deathbed scene) is simple and direct: that the only way out of this dungeon is *up*. (Ugolino's cell marks a stage in the journey comparable to that of the dungeon in Doubting Castle shown in Blake's twenty-fourth illustration of *Pilgrim's Progress*.) With all this adumbration we see that the traveller we come to in Plate 14 is doing almost all the right things. He is striding with almost the same vigour as the youth of Plate 11 (though comparison will show a slight shortening of stride); his hat is on tight; lacking wings, he is using his staff, hastening, heading exactly toward the sunlight. He is not going or looking upward, but perhaps 'up' means toward the sun? There is a mystery we must read on to understand.[1]

On the next page, in a swerve of direction that seems retrogressive, the traveller enters Death's door. Grey hairs are on his head, and beard; his staff has become a crutch; yet he has one foot over the threshold and a strong wind is pulling him forward. Must he go down to rise up, face death to find life? The final plate is oracular, a sibylline enigma that will echo back our sighs or hopes. We have followed the traveller through the door, but he is not here, only the linen clothes—not folded up but draped on the untravelling sibyl or prophetess, who sits enigmatically still at the mouth of the

[1] The legend specifies hastening 'in the evening'; yet proper visionary travelling, heading toward the sun, makes toward its rising, in 'weary night's decline'. Coleridge (in *Aids to Reflection*, 1825, p. 19) summarizes the traditional symbolism thus: 'Awakened by the cock-crow (a sermon, a calamity, a sick-bed, or a providential escape [consider how many of the *N* emblems come under these heads]) the Christian pilgrim sets out in the morning twilight, while yet the truth (the perfect law of liberty) is below the horizon. Certain necessary *consequences* of his past life and his present undertaking will be *seen* by the refraction of its light. . .'

cave, with a staff or wand in her hand. Is it the traveller's? The traveller himself is not here: if he is risen, has gone up, he has now shed staff and clothing as earlier he had shed wings and still earlier his shell-cocoon. The legend, spoken in his voice, is in a past tense: 'I *have said* to the Worm, Thou art my mother & my sister'—a kinship which he must now understand, and the reader must understand, to be the expendable portion of the soul, the staff no longer needed.

These concluding plates tell another thing. As the faces sleeping in the ground beside the worm bear witness, Paradise is not entered through the barren earth gate. Death's proper door is of stone and oak, as in Plate 15, hewn and hinged by wondrous art.

3

THE TABLES

TABLE I. THE DRAWINGS

All are pencil drawings, unless otherwise noted. Some of the categories overlap, and some listings are duplicated. Specific subjects will also be found in the alphabetical Index below. [Fig. references are to tracings or detail photographs in Appendix II.]

A. DRAWINGS ATTRIBUTED TO ROBERT BLAKE (d. 1787)

(See also headnotes of next two sections)

Sideways on page

1a–e. Five Druid figures, standing; only b unerased.

3a. Armed knight in Gothic entry follows damsel hastening into forest; ink and wash drawing.

5a. Oberon and Titania on a poppy beneath a ring of five dancing fairies; ink and wash. (Related to Blake's painting *Oberon and Titania*.)

7a–b. Two scenes, separated by clouds: (a) a crowned king dismissing someone; (b) below, a supine giant with two attending figures. Possibly the legendary Trojan Brutus assigning his comrade Corineus to the kingdom of Cornwall, and Corineus' subsequent defeat of the giant Gogmagog.

9a–c. Three Druid figures that appear in Robert Blake's water-colour in Keynes, *Blake Studies*, Pl. 5.

10b. Ceremonial crowning (Druid England?); five figures at right, three or four at left.

B. PORTRAIT HEADS AND PROFILES

All sketches of human heads are listed here, though some may not have been meant as portraits. All are presumed to be by William Blake, unless otherwise noted.

8a. Henry VIII, in a rather boyish departure from Holbein's portrait; possibly quite early, perhaps by Robert Blake.

8b. Unknown face [Fig. 13].

12b. Unknown face.

13b. Head with a fur hat.

14a,b. Unknown faces.

19a, 21a. Profiles, in ink, perhaps *of* Robert Blake; the second somewhat resembles the 1819 'Faulconberg the Bastard'.

40b. Effaced head and shoulders, with pilgrim's knapsack; conjecturally after a Gillray cartoon of 1793 [Fig. 36].

47a. Young officer in feathered hat, perhaps French.

54a. Tragic profile.

66a, 67a. Self-portraits of William Blake.

69a. Dramatic face with staring eyes.

70a. Mask-like face.

74h. Man with a family resemblance to Blake; possibly his father or a brother or some other relative.

77b. Head with long neck [Fig. 25].

82a. Head of Catherine Blake, his wife.

C. STUDIES OF DETAILS OF HUMAN BODY

Apparently sketched from life, probably early; some possibly by Robert Blake.

6a. Fingertip.

13a. Buttocks and legs.

15d. Leg.

15e. Foot.

16a. Fingers?

16c,h. Buttocks.

16e. Back view of traveller, from waist down.

21b, 33a. Pairs of lips (better drawn than the pages of lips in Robert Blake's 1777 Notebook).

36a. Foot [Fig. 17].

38a,c. Finger.

38b. Back.

61a. Arm, detail.

69b. Eye?

75h. Beard.

D. DIAGRAMMATIC OR ALPHABETIC HUMAN FORMS

64, 74b–j, 75ab. Stylized experiments (related drawings are noted in section H below). Included are the following capital letters in human form:

I. 74ɪ	O. 74l
L. 74d	P. 74m, 75a
M. 74i	T. 74k
N. 74j	VD (monogram). 74f

E. MISCELLANEOUS SMALL DRAWINGS

15a. Urinating traveller.

15b,d,h; 16b,d; 17a,b. Man-eating man, soaring.

15f. Infant in furrow, after plough.

TABLE I. THE DRAWINGS 47

15i. Dog and boy (cf. dog and piper, in 'On Anothers Sorrow').

15j. Tree trunk.

18a. Clouds.

25b. Vague sketch [Fig. 15].

32b. Vague sketch [Fig. 16].

51b. Serpent trumpet, detail.

55a. Candle in spiral sconce [Fig. 19].

58a. Banyan tree, with figure huddled against main trunk [Fig. 20].

58b. Leafless tree, human figure or figures sitting on roots and grasping trunk [Fig. 21].

62a. Vague sketch.

63b. Mandrake child, detail.

66b. Reader and alarmist on cloud [Fig. 22].

70c. Sofa with animal legs? [Fig. 23].

75d. Fish-man, or star-man?

75f. Doll-like body with godhead.

75g. Hamlet-like figure.

77c. Infant supine but lively.

89a. Clouds.

107a. Seated figure [Fig. 28].

F. LARGE DRAWINGS

1. Illustrations of *Paradise Lost* (1790–2)

Sideways on verso pages

More or less filling each page, these drawings were made before the poems of 1792 were written in *N*. I have arranged them in the order of the passages in *PL* which they seem to illustrate, and have quoted from these; Blake wrote no inscriptions here.

90a. 'Satan talking . . ./With head uplift above the wave . . . his other parts besides/Prone on the flood' (*PL* I. 192–5). At the right we see his 'ponderous shield . . . like the moon' (which Milton does not mention till lines 284–7); cf. *NT* 403. (In Emblem 58, on the facing page, Satan shortly 'rears himself' upright, as Blake's legend for the emblem tells.)

114a. The Satanic host swarming like 'faerie elves,/Whose midnight revels . . ./Some belated peasant sees' (*PL* I. 781–8). Conjectural interpretation of a very tentative sketch, from similarities to Fuseli's painting [Fig. 34] (see page note and cf. *NT* 24).

112a. Satan with shield and spear exhorting his Stygian council: ' . . . long is the way/And hard, that out of hell leads up to light' (*PL* II. 432–3). The council are sketched in, Satan's open mouth shows he is still speaking, but he is already making the track which Sin and Death will pave 'after him . . ./Over the dark abyss' (*PL* II. 1025–7).

108a. Satan springing up from the realm of Chaos and Old Night (*PL* II, 960–70, 1013). Conjectural reading of an unfinished sketch.

104a. The Holy Trinity: the Father and the Holy Ghost receiving the Son's 'mediation' (*PL* III. 222–51) or, possibly, welcoming him 'into Glory' (*PL* VI. 889–91); behind the Holy Ghost is sketched the sphere of 'a blue heaven'.

96a. Creation begun (*PL* VII. 224–7), God with compasses.

102a. Adam and Eve hand in hand on their way to the 'nuptial bower' (*PL* VIII. 510).

88a. Eve tempted by the Serpent (*PL* IX. 495–503) [Fig. 26].

110a–111a. God the Father giving directions to the Son to save mankind from Satan, who hovers below (*PL* X. 55–84) [Fig. 29].

2. Miscellaneous

Sideways on verso pages

100a. Illustration for *Lycidas* 26, 'The opening eyelids of the morn'? A waning crescent moon beside an anxious watcher for the dawn? Perhaps even related to Emblem 36. Conjectural interpretation suggested by Fuseli's *Solitude. Twilight*, which is a different response to this passage.

106a. Sketch for 'Pity' (colour print *c.* 1795), from Macbeth's self-damning prophecy, I. vii. 21–5.

98a. [See tracing, Fig. 27] Variant of 100a, but further from *Lycidas* and closer to the small drawing 94a (Emblem 60) depicting 'Cloudy Doubts & Reasoning Cares'. The head and shoulders seem encased in mail. Can this be Macbeth while uttering the 'Pity' lines?

86a. Three standing women, perhaps the three witches examining their 'ingredients' (*Macbeth* IV. i), a first design for the subject of the *Hecate* colour print of *c.* 1795 perhaps?

Upright on verso pages

Listed in approximate order of composition.

14c. The Blakes' marriage bed?—a quiet contradiction of Gillray's *The Morning After Marriage* of 5 April 1788 [Fig. 36].

16e,f. Back view of the traveller, naked, preparing to enter Death's door, where he sees his wife and children already on the threshold. (Related to Emblems 1 and 2.)

26a. The First Roman invasion of Britain (based on Milton's *History*; see page note).

12a. Daphne root-bound, a slightly larger drawing than 36b (Emblem 17); made before the Spectre poem on this page but perhaps not long before and perhaps related to it.

For other miscellaneous drawings see the next section.

G. VARIANTS OF DESIGNS OR DETAILS FOUND ELSEWHERE IN BLAKE

The order of this list is that of the approximate dates of the related works, and to some extent it duplicates preceding lists in this table. Most of the drawings here listed seem to be preliminary to, even if variant versions of, the finished work—except for the diagrammatic designs, which may well derive from the work of which they constitute squared versions: e.g. Oothoon forming the monogram VD as an abbreviated title of the work (*VDA*) in which she appears. Remote variants, such as 21c and the *Thel* title-page, of course imply no contemporaneity. (For details, see the page notes.)

1. Related to *All Religions Are One*

15a (Emblem 1). The traveller of Pl. 7.

TABLE I. THE DRAWINGS 49

2. Related to *Thel*

21c, 60a (Emblems 5, 39). Details in the title-page.

3. Related to *Songs of Innocence*

15h. Youth and dog; cf. piper and dog in bottom left of 'On Anothers Sorrow'.

76a [see Fig. 24]. Three standing adults surrounded by four children, somewhat like the audience pictured in 'The Voice of the Ancient Bard' (a late Song of Innocence, moved to *Songs of Experience*).

55b. Detail of title-page (probably made at a late stage of the preparation of the *Songs*).

4. Related to *The Marriage of Heaven and Hell*

60a (Emblem 39). Detail of title-page.

29a (Emblem 11). Comparable to Pl. 14.

59a (Emblem 38). Variant used in Pl. 16 (Ugolino).

44a, 48a. Nebuchadnezzar on all fours; used for Pl. 24.

5. Related to *Visions of the Daughters of Albion*

30a, 72a, 81a (Emblems 12, 47, 52). Details used in title-page: rainbow dancers, Oothoon on the waves, the conjuror.

28a. Sketch for 'Argument', including an erased figure, probably Theotormon, standing upright, his face distressed as Oothoon plucks the marigold; a vine-twined tree of true love beside him has also been erased. (This implies a parody of the temptation of Eve.)

51a,b. Details of serpent trumpeter used in Pl. 1.

32a. Sketch for Pl. 3, in reverse (Oothoon's vision of being devoured by Theotormon's eagle).

29a (Emblem 11). Echoed in Pl. 4.

50a [Fig. 18], 92b. Rough sketch and finished drawing for Pl. 4. (Only the shape of the wave-flame will change.)

74f. Monogram (VD) related to details in title-page and Pls. 4 and 8.

74g. Detail, Theotormon in Pl. 4.

74i,k. Details of Pl. 7.

78a. Nearly final sketch for Pl. 8.

74b. Detail of tail-piece-frontispiece.

6. Emblems engraved for *Gates of Paradise*

68a, 63a, 95a, 93a, 94a, 91a, 69c, 19b, 34a, 40a, 58c, 52a, 59a, 61b, 15g, 71a, 45a. For Pls. i, 1–16.

7. Related to *America*

27a. (Emblem 10). Broken wall, despairing figures, stacked corpses in Pls. i, ii.
75c. Variant of bottom figures in Pl. 5.
74c. Variant of supine infant in Pl. 9.
108a. Variant of Pl. 10.
71a (Emblem 46). Death's door, used in Pl. 12.
32a. Oothoon and eagle (cf. Fuseli's *Nightmare*), used in Pl. 13, after use in *VDA* 3.
45a (Emblem 24). Sibyl; variant in Pl. 14.

8. Related to *Songs of Experience*

74k. Central figures in frontispiece.
43a (Emblem 23). Lower half of title-page.
57a (Emblem 36). Used in 'Introduction'.
65a (Emblem 42). Used for 'The Angel'.
73d (Emblem 48). Related to details in 'Holy Thursday'.
74d. Related to detail in 'Holy Thursday'.
75b. Related to detail in 'The Little Vagabond'.
54b (Emblem 33). Related to 'London'.
21c, 60a, 74f,i. Details in 'The Sick Rose'.

9. Related to *Europe*

96a. Sketch for frontispiece ('Who shall bind the Infinite').
74l,m; 75c. Details in Preludium 1.
10a. Detail in Preludium 2.
51b. Serpent trumpeter used in Pl. 3.
83a. Infant in Pl. 6.
25a (Emblem 9). Variant of Pl. 7.

10. Related to *Song of Los*

60a. Similar to detail in Pl. 2.

11. Related to colour prints of 1795

106a. Final version: *Pity* colour print, after two intermediate drawings and a trial print.
44a, 48a. *Nebuchadnezzar* colour print, '1795'.
54c. Drawing for *Elohim creating Adam* colour print, *c.* 1795.
86a. Possibly sketched for the *Hecate* colour print, *c.* 1795.

TABLE I. THE DRAWINGS 51

12. Related to designs for *Night Thoughts*, 1795–7

a. Related to the Harvard sheet of drawings (H1–2) once W. M. Rossetti's

(The Harvard drawings, Figs. 32–3 below, on a sheet inscribed 'Blake' by W. M. Rossetti, were evidently sketched by D. G. Rossetti, ca. 1860, from Blake's *NT* watercolours. Some of the drawings are close to Blake's designs, some loosely analogous. The caption words, 'Idleness', 'Avarice', etc., are not Blake's nor always Young's. The large 'Pity' is a special case.)[1]

47a. H1 q, 'Joy'.
50b. H1 g, 'Suicide'.
75g. H2 c, 'Study'.
93a. H1 b, 'Despair'.
95a. H1 a, 'Doubt'.
97a. H2 d, 'Cruelty'; cf. H2 m, 'Mischief'.

b. Related to *Night Thoughts* water-colours (*NT*)

(All these Notebook drawings clearly precede the water-colours made for Young's *Night Thoughts* in 1795 and the years following; the *NT* designs and motifs almost never exactly repeat those like them in *N*; the development often is by contrariety or adaptation or analysis of one design into two or conflation of two into one. This list does not attempt to be exhaustive.)

17c. *NT* 61, traveller with staff and outstretched hand toward man (death) in doorway; for other travellers, see 52a, below.
19b. *NT* 181, boy chasing two butterflies with his hat; they light on a gravestone; cf. *NT* 441, man chasing a Moment, but without clutching and ready to follow it into Eternity.
23a. *NT* 105, man in prison cage (cf. *N* 77a note below); cf. *NT* 490, where caging means repressing 'Imagination's airy Wing' and locking up the Senses (two girls in the cage).

[1] The relation of *NT* illustrations to the Harvard drawings may be tabulated (by no means exhaustively) thus:

NT 8. H1 b, 'Pity'; see also *NT* 144.
NT 47. H1 f, 'Idleness' (same symbol; drawings a close match).
NT 115. H2 a, 'Avarice' (close match).
NT 128. H1 q, 'Joy'.
NT 142. H2 i, 'Severity' (one hand on ground, other on head; close).
NT 144. H1 b, 'Pity'; variant of 'Help' rescuing Christian from Slough of Despond in Bunyan, in Blake's illustration.
NT 156. H1 j, 'Rage'; analogue.
NT 158. H2 g, 'Distress'.
NT 172. H1 c, 'Dissipation', not close.
NT 177. H2 c, 'Study', left leg over right; not close.
NT 231. H1 b, 'Pity'.
NT 279. H1 e, 'Luxury'; not close.
NT 284. H2 k, 'Oppression' (not close); cf. *NT* 241.
NT 286. H2 h, the kneeling figure.
NT 293. H1 n, 'Reason' (with handle of similar long compass in left hand; see *NT* 360, below).
NT 312. H2 1, 'Misery'.
NT 360. H1 n, 'Reason' (with this analogue, the impression is confirmed that an instructor, beside a pupil, is pointing with the fingers of one hand and holding a long compass in the other—with the positions reversed in *NT* 360).

26a. *NT* 508, elephant falling with Roman warrior (signifying Satan's falling from Rome to Britain); cf. *MHH* 5.

30a. *NT* 205, ring dance led by Death; *NT* 520, ring dancers (cf. *VDA* title) being deluged by rain from the conjuror's end of the cloud (*N* 51a); *NT* 409, ring dancers on punch bowl; cf. also the water-colour *Oberon, Titania and Puck with Fairies* (Tate).

31a. *NT* 510, woman entering door from same angle.

36b. *NT* 258, metamorphosis of a Daphne figure: 'Half-life, half-death join'.

37a, and other sickbed-deathbed scenes. *NT* 31, 71–4, 152, 153, 155, 166, 187, 453, 477, 517, 525.

40a. *NT* 130, ladder-climber.

42a. *NT* 26, a contrary: lame man straining toward upward-soaring butterfly; he attempts to 'span' it.

44a and 48a. *NT* 299, Nebuchadnezzar.

46a. *NT* 481, hireling murderer with shield.

50b. *NT* 411, suicide with dagger.

51b. *NT* 476, serpent trumpeters; cf. Hurricane blowing serpent horn, *NT* 179.

52a. *NT* 3, 11, 25, 113, 118, 168, 169, 249, 419, 503, 505, 510, etc., travellers; see also *N* 17c above.

54b. *NT* 43, boy leading crippled age.

55b. *NT* 6, 64, 151, 290, children learning at woman's lap; at Christ's, 378, 527–8.

56a. *NT* 224, 259; cf. 196; cliff's edge.

57a. *NT* 5, 420, on similar cloud-scroll.

61b. *NT* 187, 517, pointing up from deathbed; cf. 133, thunder pointing upward; cf. 153, contrary theme.

63a. *NT* 4, woman gathering babies.

66b. *NT* 34, 477, reader with guidance upward; cf. 531.

68a. *NT* 17, cocoon with human head, aged.

69c. *NT* 13 and 16, child hatching.

71a. *NT* 419, traveller with hat and staff, entering doorway.

72a. *NT* 81, Sense running in wild joy, to be smothered by Reason; cf. 414.

73a–c. *NT* 418, girl riding bird; cf. 128, poet rapt on wing of an Angel, Christian joy. But the details in *N* are closer to Fig. 32, below, a pencil drawing unrelated to *NT*.

73d. *NT* 4, the positive contrary.

74f. *NT* 34, girl diving at left; *NT* 156.

75d. *NT* 483, Christ with star-flame in right hand and 'fierce Flames' in left (but feet not shown).

75e. *NT* 413, couple embracing in heaven (in same pose; the leaning and hurrying figure clearly the man).

77a. *NT* 470, female out of prison cage (cf. *N* 23a, above); cf. *NT* 16, escaping the egg.

81a. *NT* 476, conjuror.

83a. *NT* 28, startled hands: and dead joys; *NT* 19, side view.

85a. *NT* 473, 'Fate' (with girl 'Chance').

87a. *NT* 46, similar lunging stride; cf. 140.

90a. *NT* 403, fallen warrior claiming victory; double irony.

91a, 112a. *NT* 452, fight of Satan and Michael (cf. Keynes, *Drawings*, 22).

102a. *NT* 119, Adam and Eve as Reason and Sense.

114a. *NT* 24, sleeping shepherd with dog and scarved fairy.

TABLE I. THE DRAWINGS 53

13. Related to work of 1797 ff.

51a (Emblem 30) and b. Fairy blowing serpent trumpet; similar details in designs for Gray, no. 5 (1797) and in *Job* 21.

97a (Emblem 62). Related to water-colour *Malevolence*, 1799.

41a. Related to *Comus* illustration 6, *c.* 1801.

2a,b; 92a. Drawings for Hayley's ballad 'The Elephant', 1802.

73a,b,d. Drawings for a rejected illustration of Hayley's second ballad 'The Eagle' [cf. Fig. 34].

104a. Detail paralleled in *The Last Judgment*, *c.* 1805.

70b. Detail of weavers in the Arlington Court painting (after 1810).

41a. Related to *Paradise Regained* illustration 12.

20a. Early variant of Job among Friends, cf. *Job* 10.

80a (deriving from 16f). Sketch for *Jerusalem* 46[32].

TABLE II. POEMS AND PROSE IN ORDER OF INSCRIPTION

The numbers here assigned to Blake's poems indicate the order in which they were written in *N*, not necessarily always their order of composition (since some appear to be fair copies of earlier drafts, not extant). An asterisk (*) indicates conjectural placing or dating.

The sequence of writing on any page will be shown by the poem numbering (based usually on the evidence of position, sometimes of ink blotting on the facing page). Whether the poem was written before or after the particular segments of prose (*PA* or *VLJ*) on the same page or on the facing page is indicated by the phrase 'before *PA*' or 'after *VLJ*' and so on.

Poem number	Title or First Line (Prose in parentheses)	Date	Page
(Msc 1	Ideas of Good & Evil	*c.* 1787*	14)
(Emblem drawings, with quoted legends, on recto pages from 15 to 101		*c.* 1787–92)	
(Marriage bed drawing		After 14 Apr. 1788	14)
1*	When a Man has Married		14
2*	A Woman scaly (before *VLJ*)		93
(Large drawings, mostly on Milton subjects, on verso pp. 86–114; see Table ID		*c.* 1790*–2)	
(Msc 2*	List of subjects for a History of England	before 1793	116)
(Msc 3*	List of subjects on Exodus from Egypt		116)

Notebook Reversed

3	A flower was offerd to me		115
4	Never pain to tell thy Love		115
5	Love seeketh not itself to please		115

TABLE II. POEMS AND PROSE 55

TABLE II. POEMS AND PROSE 57

(*PA* and *VLJ*: both written in 1810—with additions possibly later;
PA was begun first, on pp. 11, 17, 18, 19, 20, 21, 23, 24, 25, 38,
39, 44, 46, 47, 51, 52, 53, 55, 56, 57, 58, 59, 60, 61, 62, 63, 64, 65
[title], 66, 67; *VLJ* was written on pp. 68, 69, 70 [title], 71, 72, 76,
77, 78, 79, 80, 81, 82, 83, 84, 85, 86, 87, 90, 91, 92, 93, 94, 95;
additions to *PA* were made after *VLJ* on pp. 71, 76, 78, 86;
other parts of *PA* of course may be late additions, but there is
no evidence in the MS.)

TABLE III. LOCATION OF *PA* AND *VLJ* SEGMENTS

Numbers have been assigned to the segments of *PA* and *VLJ* at each point of discontinuity, in the order in which they have been assembled in the Keynes and Erdman editions.

A. LOCATION BY PAGE IN *N*

p. 11	*PA* 4 (written in 1809)	p. 64	*PA* 36
17	*PA* 47	65	*PA* 1
18	*PA* 48–53	66	*PA* 37–8, 41–2
19	*PA* 54, 56–7	67	*PA* 39–40
20	*PA* 60–1, 63	68	*VLJ* 3, 5
21	*PA* 62	69	*VLJ* 4, 6, 10
*	(two leaves lost between pp. 22 and 23?)	70	*VLJ* 1, 2, 11 ('For' 1810)
23	*PA* 64	71	*PA* 43 *VLJ* 7 (earlier)
24	*PA* 65, 67, 69	72	*VLJ* 9
25	*PA* 66, 68–9	76	*PA* 44 *VLJ* 12, 15 (earlier)
38	*PA* 26	77	*VLJ* 16–18
39	*PA* 22	78	*PA* 45 *VLJ* 19 (earlier)
44	*PA* 30	79	*VLJ* 14
46	*PA* 23–4	80	*VLJ* 13, 20–1
47	*PA* 25	81	*VLJ* 22
51	*PA* 2, 5	82	*VLJ* 23
52	*PA* 6–7 (ref. to 1809)	83	*VLJ* 24
53	*PA* 8–9	84	*VLJ* 25, 27
55	*PA* 10	85	*VLJ* 26, 28, 31
56	*PA* 3, 11, 17	86	*PA* 46 *VLJ* 36 (which earlier?)
57	*PA* 12–16, 19	87	*VLJ* 38
58	*PA* 20	90	*VLJ* 29, 37
59	*PA* 21 (before 4 Aug. 1811)	91	*VLJ* 30, 32, 34, 35
60	*PA* 18, 27	92	*VLJ* 33, 39
61	*PA* 28	93	*VLJ* 40
62	*PA* 29, 31	94	*VLJ* 41
63	*PA* 32–5	95	*VLJ* 42

B. EDITORIAL ARRANGEMENT OF *PA*

PA 1	p. 65	*PA* 10	p. 55
2	51	11	56 (before Poem 149)
3	56	12–16	57
4	11	17	56
5	51 (before Poem 148)	18	60
6–7	52	19	57
8–9	53	20	58

PA 21	p. 59 (before 4 Aug. 1811)		*PA* 46	p. 86
22	39		47	17
23–4	46		48–53	18
25	47 (after Poem 129)		54	19
26	38		55	18
27	60 (before Poem 150)		56–7	19
28	61		58–9	18
29	62		60–1	20
30	44		62	21
31	62		63	20
32–5	63 (after Poem 60)		64	23
36	64		65	24
37–8	66		66	25
39–40	67		67	24
41–2	66		68	25
43	71		69	24
44	76		70	25
45	78			

C. EDITORIAL ARRANGEMENT OF *VLJ*

VLJ 1–2	p. 70		*VLJ* 24	p. 83
3	68		25	84
4	69		26	85
5	68		27	84
6	69		28	85
7–8	71		29	90
9	72		30	91
10	69		31	85
11	70		32	91
12	76		33	92
13	80		34–5	91
14	79		36	86
15	76		37	90
16–18	77		38	87
19	78		39	92
20–1	80		40	93
22	81		41	94
23	82		42	95

TABLE IV. THE EMBLEMS

I have assigned the emblems numbers according to their sequence in *N*, not chronologically. After page identification (15g = picture g on p. 15), Blake's pencilled numbers are given, then plate numbers in *GP*. Erasure or deletion of number is indicated by cancel line; 'sp' refers to spots of glue used to attach tracing paper. Then a cue title is given, sometimes quoting from the legend, and noting a salient feature or topic. ['Fig.' references are to Appendix II.]

Emblem 1 p. 15g ~~42~~/39 sp *GP* 14 — The traveller hasteth, with hat, coat, staff.

2 p. 17c ~~43~~/40 sp — Traveller 'glad to find the Grave'.

3 p. 18b 34 — Kneeling woman implores mounted knight [Fig. 1].

4 p. 19b ~~6~~/8 sp *GP* 7 — Two small girls are chased by boy with hat; one, 'luckless', is fallen; the other flies.

5 p. 21c ~~3~~ — Perfection but a moment: maiden and youth in anemone blossom.

6 p. 22a 17 — Youth wooes maiden; father turns away [Figs. 2, 3].

7 p. 23a ~~7~~/~~8~~/9 sp — Boy huddled in birdcage, bird outside [Fig. 4].

8 p. 24a 18 — Old man expels maid and youth; latter turns away.

9 p. 25a ~~32~~/23 sp — Plague.

10 p. 27a ~~53~~/24 — Death after battle (The drift of hollow states') [Fig. 5].

11 p. 29a ~~24~~/19 — Maiden hovers above fallen youth (soul over body?)

12 p. 30a unnumbered — Four 'Gay creatures', who live 'in the colours of the rainbow', dance in open circle.

13 p. 31a 35 — Soul, on cloud, enters doorway of Paradise.

14 p. 33b ~~4~~/~~5~~/11 — Mother with infant beside sickbed; coffin on floor.

15 p. 34a 16 *GP* 8 — 'My son My son'; youth attacking age.

16 p. 35a ~~11~~/~~12~~/13 — Christ with children on cloud.
(Treat first number as 12, mended from 11)

17 p. 36b unnumbered — 'As Daphne was root bound' Milton.

18 p. 37a ~~10~~/~~25~~/26 — Family at sickbed.

19 p. 39a ~~26~~/~~26~~/~~14~~/25 — Sickroom; turbaned man brings doll.

20 p. 40a *GP* 9 — Traveller begins climb to moon; couple watch.

21 p. 41a ~~37~~/~~14~~/27 — Parents embrace maid and youth at church door.

22 p. 42a unnumbered — Man, with crutch, addresses a spider.

23 p. 43a 39/15/28 — Young couple weep over elders on bier (see title-page, *Songs of Experience*)

24 p. 45a ~~13~~/~~2~~/1 sp *GP* 16 — Cowled sibyl with staff; cave; heads in the earth.

25 p. 46a unnumbered — 'Murder', a hireling at the sickbed.

26 p. 47a ~~25~~/29 — Humans soaring, naked.

27 p. 48a unnumbered — Nebuchadnezzar travelling on all fours.

28 p. 49a ~~11~~/~~27~~/~~23~~/15 — Cain and Abel, the moment before Cain flees.

29 p. 50b number erased? sp — Suicide (naked man with dagger).

Emblem 30	p. 51a	~~40~~/42	Closed ring of dancing fairies, with serpent-trumpet.
31	p. 52a	sp *GP* 11	'Aged Ignorance' clipping wings of youthful traveller.
32	p. 53a	~~51~~/43	Someone soaring? (Almost invisible drawing) [Fig. 6].
33	p. 54b	unnumbered	Boy leading aged cripple, as in 'London'.
34	p. 55b	~~50~~	Child kneeling at woman's lap (as in title-page of *Songs of Innocence*).
35	p. 56a	unnumbered	Girl on cliff-edge, menaced by sword but held back by a hand clasping her ankle.
36	p. 57a	~~8~~/34	Earth or Soul, reclining but wakeful on a couch of cloud and scroll (reversed for 'Introduction' of *Songs of Experience*).
37	p. 58c	~~45~~/33 *GP* 10	Someone drowning (*GP* caption 'Help! Help!') [Fig. 7].
38	p. 59a	~~44~~/~~29~~/30 sp *GP* 12	Ugolino family in stone prison (no caption).
39	p. 60a	~~27~~/~~28~~/44	Free girl clutched by boy.
40	p. 61b	~~11~~/~~29~~/~~29~~/31 sp *GP* 13	'What we hope we see': family turns from corpse on bed to upright spirit pointing up.
41	p. 63a	~~43~~/45 *GP* 1	'I found him beneath a tree in the Garden'.
42	p. 65a	~~47~~/46 sp	Boy rejected by earth-gazing maiden (reversed for 'The Angel', *Songs of Experience*).
43	p. 67b	~~41~~/47	Two standing or walking in or near cloister (see Emblem 34).
44	p. 68a	~~1~~/'Frontispiece' sp *GP* i	Caterpillar and human chrysalis ('What is Man/Job').
45	p. 69c	~~5~~/7 *GP* 6	'At length for hatching ripe'; winged boy breaks out of eggshell.
46	p. 71a	~~14~~/35 sp *GP* 15	'Deaths door'; aged cripple enters.
47	p. 72a	48	Girl running on waves, menaced from above (paper cut away).
48	p. 73d	~~15~~/36 sp	Humble mother holding dead infant; 'yet can I not perswade me'.
49	p. 75e	~~16~~/38	'A vision of fear/A vision of hope'; parents embrace over a child.
50	p. 77a	~~9~~/10 sp	Door of birdcage ajar; naked boy, outside, is flying toward us.
51	p. 79a	~~18~~/12	Deathbed or bier; possibly a coffin below (erased drawing) [Fig. 8].
52	p. 81a	~~19~~/32	Conjuror on rain cloud (detail in title-page, *VDA*).
53	p. 83a	~~49~~/37 sp	Rich mother with dead child in lap, 'untimely pluckd'; in Gothic chair.
54	p. 84a	unnumbered	Two men standing beside a fallen man, under an uncertain moon.
55	p. 85a	~~20~~/~~2~~/~~1~~/2	Fate 'Whose changeless brow/Neer smiles nor frowns'.

TABLE IV. THE EMBLEMS 63

Emblem 56	p. 87a	6	Boy with hat lunging; something flying up (revised as, or abandoned for, Emblem 4) [Fig. 9].
57	p. 89a	21	Large child fallen backward; nurse bending over a small child. (Faint sketch) [Fig. 10].
58	p. 91a	22/4/6 sp *GP* 5	'Upright he rears'; Satanic youth with shield and spear, in forked flame.
59	p. 93a	2/3 sp *GP* 3	'Rest Rest perturbd Spirit' (who appears as the mole who can 'work in the earth so fast').
60	p. 94a	5 *GP* 4	Man set in clouds, brooding and peering; Prince of Tyre as the 'covering cherub'.
61	p. 95a	3/4 sp *GP* 2	Hesitant suicide, Narcissistic, alarmed [Fig. 11].
62	p. 97a	25/32/33	Man lurking in ambush with weapon.
63	p. 99a	5	(Faint sketch) [Fig. 12].
64	p. 101a	26/50	'Begone & trouble me no more'. Farewell to care?

TABLE V. THE NUMBERED EMBLEMS IN SERIES

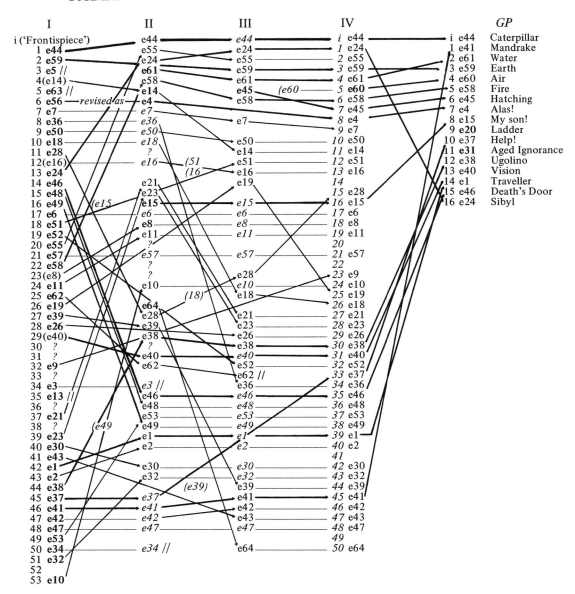

I	II	III	IV	GP	
i ('Frontispiece')	e44	e44	i e44	i e44	Caterpillar
1 **e44**	e55	e24	1 e24	1 e41	Mandrake
2 **e59**	e24	e55	2 e55	2 e61	Water
3 **e5** //	e61	e59	3 e59	3 e59	Earth
4(e14)	e58	e61	4 e61	4 e60	Air
5 **e63** //	e14	e45	(e60 — 5 **e60**	5 e58	Fire
6 **e56** —revised as— e4	e4	e58	6 e58	6 e45	Hatching
7 **e7**	e7		7 e45	7 e4	Alas!
8 **e36**	e36	e7	8 e4	8 e15	My son!
9 **e50**	e50		9 e7	9 **e20**	Ladder
10 e18	e18	e50	10 e50	10 e37	Help!
11 **e28**	?	e14	11 e14	11 **e31**	Aged Ignorance
12(e16)	e16	(51 e51	12 e51	12 e38	Ugolino
13 **e24**		(16 e16	13 e16	13 e40	Vision
14 **e46**	e21	e19	14	14 e1	Traveller
15 **e48**	e23		15 e28	15 e46	Death's Door
16 e49 (e15	e15	e15	16 e15	16 e24	Sibyl
17 **e6**	e6	e6	17 e6		
18 **e51**	e8	e8	18 e8		
19 **e52**	e11	e11	19 e11		
20 **e55**	?		20		
21 **e57**	e57	e57	21 e57		
22 **e58**	?		22		
23(e8)	?	e28	23 e9		
24 **e11**	e10	e10	24 e10		
25 **e62**		e18	25 e19		
26 **e19**	e64	(18	26 e18		
27 **e39**	e28	e21	27 e21		
28 **e26**	e39	e23	28 e23		
29(e40)	e38	e26	29 e26		
30 ?	?	e38	30 e38		
31 ?	e40	e40	31 e40		
32 **e9**	e62	e52	32 e52		
33 ?		e62 //	33 e37		
34 **e3**	e3 //	e36	34 e36		
35 **e13** //	e46	e46	35 e46		
36 ?	e48	e48	36 e48		
37 **e21**	e53	e53	37 e53		
38 ?	e49	e49	38 e49		
39 **e23**	e1	e1	39 e1		
40 **e30**	e2	e2	40 e2		
41 **e43**			41		
42 **e1**	e30	e30	42 e30		
43 **e2**	e32	e32	43 e32		
44 **e38**		(e39) e39	44 e39		
45 **e37**	e37	e41	45 e41		
46 **e41**	e41	e42	46 e42		
47 **e42**	e42	e43	47 e43		
48 **e47**	e47	e47	48 e47		
49 **e53**			49		
50 **e34**	e34 //	e64	50 e64		
51 **e32**					
52					
53 **e10**					

Explanation. The Notebook emblems, as numbered in Table IV, are here identified as e1, e2 . . . e64 and listed in columns that accommodate 53 numbers (the extent of Blake's own numbering). Column I represents Blake's first series of numberings, II his second, and so on. *GP* represents the sequence in *Gates of Paradise,* with captions for convenient reference. Arrows trace the progression of emblems, by their renumbering, from series to series. Bold face type indicates the probable first position of an emblem. A double slash // indicates the dropping of an emblem from further series. *Examples:* The table shows that Emblem 44 (**e44** in col. I) is first numbered 1, then i Frontispiece, and continued into *GP;* that e55 is first numbered 20, then 1, then 2, but not used in *GP;* that e20 and e31 (our numbering of which indicates their occurrence in *N*) were not numbered in *N* but first put into a series in *GP;* that e62 was numbered 33 for the third series and then dropped. The thickest lines trace the progression of *GP* emblems; the thinnest lines (and italics) indicate continuation in one position. Uncertainty as to where an emblem was intended to stand is shown by parentheses.

4

THE NOTEBOOK: FACSIMILE
AND TRANSCRIPT

EXPLANATION OF THE TRANSCRIPT

11 point Press Roman text represents first Notebook draft or fair copy of a poem or paragraph.

9 point Press Roman represents matter added in a first revision (except in palimpsest).

7 point Press Roman represents a second addition.

No further reduction in type size being feasible. the occasional third or fourth addition has been set in 7 point but explained in the page note. (In crowded pages smaller sizes than called for have been admitted when unlikely to produce ambiguity.)

Italics represent pencil writing—or, when specified in the page note, a variant colour of ink (often grey).

Cancellation lines are simplified and approximate. Carets represent Blake's own.

Erasures are represented by screening.

Palimpsest: when a word or letter or line is written over another, they are printed as a fraction, the denominator the original writing, the numerator the final writing. Thus $\frac{over}{under}$ signifies that 'over' is written on top of 'under'. But when the original line has been erased beyond recovery the line replacing it is simply underlined without any fraction. Otherwise the underlining of a letter or (rarely) a word signifies that it was mended, i.e. retraced to improve or correct its shape, with or without erasure of the first try.

MARGINAL KEYS

In **bold face** on the transcript page the poems and segments of prose are identified by numbers, as assigned in Tables II–IV. When helpful for reference, stanzas are marked **a**, **b**, **c** (with **a′** for a second draft of **a**, **a″** for a third draft) or lines are numbered.

Bold face letters on the photographic page stand opposite the optical centres of the drawings on the page reading from top to bottom. When only one drawing occurs it is marked **a** for reference—16a, for example, designates the drawing on *N* 16.

When Klopstock England defied

Uprose terrible Blake in his pride

For old Nobodaddy aloft

Farted & Belchd & coughd

Then swore a great oath that made heavn quake 5

And calld aloud to English Blake

Blake was giving his body ease

At Lambeth beneath the poplar trees

From his seat then started he

self
And turnd him round three times three 10
∧

The Moon at that sight blushd scarlet red

were in hell
The stars threw down their cups & fled *And all the devils that*
∧
intripled ~~were~~
Klopstock felt the ~~ninefold~~ turn 15 *Answerd with a ninefold*
yell

And all his bowels began to ~~burn~~ churn

And his bowels ~~And~~ ~~They~~ *turned ~~around~~ three times three*

And lockd in his soul with a ninefold key

That from his body it neer could be parted

Till to the last trumpet it was farted 20

rose up from
If Blake could do this when he sat ~~down to~~ shite 33

What might he not do if he sat down to write 34

Then again old nobodaddy swore

He neer had seen such a thing before

Since Noah was shut in the ark

Since Eve first chose her hell fire spark

Since twas the fashion to go naked 25

Since the old anything was created

And so feeling he begd him to turn again

And ease poor Klopstocks nine fold pain

From pity then
Then ~~after~~ *he redend round*
removed
And the spell unwound 30

If this Blake could Shite

What Klopstock did write

Poem 62 is written in pencil on top of an erased pencil drawing, sparing the central figure. Pencil strokes that show in lines 25-8 are lines of a garment, but actual deletion lines cancel 31-2 in favour of the couplet added in the left margin. Date of the poem, *c.* 1797-1800, written 'At Lambeth'. (See 'Terrible Blake', p. 352 n.)

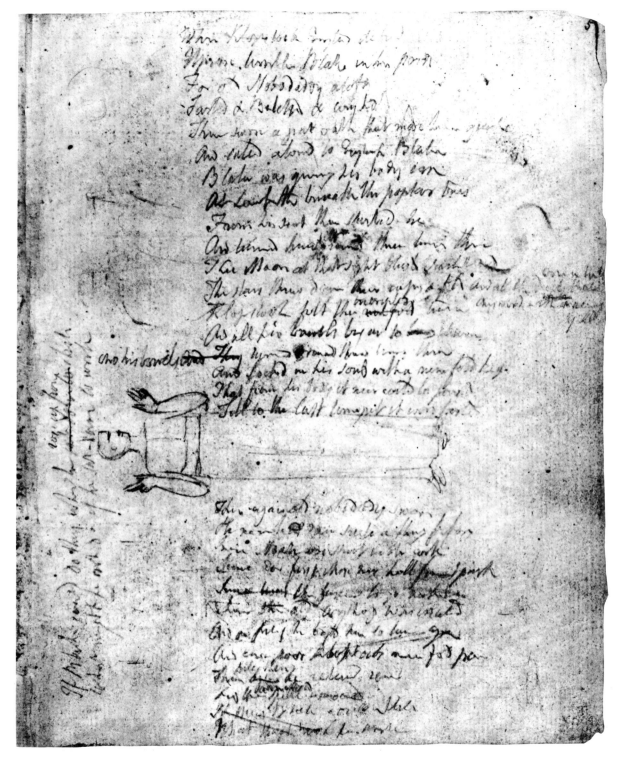

(a-e) Pencil drawing (attributed to Robert Blake) of five Druid figures. The garb and profile of the unerased figure (b) addressing the group resemble those of the tenth figure from the left in Robert Blake's water colour (Pl. 5 in Keynes, *Blake Studies*); the garments of a and the face of c resemble those of adjacent figures.

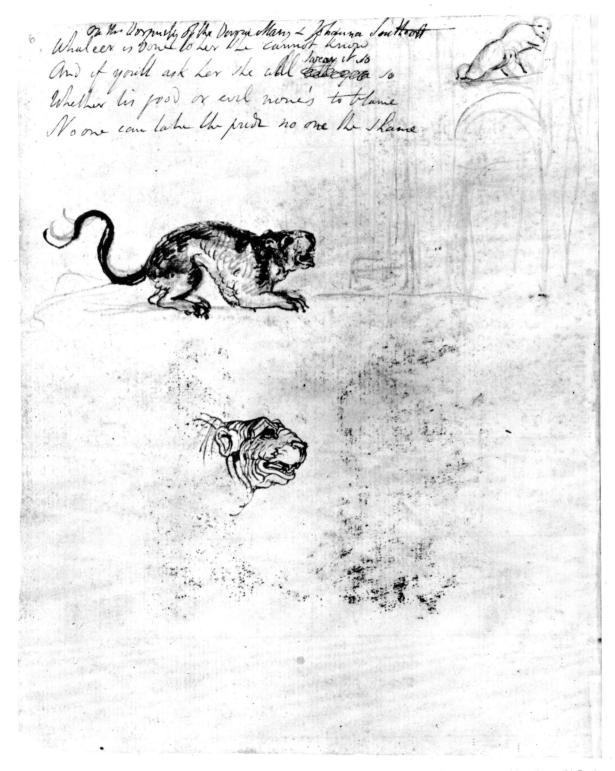

6. On the Devonshire of the Devon Mary & Johanna Southcott

Whate'er is done to her she cannot know
And if you'll ask her she will swear it so
Whether 'tis good or evil none's to blame
No one can take the pride no one the shame

a

b

(a) Pencil and ink drawing: naked man placed in window above gateway (by a friendly elephant) escapes crouching tiger. (b) Sepia drawing: detail, head of tiger. Sketches (see later version, p. 92) for Blake's engraving dated 1 June 1802, for William Hayley's ballad 'The Elephant'. Did Blake as a matter of integrity choose a different species of 'tiger' from 'The Tyger'?

Poem 63

On the Virginity of the Virgin Mary & Johanna Southcott

Whateer is done to her she cannot know

And if youll ask her she wⁱll ~~tell you~~ ^{swear it so} so

Whether tis good or evil none's to blame

No one can take the pride no one the shame

Poem 63 is in dark ink, with title added in slightly darker ink. Reference to Johanna Southcott's announcement of October 1802 that she was to give birth to the second Christ puts the date then or later.

[N2 transcript]

(a) Ink and wash drawing (attributed to Robert Blake). A Gothic subject, unidentified. Possibly Lady Macduff fleeing one of Macbeth's henchmen. *Macbeth,* IV.ii.

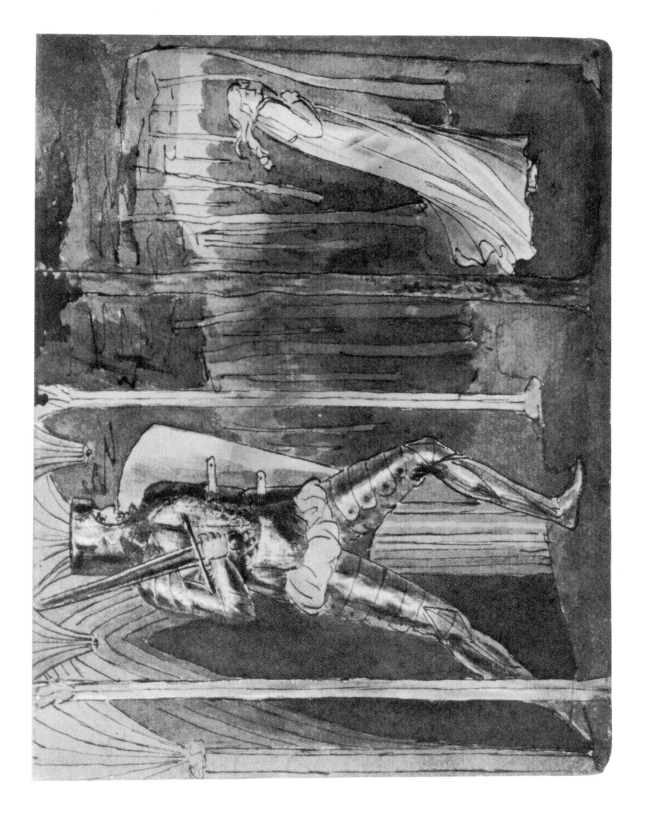

a

Tuesday Jan.y 20. 1807 between Two & Seven in the Evening — Despair

I say I shant live five years
And if I live one it will be a
Wonder June 1793

Memorandum

To Engrave on Pewter. Let there be first a drawing made
correctly with black lead pencil. let nothing be to seek. then rub
it off on the plate cover'd with white wax. or perhaps pass it
thro press. this will produce certain & determin'd forms on the
plate & time will not be wasted in seeking them afterward

Memorandum

To Woodcut on Pewter. lay a ground on the Plate & smoke it
as for Etching. then trace your outlines ~~a draw them in with a
needle~~. and beginning with the spots of light on each object
with an oval pointed needle scrape off the ground ~~instead of
etching the shadowy strokes~~ as a direction for your graver then
proceed to graving with the ground on the plate being as careful
as possible not to hurt the ground because it being black will
shew perfectly what is wanted ~~toward~~

Memorandum

To Woodcut on Copper. Lay a ground as for Etching. trace
&c & instead of Etching the blacks Etch the whites & bite it in

[N4(10)]

Msc 10 Tuesday Jan^{ry}. 20. 1807 between Two & Seven in the Evening—Despair

Msc 6

I say I shant live five years

And if I live one it will be a

Wonder June 1793

Msc 7

Memorandum

To Engrave on Pewter. Let there be first a drawing made correctly with black lead pencil, let nothing be to seek, then rub it off on the plate coverd with white wax. or perhaps pass it thro press. this will produce certain & determind forms on the plate & time will not be wasted in seeking them afterwards

Msc 8

Memorandum

To Woodcut on Pewter. lay a ground on the Plate & smoke it as for Etching, then trace your outlines & draw them in with a needle. and beginning with the spots of light on each object with an oval pointed needle scrape off the ground. & instead of etching the shadowy strokes as a direction for your graver then proceed to graving with the ground on the plate being as careful as possible not to hurt the ground because it being black will shew perfectly what is wanted towards

Msc 9

Memorandum

To Woodcut on Copper Lay a ground as for/as Etching. trace &c. & instead of Etching the blacks Etch the whites & bite it in

Msc 6, dating itself 'June 1793', is in pencil (shown by italics). Msc 7, written next, is in yellowish-brown ink. Msc 8 and 9 are in redder and darker brown ink, with current mending. These may date *c.* 1794, when George Cumberland jotted a memorandum, 'Blakes method. biting whites', on the back of a letter of 16 Dec. 1794 from J. Irvine, Aberdeen (B.M. Add. 36497 fo. 348ᵛ). The final entry, Msc 10 of 1807, is in an ink similar to that of Msc 8 and 9 but with a finer pen.

[N4 transcript]

(a) Ink and wash drawing (attributed to Robert Blake). The figures reclining in the poppy are the royal fairies Oberon and Titania, as we know from William Blake's painting *Oberon and Titania* in which the two are on a lily. The change from Shakespeare's poppy to Blake's lily is interesting symbolically.

Ink spots in the white spaces and at the top of the page were picked up from the writing on p. 4 and constitute evidence that these two pages were adjacent before misbinding.

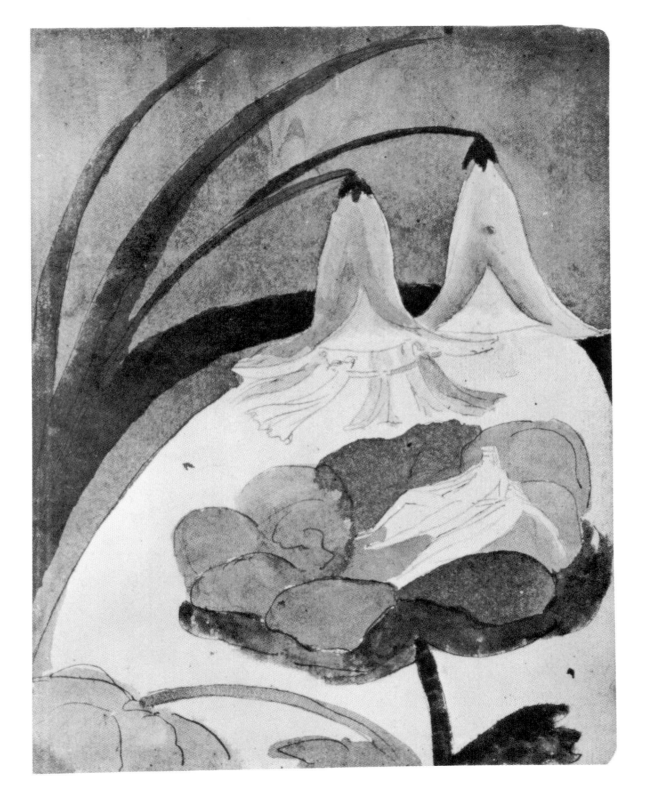

Three Virgins at the break of day

~~Whither Young Men whither away~~

3 The one was clothd in flowers of May
4 The other clothd in ~~~~ iron wire
5 The other clothd in tears & sighs
6 Dazzling bright before my eyes
1 They bore a Net of Golden twine
2 To hang upon the branches fine
7 ~~Pitying I wept to see the woe~~
8 ~~That Love & beauty ~~~~~~~~~~~~~~~~~~~~~
9 ~~~~~~ clothd in ~~~~ fire,
~~~~~ ~~~~~~~~~~ ~~~~~~~~;
And in tears clothd night & day
Melted all my soul away
When they saw my tears a smile
That did heaven itself beguile
Bore the Golden net aloft
As by downy pinions soft
Over the morning of my day
Underneath the net I stray
Now entangled ~~~~~~~ fair
Now ~~~~~~~ ~~~~~~~~~~~~ from wire
Now intreating tears & sighs
~~~~~ O when will the morning rise

Beneath the white thorn lovely may
Three Virgins at the break of day
The one was clothd in flames of fire
The other clothd in ~~~~ iron wire
The other clothd in tears & sighs
Dazzling bright before my eyes

Beneath the white thorn lovely May

Alas for woe alas for woe alas for woe
They cry & tears for ever flow

Wings they had & when they chose
~~~~~~~~~~~~ when they chose
They would ~~~~ them down at will
Or make translucent

### The Birds

He. Where thou dwellest in what Grove
Tell me Fair one tell me low
Where thou thy charming Nest dost build
O thou pride of every field

She. Yonder stands a lonely tree
There I live & mourn for thee
Morning drinks my silent tear
And evening winds my sorrow bear

He. O thou Summers harmony
I have lived & mournd for thee
Each day I mourn along the wood
And night hath heard my sorrows loud

She Dost thou truly long for me
And am I thus sweet to thee
Sorrow now is at an End
O my Lover & my Friend

He Come on wings of joy well fly
To where my Bower hangs on high
Come & make thy calm retreat
Among green leaves & blossoms sweet

(a) Pencil sketch of fingertip.

a

~~Three Virgins at the Break of day~~

~~Whither Young Man whither away~~

3 The one was clothd in flames of fire

4 The other $\frac{cl}{in}$othd in ~~sweet desire~~ $\frac{I}{i}$ron wire

5 The other clothd in ~~sighs~~ & tears & sighs 5

6 Dazzling bright before my Eyes

1 They bore a Net of Golden twine

2 To hang upon the branches fine

7 ~~Pitying I wept to see the woe~~

8 ~~That Love & Beauty~~ ~~undergo~~ 10

9 ~~To be consumd in burning fires~~

~~And in Ungratified desires~~

And in tears clothd night & day

Melted all my soul away

When they saw my tears a smile 15

That did heaven itself beguile

Bore the Golden net a$\frac{1}{f}$oft

As by downy pinions soft

Oer the morning of my day

Underneath the net I stray 20

Now intreating $\frac{flaming}{flame}$ fire

Now intreating ~~sweet desire~~ iron wire

Now intreating tears & sighs

~~When~~ the O when will Morning rise

b

*" Beneath the white thorn lovely may*
*Three Virgins at the break of day*
*The one was clothd in flames of fire*
*The other clothd in ~~sweet desire~~ iron wire*
*The other clothd in tears & sighs*
*Dazzling bright before my eyes*

c

*Beneath the white thorn lovely May*

d

Alas for wo alas for wo alas for wo

They cry & tears for ever flow

e

that soft inclose
Wings they had & ~~when they chose~~
Round their body when they chose
They would let them down at will

Or make translucent

**Poem 65**

*The Birds*

a

*He.*   *Where thou dwellest in what Grove*
*Tell me Fair one tell me love*
*Where thou thy charming Nest dost build*
*O thou pride of every field*

b

*She.*   *Yonder stands a lonely tree*
*There I live & mourn for thee*
*Morning drinks my silent tear*
*And $\frac{E}{e}$vening winds my sorrows bear*

c

*He.*   *O thou Summers harmony*
*I have livd & mournd for thee*
*Each day I mourn along the wood*
*And night hath heard my sorrows loud*

d

*She*   *Dost thou truly long for me*
*And am I thus sweet to thee*
*Sorrow now is at an End*
*O my Lover & my Friend*

e

*He*   *Come on wings of joy well fly*
*To where my Bower hangs on high*
*Come & make thy calm retreat*
*Among green leaves & blossoms sweet*

Poem 65 and parts of Poem 64 are in grey ink, here shown by italics. Poem 64 was begun in dark ink, revised in it, then revised in grey. The grey revision was then crossed out in grey. The final revision, 'iron wire', was made in dark ink in three places, including this crossed-out passage. (See next page.)

(a, b) Pencil drawing (attributed to Robert Blake) in two scenes separated by clouds: (a) a crowned king, his train held by three bearers, stretching his hand towards a retreating figure (holding reversed sword?), behind whom are sketched three or four supplicants or retainers; (b) two small figures sitting at the head of a supine figure much larger than the king: he must be a giant, since the small figures match the train-bearers in scale.

Can this be a scene preceding or following that of Blake's topic 3 in the list on p. 116, 'Corineus throws Gogmagog the Giant into the sea'? According to Milton's *History of England,* Corineus was a Trojan chief who joined Trojan Brutus in sailing to Albion, then 'kept only by a remnant of giants: whose excessive force and tyranny had consum'd the rest'. Corineus was allotted Cornwall for his domain, where the 'hugest giants' could be found lurking, and finally dealt with 'Goemagog the hugest' by hurling him 'headlong all shattered into the sea'. The king could be Brutus taking rule of Britain and directing Corineus to Cornwall.

---

*(Note on Poem 64 continued)*

The first line, 'Three Virgins at the Break of Day', though crossed out at one time, seems required in every version. The first draft consisted of twelve couplets. Next, lines 3-11 were rearranged by marginal numbering. Next, lines 9-12 were cancelled, a new couplet rhyming 'wo/flow' was written to follow the first couplet of the poem, and two new couplets were begun but left unfinished beside the cancelled lines. In grey ink, 'Beneath the white thorn lovely May' was written to replace line 2 and the revised opening lines were written out below the original poem, but then cancelled.

The version in the Pickering MS. lacks the 'white thorn' line and restores the original second line; yet it contains the phrase 'iron wire' of the final revision here, and some further phrasal variants. Conceivably 'iron wire' was a fresh thought in the Pickering draft which Blake then added to the Notebook. In either case, the Pickering draft cannot have preceded the grey ink revisions here (as erroneously conjectured in E777).

a
b

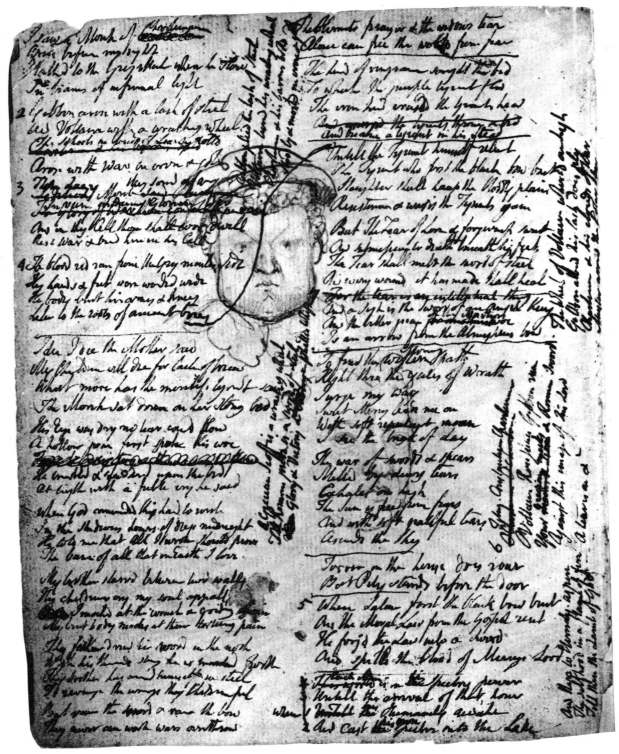

a

b

Pencil drawings: (a) head of Henry VIII; (b) a man's face, unidentified, covered by poem. (See tracing, Fig. 13, Appendix II.)

**Poem 66**

*a* 1 I saw a Monk of ~~Constantine~~ Charlemaine
Arise before my sight
I talkd to the Grey Monk where he stood
In beams of infernal light

*b* 2 Gibbon arose with a lash of steel
And Voltaire with a wracking wheel
The Schools in Clouds of Learning rolld
~~Charlemaine & his barons bold~~
Arose with War in iron & gold

*c* 3 Thou Lazy    they sound afar
~~Seditious~~ Monk ~~said Charlemaine~~
In vain condemning Glorious War
~~The Glory of War thou condemnst in vain~~
And in thy Cell thou shall ever dwell
Rise War & bind him in his Cell

*d* 4 The blood red ran from the Grey monks side
His hands & feet were wounded wide
His body bent his arms & knees
Like to the roots of ancient trees

*e* I die I die the Mother said
My Children will die for lack of bread
What more has the merciless tyrant said
The Monk sat down on her stony bed

*f* His Eye was dry no tear coud flow
A hollow groan first spoke his woe
~~From his dry tongue these accents flow~~
He trembled & shudderd upon the bed
At length with a feeble cry he said

*g* When God commanded this hand to write
In the studious hours of deep midnight
He told me that All I wrote should prove
The bane of all that on Earth I love

*h* My brother starvd between two walls
His childrens cry my soul appalls
~~But~~ I mockd at the wrack & griding chain
My bent body mocks at their torturing pain

*i* Thy father drew his sword in the north
With his thousands strong he is marched forth
Thy brother has armd himself in steel
To revenge the wrongs they Children feel

*j* But vain the sword & vain the bow
They never can work wars overthrow

Gibbon plied his lash of steel
Voltaire turnd his wracking wheel
Charlemaine & his barons bold
Stood by & mockd in iron & gold

8
a
The Roman pride is a sword of steel
Grecian Scoff is a wracking wheel
Viet Glory & Victory a ~~Ron~~ Trojan phallic Whip
plaited

The Hermits prayer & the widows tear
Alone can free the world from fear

The hand of vengeance sought the bed
To which the purple tyrant fled
The iron hand crushd the tyrants head
~~And usurpd the tyrants throne & bed~~
And became a tyrant in his stead

Untill the Tyrant himself relent
The Tyrant who first the black bow bent
Slaughter shall heap the bloody plain
Resistance & war is the Tyrants gain

But the Tear of Love & forgiveness sweet
And submission to death beneath his feet
The Tear shall melt the sword of steel
And every wound it has made shall heal

7 ~~For the tear is an intellectual thing~~
And a sigh is the Sword of an Angel King
And the bitter groan ~~for anothers~~ of the Martyrs woe
Is an arrow from the Almighties bow.

*Morning*
To find the western path
Right thro the gates of Wrath
I urge my Way
Sweet Mercy leads me on
With soft repentant moan
I see the break of day

The war of swords & spears
Melted by dewy tears
Exhales on high
The Sun is freed from fears
And with soft grateful tears
Ascends the Sky

Terror in the house does roar
But Pity stands before the door

5 When Satan first the black bow bent
And the Moral Law from the Gospel rent
He forg'd the Law into a Sword
And spilld the blood of Mercys Lord

Each Man    his
~~This world~~ is in ~~the~~ Spectres power
Untill the arrival of that hour
When ~~Untill the~~ his Humanity awake
And Cast ~~the~~ his own Spectre into the Lake

The Wheel of Voltaire whirld on high
Gibbon aloud his lash does ply
Charlemaine & his clouds of War
Muster around the Polar Star

6
Titus. Constantine Charlemaine
~~O Charlemaine~~ O Charlemaine
O Voltaire Rousseau Gibbon vain
Grecian mocks
~~Your mocks & scorn~~ & Roman Sword
Against this image of his Lord
A tear is an &c

And there to Eternity aspire
The selfhood in a flame of fire
Till then the Lamb of God

Poem 66 j cont
k
Poem 66 cont l
r m
Poem 66 cont n
t
Poem 67 a
Poem 66 cont q
b
Poem 66 cont o s
Poem 68
Poem 66 p cont
Poem 69 cont

Poem 66 (through stanza o before revision) and Poems 67 and 68 were written in dark ink, Poem 69 (before revision) in dark brown. In a darker ink than these Poem 66 was revised and stanzas p-t were added and Poem 69 was revised. In grey ink (here italics) 66n3 was revised. (The changes of ink show that 68 was written before 69 but of course after 67.)

The Grey Monk poem (66) belongs to Aug. 1803, when Blake was told by 'a Bench of Justices at Chichester' in what had once been a Grey Friars convent church that he must stand trial for sedition.

[N8 transcript]

Mock  on  Mock  on  Voltaire  Rousseau

Mock  on  Mock  on: tis  all  in  vain!

You  throw  the  san<u>d</u>  against  the  wind

<u>And</u> the  wind  blows  it  back  again
~~The~~

And  every  sand  becomes  a  Gem  5

Reflected  in  the  beams  divine

Blown  back  they  $\frac{bli}{mo}$nd  the  mock$\frac{ing}{ers}$  Eye

But  still  in  Israels  paths  they  shine

The  Atoms  of  Democritus

And  Newtons  Particles  of  Light  10

Are  sands  upon  the  Red  sea  shore

Where  Israels  tents  do  shine  so  bright

Dark ink throughout. Our revised sequence of the Notebook pages brings this 'Voltaire Rousseau' poem (70) close to the Grey Monk poem (66), in which these men are also addressed; yet the handwriting indicates some passage of time—and a leaf or leaves may be missing between these pages.

[N9 transcript]

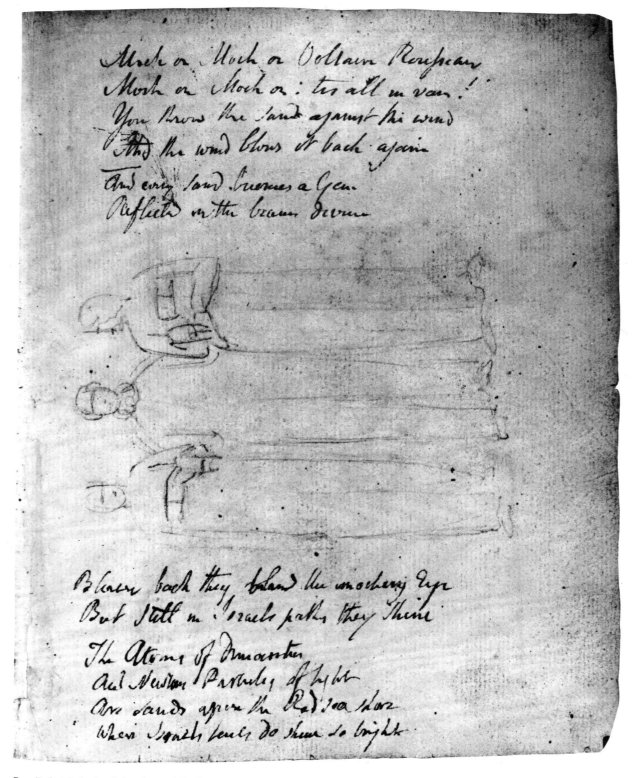

Mock on Mock on Voltaire Rousseau
Mock on Mock on: tis all in vain!
You throw the sand against the wind
And the wind blows it back again
And every sand becomes a Gem
Reflected in the beams divine

Blown back they blind the mocking Eye
But still in Israels paths they Shine

The Atoms of Democritus
And Newtons Particles of light
Are sands upon the Red sea shore
Where Israels tents do shine so bright

Pencil sketch (a, b, c) for three of the figures in Robert Blake's water colour of a Druid scene—the three at the center of the right half of Pl. 5 in Keynes, *Blake Studies.*

a

(a) Pencil drawing (cut out and pasted on the page): a strangler with two victims, all naked, among clouds; used in *Europe,* Preludium 2: Blake's conflation of two Gillray prints, *The Infant Hercules* (1784) and *The Impeachment* (6 May 1791). See my note in *Art Quarterly,* Spring 1949. (This slip was cut from the edge of a sheet containing ink drawings on both sides; only bits of lines show. The fact that it has a watermark—see Appendix IV—shows that it was not a leaf from this Notebook.)

(b-g) Erased pencil sketch (attributed to Robert Blake) of Druid or British historical figures. Only the profile and sleeve of c can be made out; e is placing a wreath or crown on f, who kneels in homage. Separated by a river or platform, three or more kneeling figures with hands up and palms together can be discerned at g. (Little is visible without photography.)

[N10(8) Pasted slip removed]

*If Men of weak Capacities* ~~in Art~~ *have alone the Power of Execution in Art M$^r$ B has now put to the test. If to Invent & to Draw well hinders the Executive Power in Art & his Strokes are still to be Condemnd because they are unlike those of Artists who are Unacquainted with Drawing* ~~& the accompanying~~ *is now to be Decided by The Public M$^r$ B s Inventive Powers & his Scientific Knowledge of Drawing is on all hands acknowledgd it only remains to be Certified whether* ~~The Fools hand or the~~ *Physiognomic Strength & Power is to give Place to Imbecillity*

*Rafael Sublime*

In a Work of Art it is not fine tints that are required but Fine Forms Fine Tints without Fine Forms are always the Subterfuge of the Blockhead

~~and whether an artist who has carried on an unabated study & practise of forty Years for I devoted myself to Engraving in my Earliest Youth are sufficient to elevate me above the Mediocrity to which I have hitherto been the victim~~

In a Work of Art it is not Fine Tints that are required but Fine Forms, fine Tints without, are loathsome

*I account it a Public Duty respectfully to address myself to The Chalcographic Society & to Express to them my opinion the result of the incessant Practi$\frac{s}{c}$e & Experience of Many Years That Engraving $\frac{a}{i}$s an*

Art is Lost in England
owing to an artfully propagated
~~in a most wretched state of injury from an~~ *opinion that Drawing spoils an Engraver* ~~which opinion has been held out to my me by such men as Flaxman Romney Stothard It~~ *I request the Society to inspect my Print of which Drawing is the Foundation & indeed the Super-structure i$\frac{t}{s}$ i$\frac{s}{t}$ Drawing on Copper as Painting ought to be Drawing on Canvas*

surface
*or any other* ~~table~~ *& nothing Else$^†$ I request likewise that the Society will compare the Prints of Bartollouzzi Woolett Strange &$^c$ with the Old English*

Compare the Modern Art
*Portraits $\frac{th}{co}$at is$_\wedge$with the Art as it Existed Previous to the Enterance of*

since which English Engraving is Lost            of th$\frac{is}{e}$ comparison
*Vandyke & Rubens into this Country & I am sure* ~~of the~~ *Result$_\wedge$will$^e$be that the Society must be of my Opinion that$^e$ Engraving by Losing Drawing has Lost*

The
*all Character & all Expression without which $_\wedge$Art is Lost.*

Grey ink, with insertions in black after the first and second paragraphs. *PA* 4, in which Blake is working up his opening remarks, must have been written after *PA* 22 (on p. 39), where we find the 'Raphael Sublime' lines designated to come in here. The dagger at line 23 must refer to a passage now lost, probably on a facing page now missing.

The paragraphs of *PA* and *VLJ* (their precise separation is an editorial convention) were evidently written in 1809 and 1810 as 'Additions' to Blake's exhibition catalogue, 'for the year 1810' (p. 70). (See Table III.)

[N11 transcript]

A large brown spot at top right (less visible in infra-red than standard photographs) continues through p. 20, dwindling from leaf to leaf—and establishing their original sequence.

Pencil drawings: (a) Daphne's metamorphosis (see earlier version, 36b); (b) man's face, unidentified (page reversed). The Daphne drawing preceded the stanzas of quarrelling Spectre and Emanation on this page but perhaps not the writing of the original stanzas on p. 13. (See Longer Note on Poem 71, Appendix I.)

**h**

Never  Never  I  return

Still  for  Victory  I  burn

Living  thee  alone  Ill  have

And  when  dead  Ill  be  thy  Grave

**i**

Thro  the  Heavn  &  Earth  &  Hell

Thou  shalt  never  never  quell

I  will  fly  &  thou  pursue

Night  &  Morn  the  flight  renew

**q**

*$^{2}$What Transgressions I commit*
*Are for thy Transgressions fit*
*They thy Harlots thou their Slave*
*And my Bed becomes their Grave*

**o**

*Poor pale pitiable form*

*That I follow in a Storm*

*Iron tears & groans of lead*

*Bind around my akeing head*

**p**

$^{1}$ *Oer $\overset{my}{\cancel{thy}}$ Sins $\overset{Thou}{sit}$ & moan*

*Hav$\frac{s}{e}$t $\overset{thou}{\cancel{I}}$ no Sins of $\frac{th}{m}$y own*

*Oer $\overset{my}{\cancel{thy}}$ Sins $\overset{thou}{\cancel{I}}$ sit & weep*

*And lull $\overset{thy}{\cancel{my}}$ own Sins fast*
*                 asleep*

**n**

*And let us go to the highest downs*

*With many pleasing wiles*

*The Woman that does not love*
*             your Frowns*
*Will never embrace your smiles*

**m**

$^{14}$ *& Throughout all Eternity*

*I forgive you you forgive me*

*As our dear Redeemer said*

*This the Wine & this the Bread*

          11                                  12

**j**

Till  $\overset{I}{\cancel{thou}}$  turn  from  Female  Love

And  $\cancel{dig}$  root  up  the  $\frac{I}{i}$nfernal  Grove

I  $\cancel{Thou}$  sha$\frac{ll}{lt}$  never  worthy  be

To  Step  into  Eternity

**k**

And  $\cancel{I}$  to  end  thy  cruel  mocks

Annihilate  the$\frac{e}{m}$  on  the  rocks

And  another  form  create

To  be  subservient  to  my  Fate

               *13*

**l**

Let  us  agree  to  give  up  Love

And  root  up  the  infernal  gr$\frac{ov}{ve}$e
Then  shall  we  return  &  see
The  worlds  of  happy  Eternity

---

Poem 71 continues from p. 13; stanzas h, i, j (with their numbering) are in the dark ink of the last revisions of p. 13; stanzas k and l and the revision of j are in the same ink but with sharpened pen; stanza l is numbered '13' in pencil; stanzas m, n, o, p, q, are all in pencil (shown by italics). I have designated them in the apparent order of inscription; yet n (in blunter pencil) *may* have been the latest. (See Longer Note, Appendix I.)

[N12 transcript]

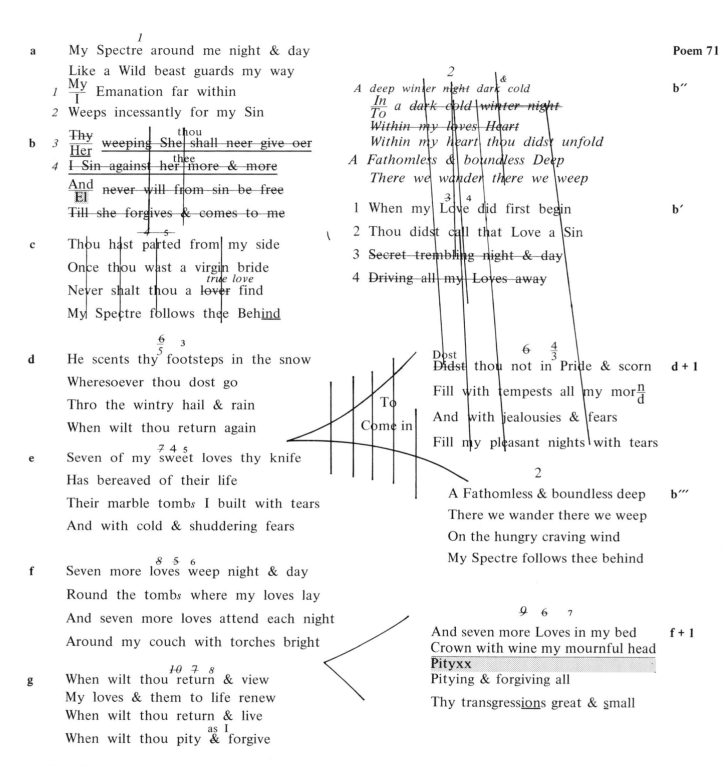

*1*

**a**  My Spectre around me night & day
Like a Wild beast guards my way
*1*  $\frac{My}{I}$ Emanation far within
*2*  Weeps incessantly for my Sin

**b**  *3*  ~~$\frac{Thy}{Her}$ weeping She shall neer give oer~~   thou
*4*  ~~I Sin against her more & more~~   thee
~~$\frac{And}{El}$ never will from sin be free~~
~~Till she forgives & comes to me~~

**c**  Thou hast parted from my side
Once thou wast a virgin bride
Never shalt thou a ~~lover~~ find   true love
My Spectre follows thee Behind

**d**  He scents thy footsteps in the snow
Wheresoever thou dost go
Thro the wintry hail & rain
When wilt thou return again

**e**  Seven of my sweet loves thy knife
Has bereaved of their life
Their marble tombs I built with tears
And with cold & shuddering fears

**f**  Seven more loves weep night & day
Round the tombs where my loves lay
And seven more loves attend each night
Around my couch with torches bright

**g**  When wilt thou ~~return~~ & view
My loves & them to life renew
When wilt thou return & live
When wilt thou pity & forgive   as I

*2*

A deep winter night dark & cold   **b″**
$\frac{In}{To}$ a ~~dark cold winter night~~
~~Within my loves Heart~~
Within my heart thou didst unfold
A Fathomless & boundless Deep
There we wander there we weep

*1*  When my Love did first begin   **b′**
*2*  Thou didst call that Love a Sin
*3*  ~~Secret trembling night & day~~
*4*  ~~Driving all my Loves away~~

$\frac{Dost}{Didst}$ thou not in Pride & scorn   **d + 1**
Fill with tempests all my mor$\frac{n}{d}$
And with jealousies & fears
Fill my pleasant nights with tears

To
Come in

*2*

A Fathomless & boundless deep   **b‴**
There we wander there we weep
On the hungry craving wind
My Spectre follows thee behind

And seven more Loves in my bed   **f + 1**
Crown with wine my mournful head
~~Pityxx~~
Pitying & forgiving all
Thy transgressions great & small

Poem 71 was begun in dark ink.  Light grey ink (italics here) was used for stanza b″ and the revision of c3; a darker grey was used for b‴.  A dark brown ink was used in the revision of g4 and in the ensuing stanzas on p. 12.  Lines b1 and 2 were written over two erased lines, not recoverable.

My Spectre' around me night & day
Like a Wild beast guards my way
My Emanation far within
Weeps incessantly for my Sin

~~They weeping they'll all ne'er give o'er~~
~~Thee against her more & more~~
~~And never will from tea to face~~
Till the forgery a comes to me

~~5~~
That hast parted from my side
Once thou wast a virgin bride
Never shalt thou a ~~this love~~ see
My spectre follows thee Behind

~~6~~ 3
He scents thy footsteps in the snow
Whensoever thou dost go
Thro the wintry hail & rain
When wilt thou return again

~~7~~ ~~4~~ 5
Seven of my sweet loves thy knife
Has bereaved of their life
Their marble tombs I built with tears
And with cold & shuddering fears

~~7~~ ~~5~~ 6
Seven more loves weep night & day
Round the tombs where my loves lay
And seven more loves attend each night
Around my couch with torches bright

~~7~~ ~~7~~ 8
When wilt thou relent & view
My loves or then to life renew
When wilt thou return & live
When wilt thou pity as I forgive

2
A deep winter ~~yet~~ ~~dark~~ cold
~~Or a dark cold winter night~~
~~Within my love Hark~~
Within my heart thou dost unfold
A Fathomless & boundless deep
There we wander there we weep

3 ~~4~~
1 When my Love did first begin
2 There did I call that Love a Sin
·3 ~~Secret trembling night & day~~
4 ~~Driving all my Loves away~~

~~6~~ ~~4~~
~~Dost thou~~ not on Pride & Scorn
Fill with tempests all my morn
And with jealousies & fears
Fill my pleasant nights with tears

2
A Fathomless & boundless Deep
There we wander there we weep
On the hungry craving wind
My Spectre follows thee behind

4 ~~6~~ 7
And seven more Loves in my bed
Crown with wine my mournful head
Pitying & forgiving all
Thy transgressions great & small

Pencil sketches:  (a) legs and buttocks of a man running or struggling forward, with a coil of a serpent around his left ankle (perhaps: cf. *Drawings,* Pl. 85); the figure seems related to that of the traveller on p. 16; (b) head with fur hat (?).

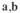

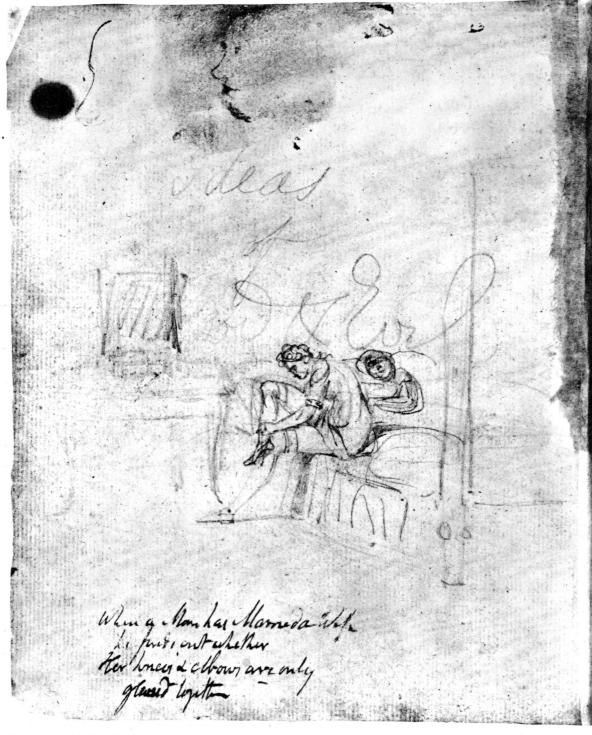

Pencil sketches:  (a) line of left profile, forehead to end of nose (Blake's?); (b) slightly shaded profile of man's face, not Blake's; (c) morning in a simply furnished London bedroom, Blake rising to work—a gentle parody or domestication of Gillray's *The Morning after Marriage or A Scene on the Continent* (5 April 1788).  (See Introduction, and Fig. 37, Appendix II.)

*I d e a s*

*o f*

*G o o d   &   E v i l*

**Poem 1**

When a Man has Married a Wife
he finds out whether
Her knees & elbows are only
gl$\frac{ue}{ewe}$d together

This page may represent William Blake's earliest use of the Notebook. Getting the sequence of these pages right lets us see that the pencilled title, 'Ideas of Good & Evil' (Msc 1), was inscribed as a title for the emblem series beginning on the facing page; it was written before the bedroom picture, probably in 1787. Poem 1 is in black ink, which blotted when wet on p. 15.

*Thus the traveller hasteth in*

*the Evening.*

$\frac{39}{42}$

**Emblem 1
(GP 14)**

Pencil sketches:  (a) a traveller (see hat, coat, belt) urinating beside a door; (b, c, h) three versions of a soaring human vulture with a body in its mouth—perhaps two bodies in b (the motif is developed on pp. 16 and 17); (d, e) back view of a left leg and side view of a left foot; (f) a crude plough with a supine infant in the furrow behind it.

(g) Emblem 1:  a traveller in belted coat, broad-brimmed hat, with staff, 'hasteneth' into the sunlight, along the angle of his shadow.  (For a full discussion of the Emblems, see Introduction.)  There are glue spots in two corners of the emblem, to hold tracing paper.

(h) Detail of monster's head; (i) boy and dog regarding each other (boy's head is redrawn from an upright to a bent position— cf. young piper with dog in left margin of 'On Anothers Sorrow'; (j) curving trunk of a tree.

[N15 transcript]

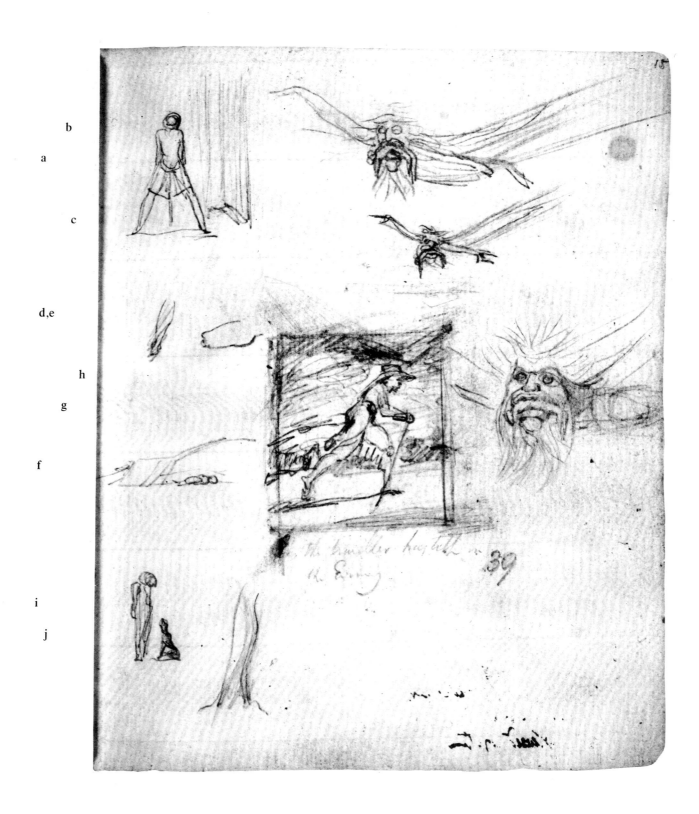

b

a

c

d,e

h

g

f

i

j

[N15]

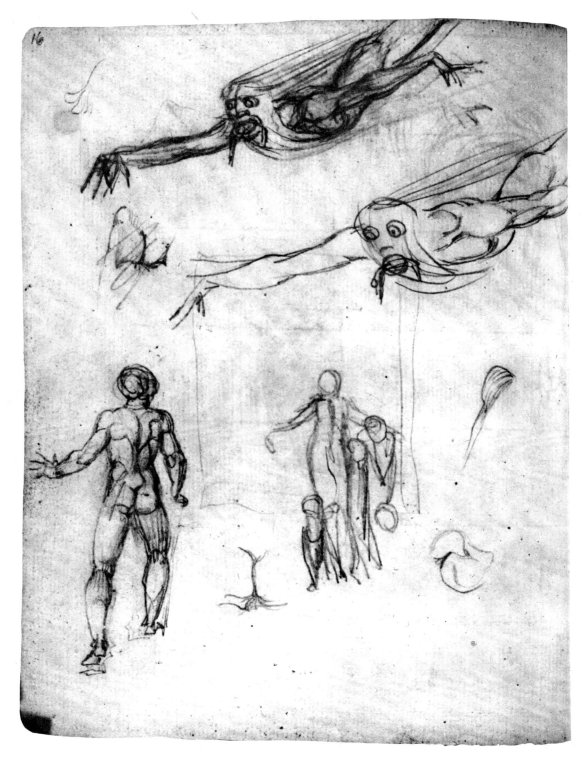

a

b

c　　　d

g

f

e

i

h

[N16]

Pencil sketches: (a) detail, perhaps of fingers for b; (b) soaring monster, hands first drawn horizontal, then erased and drawn at angle of descent (figure reshaped from 15b and made more gigantic in relation to human prey; direction of hands reversed); (c) detail of traveller's buttocks; (d) redrawing of b; (e) back view of hastening traveller, naked, details of head, right arm, both legs worked over (note stretched, open fingers of left hand; compare 17c); (f) doorway (of grave, see next page) with woman on threshold and flanked by three children (the tallest with a hat dangling on a long ribbon). When redrawn on p. 80 (for use in *J*46[32]) the woman's bent knees indicate she is facing toward us. Here her direction seems inward; yet that may not be Blake's intent, for the children are standing and facing toward the traveller and the mother must be standing still. Her gesture may be the preparation of an embrace to match the opening arms of the traveller.

(g) Detail (of muscle?); (h) detail, anus of traveller; (i) detail (of pelvis?). (Between b and d there is a pencil rub-off of the face on p. 17.)

Study of this page in relation to the next is surprisingly instructive. Technically, we see that much anatomizing has gone into the apparently simple drawing of the clothed traveller entering death's stony door in the small emblem of 17c. Dramatically, we see that the traveller's family (wife and children) have gone on before him, and thus we see why he has the courage to anticipate death's welcome—why some 'are glad when they can find the grave' (legend, p. 17).

As for the man-eating monster that soars in various shapes in these pages (15, 16, 17), perhaps sketched for some painting or illustration now lost, Blake (whether he drew the monster first or the emblems) would have been interested in their juxtaposition: the fate of the human body in these jaws is a fate threatened by the grave. Blake's traveller is no more diverted by them than was Ulysses by the heads of Scylla. (But see the note on p. 17.)

When we consider that these drawings, the traveller and family at least, must have been made before 1793 (from their relation to the emblems), it is a bit uncanny to realize that if the mother and children become Jerusalem and her daughters with hardly a change in drawing and if the traveller striding into death's door becomes the pilgrim entering the door in the frontispiece of *J*, without much change in motif, the embrace being prepared on this Notebook page is an anticipation of the compound embracings emblematized in the final pages of *J*.

Pencil sketches: (a, b) the face of the monster of pp. 15 and 16, redrawn closer in character to the heads in Fuseli's *Ulysses between Scylla and Charybdis* painted for the Milton Gallery between May 1794 and Aug. 1796—of which it is picture No. 12, illustrating *PL* II, 1019 (Pl. 23 in Schiff).

(c) Emblem 2: the traveller (clothed, with hat and staff complete) stepping into the doorway of hooded, skeletal Death, skull-faced. If we thought his stretched left hand was prepared to greet his wife and family, we now see it serving to fend off the grim hobgoblin; but of course we were also right the first time.

*Are glad when they can find*

*the grave*    $\frac{40}{43}$

I wonder who can say Speak no Ill of the Dead when it is

asserted in the Bible that the name of the Wicked shall Rot

It is Deistical Virtue I suppose but as I have none of this

I will pour Aqua fortis on the Name of the Wicked &

turn it into an Ornament & an Example to be Avoided

by Some & Imitated by Others if they Please

Columbus discoverd America but Americus Vesputius finishd & smoothd

it over like an English Engraver or Corregio or Titian &

Emblem 2

PA 47

*PA* 47 is in black ink.

There are glue spots in the four corners of the emblem, for tracing paper.

[N17 transcript]

Angels when they cause [...]
the [...]

I wonder who can say Speak no Ill of the Dead when it is
asserted in the Bible that the name of the Wicked shall Rot
It is deistical Virtue I suppose but as I have none of this
I will pour Aqua fortis on the Name of the Wicked &
turn it into an Ornament & an Example to be Avoided
by Some & Imitated by Others if they Please
Columbus discovered America but Americus Vespucius finishd & smoothd

[N17]

(a) Ink sketch of two small clouds (perhaps) beneath the words 'appropriate' and 'Lifes'.

(b) Pencil drawing, Emblem 3: a mounted man in armour, with perhaps a spear at his left side, has passed a kneeling woman, hands clasped in pleading. A castle is suggested by machicolations behind and above her. (See infra-red photograph, Fig. 1, Appendix II.)

**PA 49**  There is not because there cannot be Any Difference of Effect in the Pictures of Rubens & Rembrandt when you have seen one of their Pictures you have seen All  It i$\frac{s}{n}$ not so with Rafael Julio Romano Alb D Mich Ang   Every Picture of theirs has a different & appropriate Effect

**PA 48**  What Man of Sense will lay out his Money upon the Lifes Labours of Imbecillity & Imbecillitys Journeymen or think to Educate a~~n~~ $\frac{Fool}{Idiot}$ how to build a Universe with Farthing Balls  The Contemptible Idiots who have been call'd $\frac{G}{M}$reat Men of late Years ought to rouze the Public Indignation of Men of Sense in all Professions

**PA 58**
**PA 50**
**PA 59**

Princes appear to me to be Fools Houses of Commons & Houses of Lords appear to me to be fools they seem to me to be $_{in}$ $\frac{som}{alm}$ething Else besides Human Life

Yet I do not shrink from the Comparison in Either Relief or Strength of Colour with either Rembrandt or Rubens on the Contrary I court the Comparison & fear not the Result but not in a dark Corner   their Effects are Every Picture the same Mine are in Every Picture Different

I am really sorry to see my Countrymen trouble themselves about Politics.  If Men were Wise the Most arbitrary Princes could not hurt them  If they are not Wise the Freest Government is compelld to be a Tyranny

**PA 53**
**PA 52**

Rafael Mich Ang Alb D Jul Rom $\frac{ar}{\&}$e accounted ignorant of that Epigrammatic Wit in Art because they avoid it as a Destructive Machine as it is

That Vulgar Epigram in Art Rembrandts Hundred Guelders has intirely put an End to all Genuine & Appropriate Effect all both Morning & Night is now a dark cavern

**PA 51**  I hope my Countrymen will Excuse me if I tell them a Wholesom truth

**Emblem 3**  Most Englishmen when they look at a Picture i$\frac{mme}{34}$diately set about searching & clap the Picture into a dark corner   this when done by for Points of Light $_\wedge$ ~~this in~~ Grand Works is like looking for Epigrams in Homer One is an Epigram only A point of light is a Witticism many are destructive of all Art $_\wedge$ & no Grand Work can have them

**PA 55**  M$^r$ B repeats that there is not one Character or Expression in this Print which could be Produced with the Execution of Titian Rubens Coreggio Rembrandt or any of that Class Character & Expression can only be Expressed by those who Feel Them Even Hogarths Execution cannot be Copied or Improved.  Gentlemen of Fortune who give Great Prices for Pictures should consider the following

they Produce System & Monotony

The text is in greyish-brown ink.  *PA* 48 and 55 were written first, whence Blake went directly to the top of p. 19 (*PA* 56).
*PA* 49 and 51 were inserted next; then 58 and 59, avoiding the emblem.  Later, separation lines were drawn under sections 58-9 to squeeze in unrelated 52-3 below.  Lastly, *PA* 50 was written on top of the drawing.  The right edge of the leaf is broken away, leaving only remnants of two (?) words written downward from 'a dark cavern' (*PA* 53).

[N18 transcript]

**PA 56**

Rubenss Luxembourg Gallery is Confessd on all hands ~~because it bears the~~ eviden$^{ce}_{t}$ ~~at first view~~

it bears this Evidence in its face
to be the wo<u>r</u>k of a Blockhead ∧ how can its

Execution be any other than the Work of a

**PA 54**

Bloated ~~Awkward~~ Gods
Bl$^{o}_{e}$ckhead ∧. Mercury Juno Venus & the

rattle traps of Mythology & the lumber of an ~~old~~ awkward

French Palace are

~~all~~ thrown together

Clumsy & Ricketty
around ∧ Princes &

Princesses higgledy

piggledy On the

Contrary J<u>u</u>lio Rom
Palace of T at Mantua
is allowd on all hands

the Production of
to be ∧ a Man of the

Most Profound sense

& Genius & $\frac{Y}{h}$et his

Execution <u>is</u> pronouncd

**PA 57**

Who that has Eyes cannot see
that Rubens & Correggio must
have been very weak & Vulgar
fellows & are ~~we~~ $^{we}$ to imitate
like what
their Execution. This is ~~as if~~
says
S$^{r}$ Francis Bacon ~~should~~
~~downright assert~~ that a
healthy Child should be
taught & co<u>m</u>pelld to walk
like a Cripple while the
Cripple must be $\frac{t}{c}$aught to
6 $\frac{w}{8}$alk like healthy
people
O rare wisdom

**Emblem 4 (GP 7)**

*Ah luckless babe born under cruel star*
*And in dead parents baleful ashes bred* ~~y nts~~
*That little weenest now what sorrows are*
*Left thee for portion of thy livelihed*
*Spenser*

**PA 56 contd**

by English Connoisseurs & Reynolds their Doll to be unfit for

the Study of the Painter. Can I speak with too great Con

tempt of such Contemptible fellows. If all the Princes in Europe

like Louis XIV & Charles the first
∧were to Patronize such Blockheads I William Blake a

Mental Prince should decollate & Hang their Souls as Guilty
of Mental High Treason

The text is in the same ink as p. 18, except the emblem motto, which is in pencil. *PA 56* and *57* were written directly after *PA 55* on p. 18. *PA 54* was inserted later, where a space had been left because of the drawing.

[N19 transcript]

(a) Ink drawing, a profile possibly of Robert Blake; deleted by pen strokes in almost identical fashion to the deleting of the profile of William Blake in *An Island in the Moon*.  (See Introduction, n. 18.)  (But see also the note on 21a.)

(b) Pencil drawing, Emblem 4: used for *GP* 7: clothed boy with brimmed hat chasing small naked girls. (See variant, 87a.)  Glue spots.

(a) Pencil drawing, emblem size but unnumbered—and in gestures almost too stylized for the time of the emblems; perhaps late. The central figure looking up and the upward-pointing man suggest Job and Eliphaz in the 1825 *Illustrations of the Book of Job*, Pl. 9; the central figure's gesture of outstretched palms is Job's gesture in Pl. 10. The figure at his right may be pointing in the way Job's accusing friends do in that plate. The drawing was on the page before *PA*, however, i.e. by 1810.

The   wretched   state   of   the   Arts   in   this   Country   &   in   Europe   originating   in

the   Wretched   State   of   Political   Science   which   is   the   Science   of   Sciences

Demands   a   firm   &   determinate   conduct   on   the   part   of   Artists

to   Resist   the   Contemptible   Counter   Arts   ~~set   on   foot~~ Established   by   Such

contemptible   P$\frac{o}{al}$liticians   as   Louis   XIV   &   ~~but~~   originally   set   on   foot

by   Venetian   Picture   traders   Music   traders   &   Rhime   traders   to   the

**PA 63**

An Example of these Contrary Arts is given us in the Characters of Milton & Dryden as they are written in a Poem signed with the name of Nat Lee which per haps he never wrote & perhaps he wrote in a paroxysm of insanity In which it is said that Miltons Poem is a rough Unfinishd Piece & Dryden has finishd it Now let Drydens Fall & Miltons Paradise be read & I will assert that every Body of Understanding ~~& sen will~~ must cry out Shame on such Niggling & Poco Piu as Dryden

has degraded Milton with But at the same time I will allow that Stupidity will Prefer Dryden & Monotonous Sing Song Sing Song because it is in Rhyme ~~but for no other cause~~ from beginning to end  Such are Bartollozzi Woolett & S$\frac{tr}{rt}$ange

**PA 61**    destruction   of   all   true   art   as   it   is   this   Day.   To   recover   Art   $\frac{has}{is}$

been   the   business   of   my   life   to   the   Florentine   Original   &   if

possible   to   go   beyond   that   Original   this I   thought   the   only   pursuit

worthy   of   ~~an   Englishman.~~ a Man   To   Imitate   I   abhore   I   obstinately   adhere

to   the   true   Style   of   Art   such   as   Michael   Angelo   Rafael   Jul   Rom

Alb   Durer   left   it   ~~the   Art   of   Invention   not   of   Imitation.   Imagination~~

~~is   My   World   this   world   of   Dross   is   beneath   my   Notice   &   beneath~~

~~the   Notice   of   the   Public~~   I   demand   therefore   of   the   Amateurs   of

The *PA* text is in dark ink, not the grey-brown of pp. 18-19.  The sequence of writing is obviously 60, 61, 63.

[N20 transcript]

No real Style of Colouring ever appears

But advertising in the News Papers

Look here youll see S^r Joshuas Colouring

Look at his Pictures ~~tis quite another Thing~~
All has taken Wing

Poem 143

You dont believe I wont attempt to make ye

You are asleep I wont attempt to wake ye

Sleep on Sleep on while in your pleasant dreams

Of Reason you may drink of Lifes clear streams

Reason and Newton they are quite two things 5

For so the Swallow & the Sparrow sings

Reason says Miracle Newton says Doubt

Aye thats the way to make all Nature out

Doubt Doubt & dont believe without experiment

That is the very thing that Jesus meant 10

When he said Only Believe Believe & try

Try Try & never mind the Reason why

Emblem 5

*Every thing that grows*

*Holds in perfection but a little*

*moment*
*Shakespeare*

PA 62

art the Encouragem^t which is my due if they continue to refuse theirs is the

loss not mine. — & theirs is the Contempt of Posterity I have Enough in the Approbation of fellow

labourers this is my glory & exceeding great reward I go on

& nothing can hinder my course

Poem 132
(in PA)

And in Melodious accents I

Will sit me down & Cry. I. I.

PA 62 and Poems 132 and 142 are in dark ink; Poem 143 (written after 142) and the revision of 142 are in blacker ink. Poem 132 is a part of PA; Poem 142 was added after PA 62, perhaps immediately or p^ 'laps when Blake was writing on p. 61 on the subject of colouring.

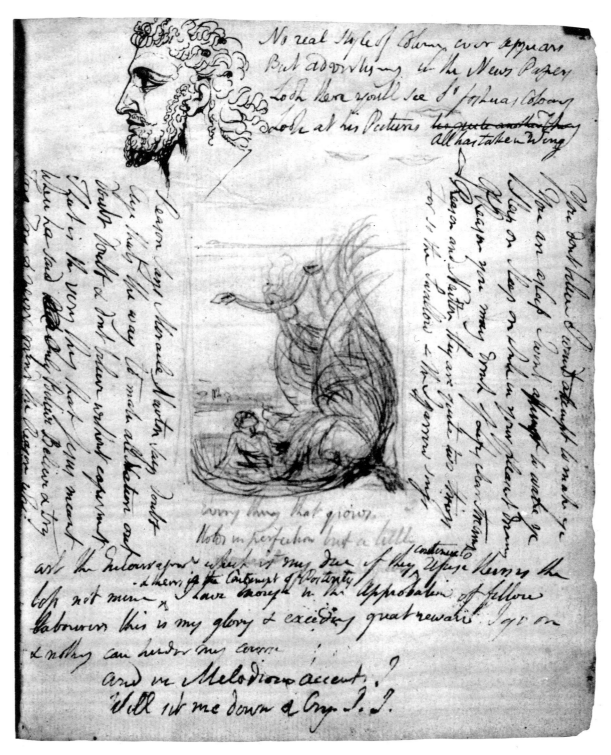

(a) Head, in black ink, similar in features and beard to *Faulconberg the Bastard* drawings of 1819; yet closer in nose to the profile of 19a.  See discussion in Introduction.

(b) Pencil drawings of three pairs of closed lips.

(c) Emblem 5:  female and male human forms of or in the blossom of a (scarlet) anemone, flower of Adonis.  (See Table I G for analogues.)

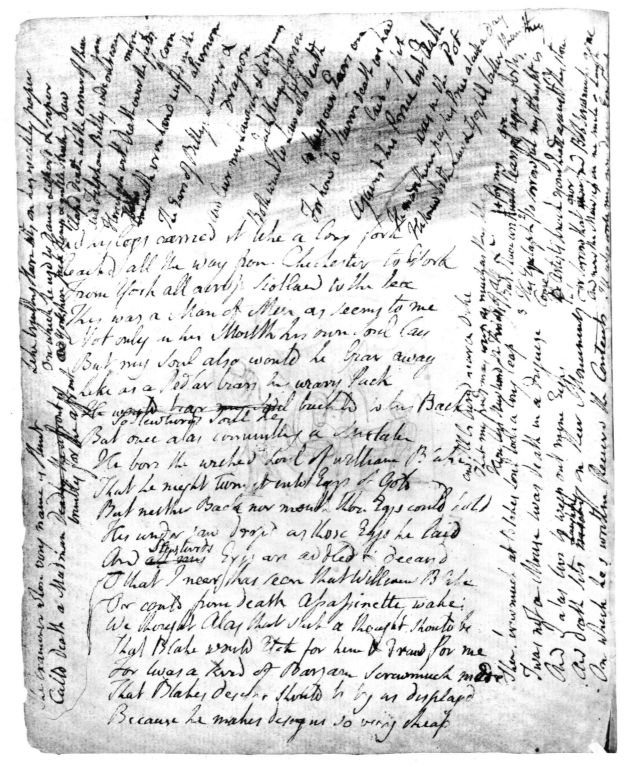

My legs carried it like a long fork
Reachd all the way from Chichester to York
From York all across Scotland to the sea
This was a Man of Men as seems to me
Not only in his Mouth his own Soul lay
But my Soul also would he Spear away
Like as a Pedlar bears his weary Pack
He would bear ~~my~~ Soul buckld to his Back
     So newthorns Soul he
But once alas committing a Mistake
He bore the wretched Soul of william Bake
That he might turn it into Eggs of Gold
But neither Back nor mouth those Eggs could hold
His under jaw droppd as those Eggs he laid
And all ~~sorts~~ Stepsons Eggs are addled & decayd
O that I neer has seen that William Bake
Or could from death Apassinette wake:
We thought Alas that such a thought should be
That Blake would Etch for him & Draw for me
For I was a kind of Bargain Servmuch made
That Blakes designs should be by us displayd
Because he makes designs so very cheap

(a)   Emblem 6:  courtship scene; the girl bends her head; the father, standing, turns away with hand to head.  (See detail and tracing, Figs. 2 and 3, Appendix II.)

The top of the page was used to sharpen a pencil point.

**Poem 78**

**Emblem 6**

The Examiner whose very name is Hunt 22
Calld Death a Madman ~~Deadly the affront~~ 23
trembling for the affront

Like trembling Hare sits on his weakly paper 24
On which he usd to dance & sport & caper 25
~~And~~ Yorkshire Jack Hemp & gentle blushing Daw 23
Clapd Death into the corner of their jaw
And Felpham Billy rode out every morn
Horseback with Death over the fields of corn
Who
~~And~~ with iron hand cuffd in the afternoon 30
The Eears of Billys Lawyer & Dragoon
And Cur my Lawyer & Dady my Jack Hemps Parson
Both went to Law with Death to keep our Ears on
For how to starve Death we had laid a plot
Against his Price but Death was in the Pot 35
He made them pay his Price alack a Day
He knew both Law & Gospel better than they

And his legs carried it like a long fork

Reachd all the way from Chichester to York

From York all across Scotland to the Sea

This was a Man of Men as seems to me

Not only in his Mouth his own Soul lay 5

But my Soul also would he bear away

Like as a Pedlar bears his weary Pack

~~He would bear my Soul~~ buckld to his Back
    So Stewhards Soul he

But once alas committing a Mistake

He bore the wrched Soul of William Blake 10

That he might turn it into Eggs of Gold

But neither Back nor mouth those Eggs could hold

His under jaw dropd as those Eggs he laid/17
    Stewhards

And ~~all my~~ Eggs are addled & decayd

O that I neer has seen that William Blake 15

Or could from death Assassinetti wake!

We thought Alas that such a thought should be

That Blake would Etch for him & draw for me

For twas a kind of Bargain Screwmuch made

That Blakes Designs should be by us displayed 20

Because he makes designs so very cheap

And Ill be buried near a Dike 49
That my friends may weep as much as they like
Here lies Stewhard the Friend of All &c 51
    Fnd of                              are
    4 for my
1 But I have writ / with tears of aqua fortis
2 His Epitaph /so sorrowful my thought is
Come
3 His Epitaph Ye Artists knock your heads against This stone 45
    our
For Sorrow that your friend Bob Screwmuchs gone
And now the Men upon me smile & Laugh
Ill also write my own dear Epitaph

Then Screwmuch at Blakes soul took a long leap
Twas not a Mouse twas Death in a disguise
And I alas live to weep out mine Eyes 40
    laughing
And Death sits ~~mocking~~ on their Monuments
On which hes written Recievd the Contents

Poem 78 is in black ink, revised in black with a rougher pen and probably at a later time. Collation indicates that two leaves may be missing between pp. 22 and 23. (See Longer Note, Appendix I.) The original poem probably began on a missing next leaf (just as Poem 71 began on p. 13 and continued on p. 12). The initial lines on p. 22 refer to the death of Schiavonetti (7 June 1810) but must predate the writing of *PA* (*c*. 1810), or the prose of *PA* would have continued from p. 21. The marginal additions to Poem 78 must have been made after Cromek's death (Mar. 1812), to which they unmistakably refer.

[N22 transcript]

eeeeeeeeeeeeeeeeeeeeeeeeeeeeeee WwwwwwwWThomas James Robert
That Painted as well as Sculptured Monuments were common among the

Cllllllln AOOJllluuummmm All    Alls Handsbritish alls Wwwwnd Bluuu
Ancients is evident from the words of the Savants who compared the Plain

uel
~~Those~~
laureello Afffffsssw Alllll Haannallitoe WWm BMilllljjjjjjjjjj Horses
~~unpainted~~ Sepulchures Painted on the outside with others ~~of~~ only of Stone. Their

Ollee  W  H y y  SS Well saitth  Blake    John   Thomas
Beauty is Confessd even by the Lips of Pasch himself. The Painters

of England are unemployd in Public Works. while the Sculptors have continual

& superabundant employment Our Churches & Abbeys are treasures of

~~Spiritual riches~~ their producing f<u>o</u>r ages back While Painting is excluded

among our almost
Painting the Principal Art has no place ~~in our~~ only public works. ~~while~~

Yet it is more adapted to solemn ornament than ~~dead~~ Marble can be as

i$\frac{t}{s}$ is capable of being                          Placed in any heigth &

Placed
indeed would make a                          Noble finish above the

Great Public Monuments                          in Westminster S$^t$ Pauls &

other Cathedrals.    To                          the Society for Encouragement

of Arts I address myself                          with ~~duty &~~ Respectful duty

& requesting their Consideratin                          of my Plan as a Great

Public ~~deed~~ means of ad                          vancing Fine Art in Protestant

Communities Monuments                          to the dead Painted by Historical

& Poetical Artists like Barry                          & Mortimer. I forbear to name

~~a li~~ living Artists tho equall<u>y</u> worthy   I say Mon$\frac{uments}{\frac{8}{7}\,9}$ so Painted must make

England What Italy is an Envied Storehouse of Intellectual Riches

Was I angry with Hayley who usd me so ill

Or can I be angry with Felphams old Mill

~~Or angry with Boydell or Bowyer or Ba~~

Or angry with Flaxman or Cromek or Stothard

Or poor Schiavonetti whom they to death botherd   5

Or angry with *Macklin or Boydel or Bowyer*
~~Boydell or Bowyer or Basire~~

*Because they did not say O what a Beau ye are*
~~Mirths all your sufferings convey sir~~

At a Friends Errors Anger Shew

Mirth at the Errors of a Foe

*Anger & Wrath my bosom rends*
*I thought them the Errors of friends*
*But all my limbs with warmth glow*
*I find them the Errors of the foe*

PA 64 was written in dark grey ink and revised and cancelled in black. Poem 79 was written in black, its revision and Poem 144 in lighter grey ink (here italics). The loops and strokes cancelling the first four lines of PA 64 are impossible to copy in print. Poem 79 was begun after 7 June 1810, the death of Schiavonetti.

a

Was I angry with Hayley who used me so ill
Or can I be angry with Felpham's Mill
Or angry with Boydell or Bowyer or Ba
Or angry with Flaxman or Cromek or Stothard
Or poor Schiavonetti whom they to death baited
Or angry with Macklin or Boydel or Bowyer
Because they did not say O what a Beau ye are
At a Friends Errors Anger shew
Mirth at the Errors of a Foe

(a) Emblem 7: a clad boy, face in hands, huddles in a birdcage, while a bird hovers outside. For the contrary emblem see p. 77. (See infra-red photograph, Fig. 4, Appendix II.) Glue spots.

the Sussex Men are Noted Fools

And weak is their brain pan
I wonder if H — the painter
Is not a Sussex Man

Prospero had One Caliban & I have Two

(a) Emblem 8: under the trees, a bearded, long-gowned old man, like one of Robert's Druids (see 7a), expels a long-dressed maiden, who looks back with hands raised, and a youth who turns away.

PA 69
Poem 80

PA 69 contd

PA 67

Emblem 8

Poem 81

PA 65

PA 69 contd    PA 7

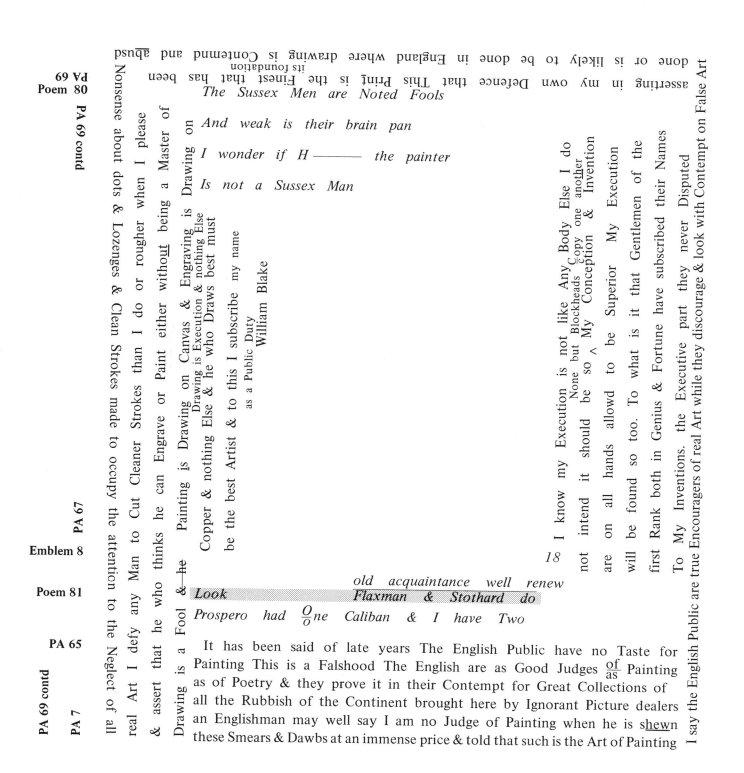

done or is likely to be done in England where drawing is Contemnd and abusd
asserting in my own Defence that This Print is the Finest that has been
its foundation
Nonsense about dots & Lozenges & Clean Strokes made to occupy the attention to the Neglect of all real Art I defy any Man to Cut Cleaner Strokes than I do or rougher when I please & assert that he who thinks he can Engrave or Paint either without being a Master of Drawing is a Fool & he

Painting is Drawing on Canvas & Engraving is Drawing on Copper & nothing Else & he who Draws best must be the best Artist & to this I subscribe my name as a Public Duty
Drawing is Execution & nothing Else
William Blake

*The Sussex Men are Noted Fools*

*And weak is their brain pan*

*I wonder if H——— the painter*

*Is not a Sussex Man*

I know my Execution is not like Any Body Else I do not intend it should be so My Conception & Invention are on all hands allowd to be Superior My Execution will be found so too. To what is it that Gentlemen of the first Rank both in Genius & Fortune have subscribed their Names To My Inventions. the Executive part they never Disputed
None but Blockheads Copy one another

18

I say the English Public are true Encouragers of real Art while they discourage & look with Contempt on False Art

*Look Flaxman & Stothard do old acquaintance well renew*

*Prospero had One Caliban & I have Two*

It has been said of late years The English Public have no Taste for Painting This is a Falshood The English are as Good Judges of/as Painting as of Poetry & they prove it in their Contempt for Great Collections of all the Rubbish of the Continent brought here by Ignorant Picture dealers an Englishman may well say I am no Judge of Painting when he is shewn these Smears & Dawbs at an immense price & told that such is the Art of Painting

Poems 80 and 81, in grey ink, precede the prose, which is in dark ink. *PA* 69, written upside down, is a continuation of 68 in the same position on p. 25.

[N24 transcript]

finest Engravings & defy the most critical judge to the Comparison Honestly
make
in my own defence Challenge a Competition with the
I in my own defence Challenge a Competition with the Villains as my works shew

Madman I have been calld Fool they Call thee

I wonder which they Envy Thee or Me

To H

You think Fuseli is not a Great Painter Im Glad

This is one of the best compliments he ever had

P.S. I do not believe that this Absurd opinion ever was set on foot till in my Outset into life it was artfully publishd both in whispers & in print by Certain persons whose robberies from me made it necessary to them that I should be left hid in a corner it never was supposed that a Copy Could be better than an original or near so Good till a few Years ago it became the interest of certain envious Knaves

the Lavish praise I have recieved from all Quarters for Invention & Drawing has Generally been accompanied by this he can concieve but he cannot Execute this Absurd assertion has done me & may still do me the greatest mischief I call for Public protection against these Villains

I am like others Just Equal in Invention & in Execution as my works shew

32 23

In a Commercial Nation Impostors are abroad in all Professions these are the greatest Enemies of Genius Mr B thinks it his Duty to Caution the Public against a Certain Impostor who . In our Art the Art of Painting these Impostors sedulously propagate an Opinion that Great Inventors Cannot Execute This Opinion is as destructive of the true Artist as it is false by all Experience Even Hogarth cannot be either Copied or Improved Can Anglus never Discern Perfection but in the Journeymans Labour

Poem 82 is in dark grey ink, Poem 83 in black. *PA* 66 begins in greyish ink, darkening in the fourth line. The insert 'Can Anglus' is in blacker ink. *PA* 70 and 68 are in dark ink; 68 continues upside down at the top, jumping to *PA* 69 on p. 24.

[N25 transcript]

Madman I have been calld Fool they Call thee

I wonder which they Envy Thee or Me

To H

You think Fuseli is not a Great Painter Im Glad

This is one of the best compliments he ever had

In a Commercial Nation Impostors are abroad in all
Professions these are the greatest Enemies of Genius

(a) Emblem 9:  two women are expiring, one in the street, held by a young man; the other on a doorstep, held by a long-skirted woman (compare 64a); a third woman kneels in frantic gesticulation.  A scene of Plague; drawn upon in *Europe* 13.  Glue spots.

(b) Obscure pencil sketch, possibly a variant of the central figure of a with hair hanging and hands flung up.  (See tracing, Fig. 15, Appendix II.)

[N25]

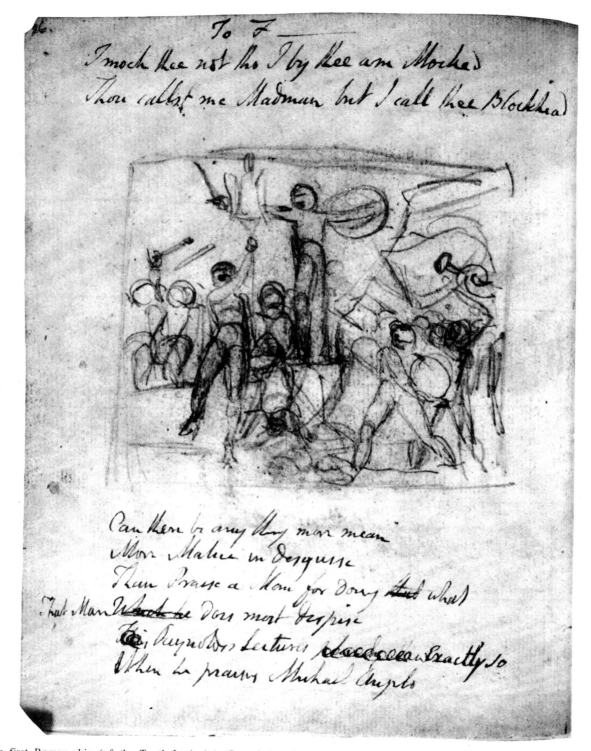

*To F——*

*I mock thee not tho I by thee am Mocked*
*Thou callst me Madman but I call thee Blockhead*

*Can there be any thing more mean*
*More Malice in disguise*
*Than Praise a Man for doing what*
*That Man does most despise*
*Reynolds Lectures Exactly so*
*When he praises Michael Angelo*

a

(a) The first Roman ship (of the Tenth Legion) in Caesar's invasion of Britain; leaping overboard is a legionnaire grasping an eagle standard; at right, in front of a square sail, is the trunk of an elephant trumpeting (literally—whimsy, or a misconception?). Both the eagle standard and (in a later Roman general's entourage) the elephant are in Milton's *History of England*, Book I. (See Introduction.)

**Poem 84**

<center>To F ———</center>

I mock thee not tho I by thee am Mocked

Thou callst me Madman but I call thee Blockhead

**Poem 85**

Can there be any thing more mean

More Malice in disguise

Than Praise a Man for doing ~~that~~ what

That Man ~~Which he~~ does most despise

~~This~~ Reynoldss Lectures ~~plainly shew~~ Exactly so

When he praises Michael Angelo

Poems 84 and 85 are in greyish-black ink; the revisions of 85:5 are in darker ink. In the same line the possessive 's' in 'Reynoldss' is to be presumed deleted, the word 'Lectures' having been changed from noun to verb in the revision.

<center>[N26 transcript]</center>

S — in  Childhood  on  the  Nursery  floor

Was  extreme  Old  &  most  extremely  poor

He  is  grown  old  &  rich  &  what  he  will

He  is  extreme  old  &  extreme  poor  still

53  24

*The drift of hollow states hard to*

*be spelld*        *Milton*

To  Nancy  F ————

How  can  I  help  thy  Husbands  copying  Me

Should  that  make  difference  twixt  me  &  Thee

Of  H s  birth  this  was  the  happy  lot

His  Mother  on  his  Father  him  begot

Poems 86 and 87 are in dark ink; Poem 88 is in black ink.

[N27 transcript]

a

*(handwritten, in Blake's hand, partly illegible)*

I —— in Child hood on the Nursery floor
Was extreme Old & most extremely poor
She is grown old & rich & what she will
He is extreme Old & extreme poor still

To Nancy F——
How can I help thy Husbands copying Me
Those that make difference twixt me & thee
Of H's birth this was the happy lot
His Mother on his Father him begot

(a) Emblem 10: Death after a battle. A variant of Blake's 1784 design *A Breach in a City the Morning after the Battle*, but closer in detail to the variant of 1805 called *War*. A woman and a bearded man stand at the right, bowing their heads above an outstretched warrior. Tumbled corpses (two at least) fill the breach, and the space between the broken edge of the wall and the body at the left has the optical appearance of a large extended leg. Atop the wall perches an eagle with outstretched left wing and head. In the center background a grove of trees is indicated; in the mid distance a small figure searches the battleground. She will reappear in *Jerusalem* 77, there winding a golden clue string leading to the gate in Jerusalem's wall. (See tracing, Fig. 5.)

[N27]

Sir Joshua praises Michael Angelo.

But Twould be Madness that we all must say

Michael Angelo Sir Joshua

Christ used the Pharisees in a rougher way

a

Hes a Blockhead who wants a proof of what he cant Perceive
And he's a Fool who tries to make such a Blockhead believe

(a) Pencil sketch for the illustration (in reverse) of *VDA* Argument: Oothoon, holding her breasts, kisses the human form of a marigold, against rays of sunlight. But traces of erased drawing at right show a man (Theotormon?) standing beside her, with hands clasped and features expressive of woe or jealousy (corners of mouth turned down), and beside him a straight tree loosely entwined by a vine (as in 'The Little Girl Lost' and 'Night'). The relation of man and tree is like, but contrary to, that in 'The Shepherd'.

[N28]

**Poem 89**

Sir Joshua Praises Mic^h/a ael Angelo  1

*Is it*
~~Tis but~~ Politeness *Tis Christian Mildness when* ~~fools~~ *Knaves Praise a Foe*
~~And counts it courage thus to praise his foe~~  2

                                        all the World would
But   Twould be Madness ~~that we all~~ must say   3
                                                  should

                                                all  must  say
                                                    might
~~It would be Christian Mildness~~              ~~to maintain~~
~~Printing his praises of~~

Should
     If  As   Michael  Angelo  ~~praising~~  prais^e/d Sir  Joshua  4
         Act

*Christ  usd  the  Pharisees  in  a  rougher  way*  5

**Poem 90**

Hes  a  Blockhead  who  wants  a  proof  of  what  he  Can't  Percieve

                              tries
And  he's  a  Fool  who  ~~seeks~~  to  make  such  a  Blockhead  believe

Poems 89 and 90 were written in dark brown ink and, to some extent, revised in the same ink; Poem 89 was then further revised in blacker ink (here indicated by italics).  (See Longer Note in Appendix I.)

[N28 transcript]

Cr —— loves artists as he loves his Meat

He C̶r̶ —— loves <sup>the</sup>∧Art but t̶h̶e̶ <sup>tis</sup>the Art to Cheat

A Petty sneaking Knave I knew

O M<sup>r</sup> Cr —— .how do ye do

He is a Cock would / wont
And would be a Cock / row if he could

24 19

Sir Joshua praised Rubens with a Smile

By calling his the ornamental Style

And yet
B̶e̶c̶a̶u̶s̶e̶ his praise of Flaxman was the smartest

When he calld him the Ornamental Artist

But sure such ornaments we well may spare 5

L̶i̶k̶e̶ a̶ f̶i̶l̶t̶h̶y̶ i̶n̶f̶e̶c̶t̶i̶o̶u̶s̶ h̶e̶a̶d̶ o̶f̶ h̶a̶i̶r̶

*A̶ C̶r̶o̶o̶k̶e̶d̶ S̶t̶i̶c̶k̶ &̶ l̶o̶u̶z̶y̶ h̶e̶a̶d̶ o̶f̶ h̶a̶i̶r̶*

6

*As Crooked limbs & louzy heads of hair*

Poems 91-3 are in dark grey ink, additions to 93:6 (and the deleting lines) in lighter grey (here italics). Poem 137 is in black ink. It seems contemporaneous with the black ink revisions of p. 28. The crow turned cock and cuckolded is apparently Cromek (of poems 91, 92); reference to Trooper Cock of the Aug. 1803 episode has been suggested but is unlikely.

a

Cr— loves artists as he loves his Meat
He Cr— loves the Art but 'tis the Art to Cheat

A Petty sneaking Knave I knew
O Mr Cr— how do ye do

[right margin, vertical]
Tis a Cock wants
a comb & a Cock of the comb

For Joshua praised Rubens with a Smile
By Calling his the ornamental Style
And yet his praise of Flaxman was the smartest
When he called him the Ornamental Artist
But som such ornaments we well may spare
Then a full thro up [...] head of hair
A Crooked stick & towzy head of hair
As Crooked limbs & towzy heads of hair

(a) Emblem 11: is this an early version of Oothoon hovering over Theotormon (*VDA* 4, developed in 92b)? Perhaps closer in theme is *MHH* 14, where a woman soars over an outstretched warrior, but in different perspective and amid flames. Perhaps closest (as it is in drawing) is *Drawings,* Pl. 40 (misinterpreted and probably misdated in Keynes's note); yet there the male lies more peacefully sideways, with left leg only slightly drawn up; he is crowned with leaves and rests his right arm on a lyre; a circular object beside him is probably a tambourine: the object in the same position here is more like a hat.

[N29]

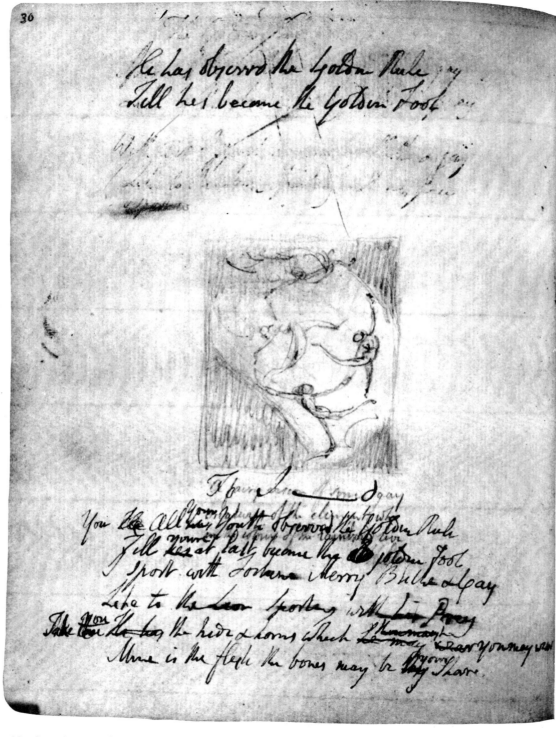

(a) Emblem 12: four elemental fairies in an open dance. The legend is from *Comus* II, 298-300. They dance with scarves in the rainbow of the title page of *VDA*. (They 'live in', are the human forms of, four elemental 'colours'.) Compare 114a.

The   Golden   Rule

He   has   observ'd   the   Golden   Rule
?Sporting   with   ?golden   ?fortune   Blithe   &   gay

Till   hes   become   the   Golden   Fool
Like   to   the   Lion   sporting   with   his   prey

With   Fortune   sporting   Merry   Blithe   &   gay

Like   to   the   Lion   sporting   with   his   prey

a   Sparrow

**Poem 95**
**Emblem 12**

To  S ———— d
*A fairy vision of some gay*

                    Your*creatures of the element who*
You   He   All   his   Youth   observed   the   Golden   Rule
            youre      *in the colours of the rainbow live*
Till   hes   at   last   become   the   old   golden   Fool
                                            *Milton*
I   sport   with   Fortune   Merry   Blithe   &   Gay

Like   to   the   Lion   Sporting   with   his   Prey
        you                          thou maist
T/M ake thou   He  has   the   hide   &   horns   which   he  may  wear  you may wear
                                                         your
Mine   is   the   flesh   the   bones   may   be   thy/his   Share

Poem 94 was written in grey ink (here italics), then erased and overwritten in dark ink; an expanded version, Poem 95, was written in the same dark ink.  The emblem with its 'gay creatures' may well have attracted to this page these verses in which Blake expresses satiric gaiety towards Stothard.

[N30 transcript]

~~M^r Cromek to~~ M^r Stothard to M^r Cromek

For Fortunes favours you your riches bring

But Fortune says she gave you no such thing

Why should you be ungrateful to your friends

Sneaking & ~~Calumny~~ Backbiting & $^O_o$dds & $^E_e$nds

I am no Homers Hero you all know

I profess not Generosity to a Foe

My Generosity is to my Friends

That for their Friendship I may make amends

The Generous to Enemies promotes their Ends

And becomes the Enemy & Betrayer of his Friends

M^r Cromek to M^r Stothard          *35*

Fortune favours the Brave old Proverbs say

But not with Money. that is not the way

Turn back turn back you travel all in vain

Turn thro the iron gate down Sneaking Lane

Poems 96 and 97 are in somewhat greyer ink than Poem 138, though the last two lines of 138 are greyish (from blotting?).

[N31 transcript]

(a) Emblem 13: a gowned female on a cloud rises through a doorway toward a central sun; her hands are raised in greeting two figures standing inside the door. (See the early drawing, Fig. 45, p. 97.) A version now untraced was described by W. M. Rossetti as 'The Soul entering Eternity. Exhibits a maiden entering a door, guarded by two spiritual women'. (Gilchrist 1863, II, 248 no. 92). A close variant is *NT*510.

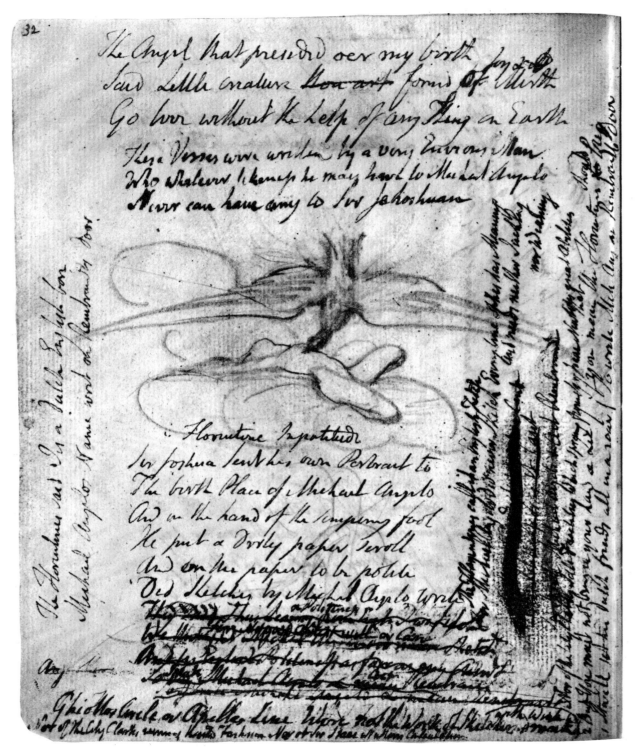

The Angel that presided oer my birth
Said Little creature formed of Mirth
Go love without the help of any thing on Earth

These Verses were written by a very Envious Man
Who whatever likeness he may have to Michael Angelo
Never can have any to Sir Joshuan

Florentine Ingratitude

Sir Joshua sent his own Portrait to
The birth Place of Michael Angelo
And on the hand of the enquiring fool
He put a Dirty paper scroll
And on the paper to be polite
Old Sketches by Michael Angelo wrote

a

b

Pencil drawings: (a) sketch for *VDA* 3 (reversed): Oothoon's vision (indicated by cloud) of being devoured by Theotormon's eagle; (b) an obscure sketch beneath Poem 99, unidentified. (See tracing, Fig. 16, Appendix II.)

[N32]

**Poem 98**

*The Angel that presided oer my birth*

*Said Little creature* ~~thou art~~ *formd* $\frac{of}{for}$ Joy & M *Mirth*

*Go love without the help of any* $\frac{King}{Thing}$ *on Earth*

**Poem 158**

These Verses were written by a very Envious Man

Who whatever likeness he may have to Michael Angelo

Never can have any to Sir Jehoshuan

**Poem 99**

a

**Poem 99b**

**Poem 99c**

The Florentines said Tis a Dutch English bore b1

Michael Angelos Name writ on Rembrandts door b2

Florentine Ingratitude

*Sir Joshua sent his own Portrait to*

*The birth Place of Michael Angelo*

*And in the hand of the simpering fool*

*He put a Dirty paper scroll*

*And on the paper to be polite* 5

*Did Sketches by Michel Angelo write*

~~They said~~ & Politeness & Politeness
~~They said~~ *Thus Learning from England* *we fetch*
For No good Artist Will or Can *was sent* 7
$\frac{We}{I}$ *thought Michael Angelo did never* sketch *Paint* 8

*And tis English Politeness as fair as my Aunt*
~~Isnt it xxxxxxxxxxxxxxxxxxxxxxxx Rembrandt~~ 9

*Any* other word
speak Act
*To* ~~say~~ *Michael Angelo &* mean *Rembrandt* 10
*Say Write Michael Angelo & mean Rembrandt*

The Florentines call it an English Fetch c1
For Michael Angelo did never Sketch Every line of his has Meaning 3
And needs neither Suckling c2
nor Weaning c4'
Tis the trading English Venetian Cant c4
Is this Politeness or is it Cant c5
To Speak Michael Angelo & Act Rembrandt c6
Nor of the City Clarks Idle Facilities c7
Which sprang from Sir Isaac Newtons great Abilities c8
should
that
If you mean the Florentines to buy c10
You must not bring in your hand a Lie c9
on Rembrandts door c12
To write Mich Ang c11
It will set his Dutch friends all in a roar c11
But You

with Wine 12

Ghiottos Circle or Apelles Line 11     Were not the Work of Sketchers drunk
~~The Florentines said This is all a Fetch~~     *For Michael Angelo never did Sketch*

Nor of the City Clarks merry hearted Fashion 13     Nor of Sir Isaac Newtons Calculation 14

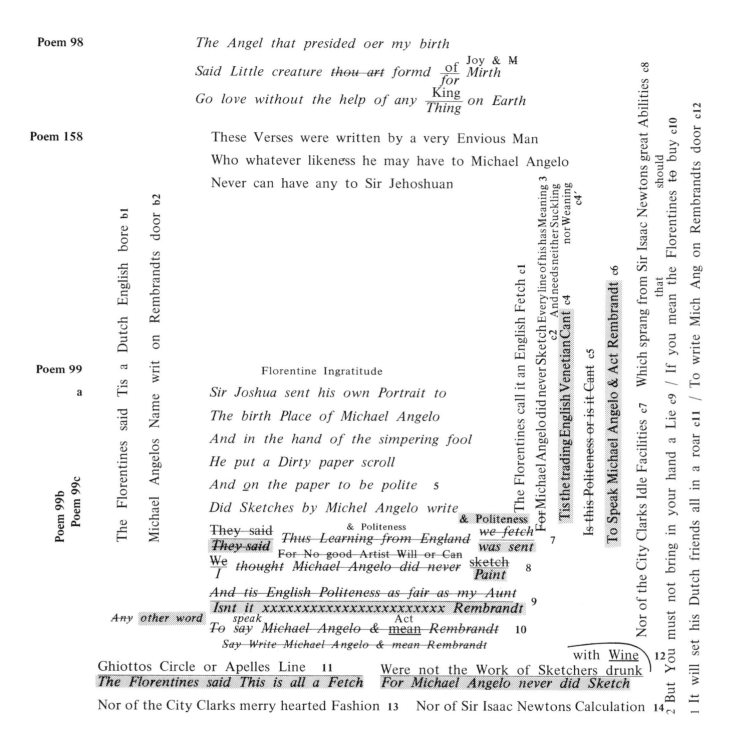

Poems 98 and 99 were begun and revised in grey ink (italics here), then further revised and completed in black. Poem 158, in black ink, was added as comment on Poem 99. In the left margin two lines were written, in dark or black ink but with different pen, before the revisions in which their theme (bore/door) is developed. Some of the revising lines were extended up the right margin and partly erased by smudging when wet. Beneath 99:9 is an erased line, of which I can make out only the concluding word, 'Rembrandt'.

A Piti $\frac{ful}{able}$ Case

The Villain at the Gallows tree

When he is doomd to die

To assuage his misery

In Virtues praise does cry

So Reynolds when he came to die

To assuage his bitter woe:

Thus aloud ~~was heard to~~ cry  [did howl &]

Michael Angelo Michael Angelo

To The Royal Academy

A strange Erratum in all the Editions

Of Sir Joshua Reynoldss Lectures

Shoud be corrected by the Young Gentlemen

And the Royal Academys Directors

Instead of Michael Angelo

Read Rembrandt ~~& you will know~~  [for it is fit]

~~That Sir Joshua never wishd to speak~~

~~Of Michael Angelo~~

If it is True What the Prophets write That the heathen Gods are all stocks & stones
Shall we for the sake of being Polite Feed them with the juice of our marrow bones
And if Bezaleel & Aholiab drew What the Finger of God pointed to their View
Shall we suffer the Roman & Grecian Rods To compell us to worship them as Gods

They stole from the Temple of the Lord
And Worshippd them that they might make [to]
Inspired Art Abhorrd
The Wood & Stone were calld
The Holy Things—And their
Sublime Intent given to their Kings
All the Atonements of Jehovah spurnd
And Criminals to Sacrifices Turnd

The Vision of Christ that thou dost see
Is my Visions Greatest Enemy
Thine has a great hook nose like thine
Mine has a snub nose like to mine
Thine is the Friend of All Mankind
Mine speaks in parables to the Blind

Thine loves the same world that mine hates
$\frac{Thy}{I}$ Heaven doors are my Hell $\frac{G}{g}$ ates
Socrates taught what Melitus
Loathd as a Nations bitterest Curse
And Caiphas was in his own Mind
A benefactor to Mankind
Both read the Bible day & night
But thou readst black where I read white

To make ~~either sense or~~ honesty  [meer common]

In all that he has writ

Poems 100 and 101 are in dark ink, Poem 160 a bit blacker; Poem 159 (EG a) is also in dark ink, the last six lines paler (from blotting or dilution).

A Pitiful Case

The Villain at the Gallows tree
When he is doomd to die
To assuage his misery
In Virtues praise does cry

So Reynolds when he came to die
To assuage his bitter woe:
Thus aloud did howl & cry
Michael Angelo Michael Angelo

To the Royal Academy
A Strange Erratum in all the Editions
Of Sir Joshua Reynolds Lectures
Should be corrected by the Young Gentlemen
& the Royal Academys Directors
Instead of Michael Angelo
Read Rembrandt for it is fit
That a forger when he writes to speak
Of Michael Angelo:

Pencil drawings: (a) two pairs of closed lips, larger than those on p. 21; (b) Emblem 14: a sickbed, with coffin beside it, in a curtained room; two persons in the bed; a woman beside them, in a curious chair, holds up and kisses an infant.

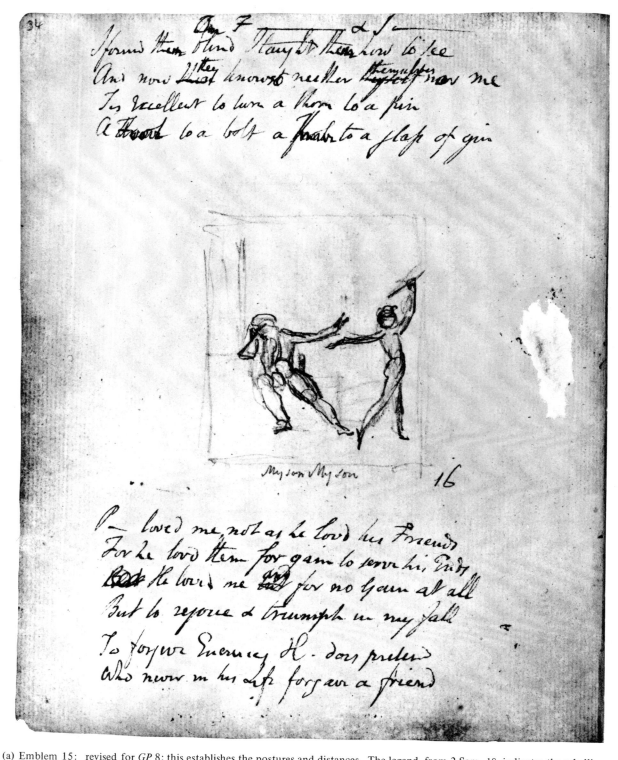

I formd them blind I taught them how to see
And now they knowst neither themselves nor me
Tis excellent to turn a thorn to a pin
A thorn to a bolt a ... to a glass of gin

My son My son                    16

I ― loved me, not as he lovd his Friends
For he lovd them for gain to serve his Pride
He lovd me and for no Gain at all
But to rejoice & triumph in my fall
To forgive Enemies H. does pretend
Who never in his Life forgave a friend

(a) Emblem 15: revised for *GP* 8; this establishes the postures and distances. The legend, from 2 Sam. 18, indicates the rebellion of Absalom against his father David (only the hilt of whose sword shows). Note that Blake draws the spine, even of a front-facing figure, in his first sketch; this can cause us to mistake a front view for a back view, e.g. the Jerusalem figure in 16f and 80a.

[N34]

**Poem 102**

$\frac{On}{To}$ F ——————— & S —————

I found the$\frac{m}{e}$ blind I taught the$\frac{m}{e}$ how to see

And now ~~thou~~ <sup>they</sup> knowst neither ~~thyself~~ <sup>themselves</sup> n<u>o</u>r me

Tis Excellent to turn a thorn to a pin

A $\frac{Fool}{knave}$ to a bolt a $\frac{knave}{Fool}$ to a glass o<u>f</u> gin

**Emblem 15**
**(GP 8)**

*My son My son*　　　　　*16*

**Poem 103**

P—— loved me, not as he lovd his Friends

For he lovd them for gain to serve his Ends

~~But~~ He loved me <sup>and</sup> ~~but~~ for no Gain at all

But to rejoice & triumph in my fall

To forgive Enemies H · does pretend

Who never in his Life forgave a friend

Poems 102 and 103 are in dark ink, but the final couplet is blacker and in a sharper pen.

[N34 transcript]

To  F  ———————

You  call  me  Mad  tis  Folly  to  do  so

To  seek  to  turn  a  Madman  to  a  Foe

If  you  think  as  you  speak  you  are  an  Ass

If  you  do  not  you  are  ~~just~~ <sup>but</sup> what  you  was

$1\frac{2}{1}$ 13

On  H————ys  Friendship

When  H————y  finds  out  what  you  cannot  do

That  is  the  Very  thing  hell  set  you  to
If  you  break  not  your  Neck  tis  not  his  fault
He  xxx          it  w$\frac{i}{1}$ll      d  do  Madness  in  the  end
~~Yet~~
                            <sup>are</sup>
But  A  pecks  of  poiso$\frac{n}{ns}$ ∧ not  ~~a~~  pecks  of  salt
              <sup>f  show</sup>
If  you          ill  peck  of  pxxxx  frind
And  when  he  could  not  act  upon  my  wife

Hired  a  Villain  to  bereave  my  Life

Poems 104 and 105 are in the same dark ink.  Only fragments of the two erased and overwritten lines (105:3-4) are visible.

[N35 transcript]

To F——

You call me Mad tis folly to do so
To speak to turn a Madman to a Foe
If you think as you speak you are an Ass
If you do not you are but what you was

On H——ys Friendship £13

When H——y finds out what you cannot do
That is the Very thing hell set you to
If you break not your Neck tis not his fault
But he peck of poison are not a peck of salt
And when he could not act upon my wife
Hird a Villain to bereave my Life

(a) Emblem 16: Christ on a cloud (compare Christ in 110a), leading children, as in Pl. 2 of 'The Little Boy found' (where the lines of body, garment, and head are similar). For variants of the same effect of tender care, see the shepherd in 'The Shepherd' and the child in 'The Lamb' (*Songs of Innocence*).

[N35]

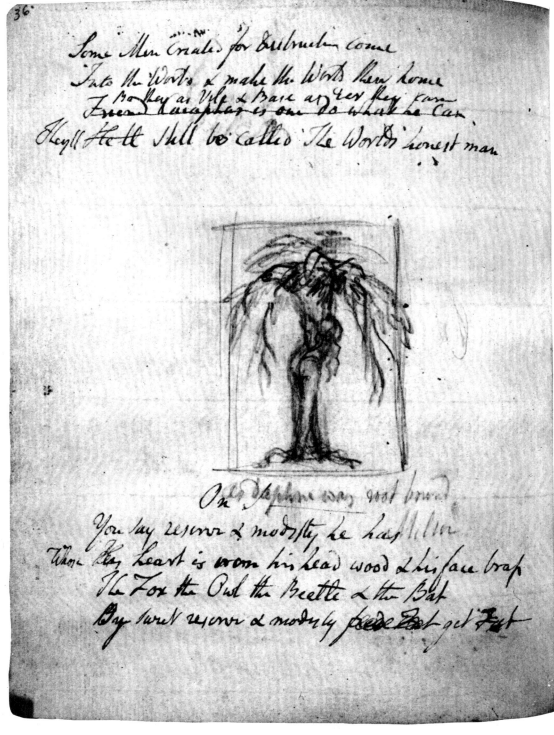

Some Men Created for Destruction come
Into the World & make the World their home
Be they as Vile & Base as eer they can
~~Friend Cacaphas~~ is one do what he can
Theyll Still be called The Worlds honest man

Old Daphne was root bound

You say reserve & modesty he has
Whose Heart is wom his head wood & his face brass
The Fox the Owl the Beetle & the Bat
By sweet reserve & modesty ~~grow Fat~~ get Fat

Pencil drawings: (a) a foot, with toes visible above the last line of Poem 106 (see tracing, Fig. 17, Appendix II); (b) Emblem 17: Daphne, who fled Apollo, root-bound by his art. Behind Milton's *Comus,* of course, is Ovid, *Metamorphoses* I, 545-52. The larger drawing, 12a, must have been made later, if Blake's use of the Notebook was in the order I have reconstructed.

[N36]

**Poem 106**

Some  Men  created  for  destruction  come

Into  the  World  &  make  the  World  their  home

Be  they  as  Vile  &  Base  as  Eer  they  can

~~Friend  Caiaphas  is  one  do  what  he  can~~

Theyll  ~~He~~ ll  still  be  called  'The  Worlds'  honest  man

**Emblem 17**
**Poem 107**

*As Daphne was root bound*

On S————

*Milton*

You  say  reserve  &  modesty  he  has

Whose  ~~His~~  heart  is  <u>iron</u>  his  head  wood  &  his  face  brass

The  Fox  the  Owl  the  Beetle  &  the  Bat

$\frac{By}{On}$  sweet  reserve  &  modesty  ~~feed Fat~~  get  Fat

Poems 106 and 107 are in dark ink; 107 seems currently mended, but the revision of 106:3 is in blacker ink. The first 'Fat' in 107:4 is written over a hole in the paper caused by earlier erasure of the 'Pecks of Poison' line in Poem 105, p. 35.

[N36 transcript]

Imitation of Pope A Compliment to the Ladies

Wondrous the Gods more wondrous are the Men

More Wondrous Wondrous still the Cock & Hen

More wondrous still the Table Stool & Chair

But Ah More wondrous still the Charming Fair

An Epitaph
Come knock your heads against this stone
For sorrow that poor John Thompsons gone

Another

I was buried near this Dike
That my Friends may weep as much as they like

Another

Here lies John Trot the Friend of all mankind
He has not left one Enemy behind
Friends were quite hard to find old authors say
But now they stand in every bodies way

~~10~~ $2\frac{6}{5}$

To H ———

Thy Friendship oft has made my heart to ake

Do be my Enemy for Friendships sake

————————

Cos<u>w</u>ay Fr<u>az</u>er & Baldwin of Egypts Lake
Fear to Associate with Blake
This Life is a Warfare against Evils
They heal the sick he casts out Devils
Hayley Flaxman & Stothard are also in doubt
Lest their Virtue should be put to the rout

One grins tother ~~one~~ spits & in corners hides
And all the ~~Righteous~~ Virtuous have shewn their backsides

Poems 108 and 109 were written in dark wet ink; the other poems were added in black ink.

Imitation of Pope A Compliment to the Ladies

Wondrous the Gods more wondrous are the Men
More Wondrous Wondrous still the Cock & Hen
More wondrous still the Table Stool & Chair
But Ah More wondrous still the Charming Fair

E 26

To H——

Thy Friendship oft has made my heart to ache
Do be my Enemy for Friendships sake

Cosway Frazer & Baldwin of Egypts Lake
Fear to Associate with Blake
This Life is a Warfare against Evils
They heal the Sick he casts out Devils
Hayley Flaxman & Stothard are also in doubt
Lest their Virtue should be put to the rout

(a) Emblem 18: a family of five gathered at the sickbed of a girl, who holds a book in her hand. Curtain suggested as in Emblem 14. A pyramidal effect results from the visitors' bending successively lower as they approach the invalid.

Genius

My title as an ~~Edeet~~ thus is prove

Not Praisd by Hayley nor by Flaxman Lovd

I am

I Rubens ~~~~ a Statesman & a Saint

~~Deception~~ Cried if ye Ill learn to Paint

~~~~

To try if Connoisseurs

You must agree that Rubens was a Fool

And yet you make him master of Your School

And give more money for his Slobbring

Than you will give for Rafaels finest Things

~~~~ Thought was a Carpenter ~~~~ scroff my good Sir

There is just the same Science in Rubens or Rubens or even

Vanloo that there is in Rafael or Mich Anglo but not

The same Genius Science is soon got the other never

can be acquird but must be Born

~~~~

~~~~

~~~~

~~~~

~~~~

Nature & Art in this together Suit

What is Most Grand is always most Minute

Rubens thinks Tables Chairs & Stools are Grand

But Rafael thinks A Head a foot a Hand

~~The Gallows~~

~~~~ in Courts of Kings

That Fools have their high finishing

~~~~ And this the Princes golden rule

The Laborious stumble of a Fool

Pencil sketches: (a) a finger, possibly; (b) a muscular back (or chest?) and shoulders. Pencil and ink sketch: (c) a finger. Perhaps these relate to the head, foot, and hand cited in Poem 114.

[N38]

Poem 111
My title as an ~~Artist~~ thus is provd
^{Genius}

Not Praisd by Hayley nor by Flaxman lovd

Poem 112
I Rubens ~~had been~~ a Statesman $\frac{\&}{or}$ a Saint
^{am}
Deceptions? O no – so I'll learn to Paint
~~He mixd them both & so he Learnd to Paint~~

Poem 113
To English Connoisseurs

You must agree that Rubens was a Fool

And yet you make him master of Your School

And give more money for his Slobberings

Than you will give for Rafaels finest Things

I understood Christ was a Carpenter And not a Brewers Servant my good Sir

PA 26
There is just the same Science in Lebrun or Rubens or even

Vanloo that there is in Rafael or Mich Angelo but not

the same Genius Science is soon got the other n<u>eve</u>r

can be acquired but must be Born

Poem 145
Swelld limbs with no outline that you can descry

That Stink in the Nose of a Stander by

But all the Pulp washd pain$\frac{ted}{T}$ finishd with labour Of an hundred Journey<u>mens</u> how dye
do Neighbour

Poem 114
~~Major Testament of~~
~~A Pretty Epigram for those who have Given high Prices for Bad Pictures~~
~~And Never a~~ Pretty Epigram for ~~those~~ the Entertainment of those
have Paid
Who ~~pay~~ Great Sums in the Venetian & Flemish Ooze

Nature & Art in this together Suit

What is Most Grand is always most $\frac{M}{m}$inute

Rubens thinks Tables Chairs & Stools are Grand

But Rafael thinks A Head a foot a hand

Poem 146
3 The Swallow sings
~~Let it be told~~ in Courts of Kings And this the Princes golden rule
That Fools have their high finishings The Laborious stumble of a Fool

1 These are the Idiots chiefest arts 2 To blend & not define the Parts

To make out the parts is the wise mans aim
But to lose them the Fool makes his foolish <u>Game</u>

Poems 111 and 112 were written in dark ink, the latter revised in grey ink (here italics) and Poem 113 begun in grey. Lines 113:5-6 were inserted in dark ink. Poems 114, 145, 146 are entirely in dark ink.

[N38 transcript]

Rembrandt or Titian to put that which is Soul & Life into

The Hebrew Nation did not write it

to be put to that Design & will never take that of Rubens

Avarice & Chastity did shite it

He who makes a Design must know the Effect & Colouring Proper

Rafael Sublime Majestic Graceful Wise

Poem 72

His Execution Power must I despise

Rubens Low Vulgar Stupid Ignorant

high labourd
Wobly pretentious stumble

Poem 131

His power of Execution I must grant

Learn the Laboreous stumble of the Subject

And from an Idiots Actions form my rule

a Fool

Go send your Children
to the Slobbering School

I do not condemn Rubens Rembrant or Titian because they did not understand Drawing but because they did not Understand Colouring how long shall

I be forced to beat this into Mens Ears

Strange
I do not condemn Bartolozzi or Woolett
because they did not understand Drawing
but because they did not understand Graving

I do not condemn Pope or Dryden because they did not Understand Imagination but because They did not understand Verse

Their Colouring Graving & Verse can never be applied to Art

That is not either colouring Graving or Verse which is Unappropriate to the Subject

PA 22

26 26 14 25

If I eer Grow to Mans Estate

Emblem 19
Poem 115

O Give to me a Womans fate

May I govern all both great & small

Have the last word & take the wall

The Cripple every Step Drudges & labours

Poem 116

And says come learn to walk of me Good Neighbours

Sir Joshua in astonishment cries out
See what Great Labour Pain him & Modest Doubt
His pains are more than others theres no Doubt
Newton & Bacon cry being badly Nurst. He is all Experiments from last to first

And how high labourd is every step
He walks & stumbles as if he crep

Here italics stand for pencil; the rest of the writing is in dark ink of various shades. *PA 22* continues up the right margin and across the top of the page, upside down.

[N39 transcript]

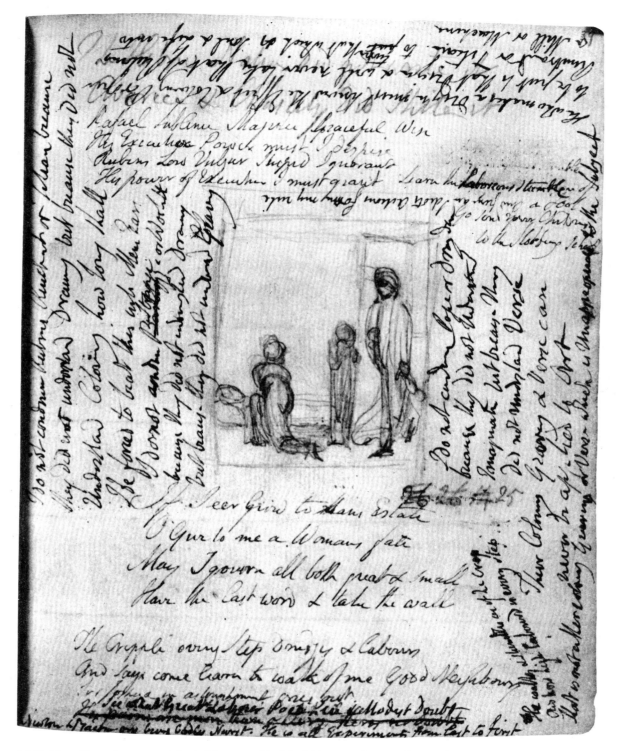

Rafael Sublime Majestic Graceful Wise
His Execution Poor & Lame...
Reubens Low Vulgar Stupid Ignorant
His power of Execution I must grant

If I grew to Mans Estate
O Give to me a Womans fate
May I govern all both great & small
Have the last word & take the wall

The Cripple every Step Drudge & Labours
And Says come learn to walk of me Good Neighbours

(a) Emblem 19: a bare, uncurtained sickroom, with sick child on a pallet; a turbaned, cloaked man enters (directly from the street?) with a doll in one hand and packages or another doll in the other.

[N39]

Pencil drawings: (a) Emblem 20: sketch for *GP* 9, deriving from Gillray's *Slough of Despond* of 2 Jan. 1793 (see Fig. 38, Appendix II); (b) head of a man, with features pencilled over (why?): he is, or was, Charles Fox, from Gillray's cartoon, with ragged hair, a knapsack (here behind his head like a hood), and shoulder straps. (In *Europe* 1 a youth bears the knapsack, and a woeful face, deriving from that of Gillray's Fox, glowers at the bottom of the page.)

Poem 117

On the Great Encouragement Gi~~ven~~ving by English Nobility & G/gentry to Correggio Rubens Rembrant Reynolds
Gainsborough Catalani DuCrowe & Dilberry Doodle

> As the Ignorant Savage will sell his own Wife
> Sword or ~~Buckle~~ Cutlass a Dagger
> For a ~~Button~~ a ~~Bauble~~ ~~a Bead or~~ $\frac{or}{a}$ Knife
> ~~Learned~~ Taught spends
> So the ~~wise~~ Savage Englishman ~~gives~~ his whole Fortune
> or to Destroy or
> On ~~For~~ a smear ~~&~~ a squall ~~that is not~~ Picture ~~nor~~ Tune
>
> And I call upon Colonel Wardle
>
> To give these Rascals a dose of Cawdle

Poem 118

> Give pensions to the Learned Pig
>
> Or the Hare playing $\frac{on}{a}$ a Tabor
>
> Anglus can never see Perfection
>
> But in the journeymans Labour

Poem 120

The Cunning sures & the Aim at yours

Emblem 20
(GP 9)

Poem 119

> All Pictures thats Panted with Sense & with Thought
> Are Painted by Madmen as sure as a Groat
> For the Greater the Fool in the Pencil more blest
> And when they are drunk they always pant best
> *They never can Rafael it Fuseli it nor Blake it*
> *If they cant see an outline pray how can they make it*
> *When Men will draw outlines begin you to jaw them*
> *Madmen see outlines & therefore they draw them*

All the writing is in dark ink except for the second half of Poem 119, which is in grey ink (shown as italics).

On H ——— the Pick thank **Poem 121**

I write the Rascal Thanks till he & I

With Tha<u>nk</u>s & Compliments are quite drawn dry

Cromek Speaks **Poem 122**

I always take my judgment from a Fool
 his judgment is so very
Because ~~I know he always judges~~ Cool
 Amiable state
Not prejudicd by feelings great or small ~~Because we know~~ he cannot feel at all

<div style="writing vertical">

When you look at a picture you always can see
If a Man of Sense has Painted he
Then never flinch but keep up a Jaw
About freedom & Jenny suck awa'

</div>

<div style="writing vertical right">

And when it smells of the Lamp we ~~will~~ can
Say all was owing to the Skilful Man
For the smell of water is b_nut small
So een let Ignorance do it all

</div>

Poem 124

Poem 123
Emblem 21

English Encouragement of Art
Cromeks opinions put into Rhyme ~~37~~ 14 27
If you mean to Please Every body you will
 Menny wouver Bunglishness
~~Set to work~~ both ~~Ignorance~~ & Skill
 Madjority Conquest
For a great ~~multitude~~ are ~~Ignorant~~ Bunglery
 Jenous looks to ham ~~looks~~ like mad Rantery
And ~~skill to them~~ seems ~~raving & rant~~
 displaying
Like ~~putting~~ oil & water into a lamp
 hold forth a huge
Twill ~~make a great~~ splutter with smoke & damp
 its all sheer loss
For ~~there is no use~~ as it seems to me wxxx
 displaying up a light we want not
Of ~~lighting a Lamp~~ when ~~you dont wish~~ to see

All the writing is in dark ink of various strengths, with mendings in the same ink. The pen used must have held little ink; in 123:2 we can see a fresh dip of the pen in the middle of the word 'Ignorance'—a caution against our making much of differences in greyness.

On H——— the Pick thank

I write the Rascal thanks till he & I
With thanks & Compliments are quite drawn dry
Cromek speaks
I always take my judgment from a Fool
Because his judgment is so very ~~cool~~
Not prepared by feelings great or small

English Encouragement of Art
Cromeks opinions put into Rhyme
If you mean to Please Every body you will
Set to work both Ignorance & Skill

For a ~~great~~ Conquest ~~~~ Ignorant Bungley
~~~~ him ~~~~ Thomas Bartlett
Like ~~pouring~~ oil & water into a lamp
hold forth ~~~~ splutter with smoke & damp
For ~~~~ it seems to me
Of ~~~~ a lamp when you don't wish to see

(a) Emblem 21: a man in swallowtail coat and another adult welcome a girl and boy, both in swirling garments (hers at ankle, his at knee) outside a Gothic door. Prodigals' return—and marriage day?

42

You say their Pictures well Painted be
And yet they are Blockheads you all agree
Thank God I never was sent to school
To be Flogd into following the Style of a Fool

The Errors of a Wise Man make your Rule
Rather than the Perfections of a Fool

The Washer Womans Song

I washd them out & washd them in
And they told me It was a great Sin

(a) Emblem 22: unnumbered (but the squarish framing lines are the size of the smaller emblems). A dramatic scene is suggested: an actor garbed as an old man with a crutch is addressing a spider (at the end of a thread).

**Poem 125**

You say their Pictures well Painted be

And yet they are Blockheads you all agree

Thank God I never was sent to school

~~To learn to admire the works of a Fool~~

To be Flogd into following the Style of a Fool

**Emblem 22**

**Poem 126**

The Errors of a Wise Man make your Rule

Rather than the Perfections of a Fool

**Poem 147**

The Washer Womans Song

I washd them out & washd them in

And they told me it was a great Sin

Poems 125 and 126 are in dark ink; Poem 147 is in darker ink from a stubbier pen.

[N42 transcript]

Rubens
When I see a Rembrant or Correggio

I think of the Crippled Harry & Slobbering Joe

question thus
And then I say to myself are artists rules

To be drawn from the works of two manifest fools

Then God defend us from the Arts I say

O
Send Battle Murder Sudden Death we pray

blind
Rather than let be such a Human Fool

Id be an Ass a Hog a Worm a Chair a Stool

?39  15  28

Great things are done when Men & Mountains meet

This is not Done by Jostling in the Street

Poems 127 and 128 are in dark ink. We can tell from an ink spot below 'Jostling' which matches one on p. 42 below 'Washer' that these pages faced each other; yet nothing on them accounts for the dark smudges on and around Emblem 23.

[N43 transcript]

When I see a Rubens Rembrandt or Correggio
I think of the Crippled Harry & Slobbring Joe
And then I question thief an artists rules
To be drawn from the Works of two manifest fools
Then God defend us from the Arts I say
Send Battle Murder Sudden death O pray
Rather than be such a blind Human Fool
To be an Ass a Hog a Worm a Chair a Stool

Great things are done when Men & Mountains meet
This is not done by Jostling in the Street

(a) Emblem 23: used in the title-page of *Songs of Experience* (in reverse). The grief of the young couple indicates that the aged couple whom they lament are dead; the height is that of a bier not a bed.

*Let a Man who has made a Drawing go on & on & he will produce a Picture or Painting but if he chooses to leave off before he has spoild it he will Do a Better Thing*

(a) Pencil drawing for the Nebuchadnezzar of *MHH* 24; compare variant, 48a.

PA 30    Let a Man who has made a Drawing go on & on & he will
produce a Picture or Painting but if he chooses to leave off
before he has spoild it he will ~~pr~~ Do a Better Thing

Dark ink.

*I have said  to  corruption  thou  art*
*my  father   to  the  worm  thou  art*
*my  mother  &  my  Sister*
*Job*

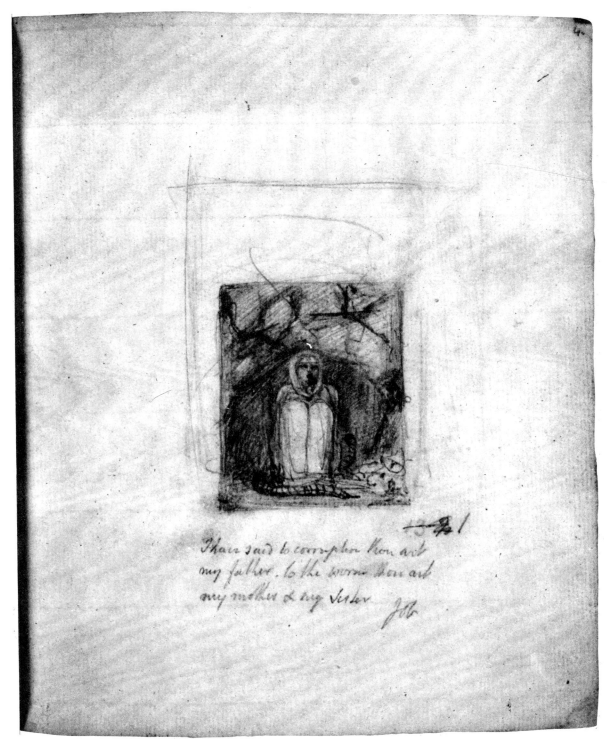

I have said to corruption thou art
my father. to the worm thou art
my mother & my sister

Job

(a) Emblem 24:  used as *GP* 16; legend from Job 17:14.  One of the three faces appearing above the ground on the right is cancelled by a loop; only two appear in the engraving.  For full description of this emblem, see above.  Glue spots.

They say there is no Straight Line in Nature this Is a Lie like
all that they say For there is Every Line in Nature But I will
tell them what is Not in Nature An Even Tint is not in Nature
it produces Heaviness Natures Shadows are Ever varying & a Still
Sky that is quite still never can produce a Natural Sky the
Same with every Object in a Picture its Spots are its beauties
Now Gentlemen Critics how do you like this You may rage

but what I say
Such Practice
done so that you
own destruction
very intimately
with Basire &
one of the most
that I ever knew
not a Man nor
is destruction of
Art the Works

I will prove by
& have already
will rage to your
Woolett I knew
by his intimacy
I knew him to be
ignorant fellows
A Machine is
a Work of Art it
Humanity & of
Machination

Delicate Hands & Heads will never appear
While Dulness &c as in the Book of Moonlight p 5

Woolett I knew did not know how to Grind his Graver
I know this he has often proved his Ignorance before
me at Basires by laughing at Basires knife tools &

(a) Emblem 25: 'Murder', unnumbered (but note similar emblems of sickbed and curtains in 33b and 37a).

**PA 23**

They say there is no Strait Line in Nature this Is a Lie like

all that they say . For there is Every Line in Nature But I will

tell them what is Not in Nature. An Even Tint is not in Nature

it produces Heaviness. Natures Shadows <sup>are</sup> Ever varying. & a Ruled

Sky that is quite Even never can Produce a Natural Sky the

same with every Object in a Picture its Spots are its beauties

Now Gentlemen Critics how do you like this      You may rage

but what I say                                  I will prove by

Such Practise                                   & have already

done so that you                                will rage to your

own destruction                                 Woolett I knew

very intimately                                 by his intimacy

with Basire &                                   I knew him to be

one of the most                                 ignorant fellows

that I ever knew                                . A Machine is

not a Man nor                                   a Work of Art it

is Destructive of                               Humanity & of

Art the Word                                    Machination ~~seems~~

**Emblem 25**
**Poem 133**

*Murder*

Delicate Hands & Heads will never appear

While Titians &<sup>c</sup> as in the Book of Moonlight p 5

**PA 24**

Woolett I know did not know how to Grind his Graver

I know this he has often proved his Ignorance before

me at Basires by laughing at Basires Knife tools &

Built in Jerusalems wall

It will lead you in at Heavens Gate

Only wind it into a ball

**Poem 61**     I ~~have given~~ <sup>give</sup> you the end of a golden string

The poems and prose are in dark ink that becomes somewhat greyer in the last three lines of prose.

If  you  play  a  Game  of  Chance  know  before  you  begin

If  you  are  benevolent  you  will  never  win

**Poem 129**

---

ridiculing  the  Forms  of  Basires  other  Gravers  till  Basire

was  quite  dashd  &  out  of  Conceit  with  what  he  himself  knew

but  his  Impudence  had  a  Contrary  Effect  on  me

  Englishmen  have  been  so  used  to  Journeymens  undecided  bungling

that  they  cannot  bear  the  firmness  of  a  Masters  Touch

**PA 25**

Every Line is the Line of Beauty it is only fumble & Bungle which cannot draw a Line this only is Ugliness   That is not a Line which Doubts & Hesitates in the Midst of its Course 25 29

**Emblem 26**

All the text is in dark ink.

(a) Emblem 26: a group of naked dancers, humans not fairies. One rises between the outstretched arms of two who face each other; beside the head of the one facing us is one of the uplifted arms, palms horizontal, of a figure with upturned face.

(b) Head of young man with collar, ruff, feathered hat.

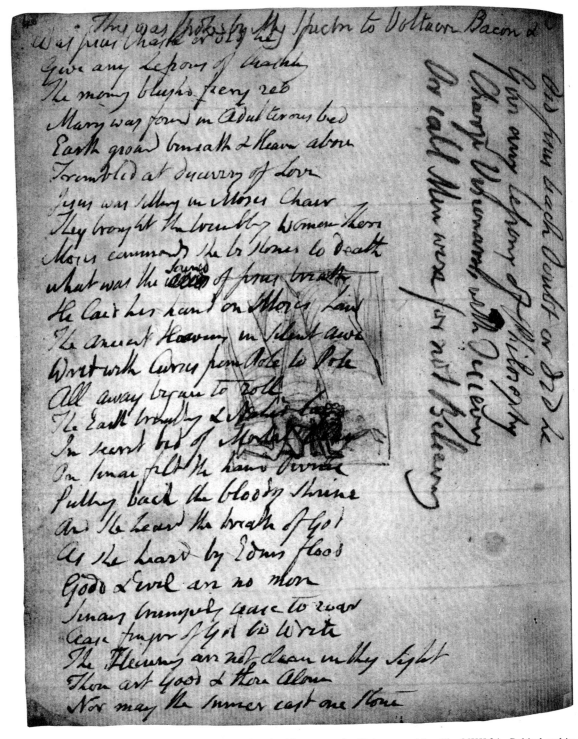

Was Jesus Chaste or did he
Give any lessons of Chastity
The morning blushd fiery red
Mary was found in Adulterous bed
Earth groand beneath & Heaven above
Trembld at discovery of Love
Jesus was sitting in Moses Chair
They brought the trembling Woman there
Moses commands she be stoned to death
What was the sound of Jesus breath
He laid his hand on Moses Law
The ancient Heavens in silent awe
Writ with Curses from Pole to Pole
All away began to roll
The Earth trembling & Naked lay
In secret bed of Mortal clay
On Sinai felt the hand divine
Putting back the bloody shrine
And she heard the breath of God
As she heard by Edens flood
Good & Evil are no more
Sinais trumpets cease to roar
Cease finger of God to write
The Heavens are not clean in thy Sight
Thou art Good & thou Alone
Nor may the sinner cast one stone

(a) Emblem 27: unnumbered, a smaller Nebuchadnezzar than in 44a, crowned with leaves and less like *MHH* 24. Behind and in front of the crawling monarch is the half erased figure of a prancing animal.

**Poem 159
(EG e)**

**Poem 159 (EG h)**

Was Jesus Chaste or did he

Give any Lessons of Chastity

The morning blushd fiery red

Mary was found in Adulterous bed

Earth groand beneath & Heaven above   5

Trembled at discovery of Love

Jesus was sitting in Moses Chair

They brought the trembling Woman There

Moses commands she be stoned to Death

What was the ~~word~~ sound of Jesus breath   10

He laid his hand on Moses Law

The Ancient Heavens in Silent Awe

Writ with Curses from Pole to Pole

All away began to roll

The Earth trembling & Naked lay   15

In secret bed of Mortal Clay

On Sinai felt the hand Divine

Putting back the bloody shrine

And she heard the breath of God

As she heard by Edens flood   20

$Go\frac{o}{d}$ & Evil are no more

Sinais trumpets cease to roar

Cease finger of God to Write

The Heavens are not clean in thy Sight

Thou art Good & thou Alone   25

Nor may the sinner cast one stone

*Did Jesus teach Doubt or did he*

*Give any lessons of Philosophy*

*Charge Visionaries with Decieving*

*Or call Men wise for not Believing*

EG e (Poem 159) is in dark brown ink; section h and the line of comment at the top of the page are in pencil (italics). By position the top note is a comment on e, but it is more appropriate as a comment on the 'Philosophy' section, h.

Thou Angel of the Presence Divine

That didst create this Body of Mine   30

Wherefore has thou writ these Laws

And Created Hells dark jaws

My Presence I will take from thee

A Cold Leper thou shalt be

Tho thou wast so pure & bright   35

That Heaven was Impure in thy Sight

Tho thy Oath turnd Heaven Pale

Tho thy Covenant built Hells Jail

Thou thou didst all to Chaos roll

With the Serpent for its soul   40

Still the breath Divine does move

And the breath Divine is Love

Mary Fear Not Let me see

The Seven Devils that torment thee

Hide not from my Sight thy Sin   45

That forgiveness thou maist win

Has no Man Condemned thee

No Man Lord! then what is he

Who shall Accuse thee. Come Ye forth

Fallen Fiends of Heavenly birth   50

That have forgot your Ancient love

And driven away my trembling Dove

To be Good only is to be
A God or else a Pharisee
*Devil*

H   23   15
27

The text continues in the dark ink of p. 97; in line 28 'Devil' is added in pencil, half covering the word 'God'. (For a full analysis of the MS. of *EG*, see 'Terrible Blake'.)

[N49 transcript]

Thou Angel of the Presence Divine
That didst create this Body of Mine
Wherefore hast thou writ these Laws
And created Hells dark Jaws
My Presence I will take from thee
A Cold Leper thou shalt be
Tho thou wast so pure & bright
That Heaven was Impure in thy Sight
Tho thy Oath turnd Heaven Pale
Tho thy Covenant built Hells Jail
Tho thou didst all to Chaos roll
With the Serpent for its soul
Still the breath Divine does move
And the breath Divine is Love
Mary Fear Not Let me see
The Seven Devils that torment thee
Hide not from my sight thy Sin
That forgiveness thou maist win
Has no Man condemned thee
No Man Lord! then what is he
Who shall accuse thee. Come Ye forth
Fallen fiends of Heavenly birth
That have forgot your Ancient love
And driven away my trembling Dove

To be Good only is to be
A God or else a Pharisee

(a) Emblem 28: an early version of Blake's pictures of Cain beside the body of Abel. See *Bible,* Pl. 15a and b, and *Drawings,* Pl. 47.

[N49]

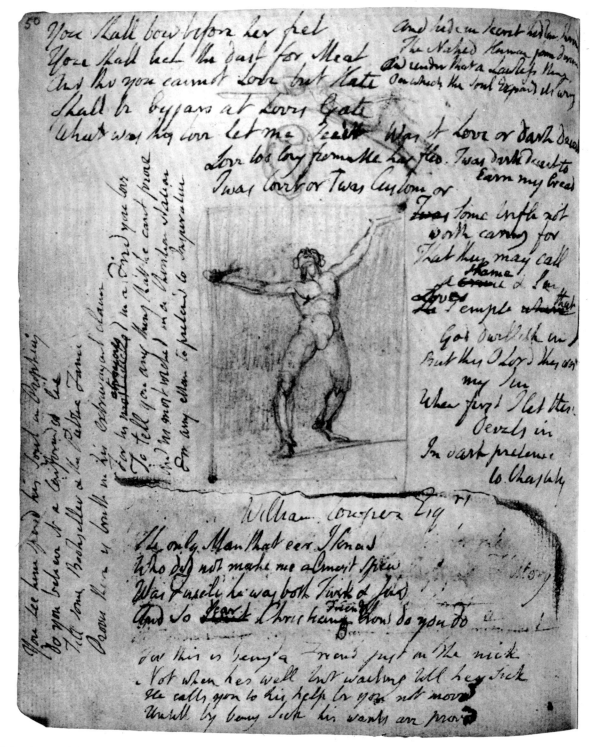

Pencil drawings: (a) Oothoon hovering over huddled Theotormon, a rough sketch for *VDA* 4, superseded by 92b. (See tracing, Fig. 18, Appendix II.)

(b) Emblem 29: erasure where number would be, but glue spots show that this emblem was one of Blake's semi-final choices for *GP*. Suicide is the theme, an appropriate picture under which to write Poem 130, an 'Epitaph for William Cowper Esq[re]'.

**Poem 159**
**(EG e)**

You shall bow before her feet

You shall lick the dust for Meat

And tho you cannot Love but Hate   55

Shall be beggars at Loves Gate

What was thy love Let me see $\frac{\text{e it}}{\text{e't}}$

And hide in secret hidden Shrine   65
The Naked Human form divine
And render that a Lawless thing
On which the Soul Expands its wing

Was it Love or Dark Deceit

Love too long from Me has fled.   Twas dark deceit to
                                                    Earn my bread   60

Twas Covet or twas Custom or

~~Twas~~ Some trifle not

worth caring for

That they may call
                        shame
a ~~crime~~ & Sin

Loves                    that
~~The~~ Temple ~~where~~

God dwelleth in

But this O Lord this was

my Sin

When first I let these

Devils in   70

In dark pretence

to Chastity

For tis ~~most wicked~~ in a Friend you love
    atrocious

To tell you any thing that he cant prove

And tis most wicked in a Christian Nation

For any Man to pretend to Inspiration

You see him spend his Soul in Prophecy

Do you believe it a Confounded lie

Till some Bookseller & the Public Fame

Prove there is truth in his extravagant claim

**Emblem 29**
**Poem 130**
**[Poem 148]**

Epitaph for William Cowper Esq^re
The only Man that eer I knew
Here lies the Man whose xxxx was Contradict[ory]
Who did not make me almost spew
He xxx seen xxxxxxxxxxxxxxxxx Hayley & Victory
Was Fuseli he was both Turk & Jew
xxx                                                to doubt
        dear            Friends
And so ~~sweet~~ Christians how do you do

**Poem 130**
**contd**

Wxxxxxxxxxx by xxng angx xxxxx xxxy throughout

For this is being a Friend just in the nick

Not when hes well but waiting till hes sick

He calls you to his help be you not mov$\frac{d}{ed}$

Untill by being Sick his wants are prov$\frac{d}{ed}$

**Poem 130**
**contd**

All the text is in dark ink, except for the mending of Poem 130, lines 7-8 (movd, provd) in pale ink. Poem 148 was written on top of the erased first stanza of Poem 130 (only part of which is, conjecturally, restored). Having written bitterly about Hayley in 130, Blake turned (in 148) to Fuseli as the only tolerable human being he knew.

[N50 transcript]

All Mental Powers by Diseases we bind
*The Canterbury Pilgrims*

But he heals the Deaf & the Dumb & the Blind
*Engraved by William Blake tho Now Surrounded*

Whom God has afflicted for Secret Ends

He Comforts & Heals & calls them Friends
*by Calumny & Envy*

Blaspheming Love blaspheming thee

Thence Rose Secret Adulteries

And thence did Covet also rise

My Sin thou hast forgiven me          75

Canst thou forgive my

     Blasphemy

Canst thou return to this

     dark Hell

And in my burning

     bosom dwell

And canst thou Die that I

     may live

               Crucify
Crying ~~Ive found~~ this
                   hi

Who     cause of distress
~~You~~ dont keep the secrets
           of Holiness

And canst thou

     Pity & forgive          80

Then Rolld the shadowy

     Man away

From the Limbs of Jesus

     to make them his prey

An Ever devoring

     appetite

Glittering with festering

     Venoms bright

But when Jesus was

     Crucified

Then was perfected his

     glittring pride

In three Nights

     *40* 42

In this Plate M^r B has resumed the style with

which he set out in life ~~wh~~ of which Heath & Stothard

were the awkward imitators at that time it is the Style of Alb Durers

Histries & the old Engravers which cannot be imitated by any one

who does not understand Drawing & which according to heath & Stothard

Flaxman & even Romney. Spoils an Engraver for Each of these

Men have repeatedly asserted this Absurdity to me in condemnation

---

*PA* 5 is in the usual dark ink; the *EG* passages are in the browner dark ink of the preceding part of e. *PA* 2 is in pencil (italics here);
it is a sort of title for the *Address*, but erased.

[N51 transcript]

a

b

Pencil drawings: (a) Emblem 30: five fairies dancing in a ring, while a sixth, sitting in the branch of a tree or flower against a crescent moon, blows a serpent-trumpet; (b) detail of the trumpet-blowing fairy. Used in fifth illustration to Gray.

of my Work & approbation of Heaven came imitation I Who am
very such a fool as to suppose that his Modern Slang can be
made out & delineated by any Engraver who knows how to cut
dots & lozenges equally well with those little parts which I
engraved after him five & twenty years ago & by which he got
his reputation as a Draughtsman

---

In three Nights he devourd
        his prey
And still he devours the
        Body of Clay
9th line

Calling thee Christ
        In Ivory & Papsun
made my Voice heard all
        over the Nation

And give with Charity a Stone
For Dust & Clay is the Serpents meat
Which never was made for Man to Eat

The Everlasting Gospel
Was from Humble or did he
Give any Proofs of Humility
When but a Child he ran away
And left his Parents in Dismay
When they had wanderd three days long
These were the words upon his tongue
No Earthly Parents I confess
I am doing my Fathers business
When the rich learned Pharisee
Came to consult him secretly
Upon his heart with Iron pen
He wrote Ye must be born again
He was too proud to take a bribe
He spoke with authority not like a Scribe
He says with most consummate Art
Follow me I am meek & lowly of heart
As that is the only way to escape
The Misers net & the Gluttons trap
He who loves his Enemies betrays his Friends

humility thus calld Pride has been blesed here thirty years
the manner in which my character both as an artist & a man may
be seen particularly in a Slandering Paper calld the examiner Published
in Beaufort Buildings & the manner in which I have routed out
the nest of villainy will be seen in a Poem concerning my three years
Herculean Labours at Felpham which I will soon Publish Secret Calumny &
open Professions of Friendship are common enough all the world over
but have never been so good an occasion of Poetic Imagery When
a Base Man means to be your Enemy he always begins with being
your Friend We all know that Editors of Newspapers trouble their
heads very little about art & science & that they are always paid for what
they do

PA 6

of my Work & approbation of Heaths lame imitation Stothard

being such a fool as to suppose that his blundering blurs can be

made out & delineated by any Engraver who knows how to cut

dots & lozenges equally well with those little prints which I

engraved after him five & twenty Years ago & by which he got

his reputation as a Draughtsman

Poem 159 (EG e contd)

Poem 161

g

d

Emblem 31 (GP 11)

PA 7

The Everlasting Gospel

Was Jesus Humble or did he
Give any Proofs of Humility
When but a Child he ran away  5
And left his Parents in Dismay
When they had wanderd three days long
These were the words upon his tongue
No Earthly Parents I confess
I am doing my Fathers business  10
When the rich learned Pharisee
Came to consult him secretly
Upon his heart with Iron pen
He wrote Ye must be born again
He was too proud to take a bribe  15
He spoke with authority not like a Scribe
He says with most consummate Art
Follow me I am meek & lowly of heart
As that is the only way to escape
The Misers net & the Gluttons trap  20
He who loves his Enemies betrays his Friends  25

Boast of high Things with Humble tone
And give with Charity a Stone

In three Nights he devourd his prey

And still he devours the Body of Clay

For Dust & Clay is the Serpents meat  95
Which never was made for Man to Eat

94 lines

Seeing this False Christ

In fury & Passion

I made my Voice heard all over the Nation

What are those &c

21 *Aged Ignorance*

What can be done with such desperate Fools
Who follow after the Heathen Schools
I was standing by when Jesus died What I calld Humility they calld Pride  24

has been blasted these thirty years

The manner in which my Character both as an artist & a Man may

be seen particularly in a Sunday Paper cald the Examiner Publishd

in Beaufort Buildings.† & the manner in which I have routed out

the nest of villains will be seen in a Poem concerng my Three Years

Herculean
Labours at Felpham which I will soon Publish. Secret Calumny &

open Professions of Friendship are common enough all the world over

but have never been so good an occasion of Poetic Imagery When

a Base Man means to be your Enemy he always begins with being

your Friend †(We all know that Editors of Newspapers trouble their

heads very little about art & science & that they are always paid for what

they put [in]

I will tell you what Joseph of Arimathea Said to my Fairy was not it very queer
Pliny & Trajan what are You here Come listen to Joseph of Arimathea

Listen patient & when Joseph has done Twill make a fool laugh & a Fairy Fun

EG e and g continue in dark ink; so does PA 6, except that its footnote (†) is in grey ink (here italics); it continues on p. 53. EG d and the inserted title, 'The Everlasting Gospel', are in black ink.

PA 8

Flaxman cannot deny that one of the very first Monuments he did I gratuitously designd for him X how much of his Homer & Dante he will allow to be mine I do not know as he went far enough off to Publish them even to Italy. but the Public will know

X at the same time he was blasting my character as an Artist to Macklin my Employer as Macklin told me at the time

& Posterity will know

Poem 159 (EG d contd)

*Right margin (vertical):* To teach doubt & Experiment Certainly was not what Christ meant 50

This surely is not what Jesus intends
But the sneaking Pride of Heroic Schools
XXXXXXXXXXXXXXXXXXXXXXXXXXXXX
And the Scribes & Pharisees Virtuous Rules
XXXXXXXXXXXXXXXXXXXXXXXXXXXXX
For he acts with honest triumphant Pride
And this is the cause that Jesus died  30
What was he doing all that time  51
From twelve years old to manly prime
Was he then Idle or the Less
About his Fathers business
Or was his wisdom held in scorn  55
Before his wrath began to burn
In Miracles throughout the Land
That quite unnervd Lord Caiaphas / the guilty hand
Antichrist If he had been the Creeping Jesus
Hed have done any thing to please us  60
Gone sneaking into Synagogues
And not usd the Elders & Priests like dogs
But Humble as a Lamb or Ass  63

He did not die with Christian Ease  31
Asking Pardon of his Enemies
If he had Caiphas would forgive
Sneaking submission can always live
He had only to say that God was the devil  35
And the devil was God like a Christian Civil
Mild Christian regrets to the devil confess
thrice
a  For affronting him so in the Wilderness  38
Like dr Priestly & Sir Isaac [Bacon &] Newton  41
1  Poor [Bare] Spiritual Knowledge is not worth a button  42
b  He had soon been bloody Caesars Elf  39
c  And at last he would have been Caesar himself  40
2  For As thus the Gospel Sr Isaac confutes  43
3  God can only be known by his Attributes  44
And as to the Indwelling of the Holy Ghost  45
Or of Christ & his / [?the] Father its all a boast
And Pride & Vanity of Imagination
That disdains to follow this Worlds Fashion
51 43

Obeyd himself to Caiaphas
God wants not Man to Humble himself  65
This is the trick of the ancient Elf
This is the Race that Jesus ran
Humble to God Haughty to Man
Cursing the Rulers before the People
Even to the temples highest Steeple  70
And when he Humbled himself to God
Then descended the Cruel Rod
If thou humblest thyself thou humblest me
Thou also dwel!st in Eternity
Thou art a Man God is no more  75
Thy own humanity learn to adore
For that is my Spirit of Life
Awake arise to Spiritual Strife
And thy Revenge abroad display
In terrors at the Last Judgment Day  80
Gods Mercy & Long Suffering
Is but the Sinner to Judgment to bring
Thou on the Cross for them shalt pray

Emblem 32

PA 9

Many People are so foolish to think that they can wound Mr Fuseli over my Shoulder they will find themselves mistaken They could not wound even Mr Barry so

A Certain Portrait Painter said To me in a boasting way Since I have Practised Painting I have lost all idea of Drawing. Such a Man must know that I lookd upon him with Contempt he did not care for this any more than West did who hesitated & equivocated with me upon the same subject at which time he asserted that Wooletts

PA 7 (contd)

[u]pon these ungracious Subjects

PA 8 and 9 continue in dark ink, the footnote of PA 7 in grey. EG d continues in black ink; lines 28-30 are on top of erased lines which may have been lines 30-1 copied prematurely. Again, lines 39-40 were overlooked after 38, but added after 42; Blake's way of unscrambling the passage was to mark the first sequence 'a b c' and the second '1 2 3'.

[N53 transcript]

Flaxman cannot deny that one of the very first Monuments he
did I gratuitously designd for him & how much of my Homer &
Dante he will allow to be mine I do not know as he went far
enough off to Publish them even to Italy. but the Public will know
& at the same time he was Blasting my character as an Artist
to Macklin my Employer as Macklin told me at the time

& Posterity will know

This world is not what it is reputed
But the Sneaking King of Heroes School
And the Son by a harming Virtuous Rule
...

A Certain Portrait Painter said to me in a boasting way since
I have Practisd Painting I have lost all Idea of Drawing Such a Man
must know that I lookd upon him with contempt he did not care for
this any more than West did who hated and equivocald with me
upon this serious Subject at which time he asserted that Woolletts
...

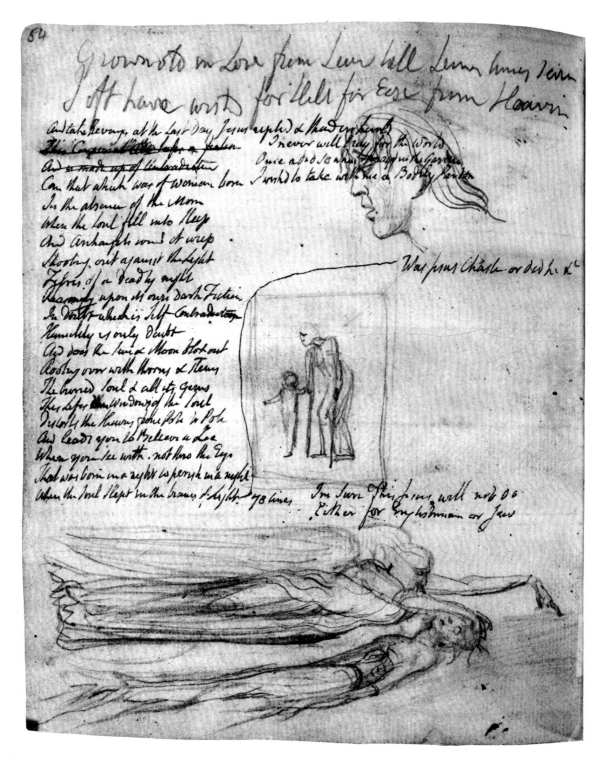

Pencil drawings: (a) tragic head, in profile, with locks over eyes—drawn before Poem 73, which bends to avoid it; (b) Emblem 33: youth leading age, a sort of skeletal sketch for 'London'; (c) a sketch for *Elohim creating Adam.*

**Poem 73**       *Grown  old  in  Love  from  Seven  till  Seven  times  Seven*

               *I  oft  have  wishd  for  Hell  for  Ease  from  H*e*aven*

**Poem 159**   And take Revenge at the Last Day    Jesus replied & thunders hurld   85
**(EG d**     ~~This Corporeal~~ ~~All lifes a fiction~~        I never will Pray for the World
**contd)**    All Corporeal lifes a               Once a did so when I prayd in the Garden
       ~~And is made up of Contradiction~~      I wishd to take with me a Bodily Pardon
       Can that which was of Woman born
       In the absence of the Morn    90
       When the Soul fell into Sleep
       And Archangels round it weep
       Shooting out against the Light
       Fibres of a deadly night
       Reaso*n*ing upon its own Dark Fiction   95                    Was Jesus Chaste or did he &c
       In Doubt which is Self Contradict $\frac{\text{ion}}{\text{ory}}$
       Humility is only Doubt
       And does the Sun & Moon blot out
       Rooting over with thorns & stems
       The buried Soul & all its Gems   100
       This Lifes <u>dim</u> Windows of the Soul
       Distorts the Heavens from Pole to Pole
       And leads you to Believe a Lie
       When you see with not thro the Eye
**Emblem 33**  That was born in a night to perish in a night  105
**f**      When the Soul slept in the beams of Light  78 lines    Im sure This Jesus will not do
                                                                Either for Englishman or Jew

Poem 73 is in pencil (italics); literally it dates November 1806, when Blake reached forty-nine. *EG* d continues in black ink. Lines d85-8 were currently inserted to replace two cancelled lines; the line 'Was Jesus Chaste or did he &c' is a cue for section e, begun on p. 48; the couplet f is evidently a comment on section d, after the totalling of lines. The total 78 was arrived at before insertions of lines 3-4, 21-4, 31-50, and 85-8 (four lines replacing two).

[N54 transcript]

Prints were superior to Basires because they had more Labour & Care
now this is contrary to the truth   Woolett did not know how to put
so much labour into a head or a foot as Basire did he did not
know how to draw the Leaf of a tree all his study was clean
strokes & mossy tints how then should he be able to make use
of either Labour or Care unless the Labour & Care of Imbecillity

The Lifes Labour of                                    Mental Weakness

scarcely Equals one                                    Hour of the

Labour of Ordinary                                     Capacity like

the full Gallop of the                                 Gouty Man

to the ordinary walk                                   of youth & health
   I allow that there is such                          a thing as high finishd
Ignorance as there may be                              a fool or a Knave.  in an
Embroiderd Coat but I say                              that the Embroidery of
the Ignorant finisher is                               not like a Coat made by
another but is an Emanation                            from Ignorance itself
& its finishing is like its master                     The Lifes Labour
of Five Hundred Idiots for                             he never Does the Work
                                                                     Himself

What is Calld the English Style of Engraving such as proceeded
from the Toilettes of Woolett & Strange (for theirs were ^Fribbles Toilettes)
can never produce Character & Expression.  I knew the Men
intimately from their Intimacy with Basire my Master & knew
them both to be heavy lumps of Cunning & Ignorance as their
works Shew to all the Continent who Laugh at the Contemptible
Pretences of Englishmen to Improve $\frac{A}{E}$rt before they even know
the first lines of Art Beginnings I hope this Print will redeem my Country
from this Coxcomb situation & shew that it is only some Englishmen

PA 10, written straight down the page, is in dark ink; the paragraph below the picture was evidently there first (avoiding drawings
a and b), for the lines above it are crowded.

Pencil drawings: (a) a curious spiral rising from a saucer holding a candle, evidently a wire sconce (see tracing, Fig. 19, Appendix II); (b) Emblem 34: a child kneeling before one (or two) seated, hooded figures beneath a pillared archway, a variant of the detail of nurse and children in the *Songs of Innocence* title-page.

(a) Emblem 35: a frantic figure with streaming hair is poised on a cliff edge. Someone's arm (partly erased) thrusts a Roman sword towards her; someone else's arm clasps her left ankle. There are rocks below.

**Poem 149**

**PA 3**  This Day is Publishd Advertizements to Blakes
Canterbury Pilgrims from Chaucer. Containing Anecdotes
of Artists.  Price 6^d

*PA 17*

*Such Prints as Woolett & Strange producd will do for those who choose to purchase the Lifes labour of Ignorance & Imbecillity in Preference to the Inspired Moments of Genius & Animation*

Why was Cupid a Boy
And why a boy was he
He should have been a Girl
For ought that I can see

For he shoots with his bow
And the Girl shoots with her Eye
And they both are merry & glad
And laugh when we do cry

And ~~Then~~ to make Cupid a Boy
                the Cupid Girls mocking
Was ~~surely a Womans~~ plan
                        cant interpret the thing
For a boy ~~never learns so much~~
Till he is become a man

And then hes so piercd with care
And wounded with arrowy smarts
That the whole business of his life
Is to pick out the heads of the darts

Twas the Greeks love of War
Turnd Love into a Boy
And $\frac{W}{w}$oman into a Statue of Stone
And away fled every Joy

**Emblem 35**

**PA 11**  and not All who are thus ridiculous in their Pretences Advertizements
in Newspapers are no proof of Popular approbation. but often the Contrary
A Man who Pretends to Improve Fine Art Does not know what
Fine Art is Ye English Engravers must come down from your high
flights ye must condescend to study Marc Antonio & Albert Durer
Ye must begin before you attempt to finish or improve & when
you have begun you will know better than to think of improving
what cannot be improvd  It is very true what you have said

Poem 149 and *PA* 3 and 11 are in dark, almost black ink; *PA* 17 is in greyer ink (italics here).

for these thirty two Years I am Mad or Else you are so PA 12

both of us cannot be in our right senses Posterity will judge

by our Works Wooletts & Stranges works are like those of Titian &

Correggio the Lifes Labour of Ignorant Journeymen Suited to the

Purposes of Commerce no doubt for Commerce Cannot endure

Individual Merit its insatiable Maw must be fed by What

All Can do Equally well at least it is so in England as I have

*I do not pretend to Paint better* PA 19

*than Rafael or Mch Anglo*
*or Julio Romano or Alb Durer*
*but I do Pretend to Paint*

*finer than Rubens or Remb$^t$*

*or Correggio or Titian. I do*

*not Pretend to Engrave finer*

*than Alb Durer $\frac{G}{P}$oltzius*

*Sadeler or Edelinck but*

*I do pretend to Engrave finer*

*than Strange Woolett Hall* PA 16

*& All*
*or Bartolozzi$_\wedge$because*

*I understand Drawing which they understand not* Emblem 36
found to my Cost these Forty Years PA 13

The Cottagers & Jocund Peasants the Views
in Kew Gardens Foots Cray & Diana &
Acteon & in short all that are Calld
Wooletts were Etchd by Jack Browne
& in Wooletts works the Etching is All
tho even in these a single leaf of a tree is never correct

& 34

    Wooletts best works were Etchd by Jack Brown Woolett Etchd very PA 15

bad himself. Stranges Prints were when I knew him all done by

Aliamet & his french journeymen whose names I forget.

    Commerce is so far from being beneficial to Arts or to Empire PA 14

as all their History shews
that it is destructive of both $_\wedge$ for the above Reason of Individual

Merit being its Great hatred. Empires flourish till they become

Commercial & then they are scatterd abroad to the four winds

PA 19, probably inserted last, is in grey ink (italics here); the rest of the page is in dark ink.

[N57 transcript]

(a) Emblem 36: a naked figure half reclining on a divan-like scroll among clouds and stars: redrawn to represent 'Earth' or 'the lapsed Soul' in the 'Introduction' of *Songs of Experience*, with little change except reversal of direction—and, in some copies, a large golden halo. Compare the cloud-borne writer or reader of 66b.

In this manner the English Public have been imposed upon for many Years under the impression that Engraving & Painting are somewhat Else besides Drawing Painting is Drawing on Canvas & Engraving is Drawing on Copper & Nothing Else & he who pretends to be either Painter or Engraver without being a Master of Drawing is an Impostor. We may be Clever as Pupils but as Artists we are & have long been the Contempt of the ~~Continent~~ Gravelot once said to My Master Basire ~~you~~ De English may be very Clever in ~~your~~ own opinions but ~~you~~ do ~~not~~ draw ~~the~~ draw

Resentment for Personal Injuries has had some share in this Public address But Love to My Art & Zeal for my Country a much Greater.

Pencil drawings: (a) figure huddled in front of a banyan tree (compare the central figure in 20a); (b) a barren tree with exposed roots, with someone (perhaps two persons) sitting on the roots and holding onto the trunk; (c) Emblem 37: used for *GP* 10, the hand of a drowning man. (See tracings, Figs. 20, 21, and 7, Appendix II.)

*In this manner the English Public have been imposed upon*

*for many Years under the impression that Engraving &*

*Painting are somewhat Else besides Drawing    Painting*

*is Drawing on Canvas & Engraving is Drawing on Copper*

*& Nothing Else & he who pretends to be either Painter*

*or Engraver without being a Master of Drawing is an*

*Impostor.    We may be Clever as Pugilists but as*

*Artists we are & have long been the Contempt of the*

*Continent ~~Aliamet~~ Gravelot once said to*

*My Master Basire    ~~You~~ De English may be very*

*clever in ~~your~~ deir own opinions but ~~you~~ dey do not*

*draw $\frac{D}{th}$e draw*

*45 33*

*Resentment for Personal Injuries has had some*

*share in this Public Address    But Love to My Art*

*& Zeal for my Country a much Greater.*

The ink of *PA* 20 is greyish (italics here).

Men think they can Copy Nature as Correctly as I copy

Imagination this they will find Impossible. & all the Copies

or Pretended Copiers of Nature from Rembrat to Reynolds

Prove that Nature becomes ~~tame~~ to its Victim nothing

but Blots & Blurs. Why are Copiers of Nature Incorrect

while Copiers of Imagination are Correct this is manifest to all

---

From Bells Weekly Messenger Aug^st 4.1811.

Salisbury July 29
A Bill of Indictment was
preferred against Peter Le Cave
for Felony but returnd Ignoramus
by the Grand Jury. It appeard
that he was in extreme indigence
but was an Artist of very superior
Merit while he was in Wilton
~~Jail~~ Goal he painted many Pieces
in the Style of Morland some of
which are stated to be even superior to the performances of that Artist. with whom
Le Cave lived many years as a Professional Assistant & he states that many

Paintings of his were only Varnished over by Morland & sold by that Artist as
his own. Many of the Principal Gentlemen of the County have visited
LeCave in the Goal & declared his drawings & Paintings in many instances
to excel Morlands. The Writer of this Article has seen many of Le Caves
Works & tho he does not pretend to the knowledge of an artist yet he considers
them as Chaste delineations of Rural Objects.

Such is the Paragraph It confirms the Suspition I entertained concerning
those two ~~Prints~~ I Engraved From for J.R.Smith. That Morland could not
have Painted them as they were the works of a Correct Mind & no Blurrer

PA 21 is in darker ink, the rule below it and Msc 17 in greyer. The text from *Bell's Weekly* of Sunday, 4 Aug. 1811, p. 248, is verbatim except for Blake's changing 'whilst' to 'while' (line 9). And Blake writes 'Jail', then 'Goal' (a common spelling) for the magazine's 'gaol'. Note that he put this account of a jailed artist beside his emblem of Ugolino in jail.

Men think they can Copy Nature as Correctly as I copy
Imagination this they will find Impossible. & all the Copiers
or Pretended Copiers of Nature from Rembrant to Reynolds
Prove that Nature becomes ~~to~~ to its Victim nothing
but Blots & Blurs. Why are Copiers of Nature Incorrect
while Copiers of Imagination are Correct this is manifest to all

From Bells Weekly Messenger Aug 4. 1811.

Salisbury July 29

A Bill of Indictment was
preferred against Peter Le Cave
for Felony but returned Ignoramus
by the Grand Jury. It appeared
that he was in extreme indigence.
but was an Artist of very Superior
Merit while he was in Wilton
~~Goal~~ Goal he painted many Pieces
in the Style of Morland some of

which are stated to be even Superior to the performances of that Artist. with whom
Le Cave lived many years as a Professional Assistant ~~the States~~ that many
Paintings of his were only Varnished over by Morland & sold for that Artist as
his own. Many of the Principal Gentlemen of the County have visited
Le Cave in the Goal & declared his Drawing & Paintings in many instances
to excel Morland. The Writer of this Article has seen many of Le Caves
Works & tho he does not pretend to the Knowledge of an artist yet he considers
them as Chaste Delineations of Rural Objects.

Such is the Paragraph It confirms the Suspicion I entertained concerning
those two ~~Prints~~ Prints I engraved From for J.R. Smith. That Morland could not
have Painted them as they were the works of a Correct Mind & no Blurrer

Pencil drawings: (a) Emblem 38: used for *GP* 12, Ugolino and children victims of priestly tyranny; (b) detail, side view of one of the huddling children (compare the *MHH* 16 version). Glue spots in two corners of the emblem.

(a) Emblem 39: youth and maiden in a dance of arrested flight, susceptible of many interpretations. Compare the two figures below the 'N' in the *MHH* title-page, the men seizing women in the *Thel* title-page, the fierce seizure in cancelled Pl. c of *America*.

**PA 18**  I also knew something of Tom Cooke who

Engraved after Hogarth ~~Cooke~~/~~Tom~~ wished to Give to

Hogarth what he could take from Rafael that

is Outline & Mass & Colour but he could^not/nt

~~& Hogarth with all his Merit never g~~

**Poem 151**

**a**  I askd my Dear Friend Orator Prigg
Whats the first part of Oratory he said
   a great wig
And what is the second then dancing a jig
And bowing profoundly he said a great wig
And what is the third then he snord like a pig
    puffing his cheeks he replied
And ~~smild like a Cherub & said~~ a Great wig

**b**  So if a Great Panter with Questions you push
**[Poem 150]**  Whats the first Part of Panting hell say a Paint Brush
And what is the second with most modest blush
    like a Cherub & say
Hell ~~nod wink~~ & smile ~~& reply~~ a pant Brush
And what is the third hell bow like a rush
With a lear in his Eye hell reply a ^Pa/Br nt brush ——

Perhaps this is all a Painter
   can want
But look yonder that house
   is the House of Rembrant
          &c

to come in Barry a Poem
That God is Colouring Newton
   does shew
And the devil is a Black outline
   all of us know
Perhaps this little Fable &c

**PA 27**  The originality of this Production makes it necessary to say a few words

While the Works ~~of Translators~~ of Pope & Dryden are lookd upon as ~~in the~~

~~Same class of~~ the Same Art with those of^2 ^8/7 ^44 Milton & Shakespeare

while the works of Strange & Woollett are lookd upon as the same

Art with those of Rafael & Albert Durer there can be no Art in a

Nation but such as is Subservient to the interest of the Monopoli

zing Trader ~~whose whole~~ / ^xxx x xx ~~who Manufactures Art by the Hands of~~

~~Ignorant Journeymen / till at length Christian Charity~~ is held out

as a Moti~~ve to encourage a Blockhead & he is Counted the~~ Greatest

~~Genius who can sell a Good for Nothing Commodity for a~~ Great

Price Obedience ~~to the Will of the Monopolist is~~ calld Virtue

---

*PA* 18 and 27 are in medium dark ink, with erasure and revision (in 18) while the ink was wet. Poem 151 and the opening couplet for Poem 150 on p. 61 are in black ink, with greyish revisions. The vertical line in *PA* 27, first placed after 'Journeymen' and then moved back to the line above, signifies deletion extending to the similar line on p. 61 after 'fingers' (*PA* 28).

[N60 transcript]

To Venetian Artists

Perhaps this little Fable may make us merry

A dog went over the water without a wherry

A bone which he had stolen he had in his mouth  5

He cared not whether the wind was north or south

As he swam he saw the reflection of the bone

This is quite Perfection, ~~heres two for~~ one ~~what a brilliant tone~~
Generalizing Tone

Snap. Snap! he has
~~Then~~ ~~He snapd &~~ lost shadow & substance too

He had them both before now how do ye do

A great deal better than I was before

Those who taste ~~Ive tasted shadow &~~ love it more & more
colouring

~~Then Reynolds said O woman most sage~~

O Dear Mother outline ~~be not in a Rage~~
of knowledge most sage

Whats the First Part of Painting she said
Patronage

And what is the second to Please & Engage

She frownd like a Fury & said Patronage

And what is the Third she put off Old Age

And smild like a Syren & said Patronage

All is Chiaro Scuro Poco Pen & Colouring  10  its all

Outline Theres no outline Theres no such thing Outline Theres no such thing

Industrious   *What we hope we see* $\frac{29}{11}$  *29   31*

an**d**   the   really   ~~Virtuous & Independent~~   Barry is   driven   out   to   make

room   for   a   pack   ~~of Idle Sycophants~~   with   whitlors   on   their

~~fingers~~ / Englishmen   rouze   yourselves   from   the   fatal   Slumber   into

which   Booksellers   &   Trading   Dealers   have   thrown   you   Under   the

artfully   propagated   pretence   that   a   Translation   or   a   Copy   of   any

kind   can   be   as   honourable   to   a   Nation   as   An   Original   ~~Belying~~

Be-lying   the   English   Character   in   that   well   known   Saying   Englishmen

Improve   what   others   Invent   This   Even   Hogarths   Works   Prove

*PA* 28 and Poem 150 are in medium dark ink; Poem 152 (a sort of continuation of Poem 151 on p. 60) is in black ink, i.e. the ink used for the addition to Poem 150 and for Poem 151.  In 150:8 the word 'one' was deleted and then restored by erasure of the deleting line.

[N61 transcript]

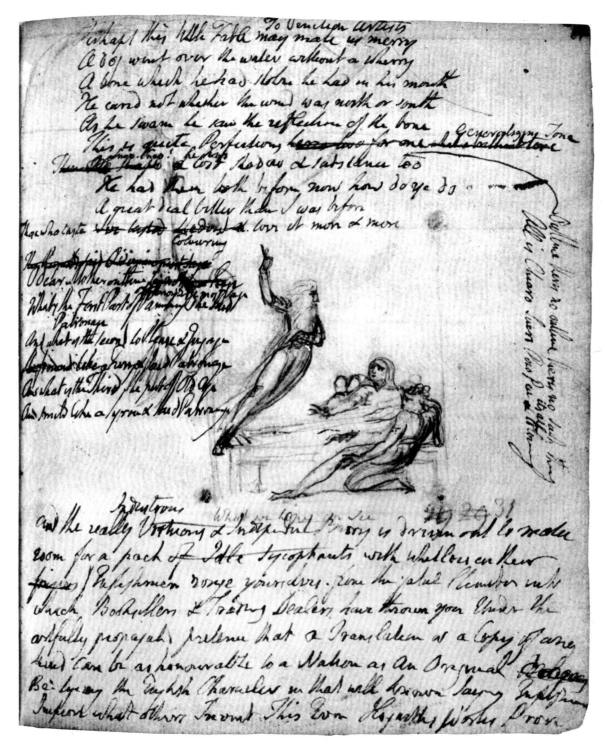

a

b

Pencil drawings: (a) detail of arm with outstretched fingers (for the main figure in b, but not followed closely); (b) Emblem 40: used for *GP* 13. Glue spots.

Soul, leaving body, instructs the family in the difference between down and up, fear and hope, i.e., in Vision. Compare Blake's early wash drawing, 'The Spirit of a Just Man Newly Departed Appearing to his Mourning Family' (Royal Library, Windsor).

1 a deleteable Falshood. No Man Can Improve An Original In
vention. ~~Nor can an Original Invention Exist without Execution Organized~~
Nor can an Original Invention Exist without Execution Organized
& minutely Delineated & Articulated Either by God or Man
4 Every Fool shook his bells throughout the Land
5 Tom Cooke cut Hogarth down with his clean Graving
with joy
6 ~~Thou many~~ Pounds of Compositions hear raw
Havoc Give in Great Offence by writing on Prooves Execute in Rhym as left & Portable as
7 Some blush at what Others can see no Crime in
drug
8 But Nobody shall see Harm in Rhyming
9 They way on my Cortitt Keep the
9 they ~~way~~ on my ~~Cortitt~~ keep the
8 Says Homer is very much Improvd by Pope
9 While I looking up to my Bromella
10 Resolved to be a very Contrary fellow
Looking up
11 Cry Tom Cooke prating, from Reverence to Venter
12 No one can finish so high as the original inventor
Be his apology for his Catalogue
Then heard many People say give me the Ideas. It is no
matter what words you put them into & Others say give
me the Design it is no matter for the Execution. These
People know Nothing of Art. Ideas cannot be Given
but in their minutely Appropriate words nor can
a Design be made without its minutely Appropriate
Execution The unorganized Blots & Blurs of Rubens &
Titian are not Art nor. can their Method ever express
Ideas or Imaginations any more that Popes Metaphysical

(a) Traces remain of a pencil drawing that once occupied the emblem position, and had framing lines, perhaps even a number; photography has been unsuccessful.

[N62]

a detestable Falshood. No Man Can Improve An Original In
~~but~~ vention. ~~Since Hogarths time we have had very few Efforts of Originality~~
Nor can an Original Invention Exist without Execution Organized

**Poem 134**

3 Dryden in Rhyme cries Milton only Plannd

4 Every Fool shook his bells throughout the Land

5 Tom Cooke cut Hogarth down with his clean Graving

6 ~~How many~~ Thousands Connoisseurs ran raving   *of*   *with joy*

Having Given great offence by writing in Prose Ill write in Rhyme as soft as ~~feather Pillows~~   Bartolloze

1 Some blush at what others can see no crime in

2 But Nobody ~~at all~~ sees *any* harm in Rhyming   *Thus*

13 Poor Schiavonetti died of the Cromek   14 A thing thats tied about the Examiners neck

7/9 Thus Hayley on his Toilette seeing the Sope

8/10 Says Homer is very much improvd by Pope

Flaxman & Stothard smelling a sweet savour Cry Blakified drawing spoils painter

9/11 While I looking up to my Umbrella    & Engraver

10/12 Resolvd to be a very Contrary Fellow

11/13 Cry ~~Tom Cooke proves~~ from ~~Circumference~~ to Center   *Looking up*   *Skumference*

12/14 No one can finish so high as the original inventor

Blakes apology for his Catalogue

~~who cries all art is a fraud & Genius a trick And Blake is an unfortunate Lunatic~~

I have heard many People say Give me the Ideas. It is no
matter what Words you put _them into & others say Give
me the Design it is no matter for the Execution. These
People Know *Enough of Artifice but* Nothing Of Art. Ideas cannot be Given
But in their minutely Appropriate Words nor Can
a Design be made without its minutely Appropriate
Execution The unorganized Blots & Blurs of Rubens &
Titian are not Art nor can their Method ever express
Ideas or Imaginations any more than Popes Metaphysical Jargon
Unappropriate Execution is the Most nauseous affectation of Rhyming
of all

*Left margin:* I do not mean smoothd up & Niggled & Poco Piud and all the beauties pickd out ~~but~~ & blurd & blotted but / Drawn with a firm hand at once with all its / & decided / ~~Spots & Blemishes which are beauties & not faults~~ / Like Fuseli & Michael Angelo Shakespeare & Milton

*Left margin lower:* & foppery

*Right margin:* minutely Delineated & Articulated Either by God or Man / He who copies does not Execute he only Imitates what is already Executed Execution is only the result of Invention

PA 29 and 31 and Poem 134 are mainly in dark grey ink, but the inserted third line and marginal insertions are in blacker. The poem's title was added below it when no room remained above; the further insertion 'who cries . . . Lunatic' refers back to the *Examiner* and needs to follow inserted lines '13-14'. The jump in numbering, from '6' to '9', was a mistake and was corrected. For Blake's fair copy see p. 65.

[N62 transcript]

Whoever looks a$\frac{t}{n}$ any of the Great & Expensive ~~of Eng~~raving Works that have   **PA 32**

been Publi<u>sh</u>d   by English Traders must <u>fee</u>l a Loathing & Disgust

$\frac{\&}{a}$ accordingly most Englishmen have a Contempt for Art ~~which~~

~~will~~ which is the Greatest Curse that can fall upon a Nation

Ive given great Provision to my Foes   **Poem 134**
And now Ill lead my false friends by the Nose   **(contd)**

**PA 35**   *Mr B submits to a more*

*severe tribunal he invites*

*the <u>a</u>dmirers of old English*

*Portraits to look at his Print*

*Modern Chalcographic*
*The ˄Connoisseurs & Amateurs*   **PA 34**
*~~ap~~ admire only the work*

*of the journeyman Picking*

*out of whites & blac<u>ks</u> in*

*what is calld Tints they*

*despise drawing which despises*

*them in return. They see*

*only whether every thing is*

*coverd down but one spot*

*of light*

*I found him beneath a tree in the Garden*   **Emblem 41**
43 45   **(GP 1)**
He who could represent Christ uniformly like a Drayman must have   **PA 33**

Queer Conceptions consequently his Executin must have been as Queer

& those must be Queer fellows <u>w</u>ho give great sums for such

nonsense & think it fine Art

But the Greater Fool<del>s</del> the Gre$\overset{a}{a}$ter Liar

Great M$\overset{m}{m}$en & Fools of do often me Inspire   **Poem 60**

PA 32 is in dark ink, the continuation of Poem 134 in dark grey, PA 33, 34, 35 in grey (italics here).
Poem 60 is in blacker ink than the rest of the page.

[N63 transcript]

(a) Emblem 41: in pencil, retouched in the grey ink of the text beside it; used as *GP* 1; (b) detail, in pencil, of the mother's hand grasping the mandrake's leaves/hair. (Note that in *a* her hand and head are drawn in alternative positions.)

Upon reading of 'a tree' and 'the Garden', in the legend, are we to see the child's head as a fallen apple?

I do not know Arthur Homer is a Liar & that there is no
such thing as Generous Contention I know that all those
with whom I have Contended in Art have Strove not to
Excell but to Starve me out by Calumny & the Arts
of Trading Combination

From Cratetos
Me Time has Crook'd. no good Workman
Is he. Infirm is all that he does

I always thought that Jesus Christ was a Snubby or
I should not have worshipd him if I had thought he
had been one of those long spindle nosed rascals

**PA 36**   I do not know whether Homer is a Liar & that there is no

such thing as Generous Contention   I know that all those

with whom I have Contended in Art have strove not to

Excell but to Starve me out by Calumny & the Arts

of Trading Combination

**Poem 135**

From  Cratetos

Me Time has Crook'd. no good $\frac{W}{w}$orkman

Is he    Infirm is all that he does

**Msc 14**   I always thought that Jesus Christ was a Snubby or

I should not have worshipd him if I had thought he

had been one of those long spindle nosed rascals

All in dark ink, the poem slightly greyer than the prose.

Chaucers   Canterbury   Pilgrims

Being   a   Complete   Index   of   Human   Characters   as

they   appear   Age   after   Age

If Men will act like a maid smiling over a Churm
They ought not when it comes to anothers turn
To grow sower at what a friend may utter
Knowing & feeling that we all have need of Butter
fie fie          you shant
False Friends O no our Friendship neer shall sever
In spite
For now we will be greater friends than ever

Having given great offence by writing in Prose
Ill write in Verse as soft as Bartolloze
Some blush at what others can see no crime in
But nobody sees any harm in Rhyming
Dryden in Rhyme cries Milton only plannd
Every Fool shook his bells throughout the land
Tom Cooke cut Hogarth down with his clean graving
Thousands of Connoisseurs with joy ran raving
*Thus* Hayley on his Toilette seeing the Sope
Cries Homer is very much improvd by Pope
*Some say* Ive given great Provision to my foes
*that*          nose
And now I lead my false friends by the toes
Flaxman & Stothard smelling a sweet savour
Cry Blakified drawing spoils painter & Engraver
While I looking up to my Umbrella

*47* 46

Resolvd to be a very contrary fellow
Cry looking quite from Skumference to Center
No one can finish so high as the original Inventor
Thus Poor Schiavonetti died of the Cromek
A thing thats tied around the Examiners neck
This is my sweet apology to my friends
That I may put them in mind of their latter Ends

Poem 153

Emblem 42
Poem 134´

Poem 134´ contd

Mainly in dark ink, but Poem 153 paler.  The additions to Poem 134´ are in grey ink (here italics).  Poem 134´ is a fair copy of the poem on pp. 62-3.

(a) Emblem 42: in ink and grey wash, over pencil erasure that seems to have been not very dissimilar. Glue spots.

Emblems 41 and 42, both in grey wash, were kept together in all Blake's numbering and renumbering, but Emblem 41 went into *GP* while 42 was used in *Songs of Experience* (to illustrate 'The Angel').

66

The English Artist may be assured that he is doing an injury & injustice to his Country while he Studies & imitates the Effects of Nature. England will never rival Italy while we servilely copy. what the Wise Italians Rafael & Michael Angelo scorned nay abhorred as Vasari tells us

call that the Public Voice which is their Error
Like as a Monkey peeping in a Mirror
Admires all his Colours brown & warm
And never once perceives his ugly form

What kind of Intellects must he have who sees only the Colours of things & not the Forms of Things

Let us teach Buonaparte & whomsoever else it may concern That it is not Arts that follow & attend upon Empire but Empire that attends upon & follows ~~~~ The Arts

It is Nonsense for Noblemen & Gentlemen to offer Premiums for the Encouragement of Art when such Pictures as these can be done without Premiums let them Encourage what Exists Already & not endeavour to counteract by tricks let it no more be said that Empires Encourage Arts for it is Arts that Encourage Empires Arts & Artists are Spiritual & laugh at Mortal Contingencies It is in their Power to hinder Instruction but not to Instruct just as it is in their Power to Murder a Man but not to make a Man

Pencil drawings: (a) left profile of a man, perhaps a variant of Blake's self-portrait 67a; (b) an alarmed *alter ego* (they seem shaped alike) kneels half astride and prods a figure half reclining on a cloud (cf. 57a) with head supported by left forearm, the right hand holding a book or writing. (See tracing, Fig. 22, Appendix II.)

(To the right of drawing a, there is a pencil rub-off of the 67a profile.)

[N66]

**PA 41**  The English Artist may be assured that he is doing an injury

& injustice to his Country while he studies & imitates the Effects

of Nature. England will never rival Italy while we servilely

copy. what the Wise Italians Rafael & Michael Angelo scorned

nay abhorred as Vasari tells us

**Poem 136**
**(within**
**PA)**

Call that the Public Voice which is their Error

Like ~~to~~ ᵃˢ a Monkey peeping in a Mirror

Admires all his colours brown & warm

And never once percieves his ugly form

**PA 42**  What kind of Intellects must he have who sees only the Colours

of things & not the Forms of Things

**PA 38**  Let us teach Buonaparte & whomsoever else it may concern That

it is not Arts that follow & attend upon ~~Empires~~ but ~~Empires~~

that attends upon & follows ~~wherever Art leads~~   The Arts

**PA 37**  It is Nonsense for Noblemen & Gentlemen to offer Premiums for the Encou

ragment of Art when such Pictures as these can be done without Premiums

let them Encourage what Exists Already & not endeavour to counteract by tricks

let it no more be said that Empires Encourage Arts for it is Arts that

Encourage Empires   Arts & Artists are Spiritual & laugh at Mortal

Contingencies   It is in their Power to hinder Instruction but not

to Instruct just as it is in their Power to Murder a Man but not to make a Man

*PA* 37 and 41 and Poem 136 are in dark ink, *PA* 42 and 38 in blacker. *PA* 38 clearly follows 37, moving from plural to singular
for 'Empire'. The sequence of composition can be deduced as 37, 41, 42, 38—an indication of the desultory method of Blake's
assembling these thoughts.

[N66 transcript]

Msc 15
PA 40

Emblem 43

PA 39

23 May 1810 found the Word Golden

A Man sets himself down with Colours & with all the Articles of Painting he puts a Model before him & he copies that so neat as to make it a Deception now let any Man of Sense ask himself one Question Is This Art. can it be worthy of admiration to any body of Understanding. Who could not do this what man who has eyes and an ordinary share of patience cannot do this neatly. Is this Art Or is it glorious to a Nation to produce such contemptible Copies Countrymen Countrymen do not suffer yourselves to be disgracd

41 of 47

No Man of Sense can think that an Imitation of the Objects

of Nature is The Art of Painting or that such Imitation which

any one may easily perform is worthy of Notice much less

that such an Art should be the Glory $\frac{\&}{of}$ Pride of a

Nation & that the man who does this is The Italians

laugh at English Connoisseurs who are ~~All~~ ^most of them^ such silly

Fellows as to believe this

All the ink is dark.  The evidence of Msc 15, which supplies a date, is nicely ambiguous:  the guideline may have been curved around it, or it may have been fitted into that curve.  Note, however, that *PA* 40 was squeezed in after *PA* 39, with a finer pen— and that Msc 15 was written with that same pen or one of the same fineness.  And if Msc 15 had not yet occupied the left margin, *PA* 40 would normally have begun there:  and yet, consideration for the self-profile may have preserved that space.

[N67 transcript]

Pencil drawings: (a) self-portrait of William Blake, left profile, with wisps of hair; evidently drawn before *PA* (1810) and before the '1810' line (see preceding note). The upper part of the face is very similar to the almost snubby Socrates in Lavater's *Physiognomy*.

(b) Emblem 43: meagerly sketched; one or two tall figures walking away from an arched doorway (the cloister of 55b? the same nuns or nurses?).

the Last Judgment is not Fable or Allegory but Vision
Fable or Allegory are a totally distinct & inferior kind
of Poetry. Vision or Imagination is a Representation of
what Eternally Exists. Really & Unchangeably. Fable
or Allegory is Formd by the Daughters of Memory. Imagination
is Surrounded by the daughters of Inspiration who in the

appear are called Jerusalem The Hebrew Bible & the Gospel
of Jesus are not Allegory but Eternal Vision or Imagination
of All that Exists. The Last Judgment is one of
these Stupendous Visions I have represented it as I
saw it to different People it appears differently as

The Last Judgment is not Fable or Allegory but Vision
Fable or Allegory are a totally distinct & inferior kind
of Poetry. Vision or Imagination is a Representation of
what Eternally Exists. Really & Unchangeably. Fable
or Allegory is Formd by the Daughters of Memory. Imagination
*Frontispiece*
is Surrouded by the daughters of Inspiration who in the

*[text written sideways, right column:]*

Note here that Fable or Allegory is Seldom
without some Vision Pilgrims Progress is
full of it the Greek Poets the same but
Allegory & & Vision & Visions of Imagination
Fable al Allegory. ought to be known
as Two Distinct Things & so calld for
the Sake of Eternal Life

*[text written sideways, left column:]*

Plato has made Socrates say that Poets
& Prophets do not Know or Understand
what they write or Utter this is a most
Pernicious Falshood. If they do not
pray is an inferior Kind to be calld
Knowing Plato confutes himself

aggregate are calld Jerusalem The Hebrew Bible & the Gospel
of Jesus are not Allegory but Eternal Vision or Imagination
of All that Exists  The Last Judgment is one of
these Stupendous Visions I have represented it as I
saw it to different People it appears differently as

*What is Man that thou shouldst  I
magnify him & that thou shouldst set
thine heart upon him  Job*

Note here that &c

All of *VLJ* 3 is in blackish ink.  Caret and '&c' indicate the place for insertion of the passage written sideways.  The line after 'Jerusalem' guides in an addition made on p. 69.

every thing else does for tho on E̶/earth things seem Permanent

they are less permanent than a Shadow as we all know

too well

    The Nature of Visionary Fancy or Imagination is very little

Known & the Eternal nature & permanence of its ever Existent
XXXXX
       XXX

Images is considerd as less permanent than the things of Vegetative

& Generative Nature yet the Oak Dies as well as the Lettuce

but Its Eternal Image & Individuality never dies. but renews

            so
by its Seed. just a̶s̶ the Imaginative Image returns ~~according to~~ by

the Seed of Contemplative Thought the Writings of the Prophets

illustrate these conceptions of

the Visionary Fancy by their

various sublime & Divine

Images as seen in the Worlds

of Vision

Fable is Allegory but what Critics call The Fable is Vision itself

                              5̶ 7
    This world of Imagination is the World of Eternity it is the Divine bosom
                *At length for hatching ripe he breaks*
into which we shall all go after the death of the Vegetated body
      of Imagination    *the shell*          *Dryden*
This World is Infinite & Eternal whereas the world of Generation
          ^

or Vegetation is Finite & ~~for a small moment~~ Temporal There

Exist in that Eternal World the Permanent Realities of Every Thing

which we see reflected in this Vegetable Glass of Nature

    All Things are comprehended in their Eternal Forms in the Divine

All the *VLJ* passages are in blackish ink. 'Existent' in the fifth line is over an erased word, with a smaller erased word below it; the smaller word looks something like 'joy'; the larger may have been 'Eternal'.

b
a

every thing else does for tho on Earth things seem Permanent
they are less permanent than a Shadow as we all know
too well

The Nature of Visionary Fancy or Imagination is very little
Known & the Eternal nature & permanence of its ever Existent
Images is considerd as less permanent than the things of Vegetative
& Generative Nature yet the Oak dies as well as the Lettuce
but its Eternal Image & Individuality never dies, but renews
by its seed. just [as] the Imaginative Image returns according by
the seed of Contemplative Thought the Writings of the Prophets
illustrate these conceptions of
the Visionary Fancy by their
various sublime & Divine
Images as seen in the Worlds
of Vision

c

Fable is Allegory but what Critics call The Fable is Vision itself

The world of Imagination is the World of Eternity it is the Divine bosom
into which we shall all go after the death of the Vegetated body
This World of Imagination is Infinite & Eternal whereas the world of Generation
or Vegetation is Finite & Temporal There
Exist in that Eternal World the Permanent Realities of Every Thing
which we see reflected in this Vegetable Glass of Nature

All Things are comprehended in their Eternal Forms in the Divine

Pencil drawings: (a) face with open mouth and staring eyes—a mask? (b) detail of an eye? (c) Emblem 45: partly redrawn for
*GP* 6: a hatching cupid, looking up (as compared to the flying boy in 77a who comes right at us).

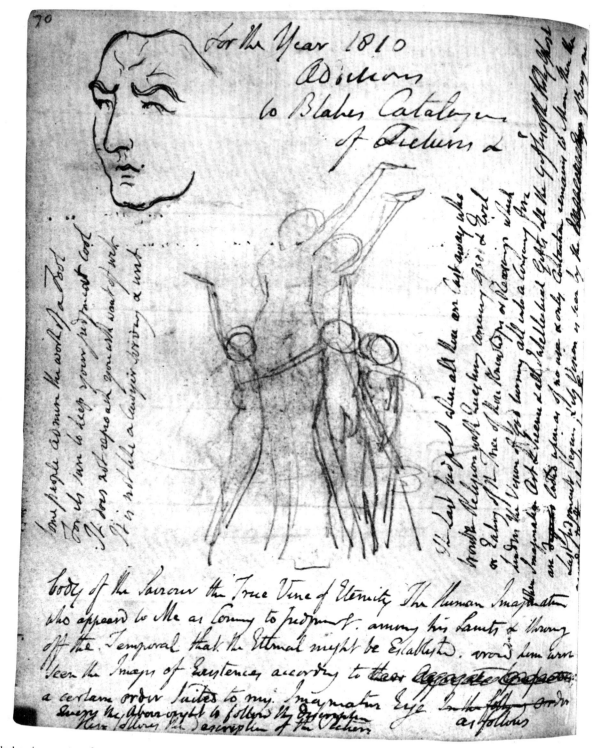

a

b

c

(a) Ink drawing: a stern face, outlined like a mask; (b) pencil sketch of the three weavers in the Arlington Court picture. All hold shuttles, but here one is a child, joining hands with two (or three) others around the adults. An erased image behind them (c), a long sofa with animal feet (see tracing, Fig. 23, Appendix II), must be an earlier, unrelated drawing. The shape taken by the writing on the page, however, was obviously not determined by the sofa but by the weavers, who must then have been present before 1810.

For the Year 1810

Additions

to Blakes Catalogue

of Pictures &c

**Poem 141**
**VLJ 2**

Some people admire the work of a Fool
For its sure to keep your judgment cool
It does not reproach you with want of wit
It is not like a lawyer serving a writ

The Last Judgment when all those are Cast away who
trouble Religion with Questions concerning Good & Evil
or Eating of the Tree of those Knowledges or Reasonings which
hinder the Vision of God turning all into a Consuming fire
When Imaginative Art & Science & all Intellectual Gifts all the Gifts of the Holy Ghost
are despisd lookd upon as of no use & only Contention remains to Man then the
Last Judgment begins & its Vision is seen by the ~~Imaginative~~ Eye of Every one
according to the situation he holds

**VLJ 11** body of the Saviour the True Vine of Eternity The Human Imagination
who appeard to Me as Coming to Judgment. among his Saints & throwing
off the Temporal that the Eternal might be $\frac{E}{e}$stablishd. around him were
seen the Images of Existences according to their ~~Aggregate Imaginations~~
a certain order Suited to my Imaginative Eye   ~~In the Following order~~
Query the Above ought to follow the Description    as follows
Here follows the description of the Picture

*VLJ* 1, 2, 11 are in dark ink, Poem 141 in somewhat greyer.

[N70 transcript]

The Learned m

    this $\frac{a}{i}$ s n

$\frac{or}{of}$ Heroes it ans

& not Spiritu

while the Bibl

of Virtue & Vic

as they are Ex

is the Real Di

Things    The

when   they   Assert   that   Jupiter   usurped   the   Throne   of   his   Father

A Jockey that is any thing of a / Jockey will never buy a Horse / by the Colour & a Man who / has got any brains will never / buy a Picture by the Colour

When I tell any Truth it is not / for the sake of Convincing those / who do not know it but for / the sake of defending those / who Do

*Deaths door*    3̶5̶ 14

Satan   &   brought   on   an   Iron   Age   &   Begat   on   Mnemosyne

or   Memory   The   Greek   Muses   which   are   not   Inspiration   as

the   Bible   is.   Reality   was   Forgot   &   the   Vanities   of   Time   &

Space   only   Rememberd   &   calld   Reality   Such   is   the   Mighty

difference   between   Allegoric   Fable   &   Spiritual   Mystery   Let   it

here   be   Noted   that   the   Greek   Fables   originated   in   Spiritual   Mystery

                                  & Real Vision

PA 43

**Emblem 46
(GP 15)
VLJ 8**

*VLJ* 7 and 8, obviously written first, are in dark ink; *PA* 43 is in grey (with a finer pen in the left margin than in the right). At bottom the phrase '& Real Vision' may have been intended as a catchword—or (see next page), the singular noun not matching the plural verb, the phrase 'and Real Visions' may have been written as a replacement.

71

[Paper cut away]

a

(a) Emblem 46: 'Deaths door', used for *GP* 15, also in *America* 12. Glue spots.

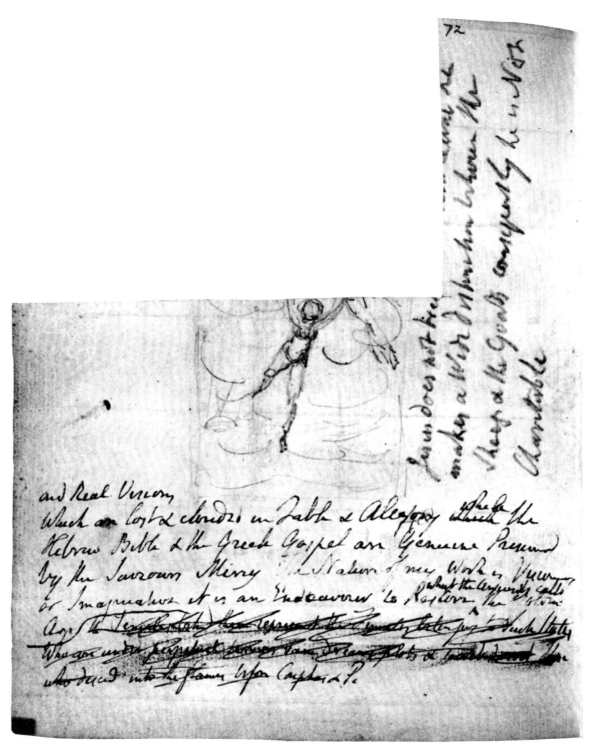

72

and Real Visions
Which are lost & clouded in Fable & Allegory while the
Hebrew Bible & the Greek Gospel are Genuine Preserved
by the Saviours Mercy The Nature of my Work is Visionary
or Imaginative it is an Endeavour to Restore what the Ancients called
the Golden Age ...

a

(a) Emblem 47: naked figure running across waves, as Oothoon in the *VDA* title-page; a sun on the left horizon; the crossed feet from above may belong to an early form of the attacking figure, or possibly to the conjuror (see 81a).

[N72]

*Jesus does not trea ... because he*
*makes a Wide Distinction between the*
*Sheep & the Goats consequently he is Not*
*Charitable*

**Emblem 47**
**VLJ 9**

and Real Visions

Which are lost & clouded in Fable & Ale$\frac{gory}{48}$ ~~which~~ while the

Hebrew Bible & the Greek Gospel are Genuine Preservd

by the Saviours Mercy The Nature of my Work is Visionary

or Imaginative it is an Endeavour to Restore ^what the Ancients calld^ the Golden

Age ~~the Females behind them represent the Females belonging to such States~~

~~Who are under perpetual terrors vain dreams plots & secret deciet Those~~

~~who descend into the flames before Caiphas & Pi~~

*VLJ* continues in dark ink from p. 71; Msc 16 is in pencil (italics). The deleted passage at bottom belongs to *VLJ* 19 on p. 78 and must have been copied here from a MS. page out of order (evidence that Blake was copying from a draft).

[N72 transcript]

To  God                                                          **Poem 74**

If  you  have  formd  a  Circle  to  go  into

Go  into  it  yourself  &  see  how  yo$\frac{u}{w}$  would  do

*Yet can I not perswade* ~~15~~  *36*                              **Emblem 48**
*me. thou art dead*
    *Milton*

*sᵹuᴉɥʇ ʎlɥʇɹɐƎ ʎlpꞁɹoM ɹoɟ poפ ʎɯ pʞuɐɥʇ I ɟI*
          ʎlpꞁɹoM
*lᴉʌǝꓷ ǝɥʇ pdᴉɥsɹoʍ I ʇɐɥʇ ʇɔǝdsns pꞁnoɥs I*

*sᵹuᴉꓘ ʎlɥʇɹɐƎ ⅋ lᴉʌǝꓷ ǝɥʇ ɯoɹɟ sʇɟᴉᵹ ǝq ʎɐW*

*pꞁɹoM ɥʇɹɐƎ sᴉɥʇ ɟo sǝɥɔᴉꓤ ǝɥʇ llɐ ǝɔuᴉS*          **6ϛ ɯǝoꓒ**

Poem 74 is in dark ink, Poem 59 in pencil.

[N73 transcript]

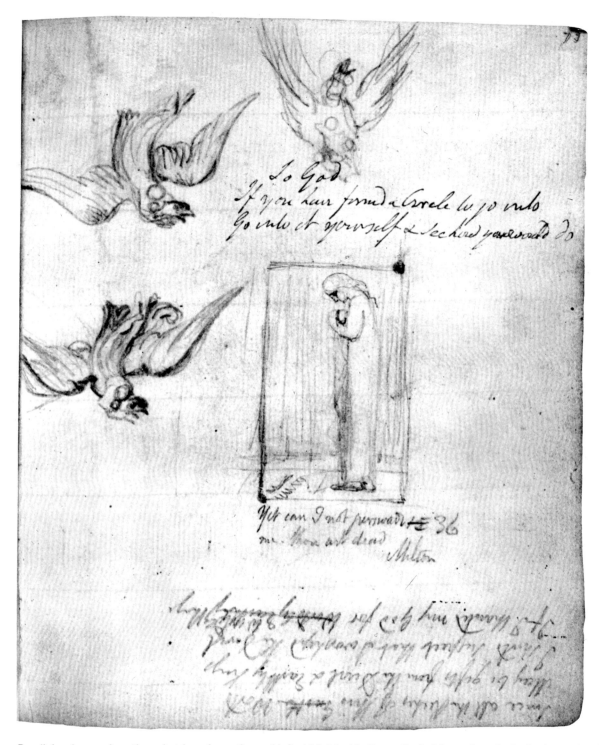

Pencil drawings: a, b, c, three sketches of a mother and infant (clutched in the mother's right arm) on the back of an eagle; cf. the larger drawing, Fig. 34 (Appendix II). A rejected design for Hayley's second ballad 'The Eagle' *c.* June 1802. (d) Emblem 48: a woman who cannot persuade herself of the death of her fair infant. (Compare the mother and child in the top picture of 'Holy Thursday', *Songs of Experience.*) Glue spots.

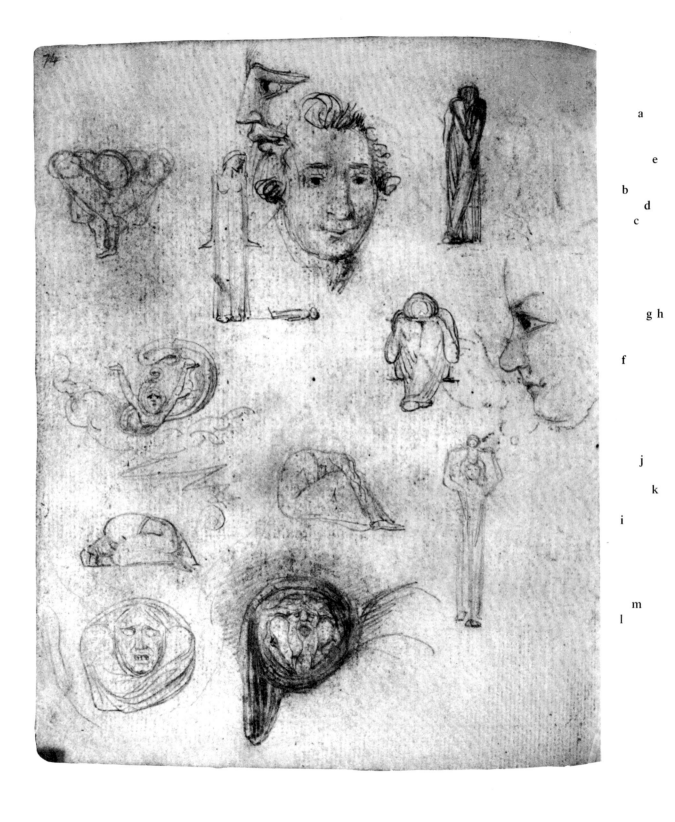

a

e

b

d

c

g h

f

j

k

i

m

l

Pencil drawings. (Lines from drawings on p. 73, the woman and bird, show through beside d, e, and g.)

Three portrait heads: (a) left profile, not identified; (d) front face, not identified; (h) left profile of a face bearing a family resemblance to Blake's—possibly his father or his brother James?

Ten diagrammatic drawings; human forms stylized into letters of the alphabet and similar shapes (see earlier examples, 64a, 73d): (b) head between knees, elbows at right angles, legs contorted into a human *Y,* a derivation from the crouched Theotormon of the *VDA* tailpiece; (c) the mother and child of 'Holy Thursday' shaped as an *L* (see note on 73d); (e) frozen form (a human *I*) of embracing lovers (as in 'The Little Girl Lost'); (f) a soaring woman (Oothoon) whose arms and scarf form a monogram *VD* (for *VDA* perhaps, since this and sketches g, i, j are abstractions from the illuminations of that work); the gesture of her arms and the curve of her scarf echo the shapes of the girl and worm emerging from the 'Sick Rose', but her chief derivation is from *VDA* 8 (the sketch for which is on p. 78), and the cloud under her defines her as a vision. The monogram picture translates the flames (rose-coloured in *VDA* 8) into scarf *and* lightning, which zigzags down from her cloud towards a moon between Figures i and j. These (i, huddled in a coffin or grave, head bent to earth; j, sitting but with head between knees; perhaps as letters they can be taken as *M* and *N*) derive from the first two Daughters of Albion (from left to right) in *VDA* 7. The lightning issuing from their vision of Oothoon (preaching liberation) may be understood as striking at their illusions (the moon that separates them in this drawing). Figure i is also like one of the human roses on the vine in 'The Sick Rose'; compare also, in a posture between i and j, the huddling woman in 'My Pretty Rose Tree'. Perhaps these alphabet drawings should be called analytic: the lightning, moon, and scarf (hinting at the scroll of prophecy) *interpret* the flames and rhetoric of *VDA*. In turn, we may suppose, this analysis assisted Blake's invention of the scarf-scroll on the soaring woman of *Europe* 3.

(g) Front view of a huddling figure, something like i, derived from the huddling Theotormon in *VDA* 4 (sketched in 50a, but particularly as developed in 92b); (k) simplification, into vertical and wingless angularity, of the poet and child of the *Experience* frontispiece; (l, m) anguished aged men, self-clutching and wrapped into the shapes of *O* and *P.* (Perhaps the poet and child make a sort of *T.*)

Pencil drawings. (Some lines, especially around d, have been impressed not from the drawings on p. 74 but from Blake's pencil work on the wings of the bird on p. 73.)

(a) Human *P* of 74m further simplified; (b) human in shape of a wrench, possibly derived from the lone figure in 'The Little Vagabond' (*Songs of Experience*); (c) a falling tangle of serpent and human forms, preliminarily or derivatively related to the design of the *Europe* Preludium; the serpentine coil may be meant to suggest a scroll; there is the suggestion of an iron weight attached to the bottom figure, such as that attached to a similar figure in *Europe* 1; compare also *America* 5; (d) a striding or swimming naked human with fish-like extremities—or is the hand a star form, and are we in the Book of Enoch? Compare Christ in *NT* 483, with flames issuing from his hands.

(e) Emblem 49: parents embracing across a troubled child; (f) a simple looking godhead—hair and beard streaming out from him to right and to left—with the body of a doll; (g) Theotormon (perhaps), on a rock or mound, acting the part of Hamlet; (h) a beard for Urizen (too large for the doll of sketch f).

The pencilled caption and numbers on this page are puzzling. The caption 'A vision of fear' can easily be applied to the falling group (c) above it; 'A vision of hope' does not so obviously suit the beard (h) beneath. Together these phrases can apply to the central drawing, of the embracing family, and the emblem numbering (16 changed to 38) is in the usual location if that drawing is the emblem. The Hamlet figure (g) is beside the numbers but far from the legend of 'fear' and 'hope', in location; in import a possible interpretation could be 'to see or not to see'.

There is evidence that these drawings (e and g) were on the page before Blake began his emblem series. If he had designed either as an emblem in the series, it would have been centred in an oblong frame and given room. The

A *vision of fear*

A  vision  of  hope

16  *38*                                                                                          **Emblem 49**

possibility that Blake had drawn the family reunion scene of e and had used it in an impressive drawing (*Drawings,* Pl. 38 or a close variant) before the autumn of 1787 is indicated by a sheet of 'Drawings of Blake' made by 'J. Flaxman from memory . . . June 1792' (Pl. 6 in Bentley, *Records*) in which these embracing parents and a child are shown, near two standing figures. For Flaxman had gone to Rome in the autumn of 1787 and not seen Blake or his drawings since. Flaxman's version and the one in *Drawings,* Pl. 38 are closely similar, with mother on left, father with forward striding right knee, one child (head sketched in twice) clutching him. *N* 75e has the positions reversed but the child still clutching the father, whose advanced right knee can almost be mistaken for another child. We can reject this evidence by supposing the Notebook drawing to be later than the one Flaxman was impressed by, but it is hard to think of the groping sketch of 75e as subsequent to what Flaxman saw. The date of a thematically related picture, Blake's engraving for Commins' *Elegy set to Music,* 1786, also may be pertinent. The Hamlet figure (g), with minor alterations, changes into King David in *GP* 8 or, more exactly, was drawn upon when Blake revised Emblem 15 (34a) into *GP* 8.

[N75 transcript]

a

b

c

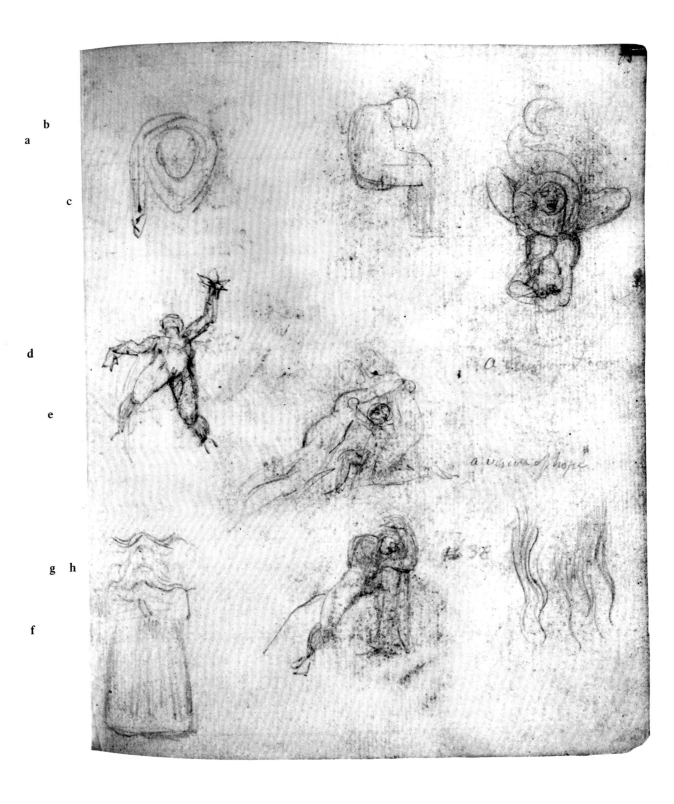

d

e

g h

f

*a vision of hope*

# 38

[N75]

(a) Pencil drawing: three standing adults surrounded by four children; compare the audience pictured in 'The Voice of the Ancient Bard' (*Songs of Experience*). (See tracing, Fig. 24, Appendix II.)

**VLJ 12**   Jesus   seated   between   the   Two   Pillars   Jachin   &   Boaz   with   the   Word
Divine                 & on each side the four & twenty Elders sitting in Judgment
of   Revelation   on   his   Knees ∧ the   Heavens   opening   around   him   by   unfolding   the
The Old H & old Earth are passing away & the N H&N Earth descending         *best as it is a work of no mind* *will do it*
clouds   around   his   throne∧ as   a   Scroll   The   Just   arise   on   his   right   &   the
A Sea of fire Issues from before the Throne                 Judgment Seat   *slew his brother*
wicked   on   his   Left   hand ∧ Adam   &   Eve   appear   first   before   the   throne   in
with the flint in his hand with which he
humiliation   Abel   surrounded   by   Innocents   &   Cain ∧ falling   with   the   head   downward

From   the   Cloud   on   which   Eve   stands   Satan   is   seen   falling   headlong   wound

round   by   the   tail   of   the   serpent   whose   bulk   naild   to   the   Cross   round   which

he   wreathes   is   falling   into   the   Abyss   Sin   is   also   represented   as   a   female

boud   in   one   of   the   Serpents   folds   surrounded   by   her   fiends   Death   is   Chaind

to   the   Cross   &   Time   falls   together   with   death   dragged   down   by   an Angel

a   Demon   crownd   with   Laurel   another   demon   with   a   Key   has   the   charge

of   Sin   &   is   dragging   her   down   by   the   hair   b$\frac{e}{y}$side   them   a   Scald   figure

is   seen   scaled   with   iron   scales   from   head   to   feet   with   precipitating   himself

into   the   Abyss   with   the   Sword   &   Balances   he   is   Og $\frac{K}{k}$ing   of   Bashan

On the Right

**VLJ 15**   ∧   Beneath   the   Cloud   on   which   Abel   kneels   is   Abraham   with   Sarah   &
Ishamael is Mahomet ∖on the left
Isaac $\frac{a}{\&}$lso   Hagar   &   Ishmael ∧ &∖   beneath   the   falling   figure   of   Cain   is   Moses

casting   his   tables   of   stone   into   the   Deeps.   it   ought   to   be   understood   that   the

Persons   Moses   &   Abraham   are   not   here   meant   but   the   States   Signified   by   those

Names   the   Individuals   being   representatives   or   Visions   of   those   States   as

they   were   reveald   to   Mortal   Man   in   the   Series   of   Divine   Revelations.   as

they   are   written   in   the   Bible   these   various   States   I   have   seen   in   my

Imagination   when   distant   they   appear   as   One   Man   but   as   you   approach

they   appear   Multitudes   of   Nations.   Abraham   hovers   above   his   posterity

which   appear   as   Multitudes   of   Children   ascending   from   the   Earth   surrounded

by   Stars   as   it   was   said $\frac{As}{the}$   the   Stars   of   Heaven   for   Multitude   Jacob   &   their

his Twelve   Sons   hover   beneath   the   feet   of   Abraham   &   recieve   their   children   from
I have seen when at a distance Multitudes of Men in Harmony appear like a single
the   Earth Infant sometimes in the Arms of a Female $\frac{this}{they}$ represented the Church

But   to   proceed $\frac{with}{in the}$   description   of   those   on   the   Left   hand.   beneath   the

Cloud   on   which   Moses   kneels   is   two   figures   a   Male   &   Female   chaind   to

*(left margin, rotated)* as two leaves forward ∧ to come in here ∧ to come in here &c on a bloody Cloud &c   Abel kneels on a bloody Cloud &c

---

*VLJ 12 and 15 are in dark ink, except that the insertion 'Ishamael is Mahomet' is in the brown ink of the late revisions on p. 77.*
*PA 44 is in greyish ink (here shown by italics). The reference of 'two leaves forward' is to p. 80, q.v.*

together by the feet they represent those who perishd by the flood beneath them

a multitude of their associates are seen falling headlong by the side of them

is a Mighty fiend with a Book in his hand which is Shut he represents the

person namd in Isaiah XXII. c & $\frac{2}{v}0.\frac{v}{0}$. Eliakim the son of Hilkiah he

drags Satan down headlong he is crownd with oak & ~~has~~ by the side

of the Scaled figure representing Og King of Bashan is a Figure with a Basket

he is Araunah the Jebusite master of the

emptiing out the vanities of Riches & Worldly Honours ∧above him are two

elevated on a Cloud

figures ∧representing the Pharisees who plead their own Righteousness before the

throne. they are weighed down by two fiends Beneath the Man with the Basket

are three fiery fiends with grey beards & scourges of fire they represent Cruel

Laws they scourge a groupe

of figures down into the Deeps

beneath them are various

figures in attitudes of

contention representing various

States of Misery which alas

every one on Earth is liable

to enter into & against which

we should all watch

   The Earth beneath these falling

The Ladies will be pleasd to
see that I have represented
the Furies by Three Men &
not by three Women It is not
because I think the Ancients
wrong but they will be pleasd
to remember that mine is
Vision & not Fable
The Spectator may suppose them
Clergymen in the Pulpit Scourging
Sin instead of Forgiving it

Groupes of figures is rocky & burning and seems as if convulsd by Earthquakes a

on fire *the Armies are fleeing upon the Mountains*

Great City is seen in the Distance ∧On the foreground hell is opened & many figures

*where Sin* $\frac{\&}{9}$ *Death* $\frac{are}{10}$ *to be closed Eternally*

are descending <u>into</u> it down stone steps & beside a Gate beneath a rock ∧howling

*by that Fiend who carries the Key* ~~& drags~~ *in one hand & drags them down with the <u>other</u>*

~~& lamenting~~ $\frac{O}{o}$n the rock & above the Gate a fiend with wings ~~dr~~ urges ~~them~~

the wicked

 ∧onwards with fiery darts

is Hazael the Syrian

he ~~represents the Assyrian~~

who drives abroad all those

beneath the steps Babylon

who rebell against their Saviour

represented by a King crowned

Grasping his Sword & his Sceptre he is just awakend out of his $\frac{G}{g}$rave ar<u>ou</u>nd him

are other Kingdoms arising to Judgment represented in this Picture ~~as in The~~

~~Prophets~~ as Single Personages according to the descri<u>p</u>tions in the Prophets The

Figure dragging up a Woman by her hair represents the Inquisition as do those contending

*threshing floor* represents a Cruel Church two Women Strangling the Man in Particular the Pit & on the sides of the Pit & in Particular the Man Strangling two Women represents a Cruel Church

The *VLJ* passages were written and revised in dark ink, in the order 16, 18, 17, then additionally revised in brown ink (here shown by italics).

[N77 transcript]

a
b

c

Pencil drawings: (a) Emblem 50 (retouched with ink; glue spots): the infant huddled in the birdcage of 23a now free of the cage, naked, flying with his hands (where the bird was), and less like an infant than like the Puckish 'evil spirit' of Fuseli's painting *The Friar's Lanthorn* (Milton Gallery, No. 31); Schiff, Pl. 51, related to *PL* IX, 634ff.); (b) head of a youth with long neck, as if looking out from behind the emblem (see tracing, Fig. 25, Appendix II); (c) insouciant infant, not flat on his back as the ones in *America* 9 and *Europe* 6. (Knife cuts above and below the infant represent someone's abandoned attempt to remove the drawing.)

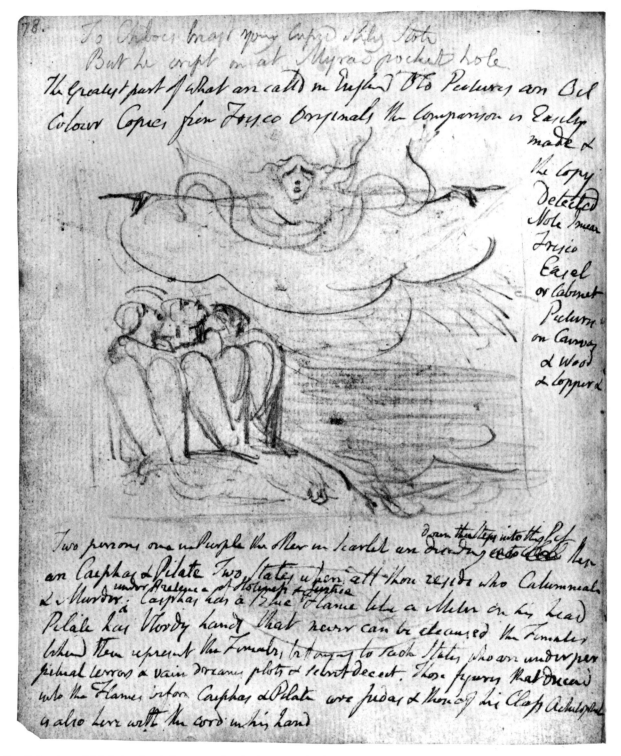

78.

To Chloes breast young Cupid slily stole
But he crept in at Myras pocket hole

The Greatest part of what are called in England Old Pictures are Bad
Colour Copies from Fresco Originals the Comparison is Easily
made &
the Copy
Detected
Note here
Fresco
Easel
or Cabinet
Picture
on Canvas
& Wood
& Copper &

Two persons one in Purple the other in scarlet are drawing down the steps into the Pit these
are Caiphas & Pilate Two States where att those reside who Calumniate
& Murder under Pretence of Holyness & Justice Caiphas has a Blue Flame like a Miter on his head
Pilate has bloody hands that never can be cleansed the Females
behind them represent the Females in torrony to such States who are under perpetual terrors & vain dreams plots & secret deceit. those figures that Descend
into the Flames before Caiphas & Pilate were Judas & those of his Class Achitophel
is also here with the cord in his hand

Pencil drawings: (a) full-size sketch, in reverse, for the *finis* page (8) of *VDA;* two of three Daughters of Albion look up at Oothoon soaring in her flame-scroll and cloud (see discussion at 74f); (b) light pencil tracing (not necessarily by Blake) of the infant of 77c, and some knife cuts coming through the paper.

a

b

[N78]

**Poem 75**

*To Chloes breast young Cupid slily stole*

*But he crept in at Myras pocket hole*

**PA 45**
The Greatest part of what are calld in England Old Pictures are Oil

Colour Copies from Fresco Originals the Comparison is Easily

made &

the Copy

Detected

Note I mean

Fresco

Easel

or Cabinet

Pictures

on Canvas

& Wood

& Copper &c

**VLJ 19**

Two persons one in Purple the other in Scarlet are descending down the Steps into the Pit ~~into Hell~~ these

are Caiphas & Pilate Two States where all those reside who Calumniate

under Pretence of Holiness & Justice

& Murder. ∧ Caiphas has a Blue Flame like a Miter on his head

Pilate has bloody hands that never can be cleansed the Females

behind them represent the Females belonging to such States who are under per

petual terrors & vain dreams plots & secret deceit.  Those figures that descend

into the Flames before Caiphas & Pilate are Judas & those of his Class Achitophel

is also here with the cord in his hand

Poem 75 is in pencil (italics here).  *VLJ* 19 is in the dark ink of *VLJ* passages on p. 77; *PA* 45 is in the brown ink of the revisions of *VLJ* on that page: evidently to Blake these were not two distinct essays.

[N78 transcript]

Now
~~When~~ Art  has  lost  its  mental  Charms

France  shall  subdue  the  World  in  Arms

So  spoke  an  Angel  at  my  birth

Then  said  Descend  thou  upon  Earth

Renew  the  Arts  on  Britains  Shore

And  France  shall  fall  down  &  adore

With  works  of  Art  their  Armies  meet

        War
And  ~~Armies~~  shall  sink  beneath  thy  feet

But  if  thy  Nation  Arts  refuse

And  if  they  scorn  the  immortal  Muse

France  shall  the  arts  of  Peace  restore

      thee           the Ungrateful
And  save  ~~thy  works~~  from  ~~Britains~~  shore

Spirit  who  lovst  Brittannias  ~~Shore~~  Isle

Round  which  the  Fiends  of  Commerce  ~~roar~~  smile

*Nail his neck to the Cross nail it with a nail*

*Nail his neck to the Cross ye all have power over his tail*

---

      ~~18~~  12

    In Eternity one Thing never Changes into another Thing Each Identity $\frac{is}{\&}$ Eternal
consequently Apuleius's Golden Ass & Ovids Metamorphoses & others of the like kind are
Fable yet they contain Vision in a Sublime degree being derived from real Vision
in More Ancient Writings  Lots $\frac{W}{w}$ife being Changed into Pillar of Salt alludes to the
Mortal Body being renderd a Permanent Statue but not Changed or Transformed
into Another Identity while it retains its own Individuality.  A Man can never
become Ass nor Horse some are born with shapes of Men who may be both but
Eternal Identity is one thing & Corporeal Vegetation is another thing Changing
Water into Wine by Jesus & into Blood by Moses relates to Vegetable Nature also

All in dark ink.

Now Art has lost its mental Charms

France shall subdue the World in Arms

So spoke an Angel at my birth

Then said Descend thou upon Earth

Renew the Arts on Britains Shore

And France shall fall down & adore

With works of Art their Armies meet

And War shall sink beneath thy feet

But if thy Nation Arts refuse

And if they scorn the immortal Muse

France shall the arts of Peace restore

And save thee from Ungrateful ~~~~~

Spirit who lovst Brittanias Isle

Round which the Fiends of Commerce smile

In Eternity one Thing never Changes into another Thing Each Identity is Eternal consequently Apuleiuss Golden Ass & Ovids Metamorphosis & others of the like kind are Fable yet they Contain Vision in a Sublime degree being derived from real Vision in More Ancient Writings Lots Wife being Changed into Pillar of Salt alludes to the Mortal Body being rendered a Permanent Statue but not Changed or Transformed into Another Identity while it retains its own Individuality. A Man can never become Ass nor Horse some are born with shapes of Men who may be both but Eternal Identity is one thing & Corporeal Vegetation is another thing being any that Water into Wine by Jesus & into Blood by Moses relates to Vegetable Nature also

(a) Emblem 51: erased and written over (and obscured in the photograph by lines showing through from p. 80, but see tracing, Fig. 8, Appendix II), a bedside or deathbed (perhaps a bier) with two adults and two or three children standing at the foot of the bed. Perhaps a coffin alongside.

Between the Figures of Adam & Eve appears a fiery Gulph descending from the Sea of fire Before the Throne in this Cataract Four Angels descend headlong with four trumpets to awake the dead. beneath these is the Seat of the Harlot named Mystery in the Revelations. She is Seized by Two Beings each with three heads they Represent Vegetative Existence. as it is written in Revelations they Strip her naked & burn her with fire . it represents the Eternal Consummation of Vegetable Life & Death with its Lusts. The writing...

Beneath her feet is a flaming...
Her Kings & Counsellors & Warriors Descend in flames Lamenting & looking upon her in Astonishment & Terror. & Hell is opend beneath her Seat on the Left hand

The Great Red Dragon with Seven heads & ten Horns . he has Adam...who have been compelld to Subdue...is bound in chains by Two Strong demons they are Gog & Magog. The Graves beneath are opend & the dead awake & obey the call of the Trumpet those on the Right hand awake in joy those on the Left in Terror. beneath the Dragons Cavern a Skeleton begins to Animate Starting into life at the Trumpets Sound while the Wicked contend beneath...

(a) Pencil drawing, developed from 16f, for Jerusalem and her three children, as in *J* 46[32]. Her knees and feet indicate a front view, but Blake's method of sketching in the spine as axis is confusing. The objects at the right are 'ruins of the Temple' (we may conclude from the preceding text, *J* 45:41); in the final picture one of the daughters is flying up and a Gothic church replaces the ruins. The drawing was on the page before the prose, i.e. before 1810.

[N80]

Between the Figures of Adam & Eve appears a fiery Gulph descending from the sea of fire $\frac{B}{f}$efore the throne in this Cataract Four Angels descend headlong with four trumpets to awake the Dead. beneath these is the Seat of the Harlot ⌃namd Mystery in the Revelations. She is ~~bound~~ siezed by Two Beings each with three heads ~~representing~~ they Represent Vegetative Existence.^as it is written in Revelations they strip her naked & burn her with fire. ⌃it represents the Eternal Consummation of Vegetable Life & Death with its Lusts The wreathed beneath her feet is a flaming Cavern in which is seen

Her Kings & Councellors & Warriors descend
In Flames Lamenting & looking upon her
in astonishment & Terror. & Hell is
opend beneath her Seat on the
Left hand

*[rotated / marginal text, left side, reading upward]*
Abel kneels on a bloody cloud descriptive of those Churches before the flood that they were filld with blood & fire & vapour of smoke even till Abrahams time the vapor & heat was not extinguishd these States Exist now Man Passes on but States remain for Ever he passes thro them like a traveller who may as well suppose that the places he has passed thro exist no more as a Man may suppose that the States he has passd thro Exist

*[diagonal text]*
no more Every Thing is Eternal

*[rotated text, right side, reading upward]*
Torches in their hands represents Eternal Fire which is the fire of Generation or Vegetation it is an Eternal Consummation Those who are blessed with Imaginative Vision see This Eternal Female & tremble at what others fear not while they laugh at what others fear

*[rotated text]*
Accusations lying on the Rock open before him

the Great Red Dragon with Seven heads & ten ⌃he has Satans book of Horns ~~who~~ he is bound in chains by Two Strong Demons they are Gog & Magog. ⌃who have been compelld to subdue their Master Ezekiel The Graves beneath are opend & the Dead awake & obey the call of the Trumpet those on the Right hand awake in joy those on the Left in Horror. beneath the Dragons Cavern a Skeleton $\frac{b}{g}$egins to Animate starting into life at the Trumpets sound while the Wicked contend with each other on the brink of *[inverted text]* their Hammer & Tongs about to new Create the Seven Headed Kingdoms

*[rotated, right margin]* XXXXVIII c 8v with

All the writing is in dark ink. *VLJ 13* is picked up on p. 76 as 'to come in'; thus it was written as an addition to *VLJ* on that page but put here as the nearest open space.

[N80 transcript]

on the Right     the Aged Woman is Brittanica the Wife of Albion Jerusalem is their Daughter

perdition. ^ a Youthful couple are awakd by their Children an Aged

Patriarch of the Atlantic Continent

He is Albion our Ancestor whose History Preceded that of the Hebrews

patriarch is awakd by his aged wife little Infants creep out of the $\frac{ground}{mould}$

flowery mould into the Green fields of the blessed who in various joyful

companies embrace & ascend to meet Eternity

The Persons who ascend to Meet the Lord coming in the Clouds with power

& great Glory. are representations of those States described in the Bible under

the Names of the Fathers before & after the Flood Noah is seen in the Midst

of these Canopied by a Rainbow. on his right hand Shem & on his Left

Japhet these three Persons represent Poetry Painting & Music the three

in Man

Powers ^ of conversing with Paradise which the Flood did not Sweep away

| | |
|---|---|
| Above Noah is the Church | The Aged Figure with Wings |
| Universal represented by a | having a writing tablet & |
| Woman Surrounded by Infants | taking account of the numbers |
| There is such a State in Eternity | who arise is That Angel |
| it is composed of the Innocent | of the Divine Presence men |
| civilized | tiond in Exodus XIVc 19v |
| Heathen & the Uncivilized | & in other Places this Angel |
| Savage who having not the | is frequently calld by the |
| Law do by Nature the things | Name of Jehovah Elohim |
| containd in the Law. This | The I am of the Oaks of |
| State appears like a Female | Albion |
| crownd with Stars driven | |

into the Wilderness She has the Moon under her feet

among

Around Noah & beneath him are various figures Risen into the Air these are Three

19 32 ^

Females representing those who are not of the dead but of those found Alive at the

being

Last Judgment they appear to be innocently gay & thoughtless not among the Condemnd

the Virgin Mary was of this Class

because ignorant of crime in the midst of a corrupted Age. ^ A Mother Meets her

numerous

Family in the Arms of their Father these are representations of the Greek Learned

& Wise as also of those of other Nations such as Egypt & Babylon in which were multitudes

who shall meet the Lord coming in the Clouds

The Children of Abraham or Hebrew Church are represented as a Stream of

Figures

~~Light~~ on which are seen Stars somewhat like the Milky way they ascend from the

Earth where Figures kneel Embracing above the Graves & Represent Religion or Civil

ized Life such as it is in the Christian Church who are the Offspring of the Hebrew

All in dark ink.

or Chaos

& in whose Sleep Creation began, his ~~Emanation or Wife is Jerusalem~~ at their head

^

who is about to be recievd like the Bride of the

Emblem 52

[N81 transcript]

perdition. a youthful couple are awaked ... the ... an ... patriarch is awaked by his aged wife ... little Infants creep out of the flowery mould into the green fields of the blessed who in various joyful companies embrace & ascend to meet Eternity

The Persons who ascend to Meet the Lord coming in the Clouds with power & great Glory. are representations of those States described in the Bible under the Names of the Fathers before & after the Flood Noah is seen in the Midst of these Canopied by a Rainbow. on his right hand Shem & on his Left Japhet these three Persons represent Poetry Painting & Music the three Powers in Man of conversing with Paradise which the flood did not sweep away

Above Noah is the Church Universal represented by a Woman Surrounded by Infants There is Such a State in Eternity it is composed of the Innocent civilized Heathen & the Uncultivated Savage who having not the Law by Nature the things Containd in the Law. This State appears like a Female crownd with Stars driven into the Wilderness She has the Moon under her feet

The Aged Figure with Wings having a writing tablet & taking account of the number who arise is That Angel of the Divine Presence mentiond in Exodus XIVc 19v & in other Places this Angel is frequently called by the Name of Jehovah Elohim The I am of the Oaks of Albion

Around Noah & beneath him are various figures Risen into the Air among these are Three Females representing those who are not of the dead but of those found alive at the Last Judgment they appear to be innocently gay & thoughtless not being among the Condemnd because ignorant of crime in the midst of a corrupted Age the Virgin Mary was of this Class A Mother Meets her numerous Family in the Arms of their Father these are representations of the Greek Learned & Wise as also of those of other Nations such as Egypt & Babylon or which were multitudes who shall meet the Lord coming in the Clouds

The Children of Abraham or Hebrew Church are represented as a Stream of Figures in which are seen Stars somewhat like the Milky way they ascend from the Earth where Figures kneel Embracing about the Graves & Represent Religion or Civilized Life such as it is in the Christian Church who are the Offspring of the Hebrew

(a) Emblem 52: conjuror atop rain clouds, used as the figure at the top of the rainbow in the title-page of *VDA*. The conjuror in the Arlington Court painting is more comfortably seated and does not cross his legs, but there are similarities not only of hands but of hair and of tension in the legs. (See separate drawing, *The Evil Demon*, Fig. 31, Appendix II.)

Just above the grave & above the spot where the Infants creep out of the Green
Stand two a Man & Woman these are the Primitive Christians The two Figures
pressing in flames by the Side of the Dragons cavern represents the Latter State of the Church
when on the verge of Perdition yet protected by a flaming sword. Multitudes
are seen ascending from the Green fields of the blessed in which a Gothic Church
is representative of true Art Called Gothic in All Ages by those who follow the Fashion

Also On the right hand of Noah A Female descends to meet her Lover or Husband
representative of that Love called Friendship which Looks for no other Heaven than their
Beloved & in him sees all reflected as in a Glass of Eternal Diamond

On the right hand of these rise the Diffident & Humble & on their left a solitary woman
with her infant these are caught up by three aged Men who appear as suddenly
emerging from the blue Sky for their help. These three Aged Men represent Divine
Providence as opposd to & distinct from divine vengeance represented by three Aged
men on the side of the Picture among the Wicked with scourges of fire

If the Spectator could Enter into these Images in his Imagination
approaching them on the Fiery Chariot of his Contemplative Thought if
he could Enter into Noahs Rainbow    or into his bosom or
could make a Friend & Companion    By the right hand of Noah
of one of these Images of wonder    a Woman with Children rep-
which always intreats him    resents the State Called Laban
to leave mortal things as he    the Syrian it is the Remains
must know then would he    of Civilization in the State
arise from his Grave then would    from thence Abraham
he meet the Lord in the Air    was taken

& then he would be happy  General Knowledge is Remote Knowledge it
is in Particulars that Wisdom consists & Happiness too. Both in Art & in
Life General Masses are as Much Art as a Pasteboard Man is Human
Every Man has Eyes Nose & Mouth this Every Idiot knows but he who
enters into & Discriminates most minutely the Manners & Intentions

Just above the graves & above the spot where the Infants creep out of the Ground

Stand two a Man & Woman these are the Primitive Christians. The two Figures

in <sub>purifying</sub> flames by the side of the Dragons cavern represents the Latter state of the Church

when on the verge of Perdition yet protected by a Flaming Sword. Multitudes

are seen ascending from the Green fields of the blessed in which a Gothic Church

is representative of true Art Calld Gothic in All Ages *by those who follow <sup>the</sup> Fashion*

*Also* On the right hand of Noah A Female descends to meet her Lover or Husband

representative of that Love calld Friendship which Looks for no other heaven than their

Beloved & in him sees all reflected as in a Glass of Eternal Diamond

On the right hand of these rise the Diffident & Humble & on their left a <sub>solitary</sub> Woman

with her infant these are caught up by three aged Men who appear as suddenly

emerging from the blue sky for their help. These three Aged Men represent Divine

Providence as opposd to & distinct from Divine vengeance represented by three Aged

men on the side of the Picture among the Wicked with scourges of fire

If the Spectator could Enter into these Images in his Imagination

approaching them on the Fiery Chariot of his Contemplative Thought if

he could Enter into Noahs Rainbow or into his bosom or

could make a Friend & Companion

of one of these Images of wonder

which always intreats him

to leave mortal things as he

must know then would he

arise from his Grave then would

he meet the Lord in the Air

*$\frac{By}{On}$ the right hand of Noah*
*a Woman with Children $\frac{rep}{ap}$*
*resents the State Calld Laban*
*the Syrian it is the Remains*
*of Civilization in the State*
*from whence Abraham*
*was taken*

& then he would be happy   General Knowledge is Remote Knowledge it

is in Particulars that Wisdom consists & Happiness too. Both in Art & in

Life General Masses are as Much Art as a Pasteboard Man is Human

Every Man has Eyes Nose & Mouth this Every Idiot knows $\frac{b}{w}$ut he who

enters into & discriminates most minutely the Manners & Intentions

*as that is calld which is without Shape or Fashion*

The text is in dark ink, with insertions in darker and wetter ink, plus some insertions in greyer ink (here in italics).

[N82 transcript]

the ~~Expression~~ Characters in all their branches is the alone Wise or Sensible
Man & on this discrimination All Art is founded.  I intreat then that the
Spectator will attend to the Hands & Feet to the Lineaments of the Countenances
they are all descriptive of Character & not a line is drawn without intention
& that most discriminate & particular <sup>as Poetry admits not a Letter that is Insignificant</sup>
so Painting admits not a Grain of Sand or a Blade

Above the Head of Noah is Seth this State calld Seth
is Male & Female in a higher state of Happiness & wisdom than
Noah being nearer the State of Innocence beneath the feet of Seth two
figures represent the two Seasons of Spring & Autumn. while
beneath the feet of Noah Four Seasons represent ~~our present changes~~
~~of Extremes~~   the Changed State made by the flood. t

By the side of Seth is Elijah he comprehends all the Prophetic

<div style="display:flex">

Characters he is seen
bowing before the throne of
The figures of Seth & his wife
the flood & their Generations
as One Man. a little below
Figures a Male & Female with
represent those who were not in

on his fiery Chariot
the Saviour. in like manner
Comprehends the Fathers before
when seen remote they appear
Seth on his right are Two
numerous Children these
the Line of the Church & yet

</div>

were Saved from among the Antediluvians who Perished. bet$\frac{wee}{37}$n Seth & these
a female figure ~~with the back turnd~~ represents the Solit$\frac{ary}{49}$ State of those
who previous to the Fl<u>ood walked with God</u>
~~*Sweet rose fair flower untimely pluckd soon faded*~~

All these <u>arise toward the opening Cloud before</u> the Throne led
~~*Pluckd in the bud & faded in the Spring*~~
& the Morning Stars sang together
onward by triumphant Groupes of Infants. ∧ Between $\frac{Seth\ \&\ Eli}{Shakespeare}$jah three
Female Figures crownd with Garlands Represent Learning & Science which
accompanied Adam out of Eden

The Cloud that opens rolling apart before the throne & before the
New Heaven & the New Earth is Composed of Various Groupes of Figures
particularly the Four Living Creatures mentiond in Revelations as Surrounding
the Throne   these I suppose to have the chief agency in removing the ~~former~~

The dark ink of p. 82 continues, with one insertion in wetter ink beginning in line 5 and running into the right margin.

the Characters in all their branches is the above Wise or Sensible Man & on this discrimination All Art is founded. I intreat then that the Spectator will attend to the Hands & Feet to the Lineaments of the Countenances they are all descriptive of Character & not a line is drawn without intention & that most discriminate & particular as Poetry admits not a Letter that is Insignificant so Painting admits not a Grain of Sand or a Blade

Above the Head of Noah is Seth this State called Seth is Male & Female on a higher State of Happiness & wisdom than Noah being nearer the State of Innocence beneath the feet of Seth two figures represent the two Seasons of Spring & Autumn. While beneath the feet of Noah Four Seasons represent the Changed State made by the flood.

By the side of Seth is Elijah he comprehends all the Prophetic Characters he is seen on his fiery Chariot bowing before the throne of the Saviour. in the same manner the figures of Seth & his wife Comprehends the Fathers before the flood & their Generations when seen remote they appear as One Man. a little below Seth on his right are Two figures a Male & Female with numerous Children these represent those who were not in the Line of the Church & yet were Saved from among the Antediluvians who Perished. between Seth & these a female figure represents the Solitary State of those who previous to the Flood walked with God

All these arise toward the opening Cloud before the Throne led onward by triumphant Groupes of Infants. Between Seth & Elijah three Female Figures crownd with Garlands represent Learning & Science which accompanied Adam out of Eden

The Cloud that opens rolling apart before the throne & before the New Heaven & the New Earth is composed of Various Groupes of Figures particularly the Four Living Creatures mentioned in Revelations as Surrounding the throne these I suppose to have the chief agency in removing the

(a) Emblem 53: another view of a mother with an infant 'untimely pluckd'; compare 73d. That mother held the child as though still alive, this mother's gesture dramatizes separation; her throne-like chair (the Gothic back may be ironic) and her dress suggest the elegance of the bead-wearing woman in *Europe* 6, beside an infant similarly outstretched. Glue spots.

[N83]

old Heavens & the old Earth to make way for the New Heaven & the New Earth to descend from the throne of God & of the Lamb. that Living Creature on the Left of the Throne Gives to the Seven Angels the Seven Vials of the wrath of God with which they hovering over the Deeps beneath pour out upon the wicked their Plagues the Other Living Creatures are directing with a Sword & with the sound of the Trumpet & with directing the Combats in the upper Elements ... Apollyon on the Left has ... is forced before the Sword of Michael & on the Right the Two Witnesses are ... their Enemies ... is Opened On the Cloud are open the Books of Remembrance of Life & of Death before that of Life ... that of Death the Pharisees ... bow in humiliation before the one ... with beams of Light pleading their own Righteousness tempests the other ... Lightnings & ... because Fools flourish under wise Rulers & are ... under Foolish Rulers it is the same with Individuals in Nature works of Art can only be produced in Perfection where the ... is either in Affluence or is Above the Law of it Poverty is the ... which at laid is laid on in our back ...

Around the Throne Heaven is open & the Nature of Eternal things Displayd All Springing from the Divine Humanity All beams from him ... as he himself has said All dwells in him He is the Bread & the Wine he is the Water of Life accordingly on Each Side of the opening Heaven appears an Apostle ... Represents Baptism ... the Lords Supper All Life consists of these Two Throwing off Error Continually & recieving Truth Continually he who is out of the Church & opposes it is no less an Agent of Religion than he who is in it. to be an Error & to be Cast out is a part of Gods Design No man can Embrace True Art till he has explord & Cast out False Art ... or he will be himself Cast out by those who have already Embraced True Art Thus My Picture is a History of Art & Science ... Which is Humanity itself What are all the Gifts of the Spirit but Mental Gifts whenever any Individual Rejects Error & Embraces Truth a Last Judgment passes upon that Individual

(a) Emblem 54, unnumbered:  a thin moon (not certainly waning or waxing) in an opening of clouds; one cloaked and one trousered figure (holding a stick or weapon) regard—or walk past—a prone figure.  The drawing scarcely indicates whether these are Good Samaritans or highwaymen.

would not have done so well if he had been properly patr Encouraged Let those who think who think so reflect

on the State of Nations under Poverty & their incapability of Art. tho Art is Above Either the Argument is better for Affluence than Poverty

Some People & not a few Artists have asserted that the Painter of this Picture

old heavens & the old Earth to make way for the New Heaven & the New

Earth to descend from the throne of God & of the Lamb. that Living Creature

on the Left of the Throne Gives to the Seven Angels the Seven Vials of the
with
wrath of God which they hovering over the Deeps beneath pour out upon

the wicked their Plagues the Other Living Creatures are descending with a Shout

& with the Sound of the Trumpet & with Directing the Combats in the upper
in the two Corners of the Picture                    Apollyon
Elements where dddddddddd Apollyon on the Left hand is foiled before the
                                                              are
Sword of Michael & on the Right the Two Witnesses subduing their Enemies

Around the Throne Heaven is Opened On the Cloud are opend the
                                                              on the Right
Books of Remembrance of Life & of Death before that of Life some figures fow
                                                              on the left
bow in humiliation before                    that of Death the Pharisees are

pleading their own Righteousness          the one shines with beams of Light

the other utters Lightnings &          tempests
    A Last Judgment is Neces          sary because Fools flourish
    Nations Flourish                  under Wise Rulers & are depressd

under foolish Rulers it is the          same with Individuals as Nations

works of Art can only be          producd in Perfection where the Man

is either in Affluence or is          Above the Care of it Poverty is

the Fools $\frac{R}{r}$od which at          last is turnd on his own back this
                                          is A Last Judgment when

**Emblem 54**
**VLJ 27**

Around the Throne Heaven is opend & the Nature of Eternal Things
                                                              Because
Displayd All Springing from the Divine Humanity All beams from him &

as he himself has said All dwells in him He is the Bread & the Wine he is the

Water of Life accordingly on Each Side of the opening Heaven appears an Apostle
that on the Right                    that on the Left Represents
one Represents Baptism & the Other the Lords Supper All Life consists of these Two
        & Knaves from our company                    or Wise Men into our Company
Throwing off Error continually & Recieving Truth Continually he who is out of

the Church & opposes it is no less an Agent of Religion than he who is in it. to be an

Error & to be Cast out is a part of Gods Design No man can Embrace True Art
                            such is the Nature of Mortal Things
till he has Explord & Cast out False Art or he will be himself Cast out by those

who have Already Embraced True Art Thus My Picture is a History of Art
        the Foundation of Society
& Science & its Which is Humanity itself. What are All the Gifts of the Spirit

but Mental Gifts Whenever any Individual Rejects Error & Embraces Truth

a Last Judgment passes upon that Individual

& tho he would not have been a greater Artist yet he would have producd Greater works of Art in proportion to

Men of Real Art Govern & Pretenders Fall

The *VLJ* text was written, in dark ink, straight down the page, with some false starts and mendings, and all the marginal additions were made in the same ink—except one, in greyer ink (here italics). The line at the bottom continues on the bottom of p. 85.

Over the Head of the Saviour & Redeemer The Holy Spirit like a Dove is
surrounded by a blue Heaven in which are the two Cherubim that bowd over the
Ark for here the temple is opend in Heaven & the Ark of the Covenant is as a Dove of Peace
The Curtains are drawn apart Christ having rent the Veil   The Candlestick & the Table
of Shew bread appear on Each side a Glorification of Angels with Harps surroud the Dove

The Temple stands on the Mount of God from it flows on each side $\frac{the}{of}$
River of Life on whose banks Grows the tree of Life among whose branches temples
& Pinnacles tents & pavilions Gardens & Groves Display Paradise with its

Inhabitants walking up                                     & down in Conversations

concerning Mental Delights                                Here they are &ᶜ as three
                                                                         leaves on
Jesus is                                                   surrounded by Beams of   **VLJ 31**

Glory in which are seen                                   all around him Infants

emanating from him—                                       these represent the Eternal

Births of Intellect from                                  the Divine Humanity

A Rainbow surrounds                                       the throne & the Glory

in which youthful                                         Nuptials recieve the
                                                          In Eternity Woman is the Emanation
infants in their hands                                    of Man she has No Will of her own
                                                              There is no such thing in Eternity
On the Side next                                          Baptism are seen those

calld in the Bible Nursing                                Fathers & Nursing Mothers
they have Crowns the Spectator may                        suppose them to be the good Kings
they represent Education                                $\frac{2}{1}$ On the Side next the   **Emblem 55**

Lords Supper. The          *Whose changeless brow*   2̶0̶   Holy Family consisting

of Mary Joseph John        *Neer smiles nor frowns*       the Baptist Zacharias
                                        *Donne*
& Elizabeth recieving the               *2*               Bread & Wine among
              the
other Spirits of Just made perfect.   J̶u̶s̶t̶ beneath these a Cloud of Women & Children
are taken up fleeing from the rolling Cloud which separates the Wicked from
the Seats of Bliss. These represent those who tho willing were too weak to Reject
Error without the Assistance & Countenance of those Already in the Truth
for a Man Can only Reject Error by the Advice of a Friend or by the Immediate
Inspiration of God it is for this Reason among many others that I have put
the Lords Supper on the Left hand of the P̶i̶c̶t̶u̶r̶e̶ Throne for it appears so
at the Last Judgment for a Protection
his means A Last Judgment is not for the purpose of making Bad Men better but for the Purpose of hindering them   **VLJ 26**

(right margin, rotated: *as a Female Will & Queens of England*)

(bottom, inverted: from opressing the Good with Poverty & Pain by means of Such Vile Arguments & Insinuations)

All the *VLJ* text is in dark ink.  The bottom line continues from p. 84.  (For *VLJ* 29, see p. 90.)

(a) Emblem 55: a man with 'changeless brow' responding impassively (and impotently? his hands, legs and waist are chained and strapped to a rock) to a changeless fate. Related to a larger drawing of *Fate* (Fig. 30, Appendix II), and to *NT* 473. Compare the description in Blake's *French Revolution,* lines 43-5, of the 'strong man' who sits 'in the den nam'd Destiny' in the Bastille: 'His feet and hands cut off, and his eyes blinded; round his middle a chain and a band / Fasten'd into the wall . . .'.

[N85]

The Painter hopes that his Friends Anytus & Melitus & Lycon
that they are not now in Ancient Greece & tho they can use the Poyson
of Calumny the English Public will be convinc'd that such a Picture
as this Could never be Painted by a Madman or by one in a State
of Outrageous manners as these Bad Men both Print & Publish by all
the means in their Power. the Painter begs Public Protection & all will
be well

The Combats of Good & Evil is Eating of the Tree of Knowledge The Combats of Truth & Error is
these are not only Universal but Particular. Each are
Personified There is not an Error but it has a Man for its
Agent that is it is a Man. There is not a Truth but

Good & Evil are Qualities in Every Man whether Good or Evil Man
it has also a Man there are menaces & destroy one another by
every Means in their power both of deceit & of open Violence The
Deist & the Christian are but the Results of these Opposing Natures
Many are Deists who would in certain Circumstances have been
Christians in outward appearance Voltaire was one of this number
he was as intolerant as an Inquisitor Manners make the
Man not Habits. It is the same in Art by Rev Works &c

(a) Pencil drawing: three women holding and examining small objects (not clearly drawn). Approached from the front of the Notebook, this is the first of a series of large illustrations of *Macbeth* and *PL*. These may be the three witches examining 'the ingredients' for their cauldron (*Macbeth*, IV.1)—the subject of Blake's *Hecate* of *c.* 1795, where Hecate is studying the recipe book. Shakespeare has three witches plus Hecate, but Blake makes Hecate one of three; she could be the commanding figure on the right.

[N86]

**PA 46**  The Painter hopes that his Friends Anytus & Melitus & Lycon ⌃will percieve

that they are not now in Ancient Greece & tho they can use the Poison

of Calumny the English Public will be convincd that such a Picture

as this Could never be Painted by a Madman or by one in a State

of Outrageous manners as these ~~Villains~~ Bad Men both Print & Publish by all

the means in their Power. the Painter begs Public Protection & all will

be well

**VLJ 36**  The Combats of Good & Evil ⌃& of Truth & Error which are the  is Eating of the Tree of Knowledge The Combats of Truth & Error is

~~same thing~~ these are not only Universal but Particular.   Each are

Personified There is not an Error but it has a Man for its

~~Actor~~ Agent that is it is a Man.     There is not a Truth but

*Eating of the Tree of Life*

Good & Evil are Qualities in Every Man whether a Good or Evil Man

it has also a Man ⌃These are Enemies & Destroy one another by

every Means in their power both of deceit & of open Violence The

Deist & the Christian are but the Results of these Opposing Natures

Many are Deists who would in certain Circumstances have been

Christians in outward appearance Voltaire was one of this number

he was as intolerant as an Inquisitor Manners make the

Man not Habits.   It is the same in Art by their Works ye

The text is all in dark ink.  *VLJ* 36 was clearly written after *PA* 46.

[N86 transcript]

The Caverns/Visions of the Grave Ive seen

And these I shewd to Englands Queen

N/Shed now the Caves of Hell I view

Who shall I Dare to shew them to

What/Egr mighty Soul in Beautys form

Shall dauntless/dare to View the Infernal Storm

Egremonts Countess dare can controll

The flames/waves of Hell that round me roll

If she refuse I still go on

Till the Heavens & Earth are gone

Still admird by Noble/worthy minds

Followd by Envy on the winds

Reengravd Time after Time

Ever in their Youthful prime

My Designs unchangd/shall still remain

Time may rage but rage in vain

For above Times troubled Fountains

On the Great Atlantic Mountains

In my Golden House on high

There they Shine Eternally

*Men are admitted into Heaven not because they have curbed & governd their Passions or have No Passions but because they have Cultivated their Understandings. The Treasures of Heaven are not Negations of Passion but Realities of Intellect from which All the Passions Emanate Uncurbed in their Eternal Glory The Fool shall not enter into Heaven let him be ever so Holy. Holiness is not The Price of Enterance into Heaven*

6

*The Modern Church Crucifies Christ with the Head Downwards But*

*Those who are cast out Are All Those who having no Passions of their own because No Intellect. Have spent their lives in Curbing & Governing other Peoples by the Various Arts of Poverty & Cruelty of all kinds Wo Wo Wo Wo Wo to You Hypocrites*

*Even Murder the Courts of Justice more merciful than the Church are compelld to allow is not done in Passion but in Cool Blooded Design & Intention*

Poem 77 is in dark ink, *VLJ* 38 in greyer ink (here italics) and with a finer pen than *VLJ* 36. Poem 77 must have been written in 1808 or earlier, since it was to accompany the painting *Satan calling up his Legions* which is alluded to in *Descriptive Catalogue* 9 as executed (and delivered).

The Sorrows of the Grave Ive seen
And there I heard to Englands Queen
And none the Caves of Hell I drew
Who shall I dare to shew them to
What mighty soul in Beautys form
Shall daunted View the Infernal storm
Egremus Cerentless can controll
The flames of Hell that round me roll
If she refuse I shall on
Till the Heavens & Earth are Gone
Still admird by Noble minds
Followd by Envy on the winds
Reengravd Time after Time
Ever in their Youthful prime
My Designs unchangd remain
Time may rage but rage in vain
For above Times troubled Fountains
On the Great Atlantic Mountains
In my Golden House on high
There they Shine Eternally

a

(a) Emblem 56: a rough sketch of the boy who chases naked females in Emblem 4 (*GP* 7); here his hat is high in the air and he has flung himself forward, but the victim escapes to the left (indicated by mere crossed lines, but see tracing, Fig. 9, Appendix II).

[N87]

South Molton Street

Sunday August ; 1807  My Wife was told by a Spirit
to look for her fortune by opening by chance a book which
she had in her hand it was Bysshes art of Poetry. She
opend the following

I saw 'em kindle with desire
While with soft sighs they blew the fire
Saw the approaches of their joy
He growing more fierce & she less coy
Said how they mingled melting rays
Exchanging love a thousand ways
Kind was the force on every side
Her new desire she could not hide
Nor would the Shepherd be denied
The blessed minute he pursued
Till she transported in his arms
Yields to the Conqueror all her charms
His panting breast to hers now joind
They feast on raptures unconfind
Vast & luxuriant such as prove
The immortality of Love
For who but a Divinity
Could mingle souls to that degree
And melt them into extasy
Now like the Phoenix both expire
While from the ashes of their fire
Spring up a new & soft desire
Like charmers thrice they did invoke
The God & thrice new Vigor took

Behn

I was so well pleased with her luck that I thought I would try
my own & opend the following
As when the winds their airy quarrel try
Justling from every quarter of the sky
This way & that the Mountain oak they bear
His boughs they shatter & his branches tear

(a) Pencil sketch:  Eve tempted by the serpent (*PL* IX, 495-503)(see tracing, Fig. 26, Appendix II); her outstretched hands seem to rejoice at and direct his 'circling spires, that on the grass / Floated redundant'; her right hand is drawn in two positions, one patting the serpent's head.  In Blake's later tempera painting he makes more of Satan's 'rising folds, that towered', and shifts the indication of dominance:  here Eve *seems* in charge, there Satan.

[N88]

**Msc 11**

Sunday August ⸳   1807 My Wife was told by a Spirit

to look for her fortune by opening by chance a book which

she had in her hand it was Bysshes Art of Poetry.   She

opend the following

> I saw 'em kindle with Desire
> While with soft sighs they blew the fire
> Saw the approaches of their joy
> He growing more fierce & she less coy
> Saw how they mingled melting rays
> Exchanging Love a thousand ways
> Kind was the force on every side ⎫
> Her new desire she could not hide ⎬
> Nor would the shepherd be denied ⎭
> The blessed minute he pursud
> Till she transported in his arms
> Yields to the Conqueror all her charms
> His panting breast to hers now joind
> They feast on raptures unconfind
> Vast & luxuriant such as prove
> The immortality of Love
> For who but a Divinity ⎫
> Could mingle souls to that degree ⎬
> And melt them into Extasy ⎭
> Now like the Phoenix both expire ⎫
> While from the ashes of their fire ⎬
> Spring up a new & soft desire ⎭
> Like charmers thrice they did invoke
> The God & thrice new Vigor took

                                        Behn

I was so well pleased with her Luck that I thought I would try

my Own & opend the following

> As when the winds their airy quarrel try
> Justling from every quarter of the Sky
> This way & that the Mountain oak they bear
> His boughs they shatter & his branches tear

Msc 11 is all in dark grey ink, the address at the top with a different pen.  A blank was left for the day of the month.

With leaves & falling mast they spread the Ground
The hollow Valleys Eccho ~~the~~ to the Sound
Unmovd the royal plant their fury mocks
Or shaken clings more closely to the rocks
For as he shoots his lowring head on high
So deep in earth his fixd foundations lie

Drydens Virgil

**Poem 140**

I rose up at the dawn of day
Get thee away get thee away
Prayst thou for Riches away away
This is the Throne of Mammon grey

Said I this sure is very odd
I took it to be the Throne of God
For every Thing besides I have
It is only for Riches that I can crave

I have Mental Joy & Mental Health
And Mental Friends & / Friendship Mental wealth
Ive a Wife I love & that loves me
Ive all But Riches Bodily

*21*

Then If for Riches I must not Pray
God knows I little of Prayers need say
So ~~as sure~~ as a Church is known by its Steeple
If I pray it must be for/of other People
He says if I do not worship him for a God
I shall eat coarser food & go worse shod
So as I dont value such things as these
You must do M^r Devil just as God please

*You may do the worst you can to you / Be assured M^r Devil I / Wont pray to you*

**Emblem 57**

I am in Gods presence night & Day
And he never turns his face away
The accuser of sins by my side does stand
And he holds my money bag in his hand
For ~~all that~~ my worldly things God makes him pay
And hed pay for more if to him I would pray And so

Msc 11 continues in dark grey ink.  Poem 140 is in black ink.

[N89 transcript]

With leaves & falling mast they spread the Ground
The hollow Valleys Echo to the sound
Unmovd the royal plant their fury mocks
Or shaken clings more closely to the rocks
For as he shoots his towring head on high
So deep in earth his fixd foundations lie

Dryden Virgil

Rose up at the dawn of day
Get thee away get thee away
Prayst thou for Riches away away
This is the Throne of Mammon grey

Said I this Sun is very idd
I took it to be the Throne of God
For every Thing besides I have
It is only for Riches that I can crave

Their Mental Joy & Mental Health
And Mental Friends & Mental wealth
For a Wife I love & that loves me
For all But Riches Bodily

Then if for Riches I must not Pray
God knows I little of Prayers need say
So as a Church is known by its Steeple
If I pray it must be for other People
He says if I do not worship him for a God
I shall eat coarser food & go worse shod
So as I dont value such things as these
You must do Mr Devil just as God please

I am in Gods presence night & day
And he never turns his face away
The accuser of sins by my side does stand
And he holds my money bag in his hand
For my worldly things God makes him pay
And Gods does pay for more of he never worth a penny

(a) Emblem 57: details unclear but suggesting the margin scenes of poverty in 'Holy Thursday' (*Songs of Experience*). See tracing, Fig. 10, Appendix II. At top left a large child has fallen backwards on its head, as the child in the bottom margin of the etched pages; under a tree at the right a mother bends over a small child (apparently) somewhat as the mother with two children in the centre margin; the rest is badly erased. (Other lines on the page are rubbed from p. 90 or show through from p. 88.)

90

Shall know them the Knave who is Converted to Deism &
the Knave who is Converted to Christianity is still a Knave
but he himself will not know it tho Every body else
does Christ comes as he came at first to Deliver
those who were bound under the Knave not to deliver
the Knave the comes to Deliver Man the Accused &
not Satan the Accuser we do not find any where
that Satan is Accused of Sin he is only accused
of Unbelief & thereby drawing Man into Sin
that he may accuse him. Such is the Last
Judgment a Deliverance from Satans Accu
sation Satan thinks that Sin is displeasing
to God he ought to know that Nothing
is displeasing to God but Unbelief
& Eating of the Tree of Knowledge
of Good & Evil

For they are no longer talking of what is Good & Evil or of what
is Right or Wrong & puzzling themselves in Satans Maze Labyrinth
But are Conversing with Eternal Realities as they Exist
in The Human Imagination We are in a World of Generation
& Death & this world we must cast off if we would be Painters

(a) Pencil drawing for *PL* I, 192-5: 'Satan . . . / With head uplift above the wave . . . his other parts besides / Prone on the flood'.
At the right is his 'ponderous shield . . . like the moon', which Milton does not mention till lines 284-6. Blake is not known to
have painted this subject. (The sequel is in Emblem 58, next page.) Cf. *NT* 403, with ironies.

[N90]

**VLJ 37**   Shall know them the Knave who is Converted to ~~Christianity~~ <sup>Deism</sup> &

the Knave who is Converted to Christianity is still a Knave

but he himself will not know it tho Every body else

does  Christ comes as he came at first to deliver

those who were bound under the Knave not to deliver

the Knave He Comes to Deliver Man the Accused &

Forgiven

not Satan the Accuser we do not find any where

that Satan is Accused of Sin he is only accused

of Unbelief & thereby drawing Man into Sin

that he may accuse him.  Such is the Last

Judgment a Deliverance from Satans Accu

sation  Satan thinks that Sin is displeasing

to God he ought to know that Nothing

is Displeasing to God but Unbelief

& Eating of the Tree of Knowledge

of Good & Evil

**VLJ 29**   Here they are no longer talking of what is Good & Evil or of what

is Right or Wrong & puzzling themselves in Satans ~~Maze~~ Labyrinth

But <u>are</u> Conversing with Eternal Realities as they Exist

in the Human Imagination We are in a World of Generation

& Death & this world we must cast off if we would be Painters

*VLJ* 37 continues from p. 86 in the same dark ink and broad pen—and is cancelled in the same ink. *VLJ* 29 continues in the same.

[N90 transcript]

Such as Rafal Mich Angelo & the Ancient Sculptors.  if we do not

cast off this world we shall be only Venetian Painters who

will be cast off & Lost from Art

The Greeks represent Chronos or Time as a very Aged Man
this is Fable but the Real Vision of Time is in Eternal Youth
I have somewhat accomodated my Figure of Time to Common
however                                                        the
opinion as I myself am also infected with it & my Visions also
infected & I see Time Aged alas too much so

Allegories are things that Relate to Moral Virtues Moral
Virtues do not Exist they are Allegories & dissimulations
                                          E
But Time & Space are Real Beings a Male & a Female
Time is a Man Space is a Woman & her Masculine Portion
is Death

*Forthwith upright* he rears from off the pool
His mighty stature                          *Milton*          4  6

the Creation
Many Suppose that before ~~Adam~~ All was Solitude & Chaos This is the most
pernicious Idea that can enter the Mind as it takes away all sublimity
from the Bible & Limits All Existence to Creation & to Chaos To the Time
& Space fixed by the Corporeal Vegetative Eye & leaves the Man who entertains
such an Idea the habitation of Unbelieving Demons Eternity Exists and
All things in Eternity Independent of Creation which was an act of Mercy I have

VLJ 30 and 32 are in dark ink; VLJ 34 and 35 are in greyish ink (here italics).

Such as Rafael Michel Angelo & the Ancient Sculptors. if we do not cast off this world we shall be only Venetian Painters who will be cast off & Lost from Art

The Greeks represent Chronos or Time as a very aged Man this is fable but the Real Vision of Time is in Eternal Youth I have somewhat accommodated my Figure of Time to the common opinion as I myself am also infected with it & my Visions also infected & I see Time Aged alas too much so

Allegories are things that Relate to Moral Virtues Moral Virtues do not Exist they are Allegories & dissimulations But Time & Space are Real Beings a Male & a Female Time is a Man Space is a Woman & her Masculine Portion is Death

his mighty Stature

Many Suppose that before the Creation All was Solitude & Chaos This is the most pernicious Idea that can enter the Mind as it takes away all Sublimity from the Bible & Limits All Existence to Creation & to Chaos To the Time & Space fixed by the Corporeal Vegetative Eye & leaves the Man who entertains such an Idea the habitation of Unbelieving Demons Eternity Exists and All things in Eternity Independent of Creation which was an act of Mercy ...

(a) Emblem 58: Satan rearing himself upright with shield and spear (which the glue spot makes look like a torch); used for *GP* 5, where the flower-like division of the flames is less pronounced. Compare Satan's head in 90a.

[N91]

Pencil drawings: (a) a potentially final drawing (developed from 2a, b) of 'tiger' and rescued man in upper window, for Hayley's ballad, 'The Elephant', of 1802; but all but the tiger and the oval outline had to be drastically changed for the engraving; (b) a fairly finished drawing for *VDA* 4 with Oothoon and Theotormon in their final outline and positions, though the shape of the wave-flame would be changed. (Odd that Blake chose this page, ten years later, for the Hayley drawing: did he see Hayley as Theotormon and his own freedom chained like Oothoon's?)

VLJ 33    repre<u>sent</u>ed those who are in Eternity by some in a Cloud within the Rainbow that

Surrounds the Throne ~~they~~ they merely appear as in a Cloud when any thing of

Creation Redemption or Judgment are the Subjects of Contemplation tho their

Whole Contemplation is Concerning these things the Reason they so app<u>ea</u>r is

The Humiliation of<sub>∧</sub> Selfhood & the<sup>the Reasoning & Doubting</sup> Giving all up to Inspiration   By this it will

be seen that I do not consider either the Just or the Wicked to be

in a Supreme State but to be every one of them States of the Sleep

~~of~~ which the Soul may fall into in its Deadly Dreams of Good &

Evil when it leaves Paradise ~~with~~<sup>following</sup> the Serpent

VLJ 39        Many Persons such as Paine & Voltaire<sub>∧</sub> say<sup>some of with the Ancient Greeks</sup> we will not

Converse concerning Good & Evil we will live in Paradise & Liberty

You may do so in Spirit but not in the<sub>∧</sub>Body<sup>Mortal</sup> as you ~~prep~~

pretend till after the Last Judgment for in Paradise they have

no Corporeal<sub>∧</sub>Body<sup>& Mortal</sup> that originated with the Fall & was calld Death

& cannot be removed but by a Last Judgment while we are in the

world of Mortality we Must Suffer   The Whole Creation Groans

to be deliverd there will always be as many Hypocrites born as

Honest Men & they will always have superior Power in Mortal

Things   You cannot have Liberty in this World without<sub>∧</sub>Moral<sup>what you call</sup> Virtue

& you cannot have Moral Virtue without the Slavery of ~~half~~ that

half of the Human Race who hate<sub>∧</sub>Moral<sup>what you call</sup> Virtue

       The Nature of Hatred & Envy & of All the Mischiefs in the World are

here depicted.   No one Envies or Hates one of his Own Party even the devils *in a More perfect Harmony*

love one another in their Way they torment one another for other reasons than *which are Not in harmony with Me & yet are*

Hate or Envy these are only employd against the Just.   Neither can Seth Envy *In harmony — But there may be things*

Msc 5    Noah or Elijah Envy Abraham but they may both of them Envy the Success *Every thing which is in harmony with me I call*

The *VLJ* passages are in dark ink.       Msc 5 is in pencil (here italics).

of Satan or of Og or Molech The Horse never Envies the Peacock nor
*A Woman Scaly & a Man all Hairy*
the Sheep the Goat but they Envy a Rival in Life & Existence whose
*Is such a Match as he who dares*
ways & means exceed their own let him be of what Class of Animals
*Will find the Womans Scales Scrape off* the the *Mans Hairs*
he will a Dog will envy a Cat who is pamperd at ~~his~~ expense of his

comfort as I have often seen  The Bible never tells us that Devils tor

ment one another thro Envy it <sup>thro</sup> is this that ~~makes~~ they torment the Just

but for what do they torment one another I answer For the Coercive

Laws of Hell  Moral Hypocrisy.  They torment a Hypocrite when he

is discoverd they $\frac{P}{p}$unish

tormentor who has suf

his torture to Escape

Self Righteousness there

there as Forgiveness of

Forgive Sin is Crucified

Criminals. & he who

Mercy in Any shape

& if possible destroyd

Hatred or Malice but

that thinks it does God

a Failure in the

ferd the Subject of

In Hell all is

is no such thing

Sin he who does

as an Abettor of

performs Works of

whatever is punishd

not thro Envy or

thro Self Righteousness

service which God

& despise
They do not Envy one another They contemn∧one another
is Satan ∧ Forgiveness of Sin is only at the Judgment <u>Seat</u> of Jesus the
*Rest Rest perturbed Spirit*    3
Saviour where the Accuser is cast out. not because he Sins but because
*Shakespeare* ~~2~~
he torments the Just & makes them do what he condemns as Sin &

what he knows is opposite to their own Identity

It is not because Angels are Holier than Men or Devils that

makes them Angels but because they do not Expect Holiness from one

another but from God only

The Player is a liar when he Says Angels are happier than

Poem 2 is in pencil (italics); *VLJ* 40 is in dark ink.

of Satan or of Og or of Moloch the Horse never envies the Peacock nor
the Sheep the Goat but they envy a Rival in Life & Existence whose
ways & means exceed their own let him be of what Class of Animals
he will a Dog will envy a Cat who is pampered at the expense of his
comfort as I have often seen The Bible never tells us that People tor
ment one another thro Envy it is then that they torment the first
but for what do they torment one another I answer For the Coercive
Laws of Hell Moral Hypocrisy They torment a Hypocrite when he is
... is discovered they punish
tormentor who has suf
his torture to Escape
Self Righteousness there
then as Forgiveness of
Forgive Sin is Crucified
Criminals & he who
Mercy in Any shape
... Destroyd
... Malice but
that thinks & does God
... Satan

a Failure in the
... the Subject of
In Hell all is
is no such thing
Sin he who does
as an Abettor of
... Works of
whatever is punished
not thro envy or
thro Self Righteousness
... Service which God

They do not envy one another They contemn one another

Sorrow when the Accuser is cast out not because he Sins but because
he torments the just & makes them do what he condemns as Sin &
what he knows is opposite to their own Identity

It is not because Angels are Holier than Men or Devils that
makes them Angels but because they do not Expect Holiness from one
another but from God only

The Player is a liar when he says Angels are happier than

(a) Emblem 59: with motto from *Hamlet* suggesting that this 'spirit' is a mole that works in the earth too fast; used for *GP* 3. Glue spots.

(a, b) Emblem 60: wash drawing on top of pencil, repeated in pencil with different proportions; reversal for *GP* 3 makes the anxious tyrant (Ezekiel was reproaching the King of Tyre) seem to be peering ahead. See drawings 98a and 100a, from which this emblem may have evolved.

Men  because  they  are  better   Angels  are  happier  than  Men<sup>& Devils</sup> because

they  are  not  always  Prying  after  Good  &  Evil  in  one  Another  &

eating  the  Tree  of  Knowledge  for  Satans  Gratification

*Thinking  as  I  do  that  the  Creator  of  this  World  is  a*

*very  $\frac{C}{c}$ruel  Being  &  being  a  Worshipper  of  Chri<u>st</u>*

*I  cannot  help  sa<u>y</u>ing  the  Son  O  how  unlike  the  Father*

First  God  Almighty

comes  with  a  Thump

on  the  Head   The<u>n</u>

Jesus  C<u>hr</u>ist  comes

with  a  b<u>a</u>lm  to

<u>h</u>eal  it

*Thou hast set thy heart as the*

5

*heart of God —      Ezekiel*

The  Last  Judgment  is  an  Overwhelming  of  Bad  Art  &

Science.   Mental  Things  are  alone  Real  what  is  Calld

Corporeal  Nobody  Knows  of  its  Dwelling  Place<sup>it</sup> is  in  Fallacy  &

its  Existence  an  Imposture  Where  is  the  Existence  Out  of  Mind

or  Thought  Where  is  it  but  in  the  Mind  of  a  Fool.   Some  People

flatter  themselves  that  there  will  be  No  L<u>ast</u>  Judgment  &

The top and bottom paragraphs are in the standard dark ink of the rest of *VLJ,* but the second paragraph is in greyish ink (here italics) and the third, which continues the thought, in a finer pen and darker ink.

[N94 transcript]

that Bad Art will be adopted & mixed with Good Art

That Error or Experiment will make a Part of Truth

& they Boast that it is its Foundation these People

flatter themselves   I will not Flatter them Error is

Created Truth is Eternal   Error or Creation will

be Burned Up & then & not till then Truth

or Eternity                                                    will   appear

It is Burnt up                                              the Moment

Men cease to                                              behold it I

assert for My                                              self that I

Do not behold                                            the Outward

Creation &                                                  that to me

it is hindrance                                            & not Action

it is as the Dirt                                          upon my feet

No part of                                 $\frac{Me}{me}$.   What it

will be Questiond   *When the Sun rises do you not see a*

round Disk of   *O that the Everlasting had not fixd   4*
*fire somewhat like a Guinea O no no*
*His canon gainst Self slaughter   3*
*Shakespeare*

I see an Innumerable company of the Heavenly host

crying Holy Holy Holy is the $\frac{L}{G}$ord God Almighty

I question not my Corporeal or Vegetative Eye any

more that I would Question a Window concerning a

Sight I look thro it & not with it .

**Emblem 61
(GP 2)**

All in dark ink.  The end of *VLJ*.

that Bad Art will be adopted & mixed with Good Art
That Error or Experiment will make a Part of Truth
& they Boast that it is its Foundation these People
flatter themselves I will not Flatter them Error is
Created Truth is Eternal Error or Creation will
be Burned Up & then & not till then Truth

or Eternity
It is Burnt up
then cease to
apear for My
Do not behold
Creation &
it is Hindrance
It is as the Dirt
No part of

will appear
the Moment
behold it
self that I
the outward
that to me
& not Action
upon my feet
Me. What it

will be Questiond When the Sun rises do you not See a
round Disk of fire somewhat like a Guinea O no no
I see an Innumerable company of the Heavenly host
crying Holy Holy Holy is the Lord God Almighty
I question not my Corporeal or Vegetative Eye any
more that I would Question a Window concerning a
Sight I look thro it & not with it

(a) Emblem 61: pencil (badly rubbed when the facing emblem was pencil); the legend tells us that this startled man is contemplating suicide: what he must see is his reflection in the water. The rain that appears in *GP* 2 is not indicated in this drawing. Glue spots. (See infra-red photograph, Fig. 11, Appendix II.)

[N95]

Lines

Written on hearing the Surrender of Copenhagen

The Glory of Albion is tarnished with shame
And the pride of her might is the crown of her fame
Her giant strength blesses the nations no more
And the race of the Sun of her honour is oer

Like an Eagle she soared in the youth of her pride
And her joy was the Battle of Freedom to guide
As the fierce tearing lightning she sped on the winds
And her young on the shade of her pinions reclind

Her haunt was the rock & she chased in dismay
The Vulture & Wolf from her Eyrie away
And when the wild tempest howld over the wave
Her delight was the wretch from its fury to save

But her giant strength blesses the nations no more
And the race of the Sun of her honour is oer
She hath tasted of blood & her anger hath hurld
The flames shaft of war over a desolate world

O England. when mercy soft murmurd her prayer
And bade the blood of the nations to spare
Thy soul was for War & thy haughty behest
Chasd the Seraph of Peace from thy merciless breast

(a) This pencil drawing illustrates *PL* VII, 225ff. and becomes the frontispiece of *Europe*. The pencilled motto is from, or becomes part of, *Europe* 2:13.

[N96]

## Lines

Written on hearing the surrender of Copenhagen

*What shall bind*
*The Infinite*

The Glory of Albion is tarnishd with shame
And the field of her might is the bourn of her fame
Her giant strength blesses the Nations no more
And the race of the Sun of her honour is oer

Like an Eagle she soard in the Youth of her pride
And her joy was the Battle of Freedom to guide
As the fate bearing lightning she sped on the wind
And her young in the shade of her pinions reclind

Her haunt was the rock & she chased in dismay
The Vulture & Wolf from her Eyrie away
And when the wild tempest howld over the wave
Her delight was the weak from its fury to save

But her giant strength blesses the nations no more
And the race of the Sun of her honour is oer
She hath tasted of blood & her anger hath hurld
The flame shaft of war oer a desolate world

O England. when mercy soft murmurd her prayer
And bade the blood of the nations to spare
Thy soul was for War & thy haughty behest
Chast the Seraph of Peace from thy merciless breast

Msc 12 is in dark grey ink, with pen similar to that used on p. 88 for Msc 11.  The pencil inscription (italics) under the first stanza is a motto for the drawing.

[N96 transcript]

The Seraph of Peace from thy fury had fled

In the gloom of the North she had pillowd her head

But thy vengeance pursud her bewilderd with care

She awoke to fierce havoc to groans & Despair

O bring not the laurel wreathe constant to fame

And rend not heavens concave with shouts of acclaim

25 32 33

When the spoil & the plunder shall rise on the wave

The plunder of friends & the spoil of the brave

For the triumph which Liberty hallowd is fled

And the might of the Tyrant has raged in its stead

And changd is the radiance that streamd oer the heath

To the warning of Nations.  the meteor of Death

Birmingham                                              J.

Msc 12 continues in the same pen and ink.  Date, *c.* Autumn 1807.  The handwriting is Blake's; the poem was evidently copied from a newspaper or magazine.  Often signing himself 'Birmingham J.', James Bisset (*c.* 1762-1832), a Whiggish bookseller and artist of Birmingham, contributed occasional verses of this sort to London periodicals. (See my note in *BNYPL,* 1968.)

The seraph of Peace from thy fury had fled
In the gloom of the North she had pillowed her head
But thy vengeance pursued her bewildered with care
She awoke to fierce havoc to groans & Despair

O bring not the Laurel wreath constant to fame
And rend not heavens concave with shouts of acclaim

When the spoil & the plunder shall rise on the wave
The plunder of friends & the spoil of the brave

For the triumph which Liberty hallowd is fled
And the night of the Tyrant has raged in its stead
And changd is the radiance that streamd oer the heath
To the warning of Nations. the meteor of death

Birmingham                                              J.

(a) Emblem 62: drawn on for a detail of the water colour *Malevolence* of 1799. Blake's copying a poem on the British siege of Copenhagen beside this lurking assassin (with background details suggesting a city) may not have been mere chance.

(a) Pencil drawing, from which Emblem 60 (94a, b) derives: a figure hunched in pillows of cloud much as in the emblem, but with helmet and bib of chain mail. (See tracing, Fig. 27, Appendix II.) As one of the large drawings, this should illustrate Milton—or Shakespeare. My guess is Macbeth in his doubting, self-condemning soliloquy in I.vii.21-5, his vision of himself in opposition to Pity (illustrated four leaves on, 106a) and guilty of 'Vaulting ambition'. The emblem, chain mail gone, shifts to the King of Tyre, who has similarly 'set himself as the heart of God'. *GP* 4 finds the archetypal Covering Cherub in 'Cloudy Doubts & Reasoning Cares'.

[N98]

Poem 159
(EG c)

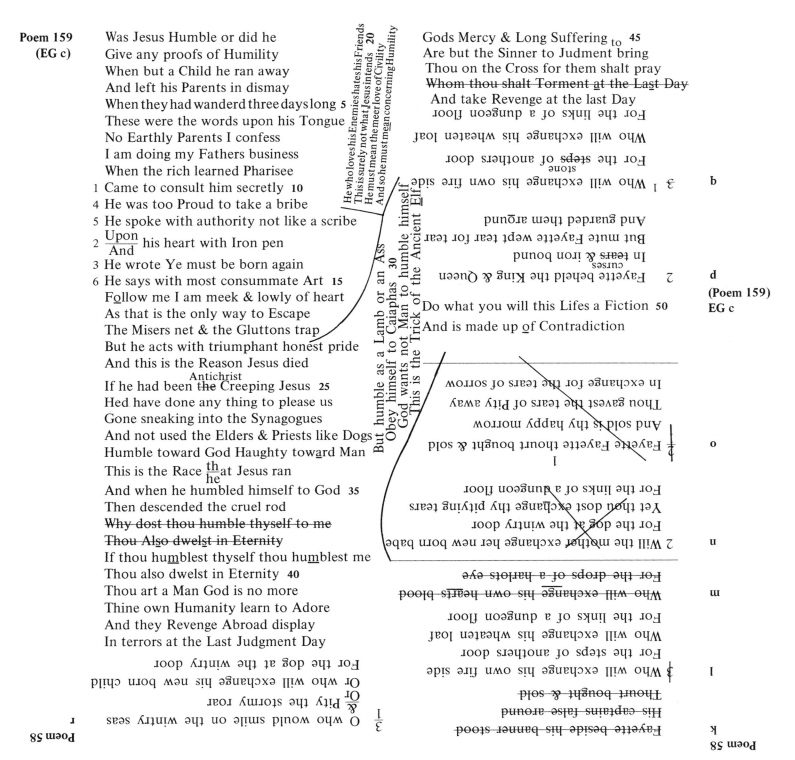

Was Jesus Humble or did he
Give any proofs of Humility
When but a Child he ran away
And left his Parents in dismay
When they had wanderd three days long 5
These were the words upon his Tongue
No Earthly Parents I confess
I am doing my Fathers business
When the rich learned Pharisee
1 Came to consult him secretly 10
4 He was too Proud to take a bribe
5 He spoke with authority not like a scribe
2 Upon / And his heart with Iron pen
3 He wrote Ye must be born again
6 He says with most consummate Art 15
Follow me I am meek & lowly of heart
As that is the only way to Escape
The Misers net & the Gluttons trap
But he acts with triumphant honest pride
And this is the Reason Jesus died
If he had been ~~the~~ Creeping Jesus 25   [Antichrist]
Hed have done any thing to please us
Gone sneaking into the Synagogues
And not used the Elders & Priests like Dogs
Humble toward God Haughty toward Man
This is the Race th/he at Jesus ran
And when he humbled himself to God 35
Then descended the cruel rod
~~Why dost thou humble thyself to me~~
~~Thou Also dwelst in Eternity~~
If thou humblest thyself thou humblest me
Thou also dwelst in Eternity 40
Thou art a Man God is no more
Thine own Humanity learn to Adore
And they Revenge Abroad display
In terrors at the Last Judgment Day

He who loves his Enemies hates his Friends
This is surely not what Jesus intends 20
He must mean the meer love of Civility
And so he must mean concerning Humility

But humble as a Lamb or an Ass
Obey himself to Caiaphas 30
God wants not Man to humble himself
This is the Trick of the Ancient Elf

Gods Mercy & Long Suffering to 45
Are but the Sinner to Judment bring
Thou on the Cross for them shalt pray
~~Whom thou shalt Torment at the Last Day~~
And take Revenge at the last Day

For the links of a dungeon floor
Who will exchange his wheaten loaf
For the ~~steps~~ of anothers door   [stone]
3 1 Who will exchange his own fire side   b

And guarded them around
But mute Fayette wept tear for tear
In tears & iron bound   [curses]
2 Fayette beheld the King & Queen   d

(Poem 159)
EG c

Do what you will this Lifes a Fiction 50
And is made up of Contradiction

In exchange for the tears of sorrow
Thou gavest the tears of Pity away
And sold'st thy happy morrow
1 Fayette thought bought & sold   o

For the links of a dungeon floor
Yet thou dost exchange thy pitying tears
For the dog at the wintry door
2 Will the mother exchange her new born babe   n

For the drops of a harlots eye
~~Who will exchange his own hearts blood~~   m
For the links of a dungeon floor
Who will exchange his wheaten loaf
For the steps of anothers door
3 Who will exchange his own fire side   l

~~Thout bought & sold~~
~~His captains false around~~
~~Fayette beside his banner stood~~   k

Poem 58

For the dog at the wintry door
Or who will exchange his new born child
Or & Pity the stormy roar
1/3 O who would smile on the wintry seas   r

Poem 58

EG c is in black ink; in line 51 Blake mended 'made upon' to 'made up of'.
'curses' in stanza p and in the final numbering of q and r.
Poem 58 is in dark ink, including revision, numerals, and deletion marks, but black ink is used in the change from 'tears' to

Poem 57 is in pencil (italics here); Poem 58 in dark ink. Poem 58 dates after news reached London of Lafayette's jailing in an Austrian dungeon, i.e. after 25 Oct. 1792. (See analysis of Poem 58 in E 779-80.)

**Poem 57**

a — $\frac{4}{3}$

*Several Questions Answerd*

*What is it men in women do require*
*The lineaments of Gratified Desire*
*What is it women do in men require*
*The lineaments of Gratified Desire*

b
(= 50′) — 2

*The look of love alarms*
*Because tis filld with fire*
*But the look of soft deceit*
*Shall Win the lovers hire*

Emblem 63
c
(= 51′) — 3

*Soft deceit & Idleness*
*These are Beautys sweetest dress*

d
(= 41′) — 1

*He who binds to himself a joy*
*Doth the winged life destroy*
*But he who kisses the joy as it flies*
*Lives in Eternitys sun rise*

e
(= 30′) — 5

*An ancient Proverb*

*Remove away that blackning church*
*Remove away that marriage hearse*
*Remove away that —— of blood*
*Youll quite remove the ancient curse*

**Poem 58h**

Fayette beside King Lewis stood
He saw him sign his hand
And soon he saw the famine rage
About the fruitful land

i

Fayette beheld the Queen to smile
And wink her lovely eye
And soon he saw the pestilence
From street to street to fly

j

Fayette beheld the King & Queen
In tears & iron bound
But mute Fayette wept tear for tear
And guarded them around

**Poem 58**

a

1  Let the Brothels of Paris be opened
2  With many an alluring dance
3  To awake the Pestilence [Physicians] thro the city
4  Said the beautiful Queen of France

b

9  The King awoke on his couch of gold
10  As soon as he heard these tidings told
11  Arise & come both fife & drum
12  And the Famine shall eat both crust & crumb

c

Then old Nobodaddy aloft
Farted & belchd & coughd
7  And said I love hanging & drawing & quartering
8  So Every bit as well as war & slaughtering

d

Damn praying & singing
Unless they will bring in
The blood of ten thousand by fighting or swinging

e

5  Then he swore a great & solemn Oath
6  To kill the people I am loth
But If they rebel they must go to hell
They shall have a Priest & a passing bell

f

The Queen of France just touchd this Globe
And the Pestilence darted from her robe
But the bloodthirsty people across the water
Will not submit to the gibbet & halter
But our good Queen quite grows to the ground
There is just such a tree at Java found
And a great many suckers grow all around

g

Fayette Fayette thourt bought & sold
For well I see thy tears
Of Pity are exchangd for those
Of selfish slavish fears

(a) Emblem 63: thoroughly erased (and further obscured by rub-off from p. 98). Tracing proves futile.

(a) Pencil drawing: possibly an illustration for *Lycidas* 26, 'The opening eyelids of the morn': a waning crescent moon beside an anxious watcher for the dawn. Fuseli's different response to the passage, in Milton Gallery painting No. 37 (Schiff, Pl. 43), inspires this conjecture. His crescent is waxing and his watcher dozing, but the components of the two pictures are comparable.

Was Jesus gentle or did he  
Give any mar<u>ks</u> of Gentility  
When twelve years old he ran away  
And left his Parents in dismay  
When after three days sorrow found   5  
Loud as Sinai's trumpet sound  
No Earthly Parents I confess  
My Heavenly Fathers business  
Ye understand not what I say  
And angry force me to obey   10  
Obedience is a duty then  
And favour gains with God & Men  
John from the Wilderness loud cried  
Satan gloried in his Pride  
Come said Satan come away   15  
Ill soon see if youll obey  
John for disobedience bled  
But you can turn the stones to bread  

Gods high king & Gods high Priest  
Shall Plant their <u>G</u>lories in your breast   20  
If Caiaphas you will obey  
If Herod you with bloo<u>d</u>y Prey  
Feed with the Sacrifice & be  
Obedient fall down worship me  
Thunders & lightnings broke around   25  
And Jesus voice in thunders sound  
Thus I sieze the Spiritual Prey  
Ye smiters with disease make way  
I come Your King & God to sieze  
Is God a Smiter with disease   30  
The God of this World raged in vain  
He bound Old Satan in his Chain  
And bursting forth ~~with~~ his furious ire  
Became a Chariot of fire  
Throughout the land he took his course   35  
And traced Diseases to their Source  
He cursd the Scribe & Pharisee  

**Poem 76**

a  
2 O I cannot cannot find  
The undaunted courage of a Virgin Mind  
For <u>Soon / Early</u> I in love was crost  
Before my flower of love was lost  

b  
1 An old maid early eer I knew  
Ought but the love that on me grew  
And now Im coverd oer & oer  
And wish that I had been a Whore  

**Poem 56**

Her whole Life is an Epigram smack smooth & n<sup>ea</sup>obly pend  
Platted quite neat to catch applause with a sliding noose at the end  

EG b is in black ink.

Poem 56 is in dark ink, Poem 76 in black ink with stanza numbers in pencil.

Poem 55    Motto to the Songs of Innocence & of Experience

a    The Good are attracted by Mens perceptions
     And Think not for themselves
     Till Experience teaches them to catch
     And to cage the Fairies & Elves

b    And then the Knave begins to snarl
     And the Hypocrite to howl
     And all his good Friends shew their private ends
     And the Eagle is known from the Owl

EG b    Trampling down Hipocrisy

Where eer his Chariot took its way

There Gates of Death let in the Day    40

Broke down from every Chain & Bar

And Satan in his Spiritual War

Dragd at his Chariot wheels loud howld

The God of this World louder rolld

The Chariot Whe$\frac{el}{ld}$s & louder still    45

His voice was heard from Zions hill

And in his hand the Scourge shone bright

He scourgd the Merchant Canaanite

From out the Temple of his Mind
*Begone & trouble me no more*
And in his Body tight does bind    50        26   50

Satan & all his Hellish Crew

And thus with wrath he did subdue
*If you trap &c*
The Serpent Bulk of Natures dross
*Riches*
Till he had naild it to the Cross
*Experiment*
He took on Sin in the Virgins Womb
*An answer to the Parson*
And on the Cross he Seald its doom
*O Lapwing &c*
He took on Sin in the Virgins Womb    55

And put it off on the Cross & Tomb

To be Worshipd by the Church of Rome

Msc 4

On 1 Plate

Poem 54'

Who shall claim the

Of Thought is death
And the want of
And strength & breath
h    4    If thought is life
Of thought is death
But the want of
And strength & breath
g    4    Thought is life
Or if I die
If I live
A happy fly
f    5    Then am I
Shall brush my wing
Till some blind hand
And drink & sing
e    3    For I dance
A man like me
Emblem 64    Or art not thou
A fly like thee
d    2    Am not I
And so do thou
And dies in peace
Forgives the plow
c    The cut worm
Hath brushd away
My guilty thoughtless hand
Thy summer play
b    1    Little fly
Shattered fled
All thy gilded painted pride
Brushd across thy summer joy
a    Poem 54    Woe alas my guilty hand

EG b continues in black ink.

Msc 4 is in pencil (italics); no plate has been found with these poems gathered on it. Poem 54 is in black ink, and the unfinished line I have marked 54' is in the same ink and pen. Poem 55 is in dark ink. (See analysis of Poem 54 in E 716-17.)

[N101 transcript]

a

Trampling down Hypocrisy
Where eer his Chariot took its Way
There Gates of death let in the day
Broke down from every Chain & Bar
And Satan in his Spiritual War
Dragd at his Chariot wheels loud howld
The Gods of this World louder tolld
The Chariot Wheels & louder still
His voice was heard from Hill to Hill
And in his hand the Scourge shone bright
He Scourgd the Merchant Canaanite
From out the Temple of his Mind
And in his Body tight does bind
Satan & all his Hellish Crew
And thus with wrath he did subdue
The Serpent Bulk of Natures dross
Till he had naild it to the Cross
~~He took on Sin in the Virgins Womb~~
~~.....~~
He took on Sin in the Virgins Womb
And put it off on the Cross & Tomb
To be Worshipd by the Church of Rome

trouble me no more
758

(a) Emblem 64: the motto has been (since Martial) traditionally applied to 'dull Care'. The man commanding her departure has a vine or bells wound around his left leg.

(a) Pencil drawing, Adam and Eve walking hand in hand among tree trunks. They must be on their way to the 'nuptial bower' (*PL* VIII, 510). They did not go so serenely into the 'thickest wood', after their fall, to find fig leaves (IX, 1100ff.). (Both figures were drawn and erased in different positions, leaving remnants of earlier heads and legs beside the final ones.)  No painting is known.

Italics here stand for grey ink (in Poems 46, 48-50) or for pencil (in Poems 51-3 and the revisions of 46). Poems 35′ and 47 are in medium dark ink, revised in black ink. Poem 48, in grey, has its title in black. In 48:4 'secret' was written first in pencil, then in grey ink. The last line of Poem 53 is written on top of a rule which had been drawn before its addition.

**Poem 46**

*The Question Answerd*

*What is it men ~~of~~ <sup>in</sup> women do require*
*The lineaments of Gratified Desire*
*What is it women do ~~of~~ <sup>in</sup> men <sup>r</sup>⁄<sub>d</sub> equire*
*The lineaments of Gratified Desire*

---

**Poem 35′**

**b**  Because I was happy upon the heath
   And smild among the winters ~~wind~~ snow
   They clothed me in the clothes of death
   And taught me to sing the notes of woe

**c**  And because I am happy & dance & sing
   They think they have done me no injury
   And are gone to praise God & his Priest & King
   ~~Who wrap themselves up in our misery~~
   Who make up a heaven of our misery

**Poem 47**

Lacedemonian Instruction
Come hither my boy tell me what thou seest there
A fool tangled in a religious snare

---

**Poem 48**

Riches

*The ~~we~~ <sup>count</sup>⁄<sub>weal</sub> countless gold of a merry heart*
*The rubies & pearls of a loving eye*
*The ~~idle man~~ <sup>indolent</sup> never can bring to the mart*
*Nor the ~~cunning~~ <sup>secret</sup> hoard up in his treasury*

---

**Poem 49**

*An answer to the parson*

*Why of the sheep do you not learn peace*

*Because I dont want you to shear my fleece*

---

**Poem 50**

*Holy Thursday*

**a**  *Is this a holy thing to see*

   *In a rich & fruitful land*

   *Babes reducd to misery*

   *Fed with cold & usurous hand*

**b**  *Is that trembling cry a song*

   *Can it be a song of joy*

   *And so great a number poor*

   *Tis a land of poverty*

**Poem 51**

**a**  The Angel
*I dreamt a dream what can it mean*
*And that I was a maiden queen*
*Guarded by an angel mild*
*Witless woe was neer beguild*

**b**  *And I wept both night & day*
*And he wiped my tears away*
*And I wept both day & night*
*And hid from him my hearts delight*

**c**  *So he took his wings & fled*
*Then the morn blushd rosy red*
*I dried my tears & armd my fears*
*With ten thousand shields & spears*

**d**  *Soon my angel came again*
*I was armd he came in vain*
*For ~~But~~ the time of youth was fled*
*And grey hairs were on my head*

**Poem 52**

*The look of love alarms*

*Because tis filld with fire*

*But the look of soft deceit*

*Shall win the lovers hire*

**Poem 53**

~~*Which are beauties sweetest dress*~~
*Soft deceit & idleness*
*These are beauties sweetest dress*

**c**  *And their sun does never shine*

   *And·their fields are bleak & bare*

   *And their ways are filld with thorns*

   *Tis eternal winter there*

**d**  *But whereeer the sun does shine*

   *And whereeer the rain does fall*

   *Babe can never hunger there*

   *Nor poverty the mind appall*

The Question Answerd
What is it men in women do require
The lineaments of Gratified Desire
What is it women do in men require
The lineaments of gratified Desire

Because I was happy upon the heath
And smild among the winters snow
They clothed me in the clothes of death
And taught me to sing the notes of woe

And because I am happy & dance & sing
They think they have done me no injury
And are gone to praise god & his Priest & King
Who make up a heaven of our misery
Come hither my boy tell me what thou seest there
A fool caught in a religious snare

The countless gold of a merry heart
The rubies & pearls of a loving eye
The indolent never can bring to the mart
Nor the secret hoard up in his treasury

An answer to the parson
Why of the sheep do you not learn peace
Because I dont want you to shear my fleece

Holy Thursday
Is this a holy thing to see
In a rich & fruitful land
Babes reduced to misery
Fed with cold & usurous hand

Is that trembling cry, a song
Can it be a song of joy
And so great a number poor
Its a land of poverty

I dreamt a dream that can it mean
And that I was a maiden queen
Guarded by an angel mild
Witless woe was neer beguild

And I wept both night & day
And he wiped my tears away
And I wept both day & night
And hid from him my hearts delight

So he took his wings & fled
Then the morn blushd rosy red
I dried my tears & armd my fears
With ten thousand shields & spears

Soon my angel came again
I was armd he came in vain
For the time of youth was fled
And grey hairs were on my head

The look of love alarms
Because tis filld with fire
But the look of soft deceit
Shall win the lover hire

Soft deceit & idleness
These are beauties sweetest dress

and their sun does never shine
And their fields are bleak & bare
And their ways are filld with thorns
Its eternal winter there

But where eer the sun does shine
And where eer the rain does fall
Babe can never hunger there
Nor poverty the mind appall

[N104]

(a) Pencil drawing: the Holy Trinity; God the Father, under the wings of the dove-like Holy Ghost or Comforter, accepts the Son's offer to give his life for man—to deprive Satan 'of his vaunted spoil' (*PL* III, 222-51). Satan, barely sketched in, hovers at the left below the clouds.

The circle at the top, from which the Ghost is flying, can be seen in detail in Blake's paintings of the Last Judgment. It is 'a blue Heaven' where the Holy Spirit dwells with two Cherubim (*VLJ* 28, p. 85). The third of Blake's later water colours for *PL* is assigned to this passage and derives from the present sketch, without the dove or heaven. In it God is more reserved in embrace, however, and perhaps I am wrong to assign the present illustration to the same passage. Blake may have had in mind the more jubilant scene of *PL* VI, 889-91, where the triumphant Son is welcomed home 'into Glory'; the prodigal son embrace, as at the end of *J,* would be more in keeping with the latter scene.

Compare 110a, 111a.

Italics here mean grey ink in Poems 37 and 38 but pencil in Poems 42-5 (and the title of 38). Poems 39 and 40 are in dark ink, 41 in ink a bit darker. The final line of 38 is cancelled in black ink. (See analysis of Poem 38 in E 773.)

**Poem 37**

    *Day*
      *Sun*
    *The ~~day~~ arises in the East*
    *Clothd in robes of blood & gold*
    *Swords & spears & wrath increast*
          *bosom*
    *All around his ~~ancles~~ rolld*
    *Crownd with warlike fires & raging desires*

**Poem 38**

**a**
        *~~The Marriage Ring~~*    *The Fairy*
    *Come hither my sparrows*
    *My little arrows*
    *If a tear or a smile*
    *Will a man beguile*
    *If an amorous delay*     **5**
    *Clouds a sunshiny day*
         *step*
    *If the ~~tread~~ of a foot*
    *Smites the heart to its root*
    *Tis the marriage ring*
    *Makes each fairy a king*    **10**

**b**
    *So a fairy sung*
    *From the leaves I sprung*
    *He leapd from the spray*
    *To flee away*
    *But*
    *~~And~~ in my hat caught*    **5**
    *He soon shall be taught*
    *Let him laugh let him cry*
    *Hes my butterfly*   *For I've pulld out the Sting*
    *Of the*       *& Ive pulld out the Sting*
    *~~And a~~ marriage ring*
    *~~Is a foolish thing~~ Is a childs play thing*    **10**

**Poem 39**

    The sword sung on the barren heath
             in
    The sickle $\frac{\text{in}}{\text{on}}$ the fruitful field
    The sword he sung a song of death
    But could not make the sickle yield

**Poem 40**

    Abstinence sows sand all over
    The ruddy limbs & flaming hair
    But Desire Gratified
    Plants fruits of life & beauty there

**Poem 41**

    In a wife I would desire
    What in whores is always found
    ~~The~~ lineaments of Gratified desire
                  *drink*
    *But kiss him & give him both ~~food~~ & apparel*

**Poem 42**
           *Trap*
*If you ~~catch~~ the moment before its ripe*
            *trap*
*The tears of repentance youl$\frac{l}{d}$ certainly wipe*
*But if once you let the ripe moment go*
      *can*
*Youl~~l~~ ∧ never wipe off the tears of woe*

**Poem 43**
          *Eternity*
          *to*
*He who binds himself ~~to~~ a joy*
*Does the winged life destroy*
*But he who ~~just~~ kisses the joy as it flies*
*Lives in ~~an eternal~~ sun rise*
      *eternity's*

**Poem 44**
      *The Kid*
    *Thou little Kid didst play*
      $\frac{\&^c}{D}$

**Poem 45**

**a**
       *The littl$\frac{e}{}$ ~~pretty~~ Vagabond*
 *D*       *A*
 $\frac{D}{O}$*ear Mother Dear Mother the church is cold*
*But the alehouse is healthy & pleasant & warm*
*Besides I can whe$\frac{re}{n}$ I am usd well*
*The poor parsons with wind like a blown bladder swell*
*~~Such usage in heaven makes all go to hell~~*

**b**
*But if at the Church they would give us some Ale*
*And a pleasant fire our souls to regale*
*We'd sing and we'd pray all the livelong day*
*Nor ever once wish from the Church to stray*

**c**
*Then the parson might preach & drink & sing*
*And wed be as happy as birds in the spring*
*And Modest dame Lurch who is always at Church*
*Would not have bandy children nor fasting nor birch*

**d**
              *rejoicing*
*Then God like a father ~~that joys for~~ to see*
*His children as pleasant & happy as he*
*Would have no more quarrel with the Devil or the Barrel*
*~~But shake hands & kiss him & thered be no more hell~~*

Day
The sun arises in the East
Clothd in robes of blood & gold
Swords & spears & wrath increast
All around his bosom rolld
Crownd with warlike fires & raging desires

Come hither my sparrows
My little arrows
If a tear or a smile
Will a man beguile
If an amorous delay
Clouds a sunshiny day
If the step of a foot
Smites the heart to its root
Tis the marriage ring
Makes each fairy a king

So a fairy sung
From the leaves I sprung
He leapd from the spray
To flee away
But in my hat caught
He soon shall be taught
Let him laugh let him cry
Hes my butterfly
For Ive pulld out the sting
Of the marriage ring

The sword sung on the barren heath
The sickle in the fruitful field
The sword he sung a song of death
But could not make the sickle yield

Abstinence sows sand all over
The ruddy limbs & flaming hair
But Desire Gratified
Plants fruits of life & beauty there

In a wife I would desire
What in whores is always found
The lineaments of Gratified desire

But leave him & give him both drink & apparel
591

If you trap the moment before tis ripe
The tears of repentance youl certainly wipe
But if once you let the ripe moment go
You can never wipe off the tears of woe

Eternity
He who bends to himself a joy
Does the winged life destroy
But he who kisses the joy as it flies
Lives in eternitys sun rise
eternitys

The Kid
Thou little Kid didst play
&c

The little Vagabond
Dear Mother Dear Mother the church is cold
But the alehouse is healthy & pleasant & warm
Besides I can tell where I am used well
The poor parsons with wind like a blown bladder swell

But if at the church they would give us some ale
And a pleasant fire our souls to regale
Wed sing and wed pray all the live long day
Nor wish once wish from the church to stray

Then the parson might preach & drink & sing
And wed be as happy as birds in the spring
And Modest dame Lurch who is always at Church
Would not have bandy children nor fasting nor birch

Then God like a father rejoicing to see
His children as pleasant & happy as he
Would have no more quarrel with the Devil or the Barrel
But kiss him & give him both drink & apparel

(a) Pencil sketch for *Pity* (a far cry from the colour print of *c.* 1795), developing an image in Macbeth's vision (I.vii.21-5) of his deed's cutting him off from Pity, which will trumpet his damnation to every eye/ear 'like a naked new-born babe, / Striding the blast, or heaven's cherubim, horsed / Upon the sightless couriers of the air . . .'.  Blake's 'sightless' horses are like his 'invisible worm', shown to us but blind themselves—as of course Macbeth is as he vaults on.

Italics here stand for grey ink, in Poem 33, otherwise for pencil. The rest is in medium dark ink.

Poem 33

a
*O how sick & weary I*
*Underneath my mirtle lie*
         *To my Mirtle*

b  *5 Why should I be bound to thee*
   *6 O my lovely mirtle tree*

c  *Love free love cannot be bound*
   *To any tree that grows on ground*

d  *1 To a lovely mirtle bound*
   *2 Blossoms showring all around*

e  *Like to dung upon the ground*
   *Underneath my mirtle bound*

a′  *3 O how sick & weary I*
    *4 Underneath my mirtle lie*

Poem 34

a
Nought loves another as itself
Nor venerates another so
Nor is it possible to Thought
A greater than itself to know

                      how can I
b  And ~~Then~~ father ~~I cannot~~ love you
   Or~~Nor~~ any of my brothers more
   I love ~~myself so does the bird~~ you like the little bird
   That picks up crumbs around the door

c  The Priest sat by $\frac{a}{n}$nd heard the child
   In trembling zeal he siezd his hair
   ~~The mother followd weeping loud~~
   ~~O that I such a fiend should bear~~
   He ~~Then~~ led him by the little coat
   ~~To show his zealous priestly care~~
   And all admird his priestly care

e  The weeping child could <u>not</u> be heard
   The weeping parents wept in vain
   ~~They bound his little ivory limbs~~
   ~~In a cruel Iron chain~~
   They ~~And~~ strip'd him to his little shirt
   & bound him in an iron chain

Poem 29′                                                    b
*Deceit to secresy* ~~inclind~~ *confind*
*Lawful cautious* ~~changeful and~~ *& refind*
*Modest prudish & confind*
*To every thing but*
~~Never is to~~ *interest blind*

~~And chains & fetters every mind~~
*And forges fetters for the mind*

The Chimney Sweeper                                        Poem 35

*A little black thing among the snow*                      a

*Crying weep weep in notes of woe*

*Where are they father & mother say*

*They are both gone up to Church to pray*

Merlins prophecy                                           Poem 36

The harvest shall flourish in wintry weather              a
When two virginities meet together

The King & the Priest must be tied in a tether            b
Before two virgins can meet together

Poem 34                                                    d
And standing on the altar high
Lo what a fiend is here said he
One who sets reason up for judge
Of our most holy mystery

                And
~~They~~ burnd him in a holy ~~fire~~ place                f
Where many had been burnd before
The weeping parents wept in vain
Are Such things ~~are~~ done on Albions shore

Italics here stand for pencil; the rest of the writing is in dark ink with irregular greyer patches.

**Poem 27**

a

~~How came pride in Man~~
~~From Mary it began~~
~~How Contempt & Scorn~~

b

~~What a World is Man~~

**Poem 28**

~~His Earth~~   The human Image

a

*Pity*
―――  could be no more
Mercy   If we did not make somebody poor
~~If there was nobody poor~~
And Mercy no more could be
If all were as happy as we

b

And mutual fear brings Peace
Till the selfish Loves increase
Then Cruelty knits a snare
And spreads his ~~nets~~ baits with care

c

He sits down with holy fears
And waters the ground with tears
Then humility takes its root
Underneath his foot

d

*Soon*
―――  spreads the dismal shade
**Spr**
Of Mystery over his head
And the catterpiller & fly
Feed on the Mystery

e

And it bears the fruit of deceit
Ruddy & sweet to eat
And the raven his nest has made
In its thickest shade

f

The Gods of the Earth & Sea
Sought thro nature to find this tree
But their search was all in vain
~~Till they sought in the human brain~~
*There grows one in the human brain*

g

They said this mystery never shall cease
*promotes*
The prest ~~loves~~ war & the soldier peace
*promotes*

---

~~How to know Love from Deceit~~

*Love to faults is always blind*
*Always is to joy inclind*
*Lawless* ~~*Always*~~ *wingd & unconfind*
*And breaks all chains from every mind*

**Poem 29**

There souls of men are bought & sold
And
―――― ~~cradled~~ infancy ~~is sold~~ for gold
There milk fed
And you^th to slaughter houses led
    ths
    *beauty*
And ~~maidens~~ for a bit of bread

**Poem 28**

h

---

The wild flowers Song
As I wanderd the forest
The green leaves among
I heard a wild ~~thistle~~ flower
  Singing a Song
    Earth
I slept in the ~~dark~~ &c

**Poem 22′**

a

b

The Sick rose
O rose thou art sick
The invisible worm
That flies in the night
In the howling storm

**Poem 30**

a

Hath found out thy bed
Of crimson joy
~~A dark secret love~~   And ~~his~~ *her* dark secret love
~~Doth life destroy~~   Does thy life destroy

b

---

Soft Snow
I walked abroad in a snowy day
I askd the soft snow with me to play
She playd & she melted in all her prime
~~Ah that sweet love should be thought a crime~~
*And the winter calld it a dreadful crime*

**Poem 31**

An ancient Proverb
Remove away that blackning church
Remove away that marriage hearse
          *man*
Remove away that ~~place~~ of blood
~~Twill~~ quite remove the ancient curse
*You'll*

**Poem 32**

The Human Image

Pity could be no more
If we did not make somebody poor
And Mercy no more could be
If all were as happy as we

And mutual fear brings Peace
Till the selfish loves increase
Then Cruelty knits a snare
And spreads his baits with care

He sits down with holy fears
And waters the ground with tears
Then humility takes its root
Underneath his foot

Soon spreads the dismal shade
Of Mystery over his head
And the catterpiller & fly
Feed on the Mystery

And it bears the fruit of deceit
Ruddy & sweet to eat
And the raven his nest has made
In its thickest shade

The Gods of the Earth & Sea
Sought thro nature to find this tree
But their search was all in vain
Till they sought in the human brain
There grows one in the human brain
They said this mystery never shall cease
The priest ... & the soldier please
promotes

Love to faults is always blind
Always is to joy inclind
Always wings & unconfind
And breaks all chains from every mind

There souls of men are bought & sold
And ... infancy ... for gold
And youth to slaughter houses led
And ... for a lot of bread

As I wanderd the forest
The green leaves among
I heard a ... flower
Singing a song
I slept in the Earth

The sick rose

O rose thou art sick
The invisible worm
That flies in the night
In the howling storm
Hath found out thy bed
Of crimson joy
And her dark secret love
Does thy life destroy

I walked abroad in a snowy day
I askd the soft snow with me to play
She playd & she melted in all her prime
Ah that sweet love should be thought a crime
And the winter ...
Remove away that blackning church
Remove away that marriage hearse
Remove away that ... of blood
Youll quite remove the ancient curse
Youll

(a) Pencil sketch, probably Satan springing up from the realm of Chaos and Night and their tumultuous cohorts of the abyss (*PL* II, 960-70, 1013). The central figure (first drawn at right and partly erased) has arms upraised and wings outspread (but wings, arms, and head have been redrawn in various positions). Of two versions of Fuseli's *Satan bursts from Chaos* in Schiff (Pl. 21, 22), the first (see Fig. 34, Appendix II) is rather close to Blake's in conception (if Blake's Satan is rising from a cloud of human forms over a watery gulf); in 21 Satan has one arm up and one outward, and in 22 his left knee is raised as here (and in *America* 10.)

b′

Burnt in distant deeps or skies
The cruel fire of thine eyes
Could heart descend or wings aspire
What the hand dare sieze the fire

d′  5
         ~~dare~~ he ~~smile laugh~~
  3 And did/is he ~~laugh~~/his work to see
    ~~What the shoulder what the knee~~
       ankle
  Dare
  4 ~~Did~~ he who made the lamb make thee
  1 When the stars threw down their spears
  2 And waterd heaven with their tears

---

Tyger Tyger burning bright      a′
In the forests of the night
What Immortal hand &/or eye
Dare frame thy fearful symmetry

And what shoulder & what art      c′
Could twist the sinews of thy heart
And when thy heart began to beat
What dread hand & what dread feet

When the stars threw down their spears      d″
And waterd heaven with their tears
Did he smile his work to see
Did he who made the lamb make thee

Tyger Tyger burning bright      f′
In the forests of the night
What immortal hand & eye
Dare frame thy fearful symmetry

Italics stand for pencil in the double insertion 'days' in Poem 21 and in the final line of Poem 24, elsewhere for grey ink.  My numbering shows the order in which the poems were written on the page:  two in grey ink, then two in black, then 'To Nobo-daddy' in grey; then, in medium dark ink, the rose poem and 'The Tyger' and the continuation of 'London'.  Later a blacker ink was used to revise 'London' and 'The Tyger'. (See analyses of 'London' and 'The Tyger' in E 718-19 and 717.)

**Poem 20**

a

*London*

*I wander thro each dirty street*
*Near where the dirty Thames does flow*
          mark
*And see in every face I meet*
*Marks of weakness marks of woe*

b

*In every cry of every man*
     every infants cry of fear
*In every voice of every child*
*In every voice in every ban*
       mind       d
*The german forg__ manacles I hear*
           ed
  How
  links I hear

c

*But most the chimney sweepers cry*
*Blackens oer the churches walls*  Every blackning
                                   church appalls
*And the hapless soldiers sigh*
*Runs in blood down palace walls*

**Poem 20**
d

But most the midnight harlots curse
From every dismal street I hear
Weaves around the marriage hearse
And blasts the new born infants tear

      thro wintry
But most from every streets I hear
How the midnight harlots curse
Blasts the new born infants tear
And hangs with plagues the marriage hearse
       smites
But most the shrieks of youth
                        I hear
But most thro midnight &c
How the youthful

**Poem 22**

a

     slept
*I was fond in the dark*

d′

*In the silent night*
*I murmurd my fears*
*And I felt delight*

b
d″

*In the morning I went*
*As rosy as morn*

d‴

*To seek for new Joy*
*But I met with scorn*

**Poem 24**

a

———— To Nobodaddy ————

*Why art thou silent & invisible*
  Father
*Man of Jealousy*
*Why dost thou hide thyself in clouds*
*From every searching Eye*

b

*Why darkness & obscurity*
*In all thy words & laws*
*That none dare eat the fruit but from*
*The wily serpents jaws*      females loud
*Or is it because Secresy gains feminine applause*

**Poem 25**

       modest lustful rose
The rose puts envious puts forth a thorn
     humble
The coward sheep a threatning horn
While the lilly white shall in love delight
And the lion increase freedom & peace

The prist loves war & the soldier peace
Nor a thorn nor a threat stain her beauty bright

---

**Poem 21**

a

*When the voices of children are heard on the green*
*And whisprings are in the dale*
                days
*days The desires of youth rise fresh in my mind*
*My face turns green & pale*

b

*Then come home my children the sun is gone down*
*And the dews of night arise*
*Your spring & your day are wasted in play*
*And your winter & night in disguise*

**Poem 23**

a

Are not the joys of morning sweeter
Than the joys of night
And are the vigrous joys of youth
Ashamed of the light

b

Let age & sickness silent rob
The vineyards in the night
But those who burn with vigrous youth
Pluck fruits before the light

The Tyger

**Poem 26**

a

1    Tyger Tyger burning bright
    In the forests of the night
                          or
    What immortal hand __ eye
                          &
Dare Could frame thy fearful symmetry

b

     Burnt in
2    In what distant deeps or skies
The cruel Burnt the fire of thine eyes
    On what wings dare he aspire
    What the hand dare sieze the fire

c

3    And what shoulder & what art
    Could twist the sinews of thy heart
    And when thy heart began to beat
    What dread hand & what dread feet

d

    Could fetch it from the furnace deep
                 y
    And in th__ horrid ribs dare steep
                 e
    In the well of sanguine woe

    In what clay & in what mould
    Were thy eyes of fury rolld
    Where            where
4   What the hammer what the chain
    In what furnace was thy brain
                              dread grasp
    What the anvil what the arm arm grasp clasp

e

         C
Dare __ould its deadly terrors clasp grasp clasp
         I

6    Tyger Tyger burning bright
    In thee forests of the night
    W
    __hat immortal hand & eye
    I
              frame
    Dare form thy fearful symmetry

f

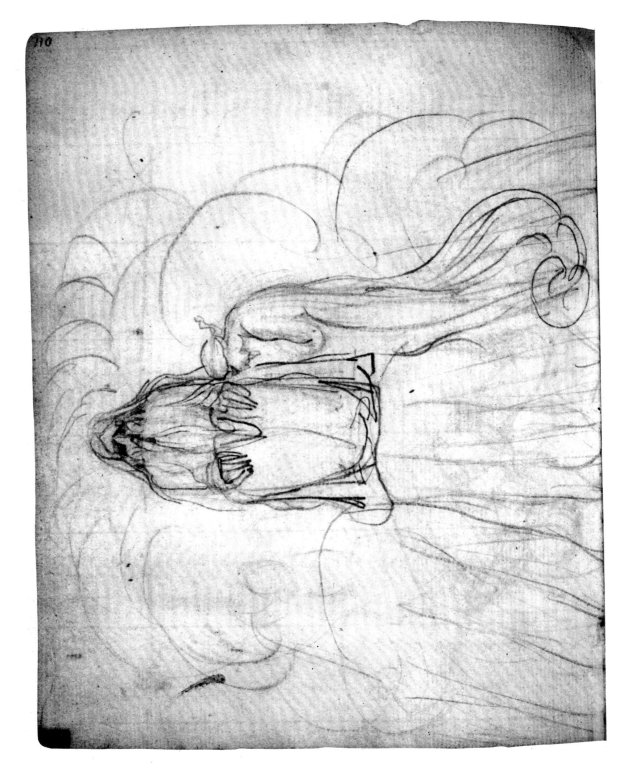

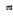

[N110]

(a) Pencil drawing, filling this page and half the next: God the Father giving directions to the Son to save mankind from Satan, who hovers over the abyss or (as we take note of the web of lines around him) struggles like a trapped fly. (This illustrates, I believe, *PL* X, 55-84). What seems to descend from the clouds around the throne, however, is not precisely a web, nor is it rain nor thunderbolts; from the devil's point of view it can seem to be the lines of his own orbiting.

But perhaps the hovering figure (on p. 111) is not Satan; consider the rounded breasts. Perhaps it is Eve, subject of the conversation in heaven, or perhaps Sin herself, Satan's incestuous daughter.

For a composite plate of the two pages, see Fig. 29, Appendix II.

Dark ink throughout, except for pencil cancellation of 'orbs' and insertion of 'light fled' in Poem 19.

**Poem 18**

**a**

Thou hast a lap full of seed
And this is a fine country
Why dost thou not cast thy seed
And live in it merrily

**b**

    Shall I
Oft Ive cast it on the sand
    turn
And turnd it into fruitful land
For But on no other ground can
Can I sow my seed
    tearing
Without pulling up
Some stinking weed

---

**Poem 19**

The Earths Answer

**a**

Earth raisd up her head
From the darkness dread & drear
  orbs
Her eyes fled dead  *light fled*
Stony dread!
And her locks coverd with grey despair

**b**

Prisond on watry shore
  Starry
Starry jealousy does keep my den
Cold & hoar
Weeping oer
           father of
I hear the father of the ancient men

**c** Selfish Cruel father of men
Cruel jealous wintry fear
         .selfish.
Can delight
Chaind Closd in night
The virgins of youth & morning bear

**d**

Break this heavy chain
    freeze
That does close my bones around
Selfish vain
Eternal Thou my bane
    free
That Hast my love with bondage bound

**Poem 19**

**c´**

Does spring hide its delight joy
When buds & blossoms grow
Does the sower sow
Sow His seed by night
Or the plowman in darkness plow

**Poem 17´**

**(e´)**

in a mirtle shade

1 Why should I be bound to thee
O my lovely mirtle tree
Love free love cannot be bound
To any tree that grows on ground

**k**

---

**Poem 17´**

**j**

To a lovely mirtle bound
Blossoms showring all around

**j´** 2 O how sick & weary I
Underneath my mirtle lie
Like to dung upon the ground
Underneath my mirtle bound

3 Oft my mirtle sighd in vain
To behold my heavy chain
    my father saw
Oft the priest beheld us sigh
And laughd at our simplicity

So I smote him & his gore
Staind the roots my mirtle bore
But the time of youth is fled
And grey hairs are on my head

**l**

**h´**

Thou hast a lap full of seed
And this is a fine country
Why dost thou not cast thy seed
And live in it merrily

Shall I
~~Shall I~~ cast it on the sand
And ~~turn~~ turn it into fruitful land

For ~~not~~ on no other ground ~~can~~
Can I sow my seed
Without ~~tearing~~ tearing up
Some stinking weed

The Earths Answer

Earth raisd up her head
From the darkness dread & drear
Her ~~eyes~~ fled locks light fled
Stony dread;
And her locks coverd with grey despair

Prisond on watry shore
~~Starry~~ Starry jealousy does keep my den
Cold & hoar
Weeping o'er
I hear the father of the ancient men

Selfish father of men
Cruel jealous ~~selfish~~ selfish fear
Can delight
Chaind in night
The virgins of youth & morning bear

Break this heavy chain
That does ~~close~~ freeze my bones around
Selfish vain
Eternal ~~bane~~ bane
That ~~hast~~ free love with bondage bound

~~Love sweet love was thought a crime~~

in a myrtle shade

1 Why should I be bound to thee
O my lovely myrtle tree
Love free love cannot be bound
To any tree that grows on ground

2 ~~Thou~~ seek a weary on
Underneath my myrtle lie
Like to dung upon the ground
Underneath my myrtle bound

3 Oft my myrtle sighd in vain
To behold my heavy chain
Oft ~~my father~~ my self
And weep at our simplicity

So I smote him & his gore
Staind the roots my myrtle bore
But the time sprung as I fled
And my hairs were my head

~~Does spring hide its joy~~
Where buds & blossoms grow
~~Does~~ the sower sow
Sow ~~his seed~~ by night
Or the ploughman in darkness plow

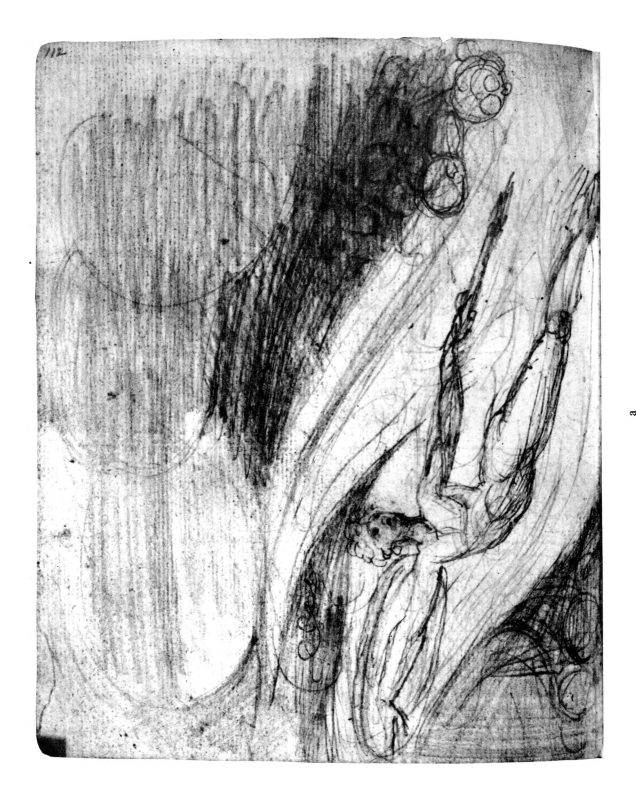

(a) Pencil drawing, full page: Satan with shield and spear, beginning to soar upward to make the track which Sin and Death will pave after him, 'a broad and beaten way / Over the dark abyss' (*PL* II, 1025-7), yet still exhorting his Stygian council: 'long is the way / And hard, that out of Hell leads up to light' (*PL* II, 432-3). His mouth is open in speech; the circles sketched on each side of his track indicate his audience. The large circles above must be the 'three folds' of the gates of Hell (*PL* II, 645-7).

In the colour print *Satan exulting over Eve,* a Satan with a very different face, and wings, hovers in a similar position but is not going anywhere.

As illustrations of Milton's poem the Notebook drawings follow Satan's action in the sequence noted in Table I: 90a, 91a, 114a, 112a, 108a; and continue in 104a, 96a, 102a, 88a, and 110-11a. There are no precise parallels in the extant paintings of Fuseli's Milton Gallery, but a consultation of the illustrations in Schiff, Pl. 5-27, is instructive. The face of Blake's Satan, in these drawings, is closer to Fuseli's conception of the 1770s and 1780s (Schiff, Pl. 27, 21 [surely misdated], 13, and, for Blake's continuance, 12). Fuseli's painting of Satan's head, *c.* 1790 (Schiff, Pl. 5) is transitional to the Gallery paintings and, in a sense, moves past these drawings of Blake's in the direction of the horrible. Drawings for the Milton Gallery paintings may have been made in the time of Blake's Notebook drawings and may have been similarly transitional, but the actual paintings of the group under consideration were made between 1794 and 1799, several years after these drawings. We can only conjecture what influences may have passed between Blake and Fuseli earlier.

One conjecture, however, can be made with the evidence before us. Sketch 114a (see note) can be understood as Blake's interpretation of Fuseli's application to *PL* I, 781-8 of a painting Fuseli had made in 1785 of a shepherd's dream based on *Faerie Queene* II.viii.4 (Schiff, p. 142 and Pl. 42; the Gallery painting is reproduced below, Fig. 35, Appendix II). Fuseli's four fairies swirl in the air in an open ring (like the rainbow fairies of Emblem 12, 30a), all with scarves. Blake indicates some scarves but has only begun the figures: four loops for heads, a spinal axis for the curve of the sleeper, a butterfly where Fuseli has a fairy-mounted bat, and obscure indications of the group on the ground perhaps including the wing-brimmed hat of a seated fairy. The overall correspondence between painting and sketch, however, is about as close as Blake would come to imitating Fuseli.

Poems 13 and 14, at the top, are in brown ink; Poem 15 and the original couplet of 16 are in darker ink. Poem 17 is in grey ink (italics here) with some revisions and additions in darker ink. The mending of 'men' in stanza g is probably from 'man'. (See Longer Note, Appendix I.)

**Poem 13**

a
    I feard the ~~roughness~~ fury of my wind
    Would blight all blossoms fair & true
    And my sun it shind & shind
   And ~~But~~ my wind it never blew

b
    But a blossom fair or true
    Was not found on any tree
    For all blossoms grew & grew
    Fruitless false tho fair to see

**Poem 15** — *Thames*

a
    Why should I care for the men of thames
    Or the cheating waves of charterd streams
    Or shrink at the little blasts of fear
    That the hireling blows into my ear

b
    Tho born on the cheating banks of Thames
    Tho his waters bathed my infant limbs
    The Ohio shall wash his stains from me
    I ~~spurnd his waters away from me~~
    I was born a slave but I ~~long~~ go to be free

**Poem 17** — Infant Sorrow

a
    *My mother groand my father wept*
    *Into the dangerous world I leapt*
    *Helpless naked piping loud*
    *Like a fiend hid in a cloud*

b
    *Struggling in my fathers hands*
    *Striving against my swaddling bands*
    *Bound & weary I thought best*
    *To sulk upon my mothers breast*

c
    *And I ~~grew~~ smild soothd day after day*
    *Till upon the ground I stray*
    *And I ~~grew~~ smild night after night*
    *Seeking only for delight*

d
    *But upon the nettly ground*
    *No delight was to be found*

d′
    *And I saw before me shine*
    *Clusters of the wandring vine*
    *And many a lovely flower & tree*
    *And beyond a mirtle tree*
    *Stretchd ~~its~~ their blossoms out to me*

**Poem 14**

a
Silent Silent Night
Quench the holy light
Of thy torches bright

b
For possessd of Day
Thousand spirits stray
That sweet joys betray

c
Why should joys be sweet
Used with deceit
Nor with sorrows meet

d
But an honest joy
Does itself destroy
For a harlot coy

**Poem 16**

O lapwing thou fliest around the heath
Nor seest the net that is spread beneath
*Why dost thou not fly among the corn fields*
*They cannot spread nets where a harvest yields*

My father then
e
*But many a*
*~~But a Priest~~ with holy look*
*In ~~his~~ their hands a holy book*
*Pronouncd curses on ~~his~~ my head*
*~~Who the fruit or blossoms shed~~*
And bound me in a mirtle shade

f
*~~I beheld the Priests by night~~*
*They*
*~~He~~ embraced my mirtle bright* the blossoms
*~~I beheld the Priests by day~~*
*Where beneath my vines he lay* Underneath the they

g
*~~Like a serpents in the night~~* to
*They*
*~~He~~ embraced my mirtle bright* blossoms
*Like a ~~serpent in the~~ day* holy men to by
*Underneath ~~my~~ vines he lay* the they
*So I smote ~~him~~ them & ~~his~~ their gore*

h
*Staind the roots my mirtle bore*
*But the time of youth is fled*
*And grey hairs are on my head*

i
When I saw that rage was vain
And to su$\frac{lk}{ck}$ would nothing gain
~~I began to so Seeking many an artful wile~~ Turning many a trick or wile
I began to soothe & s$\frac{m}{o}$ile

I heard an ~~angel~~ singing of my woe
Wanton blythe & all blossoms fair & true
And may Sun it shend & shew
And ~~But~~ my wind it never blew

But a blossom fair or true
Was not found on any tree
For all blossoms grow & grew
Fruitless false tho fair to see

Why should I care for the men of Thames
Or the cheating waves of charterd streams
Or shrink at the little blast of fear
That the hireling blows into my ear

Tho born on the cheating banks of Thames
Tho his waters bathd my infant limbs
~~I The Thames shall wash his stains from me~~
~~I flow~~ ~~her water away from~~
I was born a slave but I ~~go~~ to be free

~~Infant Sorrow~~
My mother groand my father wept
Into the dangerous world I leapt
Helpless naked piping loud
Like a fiend hid in a cloud

Struggling in my fathers hands
Striving against my swaddling bands
Bound & weary I thought best
To sulk upon my mothers breast

And ~~I sooth~~ day after day
Till upon the ground I stray
And I ~~smild~~ night after night
Seeking only for delight

~~But upon the~~
~~delight~~
And I saw before me shine
Clusters of the ~~ranging~~ ~~my~~ vine
And many a lovely flower & tree
~~And branches~~
~~their~~ ~~blossoms~~ ~~out to me~~
stretch blossoms out to me

Silent Silent Night
Quench the holy light
Of thy torches bright

For possessd of Day
Thousand spirits stray
That sweet joys betray

Why should joys be sweet
Used with deceit
Nor with sorrows meet

But an honest joy
Does itself destroy
For a harlot coy

O lapwing thou fliest around the heath
Nor seest the net that is spread beneath
Why dost thou not fly among the corn fields
They cannot spread nets where a harvest yields

~~My father then~~
~~with holy look~~
In her hands a holy book
Pronounced curses on my head
Who the fruits or blossoms shed
And bound me in a myrtle shade

~~Beneath the lovely ~~ ~~by night~~
~~They embraced ~~ ~~the myrtle bright~~
~~beneath the ~~ ~~by day~~
~~Underneath the ~~ ~~vine they lay~~

~~Like to serpents in the night~~
~~They embraced my ~~ ~~bright~~
~~Like to serpents ~~ ~~by the day~~
~~Underneath ~~ ~~my vine they lay~~

So I smote them & their gore
Staind the roots my myrtle bore
But the time of youth is fled
And grey hairs are on my head

When I saw that rage was vain
And to sulk would nothing gain
I began to sooth & smile

(a) Pencil sketch: conjecturally the Satanic host swarming like 'faerie elves, / Whose midnight revels . . . / some belated peasant sees' (PL I, 781-8). The loops at bottom right will be the faithful dog at the feet of the sleeping peasant, whose body extends toward the centre; a fairy with a long scarf dances above; heads for three other fairies are sketched in the air, a butterfly to their left; below there will be various creatures. Compare Fuseli's 1793 painting in Appendix II (Fig. 35) and note on p. 112. See also NT 24.

a

Poems 9-12 and the rules between them were written in brown ink, and Poems 10-12 were revised in it. Grey ink (italics here) was used to give a title to Poem 12 and to revise Poem 10. Pencil (also italics) was used to revise 11a:2; further revisions of that line and of 11e:4 were made in black ink. The vertical line is in pencil.

**Poem 9**

a  I asked a thief if ~~he'd~~ <sup>to</sup> steal me a peach

And $\frac{H}{h}$e turn$\frac{ed}{d}$ up his eyes

I askd a lithe lady to lie her down

And $\frac{H}{h}$oly & meek she cries

b  As soon as I went an angel came

And $\frac{H}{h}$e winkd at the thief

And he smild at the dame

And without one word ~~spoke~~ said

Had a peach from the tree

And twixt earnest & ~~joke~~ <u>game</u> And still as a maid

He $\frac{E}{e}$njoyd the $\frac{La}{da}$dy

**Poem 10**

a  I heard an Angel singing

When the day was springing

Mercy Pity & Peace

Is the worlds release

b  Thus he sung all day

Over the new mown hay

Till the sun went down

And haycocks looked brown

c  I heard a Devil curse

Over the heath & the furze

Mercy could be no more

If there was nobody poor

d  And pity no more could be

If all were as happy as we

*At his curse*

~~Thus he sang & the sun went down~~

And the heavens gave a frown

e  ~~And~~ ~~$\frac{Down}{down}$~~ ~~pourd the heavy rain~~

~~Over the new reapd grain~~

~~And Mercy & Pity & Peace descended~~

~~The Farmers were ruind & harvest was ended~~

f  g  ~~And Mercy Pity & Peace~~   ~~And~~ <sup>by</sup> ~~distress increase~~

~~Joyd at their increase~~   ~~Mercy Pity Peace~~

~~With Povertys Increase~~   ~~By Misery to increase~~

~~Are~~   ~~Mercy Pity Peace~~

h  And Miseries increase

Is Mercy Pity Peace

1    A cradle song

**Poem 11**

a  3  Sleep Sleep; in thy sleep Little sorrows sit & weep

4  ~~Thou wilt every secret keep~~ ~~Canst~~ <sup>Canst</sup> $\frac{T}{t}$hou any secret keep

1  Sleep Sleep beauty bright

~~Thou shalt taste the joys of night~~

2  Dreaming oer the joys of night

b  ~~Yet a little while the moon~~

~~Silent~~

c  3  As thy softest limbs I ~~touch~~ ~~stroke~~ feel

Smiles as of the morning ~~broke~~ steal

Oer thy cheek & oer thy breast

Where thy little heart does rest

d  4  O the cunning wiles that creep

In thy little heart asleep

When thy little heart does wake

Then the dreadful lightnings break

e  2  Sweet Babe in thy face

Soft desires I can trace

Secret joys & secret smiles

~~Such as burning youth beguiles~~ Little pretty infant wiles

f  5  From thy cheek & from thy eye

~~O the cunning wiles that creep~~

Oer the youthful harvests n$\frac{igh}{xxp}$

<sup>infant</sup>

Infant ~~Female~~ wiles & ~~female~~ smiles

Heaven & Earth of peace beguiles

*Christian forbearance*

**Poem 12**

a  I was angry with my friend

I told my wrath my wrath did end

I was angry with my foe

I told it not my wrath did grow

b  And I waterd it in fears

Night & morning with my tears

And I sunned it with smiles

And with soft deceitful wiles

c  And it grew by day & night

Til it bore an apple bright

~~And I gave it to my foe~~

And my foe beheld it shine

And he knew that it was mine

~~And~~

d  And into my garden stole

When the night had veild the pole

In the morning Glad I see

My foe outstretchd beneath the tree

Poems 3-8 and the rules between them were written in brown ink; revisions were made in the same ink, except for the use of grey ink (italics) in the revision of 3b:3, of pencil in the revision italicized in 7b:3, and of black ink in the revision of 8b:4. The vertical lines are in pencil.

In 5c:2 'anothers' is a mistake for 'another'; the final stroke may be a slip, however, not an intentional *s*.

**Poem 3**

**a**

A flower was offerd to me
Such a flower as may never bore
But I said Ive a pretty rose tree
And I passed the sweet flower oer

**b**

Then I went to my pretty rose tree
     To tend it by day & by night
~~In the silent of the night~~
          turnd away ~~was~~ filld with Jealousy
But my rose ~~was turned from me~~
And her thorns were my only delight

**Poem 4**

**a**

          pain
~~Never seek to tell thy Love~~
~~Love that never told can be~~
~~For the gentle wind does move~~
~~Silently invisibly~~

**b**

I told my love I told my love
I told her all my heart
Trembling cold in ghastly fears
Ah she doth depart

**c**

Soon as she was gone from me
A traveller came by
Silently invisibly   O was no deny
~~He took her with a sigh~~

**Poem 5**

**a**

Love seeketh not itself to please
Nor for itself hath any care
But for another gives its ease
And builds a heaven in hells despair

**b**

So sung a little clod of clay
Trodden with the cattles feet
But a pebble of the brook
Warbled out these metres meet

**c**

Love seeketh only self to please
To bind anothers to its delight
Joys in anothers loss of ease
And builds a hell in heavens despite

**Poem 6**

**a**

I laid me down upon a bank
Where love lay sleeping
I heard among the rushes dank
Weeping Weeping

Then I went to the heath & the wild
To the thistles & thorns of the waste
And they told me how they were beguild
$\frac{D}{T}$riven out & compelld to be chaste

**Poem 7**

**a**

I went to the garden of love
And $\frac{I}{a}$ saw what I never had seen
A chapel was buil$\frac{t}{d}$ in the midst
Where I used to play on the green

**b**

And the gates of the chapel w$\frac{ere}{as}$ shut
And thou shalt not writ over the door
*So* ~~And~~ I turnd to the garden of love
That so many sweet flowers bore

**c**

And I saw it was filled with graves
And tomb-stones where flowers should be
And priests in black gounds were walking their rounds
And binding with briars my joys & desires

**Poem 8**

**a**

I saw a chapel all of gold
That none did dare to enter in
And many weeping stood without
Weeping mourning worshipping

**b**

I saw a serpent rise between
The white pillars of the door
And he forcd & forcd & forcd
          Down the golden hinges tore
~~Till he broke the pearly door~~

**c**

And along the pavement sweet
Set with pearls & rubies bright
All his slimy length he drew
Till upon the altar white

**d**

Vomiting his poison out
On the bread & on the wine
So I turnd into a sty
And laid me down among the swine

A flower was offerd to me
Such a flower as may never bore
But I said Ive a pretty rose tree
And I passed the sweet flower oer

Then I went to my pretty rose tree
To tend it by day & by night
But my rose turnd away with jealousy
And her thorns were my only delight

Never seek to tell thy love
Love that never told can be
For the gentle wind does move
Silently invisibly

I told my love I told my love
I told her all my heart
Trembling cold in ghastly fears
Ah she did depart

Soon as she was gone from me
A traveller came by
Silently invisibly O was no deny

Love seeketh not itself to please
Nor for itself hath any care
But for another gives its ease
And builds a heaven in hells despair

So sung a little clod of clay
Trodden with the cattles feet
But a pebble of the brook
Warbled out these metres meet

Love seeketh only self to please
To bind another to its delight
Joys in anothers loss of ease
And builds a hell in heavens despite

I laid me down upon a bank
Where love lay sleeping
I heard among the rushes dank
Weeping weeping

Then I went to the heath & the wild
To the thistles & thorns of the waste
And they told me how they were beguild
Driven out & compelld to be chaste

I went to the garden of love
And I saw what I never had seen
A chapel was built in the midst
Where I used to play on the green

And the gates of this chapel were shut
And thou shalt not writ over the door
So I turnd to the garden of love
That so many sweet flowers bore

And I saw it was filled with graves
And tomb stones where flowers should be
And priests in black gowns were walking their rounds
And binding with briars my joys & desires

I saw a chapel all of gold
That none did dare to enter in
And many weeping stood without
Weeping mourning worshipping

I saw a serpent rise between
The white pillars of the door
And he forcd & forcd & forcd
Down the golden hinges tore

And along the pavement sweet
Set with pearls & rubies bright
All his slimy length he drew
Till upon the altar white

Vomiting his poison out
On the bread & on the wine
So I turnd into a sty
And laid me down among the swine

1 Giants ancient inhabitants of England

2 The Landing of Brutus

3 Corineus throws Goëmagog the Giant into the sea

4 King Lear

5 The Ancient Britons according to Caesar ~~Hyperborean~~

6 The Druids

7 The Landing of Julius Caesar

8 Boadicea inspiring the Britons against the Romans ⸺ The Britons distress & depopulation

9 Alfred in the countryman's house ⸺ Women seeking from War

10 Edwin & Morcar stirring up the Londoners to resist W the Conqr ⸺ Women in a siege

11 Wm Conqr Crowned

12 King John & Magna Charta

13 Edward at Calais ⸺ A Famine occasioned by the Popish interdict

14 Edward the Black Prince brings his Captives to his father

15 The Penance of Jane Shore

~~16~~ 16 The Plague ⸺ ~~17 The Reformation by H VIII.~~

~~17~~ 17 The fire of London ⸺ 18 Christianity

16 18 The Cruelties used by Kings & Priests ~~at...~~

21 19 A prospect of Liberty

22 20 — A Cloud

Msc 2
1 Giants ancient inhabitants of England
2 The Landing of Brutus
3 Corineus throws Gogmagog the Giant into the sea
4 King Lear
5 The Ancient Britons according to Caesar   ~~The frontispiece~~
6 The Druids
7 ꚍhe Landing of Julius Caesar
8 Boadicea inspiring the Britons against the Romans   The Britons distress & depopulation
9 Alfred in the countrymans house                      Women fleeing from War
                                                         Women in a Siege
10 Edwin & Morcar stirring up the Londoners to resist W the Conqʳ
11 W the Conq Crownd
12 King John & Mag Charta
13 Edward at Calais   A Famine occasiond by the Popish interdict
14 Edward the Black Prince brings his Captives to his father
15 The Penance of Jane Shore
19 ~~17~~ 1�text,6 The Plague   ~~17 The Reformation by~~ H VIII.
20 ~~18~~ 17 The fire of London        18 ~~Ch I beheaded~~
16    18 The Cruelties used by Kings & Priests ~~whose arts~~
21 ~~19~~ A prospect of Liberty
22 ~~20~~ A Cloud

Msc 3
*Exodus*          *Egypt*

*1  Aaron xxx xxxx*          *11  Darkness*

*2  Moses xxxxxxxd*          *12  First born Smitten*

*3  River turnd to blood*    *13  Red Sea Egyptians Drownd*

*4  Frogs*

*5  Lice*

*6  Flies Swarms of Flies*

*7  Murrain of Beasts*

*8  Boils & Blains*

*9  Hail*

*10  Locusts*

P. 116 is much rubbed; it was probably for years the back of the book, though the collation indicates that four or more leaves may be missing here (see Introduction).  The name or word 'Frank' in the bottom right corner in dark ink is not in Blake's hand. Msc 2 is in black ink; Msc 3 is in pencil (italics here) and is not picked up by standard photography; yet it may not have been

[N116 transcript]

An Original Engraving by William Blake *from*
*his Fresco Painting of Chaucers Canterbury Pilgrims*

M^r B having from early Youth cultivated the two Arts Painting

& Engraving & during a Period of Forty Years never suspended his Labours

on Copper for a single Day submits with Confidence to Public Patronage &

requests the attention of the Amateur in a Large ~~Work~~ *Stroke Engraving* 3 feet 1 inch long by

one foot high  Containing Thirty original high finishd whole Length Portraits

on Horseback  Of Chaucers Characters, where every Character & every

Expression. every Lineament of Head Hand & Foot. every particular of Dress

or Costume. where every Horse is appropriate to his Rider & the Scene or Landscape

with its Villages Cottages Churches & the Inn in Southwark is minutely labourd

not by the hands of Journeymen but by the Original Artist himself even to the

Stuffs & Embroidery of the Garments. the hair upon the Horses the Leaves upon

the Trees. & the Stones & Gravel upon the road; the Great Strength of Colouring

& depth of work peculiar to M^r B's Prints will be here found accompanied

by a Precision not to be seen but in the work of an Original Artist

Sir Jeffery Chaucer & the nine & twenty Pilgrims on

their Journey to Canterbury

The time chosen is early morning before Sunrise. when

---

The odd sheet containing pp. 117-20 was salvaged from a sheet printed for Hayley's 1802 *Ballads* (see note on p. 118). Msc 13 must have been written in 1809 (or 1810), but Poem 159 on p. 120 (section i of *EG*) not before 1818. The sheet was probably sewn into the Notebook by Blake himself, not before use but to preserve its text of *EG* i. (See Longer Note, Appendix I.)

The text of Msc 13 is in standard dark ink throughout, except for an insertion in the subtitle in grey ink (here italics). One Chaucer prospectus had been published before 15 May 1809, if its printed date was right. But the exhibition perhaps was delayed till autumn (see Bentley, *Records,* p. 215 but also 219 and note). The second printed prospectus, undated, draws upon this draft; the reference in line 5 to labours of 'Forty Years' alludes to the end of Blake's apprenticeship in Aug. 1779 and thus points to Aug. 1809, when the exhibition may still have been to come.

---

erased but only rubbed away. Msc 2 must be the list of topics for *'The History of England, a small book of Engravings. Price 3s.'* which Blake advertised on 10 Oct. 1793. No copies survive, but the price for twenty to twenty-four plates (indicated by the list) suggests a small emblem size. (David Bindman suggests that 'Frank' should read 'Frontis[piece]', starting a new list.)

Blake deleted the number '5' when he considered making that picture 'The frontispiece'. His first renumbering reversed topics 16, 17, 18 to 17, 18, 16. His second made room for two new topics numbered 17 and 18, kept the original 18 as 16, and re-numbered the others to total twenty-two. He later cancelled the new topics 17 and 18 without cancelling their numbers. Further additions after 8 and 12 were not numbered but would bring the total to twenty-four.

Msc 3, probably headed 'Exodus from Egypt', though 'Exodus' is the only certain word, and I once read 'VII' where I now believe I see the 'gpt' of 'Egypt'; there is a long blank between. The first topic could possibly be 'Aaron set apart' (something like 'art' is visible). A still less substantial guess for the second would be 'Moses summond' (there is a word of about that length ending in 'd'). This would require topic 1 to derive from Exodus 28 and topic 2 from Exodus 3. The more legible topics proceed in the Bible order: (3) ch. 7:17-21; (4) ch. 8:2-14; (5) ch. 8:16-18; (6) ch. 8:21-31; (7) ch. 9:3-7; (8) ch. 9:9-11; (9) ch. 9:18-34; (10) ch. 10:4-19; (11) ch. 10:21-6; (12) ch. 11:5-12:30; (13) ch. 14:27-30. Of these, only topic 12 appears in Blake's known work, a painting for Butts called *Pestilence—the Death of the First Born.*

[N117 transcript]

# Blakes Chaucer

An Original Engraving by William Blake, from
his Fresco Painting of Chaucers Canterbury Pilgrims

Mr B having from early Youth cultivated the two Arts Painting
& Engraving & during a Period of forty Years never suspended his Labours
on Copper for a single day submits with Confidence to Public Patronage &
requests the attention of the Amateurs in a Large Work Strokes Engraving 3 feet 1 inch long by
one foot high Containing Thirty original high finished Whole Length Portraits
on Horse back Of Chaucers Characters. where every Character & every
Expression. every Lineament of Head Hand & Foot. every particular of Dress
or Costume. where every Horse is appropriate to his Rider & the Scene or Landscape
with its Villages Cottages Churches & the Inn in Southwark is minutely Laboured
not by the hands of Journeymen but by the Original Artist himself even to the
Stuffs & Embroidery of the Garments. the hair upon the Horses the Leaves upon
the Trees. & the Stones & Gravel upon the road; the Great Strength of Colouring
& depth of work peculiar to Mr B's Prints will be here found accompanied
by a Precision not to be seen but in the work of an Original Artist

Sir Jeffery Chaucer & the nine & twenty Pilgrims on
their Journey to Canterbury

The time Chosen is early morning before Sun rise. when

118

the jolly Company are just quitting the Tabarde Inn. The Knight &
Squire with the Squires Yeoman lead the Procession: then the Youthful Abbess
her Nun & three Priests. her Greyhounds attend her.

"Of small hounds had she that she fed
With roast flesh milk & wastel bread"

Next follow the Friar & Monk. then the Tapiser the Pardoner, the
Sompnour & the Manciple. After these "Our Host" who occupies the Center
of the Cavalcade (the Sun afterwards exhibited on the road may be seen depicted
in his jolly face) directs them to the Knight (whose solemn Gallantry no
less fixes attention) as the person who will be likely to commense their
Task of each telling a Tale in their order. After the Host, follow the Shipman,
the Haberdasher, the Dyer, the Franklin, the Physician the Plowman, the
Lawyer, the Poor Parson, the Merchant, the Wife of Bath the Cook. the
Oxford Scholar. Chaucer himself & the Reeve comes as Chaucer has
described "and ever he rode hinderest of the rout"

These last are issuing from the Gateway of the Inn the Cook &
Wife of Bath are both taking their mornings draught of comfort. Spectators
stand at the Gateway of the Inn & are composed of an old man a woman
& children The Landscape is an Eastward view of the Country from the Tabard
Inn in Southwark as it may be supposed to have appeard in Chaucers

The edges of printed letters at the torn top edge of the paper identify it as salvaged from the inner margin of the first sheet (pp. 41-8) of the fourth fascicle of William Hayley's *Designs to a Series of Ballads* (1802) for which Blake engraved the plates. The printer had supplied him with unsewn sheets of each ballad, and they had not sold well.

Msc 13    the jolly Company are just quitting the Tabarde Inn.  The Knight &

Squire with the Squires Yeoman head the Procession: then the Youthful Abbess

her Nun & three Priests.  her Grayhounds attend her.

        "Of small Hounds had she that she fed

        With roast flesh milk & wastel bread"

Next follow the Friar & Monk. then the Tapiser the Pardoner. the

Sompnour & the Manciple.  After these "Our Host" who occupies the Center

of the Cavalcade (the Fun afterwards exhibited on the road may be seen depicted

in his jolly face) directs them to the Knight (whose solemn Gallantry no

less fixes attention) as the person who will be likely to commense their

Task of each telling a Tale in their order.  After the Host, follow, the Shipman,

the Haberdasher, the Dyer, the Franklin, the Physician the Plowman, the

Lawyer, the Poor Parson, the Merchant, the Wife of Bath the Cook. the

Oxford Scholar.  Chaucer himself & the Reeve comes as Chaucer has

    described

        "And ever he rode hinderest of the rout"

These last are issuing from the Gateway of the Inn the Cook &

Wife of Bath are both taking their mornings draught of comfort.  Spectators

stand at the Gateway of the Inn & are composed of an old man a woman

& children

        The Landscape is an Eastward view of the Country from the Tabarde

Inn in Southwark as it may be supposed to have appeard in Chaucers

Blake in writing this document seems to have been unusually conscious of preparing an address to the public for a printer to set in type.  He took care to use quotation marks, and when he began attending to commas he put them busily to work—confusingly, for editors have mistaken the comma after 'follow' for an *s* and have read 'follows'.

[N118 transcript]

time. interspersed with Cottages & Villages, the first beams of the Sun, are
seen above the Horizon. some buildings & spires indicate the situation of
the Great City.  The Inn is a Gothic Building which Thynne in his Glossary
says was the Lodging of the Abbot of Hyde by Winchester.  On the Inn is
inscribed its title & a proper advantage is taken of this circumstance
to describe the Subject of the Picture.  the Words written in Gothic Letters
over the Gateway are as follow 'The Tabarde Inne by Henr̲y̲ Baill̲y̲
the Lodgynge House for Pilgrims who Journey to Saint Thomass Shrine
at Canterbury

      The Characters of Chaucers Pilgrims are the Characters that compose
all Ages & Nations, as one Age falls another rises.  different to Mortal Sight
but to Immortals only the same, for we see the same Characters repeated
again & again in Animals in Vegetables in Minerals & in Men.  Nothing
new occurs in Identical Existence ∴  Accident ever varies Substance can
never suffer change nor decay

tome. interspersed with Cottages & Villages, the first beams of the sun, are seen above the Horizon. some buildings & spires indicate the situation of the Great City. The Inn is a Gothic Building which Thynne in his Glossary says was the Lodging of the Abbot of Hyde by Winchester. On the Inn is inscribed its title & a proper advantage is taken of this circumstance to describe the subject of the Picture. the Words written in Gothic Letters over the Gateway are as follow 'The Tabarde Inne by Henry Baillie the Lodgynge House for Pilgrims who journey to Saint Thomass Shrine at Canterbury

The Characters of Chaucers Pilgrims are the Characters that compose all Ages & Nations: as one Age falls another rises. different to Mortal Sight but to Immortals only the Same, for we see the Same Characters repeated again & again in Animals in Vegetables in Minerals & in Men. Nothing new occurs in Identical Existence: Accident ever varies Substance can never suffer change nor decay

Was was Born of a Virgin Poor
With narrow Soul & bodys demean
If he intended to take ones sin
The Mother should an harlot been
Just such a one as Magdalen
With heaven dearly in her Pen
Or whose was Virgin still more sweet And more seeking
Or what was it which he took on
That he might bring Salvation
A Body subject to be Crucified
From neither pain nor grief exempted
Or such a body as might not feel
The passion that with sinners dead
Yes but they say he never fell
Ask Caiaphas for he can tell
He mockd the sabbath & he mockd
The sabbath God & he unlockd
The Evel spirits from their shrine
And turnd Disturbers in to Divines
He turnd the devils into Swine

That he might tempt the Jew to Dine
Since which a Pig has got a cote
That for a Jew man be mistook
Oh your Parents what says he
Woman what have I do with thee
No earthly Parents I confess
I am doing my Fathers Business
He scornd his earthly Parents scorns his God
And mockd the one & the other Rod
His seventy Disciples sent
Against Religion and Government
They by the sword of Justice fell
And him their Cruel Murderer tell
He left his wandering trade to roam
A wandering Vagrant without Home
And thus he others labour not
That he might live above Controll
The Publicans & Harlots he
Selected for his Company
And from the Adulteress turnd away
God's righteous law that lost its Prey
... of secret sins act of God
And ... in the Bloody Reign of War
And ... around from Star to Star

Note the printed catchword 'And' beneath the third line. See note on p. 118.

[N120]

**Poem 159**
**(EG i)**

Was Jesus Born of a Virgin Pure

With narrow Soul & looks demure

If he intended to take on Sin

The Mother should an Harlot been

Just such a one as Magdalen  5

With seven devils in her Pen

Or were Jew Virgins still more Curst And more sucking
Or what was it which he took on

That he might bring Salvation  10

A Body subject to be Tempted

From neither pain nor grief Exempted

Or such a body as might not feel

The passions that with Sinners deal

Yes but they say he never fell  15

Ask Caiaphas for he can tell

He mockd the Sabbath & he mockd

The Sabbaths God & he unlockd

The Evil spirits from their Shrines

And turnd Fishermen to Divines  20

He turnd the devils into Swine  *  27

*devils nurst*

That he might tempt the Jews to Dine

Since which a Pig has got a look

That for a Jew may be mistook  30

Obey your Parents what says he

Woman what have I to do with thee

No Earthly Parents I confess

I am doing my Fathers Business

He scornd ~~his~~ *Earths* Parents scornd ~~his~~ *Earths* God  35

And mockd the one & the others Rod

His Seventy Disciples sent

Against Religion & Government

They by the Sword of Justice fell

And him their Cruel Murderer tell  40

He left his Fathers trade to roam

A wandring Vagrant without Home

And thus he others $\frac{la}{w}$bour stole

That he might live above Controll

The Publicans & Harlots he  45

Selected for his Company

And from the Adulteress turnd away

Gods righteous Law that lost its Prey

{ *$\frac{Oer}{End}$turnd the Tent of Secret Sins & its Golden*
  *cords & Pins Tis the Bloody Shrine of War*
  *Pinnd around from Star to Star*  24

*25/26*

*Halls of Justice hating Vice $\frac{Wh}{Th}$ere the Devil Combs his Lice*

---

*EG* i (Poem 159) is written in black ink, with revision in greyer ink (here italics) or pencil (the second 'Earths' of line 35, here also italics), except that the 'Halls of Justice' lines in the right margin were added in a darker ink with a sharper pen.

This section of *EG* is almost certainly a sequel to the initial sections (j, k) written on the separate leaf of 1818 watermark notepaper, reproduced in Appendix III. In turn it precedes the sections in the Notebook proper. (See Longer Note, Appendix I.)

[N120 transcript]

# 5

# APPENDICES

# APPENDIX I

## LONGER NOTES ON POEMS

FOR most of the Notebook poems our typographical transcripts with accompanying notes should suffice to give the information needed to interpret the photographs. Longer notes are supplied for cases that are exceptional in complexity of data or of interpretation. For analysis and discussion of the textual variants and changes of each of the poems, the reader is referred to the Textual Notes in my edition of *The Poetry and Prose of William Blake*. Note that revision and improvement of these Textual Notes have been made with each printing since the first, 1965; corrections in the fourth printing, 1970, were particularly important. The fifth printing, 1977, is to incorporate the latest refinements achieved by the present publication.

Longer notes are supplied for the following:

Poem 17 'Infant Sorrow' and Poem 33 'To my Mirtle'.
Poem 71 'My Spectre around me night & day'.
Poem 78 'And his legs carried it like a long fork'.
Poem 89 'Sir Joshua Praises Michael Angelo'.
Poem 159 'The Everlasting Gospel.'

## Poem 17 (pp. 113, 111) and Poem 33 (p. 106); titles 'Infant Sorrow' and 'To my Mirtle'

The title 'Infant Sorrow' belongs only to stanzas a and b of Poem 17 and was probably inserted only when they were being copied out to be one of the *Songs of Experience*. The title 'To my Mirtle' belongs only to the lines that were selected from the stanzas of Poem 17 on p. 111 and arranged into a six-line strophe (Poem 33) on p. 106. Poem 17 in its fuller drafts on pp. 113 and 111—of eight stanzas (a–h), then of eight or nine stanzas (abcde′j′kl *or* abicd′j′kl), then of ten (abicd′ekj′lh′)—has no proper title but constitutes (chiefly by virtue of st. h or h′) a cycle poem from infancy to grey hairs.

The successive stages of the manuscript are extremely difficult to deduce. The ink of the first fair copy (including the revision *en passant* of st. d and the revision of 'grew' to 'soothd' in line c 1) on

p. 113 is rather uniformly greyish. But in the subsequent revisions on p. 113 and in the first draft and revisions on p. 111 distinctions of shade are blurred and sometimes misleading; variations from greyer to darker shades seem to occur from one dip of the pen to the next.

Blake's first draft, in greyish ink, consisted of sts. a–h followed by a greyish horizontal rule. As noted, the revision of d to d′ was made in draft, but it is difficult to say whether the two lines here designated d were at once cancelled and d′ written as the first full fourth stanza, or whether Blake first wrote a full stanza consisting of d and d′ 1–2 and subsequently cancelled d and added d′ 3–4 at the other end.

Before further revisions Blake probably went on to p. 111 (preserving the illustration on p. 112), wrote Poems 18 and 19 there, and then below them wrote the stanzas here designated j–l, combining the mirtle theme of p. 113 with the motif of 'free love with bondage bound' of Poem 19, 'Earths Answer'. He may have thought of these new stanzas as the draft of a separate poem, on love, not infancy. Ultimately they were made into the six lines of Poem 33, on p. 106. And they do not, before revision, fit anywhere into the unrevised poem on p. 113—unless meant to come immediately after st. d with the effect of cancelling the rest of p. 113. If we assume that to have been Blake's intent, however, his continuing to work over sts. e–h must be taken to indicate his deciding not to act on it.

Blake's first series of revisions on p. 113 are confined to that page. They change the singular 'Priest' and associated pronouns and 'serpent' and 'vine' in sts. e–h to 'Priests', 'serpents', and 'vines' with plural pronouns. (The 'priest' of st. 1 on p. 111 is undisturbed.) Other revisions, made perhaps at the same time, perhaps subsequently, change some of the flowering tree images. In d′ 'a mirtle tree' with 'its blossoms' becomes 'many a lovely flower & tree' with 'their blossoms'. In the next stanza (e), as if in adjustment to these changes, 'fruit or blossoms' is cancelled and 'a mirtle shade' is introduced. (The accidental double t in 'fruitt' may cover a mending from 'fruits'.) In sts. f and g 'mirtle' is replaced by 'blossoms', perhaps for the more dramatic or delayed appearance of 'the roots my mirtle bore' in st. h.

Blake's next move was to draw cancelling pen strokes through all the lines of st. f and the first two lines of g. But then he restored the latter by numbering all four lines of g to put the second couplet first. He would not finally drop sts. f and g until he had found a replacement for st. g as the link to terminal stanza h. Put another way, there was no place in the poem for the stanzas on p. 111 until f and g *were* dropped.

In Blake's next series of revisions a new stanza (i) was inserted in the bottom right corner of p. 113 and marked to go in between b and c. Then the artful smiling introduced in st. i was, momentarily, carried into st. c by the insertion of 'smild' above the cancelled 'grew' in c 1 in place of 'soothd'; before cancelling 'soothd', however, Blake cancelled 'smild' instead.

After the series of revisions just described, the next or perhaps a concurrent change reduced the plural villain 'priests' back to a single 'father'—derived perhaps from the selfish cruel 'father of men' cancelled from 'Earths Answer' only *after* sts. j–l were written on the same page (111), forcing Blake to go up into the pencil drawing to write his replacing stanza. In e1 'My father then' replaced 'But many a priest', and in e2 the inserted 'their' was cancelled with a heavy stroke, in effect (and doubtless in intent) restoring the lightly cancelled 'his'. Then, ignoring the pronouns in sts. g and h (and in effect cancelling those stanzas), he turned to p. 111, revised 'the priest beheld' to 'my father saw' in st. 1, and in the remaining space below it recopied st. h (as h′) with the pronoun changed back from 'their'

to 'his'. This meant that Blake had decided to use the stanzas on p. 111, which he now arranged in the order kj'l by numbering them 1,2,3, as the route to st. h, the terminal stanza of gore and grey hairs. Probably at this point he indicated the cancellation of st. g by smudging its line numbers with wet ink.

The poem, a cycle from birth to death or old age, now consisted of ten stanzas: a,b,i,c,d,'e,k,j',l,h'. At this point, to make the linkage between st. e and st. k explicit, he copied the last part of e4, the phrase 'in a mirtle shade', as a catch-phrase above st. k.

(The function of 'in a mirtle shade' as a catch-phrase has long been misunderstood. In 1926 Max Plowman called attention to it but in the context of a mistaken reconstruction of the sequence of the writing on p. 111. In both Keynes's and my own editions the phrase has been treated as the title of an independent poem—which would suit perhaps if taken without st. h'. Now Donald K. Moore has helped get the sequences right.)

Blake's next step, possibly after a considerable interval, was to insert the title 'Infant Sorrow' above st. a.

There remain some vertical and diagonal crossing lines to be accounted for, as well as the origin of Poem 33 on p. 106. On p. 113 the two stanzas destined for 'Infant Sorrow' are lined vertically in pencil, signifying their transfer to the *Songs*. Stanzas c–d', however, are firmly crossed out by vertical and diagonal strokes of a pen held sideways, and the second column of stanzas by three vertical strokes of the same sort but less visible because the pen was running out of ink. The effect (and probable purpose) was to isolate the stanzas (a,b) chosen for copying out. Otherwise the cancelling was not a part of the critical growth of the longer poem, since sts. f and g had already been cancelled and h had been transferred to p. 111 and e had at least been marked for transfer by the insertion of the catch-phrase on that page.

Vertical pencil lines of the sort indicating transfer elsewhere were drawn through all the stanzas on p. 111 (except the replacement st. 19c' buried in the drawing). Poem 18 was probably copied out (as 'Experiment') for that '1 Plate' called for by the memorandum on p. 101 which has not survived. 'Earths Answer' was used in *Songs of Experience*. And the mirtle tree stanzas? We can see that they were, except for the stanza (h') that makes the cycle poem, transferred by couplets to p. 106 and there shaped into an unprogressive lament or tableau and titled 'To my Mirtle'. Without changing a word, Blake copied out the first couplet of st. j' (but erased it while wet); then all of st. k; then, after a space, the two lines of j and, in reverse order, the two couplets of j'. He then cancelled the second couplet of k and the second, now first, couplet of j', numbering the lines to move the k couplet to the end of a six-line poem of three couplets but no stanzas. This he gave a title and did not cancel or transfer from the Notebook. (The diagonal lines that seem to cross it are details of the original pencil drawing on the page which Blake wrote his poem on top of.)

## Poem 71 (pp. 13, 12) 'My Spectre around me night & day'

This poem may be analysed as developing through nine drafts, the first seven on p. 13, with the seventh overflowing on to p. 12, and additions and revisions on p. 13 carrying the work into a ninth.

In dark ink Blake wrote what we may call draft A: seven stanzas in fair copy, a b c d e f g, the first two referring to 'My Spectre' and 'My Emanation' in the third person ('she' in b4) but the rest addressing the Emanation directly as 'Thou'. Revision began with the erasure and rewriting of b1–2,

keeping the third person ('She', 'Her weeping'). Next Blake decided to begin the direct address in st. b. He revised the pronouns of b1–2 to 'Thy', 'thou', and 'thee', cancelled b3–4, and wrote two new lines, b′ 1–2, in the adjacent space. But then he cancelled all of st. b and filled out b′ to a full quatrain to replace b. The result, draft B, consisted of seven stanzas: a b′ c d e f g, not yet numbered.

Blake next considered making a stanza of a3–4 and b1–2, numbering these lines '1 2 3 4' in the left margin (thus restoring cancelled lines b1–2 for the moment and rejecting a1–2). During this tentative revision (not enforced by cancel lines) he also apparently considered using lines b′1–2 in place of a3–4 (a thematic variant); he actually cancelled b′3–4, but next he restored all four lines of b′ by numbering them '1 2 3 4' and cancelling the numbers he had written alongside a3–4 b1–2, in effect restoring the original st. a and recancelling b. In the same ink he wrote two amplifying stanzas, d+1 and f+1, not numbering them but marking them 'To come in' after d and f respectively. The result, draft C, begins with a and b′ and continues, with these inserts, from c to g, thus: a b′ c d d+1 e f f+1 g—nine stanzas.

In a later impulse of revision, using grey ink, Blake created a new second stanza, b″, made a revision in c3 ('lover' to 'true love'), and numbered ten stanzas thus: a(1) b″(2) b′(3) c(4) d(5) d+1(6) e(7) f(8) f+1(9) g(10)—draft D, the first draft with stanzas numbered.

Later, returning to dark ink, Blake made two successive modifications of draft D, trying d+1 as the third stanza. The first of these (draft E) rearranges, by renumbering, the middle stanzas: d+1(3) b′(4) c(5) d(6). The whole is still ten stanzas. The second (draft F) reduces the whole to seven stanzas by cancelling sts. b′ and c, and bypassing d, for the numbered result: a(1) b″(2) d+1(3) e(4) f(5) f+1(6) g(7).

A final step (made in a different ink, dark grey but not here set off typographically) was to write a new second stanza, b‴, cancel sts. b″ and d+1, and restore (by numbering) sts. d and b′, for the following numbered sequence (draft G): a(1) b‴(2) d(3) d+1(4) e(5) f(6) f+1(7) g(8). Blake continued, perhaps immediately, to write sts. h, i, j on p. 12, numbering them 9, 10, 11 as he went (in the same dark ink used in the final revisions on p. 13). They constitute an answer by the Emanation to her male pursuer; the draft G revision inserting 'as I' in g4 sharpens the indication of personal dialogue and seems made in anticipation of the continuation on p. 12. This eleven-stanza poem, before revision of j(11), we may call draft H, though in effect it constitutes simply the completion of draft G.

In the same ink but with a sharpened pen, Blake next revised the pronouns of st. j(11) to give himself (or the male self) the final word, and continued it in two more stanzas, numbering them 12 and 13 (draft I).

Blake ultimately added five more stanzas, in pencil—chosen perhaps for tentativeness, perhaps thinking that pencil would do least damage to his Daphne drawing: note that he first avoided this page altogether (writing his poem on p. 13) and then wrote tidily above and below the drawing. Stanza q was undoubtedly crowded in last, but the sequence of the other four stanzas in pencil is difficult to determine; I have designated them m n o p in the likeliest order. St. m may have been written first as a possible replacement of st. '13' and then given an introductory '&' and the number '14' to be its continuation. St. n is most manageable as a sequel to m (it will not do to follow o, p, or q); yet it is in a very blunt pencil and may be the latest afterthought. Sts. o, p, and q have nothing to do with the conclusion of the poem but constitute one more try at revising its beginning. St. o is

addressed *to* the Emanation; st. p, before pronoun revision, could be her retort; q could be its continuation (the reference to 'thy Harlots', in context, seems to require a female speaker). The revision of p suits it to the male speaker, with q following as the female's reply. Blake's numbering of these '1' and '2' implies a new version of the whole. (His omitting numbers from n and o constitutes their rejection.) But it cannot be reconstructed by simple substitution of these two stanzas for the two that have served as 1 and 2 in drafts G, H, I, namely sts. a and b''', since the latter stanza prepares for the reference to the spectre in the next stanza, d, which would be left dangling if preceded by p(1) q(2). A feasible draft J, however, could be made by dropping st. d; it would read: p(1) q(2) d+1(3) e(4) f(5) f+1(6) g(7) h(8) i(9) j(10) k(11) l(12) m(13). The striking thing about this draft is its entire exclusion of the term 'Spectre' (an exclusion partly accomplished in the revisions between drafts B and C) and the term 'Emanation'. The exclusion would seem to have much to recommend it, not only the removing of esoteric terminology and the shaping of the poem into a universal dialogue between male and female, but also the elimination of a confusion of persons that seems to have developed as soon as the original seven-stanza poem began to be revised. At first 'I', 'My Spectre', and 'My Emanation' are clearly distinguished. Gradually an identification of 'I' and 'Spectre' intrudes upon and threatens to reduce this trio of two males pursuing one female into a pure 'I-Thou' argument; references to the Spectre (even in the 'rescue' stanza, b''') have become only vestigial in the poem as a whole. Only Blake's failure to cancel st. d and to renumber the other stanzas prevents us from accepting with full confidence as his final intention the draft J which is reconstructed above.

A possible relationship between the Spectre poem and the Daphne drawing on p. 12 should be noted. While, as we have seen, the drawing probably preceded the poem, it would be characteristic of Blake to choose an appropriate picture to write his poem beside. The thematic relevance of Blake's poem to Milton's Masque, quoted in the legend under the Daphne picture, is superficially obvious and might repay further consideration. In Milton's poem, Comus desires the Lady to sit, not flee, or he will chain her nerves in stone or make her root-bound 'as Daphne was that fled Apollo'. Blake's Spectre desires the Emanation to stop fleeing, *yet also* to stop becoming infernally rooted.

## Poem 78 (p. 22) 'And his legs carried it like a long fork'

Two leaves may be missing between pp. 22 and 23 (see Introduction, pp. 5 and 6). They may have contained two recto emblems, some passages of *PA*, and more lines belonging to Poem 78.

This possibility permits the following hypothetical explanation of what is otherwise a puzzling matter, the conflict between internal and external indications of the date of the poem's composition. In the poem, R. H. Cromek's death is unmistakably referred to as having occurred; yet Cromek died in March 1812, whereas the context of the poem in *N* seems to require a date of ca 1810. If 1812 is accepted as the date of the poem, it is difficult to understand why p. 22 was left blank when *PA* was being written on preceding and following pages; indeed, before the writing of *PA*, this page would presumably have been used for satiric verses when Poems 79 and following were being inscribed on pp. 23 ff. But Poem 78, like 79, refers to Schiavonetti's death (7 June 1810) and could have been started then.

A completely tidy hypothesis would also account for the extant poem's beginning *in medias res*. My conjecture is that the original poem was written not long after 7 June 1810, that it began on one of the missing leaves, continued as the first writing on p. 22 ('And his legs' etc.), and was concluded

on the missing leaves. (For a similar kind of working backward, compare Poem 71, begun on p. 13 and continued on p. 12.) The supposition that originally the poem carried on into another page would explain the curious fact that the basic text on p. 22, which has the appearance of fair copy, ends in mid air, i.e. in the first line of a rhymed couplet.

The insertions in the left margin, it is true, must have been prompted by the attack on Blake as mad in the *Examiner* of 17 September 1809, and they sound like a fairly immediate response, making comparisons to Prince Hoare's paper, *The Artist*, which ceased publication in December 1809. But the insertions in the right margin, completing the couplet but presumably revising the contents, declaring Cromek dead and gone, 'Recievd' by Death and lamented by his surviving fellow conspirator, must have been added after his death in 1812.

The conjecture is, in short, that in 1812 Blake returned to this two-page poem, cancelled the concluding part (but not the part that preceded 'And his legs'), and inserted a new, post-Cromekian conclusion in the right margin of p. 22. The hypothesis does not imply Blake's tearing out the missing leaf or leaves, for they would have contained the beginning of the poem.

## Poem 89 (p. 28) 'Sir Joshua Praises Michael Angelo'

The complications of this text may be disentangled as a series of drafts, often abandoned before completion. Blake first thinks of Reynolds's brashness in putting his hypocritical praises into print:

Draft A, not finished:

Sir Joshua Praises Michael Angelo
And counts it courage thus to praise his foe
Printing his praises of

Draft B substitutes a new third line:

It would be Christian Mildness to maintain

Draft C is complete:

Sir Joshua Praises Michael Angelo
Tis but Politeness thus to praise his foe
Twould be Madness that we all must say
Act Michael Angelo praising Sir Joshua

One understands the part Joshua Reynolds is acting, that is to say, but who could act the mad part of Michael Angelo praising *him*? Blake simplifies to a direct conception of such praising (draft D):

But Twould be Madness all the World should say
As Michael Angelo praisd Sir Joshua

Draft E makes this less outrageous by replacing 'As' with 'If'. Finally, draft F (with a subdraft in which 'fools' is changed to 'Knaves' in the second line) enlarges the poem to five lines:

Sir Joshua Praises Michael Angelo
Tis Christian Mildness when Knaves Praise a Foe
But Twould be Madness all the World would say
Should Michael Angelo praise Sir Joshua
Christ usd the Pharisees in a rougher way

## 'The Everlasting Gospel'

## Poem 159 (pp. 33, 48–54, 98, 100–1, 120; and manuscript in Appendix III)

See also E791–6 and especially 'Terrible Blake', for a very full textual analysis of this poem.

Here is a table of all the sections of *EG*, as designated originally by Keynes, with cue titles for convenience.

a  (opposing Visions of Christ) *N* 33
b  (Was Jesus gentle) *N* 100–1
c  (Was Jesus Humble) *N* 98
d  (Was Jesus Humble, revised) *N* 52–4, headed 'The Everlasting Gospel' and concluded with the tally '78 lines' and a catch-line to cue in section e
e  (Was Jesus Chaste) *N* 48–52, concluded with the tally '94 lines'
f  (This Jesus will not do) *N* 54, a couplet written marginally near the end of section d
g  (Seeing this False Christ) *N* 52, a couplet written below e and followed by a catch-phrase 'What are those &c' to cue in another section which does not correspond exactly with any of those extant
h  (Did Jesus teach doubt) *N* 48, two couplets written in the margin of e, possibly related to the comment near it: 'This was spoke by My Spectre to Voltaire Bacon &c'
i  (Virgin Pure) *N* 120

Sections in the separate Rosenbach MS. (Appendix III)

j  (Covenant of Jehovah) prose paragraph on p. 1 of folded leaf
k  (If Moral Virtue) 14 lines on p. 4 marked 'This to come first' and numbered '1'
l  (What can this Gospel) 43 lines on pp. 2–4, numbered '2'
m  (What are those), section alluded to in g and presumably lost (or an intended revision of lines 11 ff. of k)

It is my deduction that the order of writing of the twelve surviving and one lost fragments was: j, l, k, i, (m), a (with some doubt), e, g, h(?), b, c, d, f (except that the lost m, if a variant of k, may have preceded i). To me, passages j, l, k, the first prose, the second little more than rhymed prose, and the third spirited verse moving unsteadily toward dramatic vision, are preliminary gropings rendered obsolete and redundant by the Notebook sections b,d,e,h. Section i is transitional, especially in the

ambiguity of its irony; Blake wished to preserve it, if it is true that he is responsible for the binding into *N* of the scrap of paper that contains i. But a fresh beginning is made next in the Notebook proper—at a time, 1818 or later, when there were only a few scattered open pages left for use.

Leafing forward from the front of the Notebook, Blake was not skipping any blanks of great size when he inscribed section a on p. 33, though there were slightly larger spaces on pp. 27, 28, and 30. He might next have used pp. 44–5, but the larger opening from p. 48 to p. 52 was discernibly more useful. Here he wrote e, and the next large blanks he found had room for c, on p. 98, and b, on pp. 100–1 (though p. 64 may only now have been inscribed with the prose remark about Jesus' nose which is thematically related to a). Finally Blake rewrote c as d, squeezing it in after e on pp. 52–4, with f as a sort of marginal note on p. 54, and inserting a title, 'The Everlasting Gospel', at the head of d.

It must be recognized that it is only editorial sensitivity to fitness that confirms section a as a part of *EG*. It does well as Prologue, where Keynes places it; yet neither inclusion nor placing is clearly authenticated. The first 'Humble' section, c, is of course a discarded draft; so surely are i, j, k, l, unless we choose to rescue i for a summary—but where? Blake's placing the title above d hardly leaves room for a Prologue, whether i or a; can i really serve as Epilogue? Blake seems to have been discarding g (with the lost m); h ('Did Jesus teach doubt') may be but a start and f ('This Jesus will not do') a note. Perhaps Blake's 'final' sequence was d e b (Humble, Chaste, Gentle); we are sure of d e; and b could easily follow e, as it did in composition. The extension of the concluding couplet of b into a triplet looks as if it were current, but it may have been a later change signifying a decision to end the poem here. (And this would leave i and a quite out of the picture.) The 'pure' editorial reduction of the text must be d e b, I suspect.

Good structural arguments could be made for the crescendo sequence d b e (Humble, Gentle, Chaste), however, and even for e d b (Chaste, Humble, Gentle) or b e d (Gentle, Chaste, Humble). And if we are to admit insertions between the title and d, we may have the two couplets of h as an opening refrain. Of possible arrangements assigning auxiliary functions to h, i, and even a, an attractive sequence might be: h i d e b a. Yet it is perhaps even more important to recognize the shape of the poem that was emerging as Blake modelled each new section in more markedly parodistic relation to the last. Vision against Vision: Was Jesus Chaste? Was Jesus Gentle? Was Jesus Humble? Each set of Contradictions explodes or 'rolls away' into another—taken in either direction. To plagiarize lines 50–1 of section c: do what we will this Poem's a Fiction and is made up of Contradiction.

# APPENDIX II

## DETAILS AND TRACINGS OF DRAWINGS
## RELATED WORKS

### 1. NOTEBOOK DRAWINGS: DETAILS AND TRACINGS

SOMETIMES the best photograph of a whole page does not represent the details of an emblem drawing as well as an otherwise less satisfactory photograph. Such are drawn upon for details here. Tracings are supplied for some of the drawings that do not show up clearly in any photograph.

#### a. EMBLEM DRAWINGS

Fig. 1. 18b (Emblem 3) infra-red photograph
Fig. 2. 22a (Emblem 6) infra-red photograph
Fig. 3. 22a (Emblem 6) tracing
Fig. 4. 23a (Emblem 7) infra-red photograph
Fig. 5. 27a (Emblem 10) tracing
Fig. 6. 53a (Emblem 32) tracing

Fig. 7. 58c (Emblem 37) tracing
Fig. 8. 79a (Emblem 51) tracing
Fig. 9. 87a (Emblem 56) tracing
Fig. 10. 89a (Emblem 57) tracing
Fig. 11. 95a (Emblem 61) infra-red photograph
Fig. 12. 99a (Emblem 63) tracing

#### b. OTHER NOTEBOOK DRAWINGS (TRACINGS)

Fig. 13. 8b (face)
Fig. 14. 12b (face)
Fig. 15. 25b (unidentified: roots and trunk?)
Fig. 16. 32b (unidentified: a plant?)
Fig. 17. 36a (right foot)
Fig. 18. 50a (Oothoon above Theotormon, early sketch)
Fig. 19. 55a (a candle in a sconce)
Fig. 20. 58a (figure beneath a banyan tree)
Fig. 21. 58b (figure[s] at base of a barren tree)
Fig. 22. 66b (reader on a cloud being nudged by kneeling figure)
Fig. 23. 70c (sofa, or turtle?) palimpsest drawing beneath 70b
Fig. 24. 76a (group of three adults, several children)
Fig. 25. 77b (head)
Fig. 26. 88a (Eve and the serpent)
Fig. 27. 98a (head-clutching warrior: Macbeth?)
Fig. 28. 107a (sitting figure)
Fig. 29. Composite photograph of pp. 110–11

## 2. RELATED DESIGNS BY BLAKE

Fig. 30. *Fate* (cf. Emblem 55, *N*85a), pencil drawing exhibited at the Tate Gallery in 1970
Fig. 31. *The Evil Demon* (cf. Emblem 52, *N*81a), pencil drawing in the Harvard College Library (H3)
Fig. 32. Sheet of allegorical drawings (related to *NT*) in the Harvard College Library, recto (H1)
Fig. 33. Sheet of allegorical drawings, verso (H2)  (But H1–2 are copies by D. G. Rossetti)
Fig. 34. Rejected design for Hayley's Eagle ballad (cf. *N* 73a–c), pencil drawing in Print Room, British Museum (1929–7–13–271ʳ)

## 3. RELATED DESIGNS BY HENRY FUSELI

Fig. 35. *The Shepherd's Dream from 'Paradise Lost'* (1793) Tate Gallery (variant of Schiff, Pl. 42, 1785)
Fig. 36. *Satan bursts from Chaos* (*Satan fliegt ohne Antwort auf vom Chaos*), collection of Mrs. Jocelyne B. Murray-Crane, New York (Schiff, Pl. 21)

## 4. RELATED DESIGNS BY JAMES GILLRAY

Fig. 37. *The Morning after Marriage* (5 April 1788) (cf. *N* 14c)
Fig. 38. *The Slough of Despond; Vide The Patriots Progress* (2 January 1793) (cf. *N* 40a)

## 5. RELATED DESIGN BY THOMAS STOTHARD

Fig. 39. *The Reception*, 'Christian's conduct amidst the difficulties he had passed through meeting with the approbation of Discretion, Prudence, Piety & Charity, he is by them received joyfully into the Palace Beautiful.' Engraved by Jos. Strutt (1 March 1789) for Bunyan's *Pilgrim's Progress*, London, 1792, f.p.220 (British Museum)

## 6. RELATED DESIGNS FROM THE EMBLEM TRADITION

Fig. 40. *Bring my soule out of Prison*, engraved by Will Simpson for Francis Quarles, *Emblemes*, London, 1635, Book 5, Emblem 10 (Arents Collection, The New York Public Library)
Fig. 41. *Of the Use of Self-Denial*, engraved probably by Ovenden after Wale for John Wynne, *Choice Emblems*, London, 1772, Emblem 24 (British Museum)
Fig. 42. *Of Vain Pursuits*, engraved probably by Ovenden after Wale for *Choice Emblems*, Emblem 27

# 1. NOTEBOOK DRAWINGS: DETAILS AND TRACINGS

## a. EMBLEM DRAWINGS

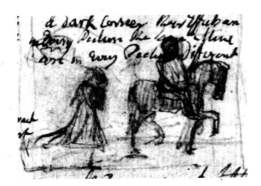

FIG. 1. 18b (Emblem 3)

FIG. 2. 22a (Emblem 6)

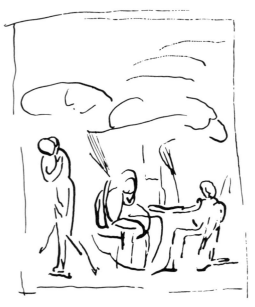

FIG. 3. 22a (Emblem 6)

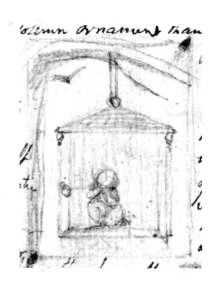

FIG. 4. 23a (Emblem 7)

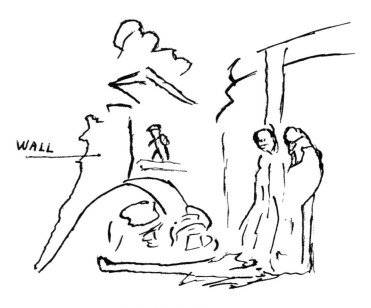

WALL

FIG. 5. 27a (Emblem 10)

FIG. 6. 53a (Emblem 32)

FIG 7. 58c (Emblem 37)

FIG. 8. 79a (Emblem 51)

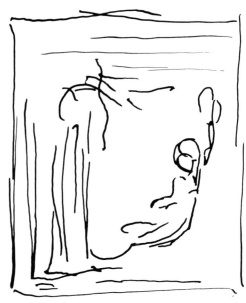

FIG 9. 87a (Emblem 56)

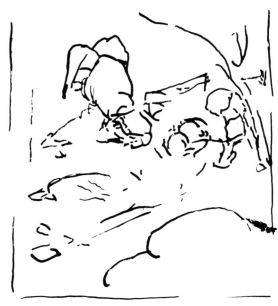

FIG. 10. 89a (Emblem 57)

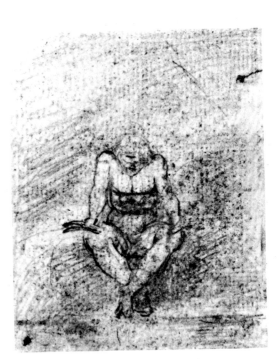

FIG. 11. 95a (Emblem 61)

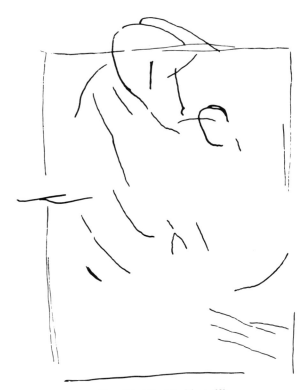

FIG. 12. 99a (Emblem 63)

79

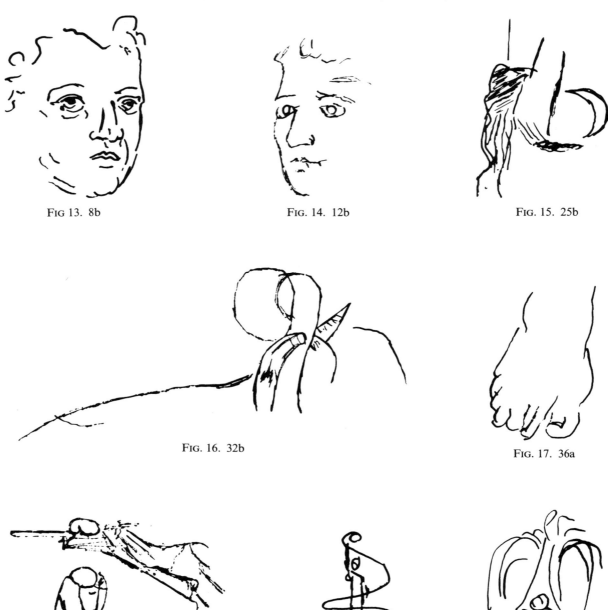

FIG 13. 8b

FIG. 14. 12b

FIG. 15. 25b

FIG. 16. 32b

FIG. 17. 36a

FIG. 18. 50a (Oothoon above Theotormon)

FIG. 19. 55a

FIG. 20. 58a

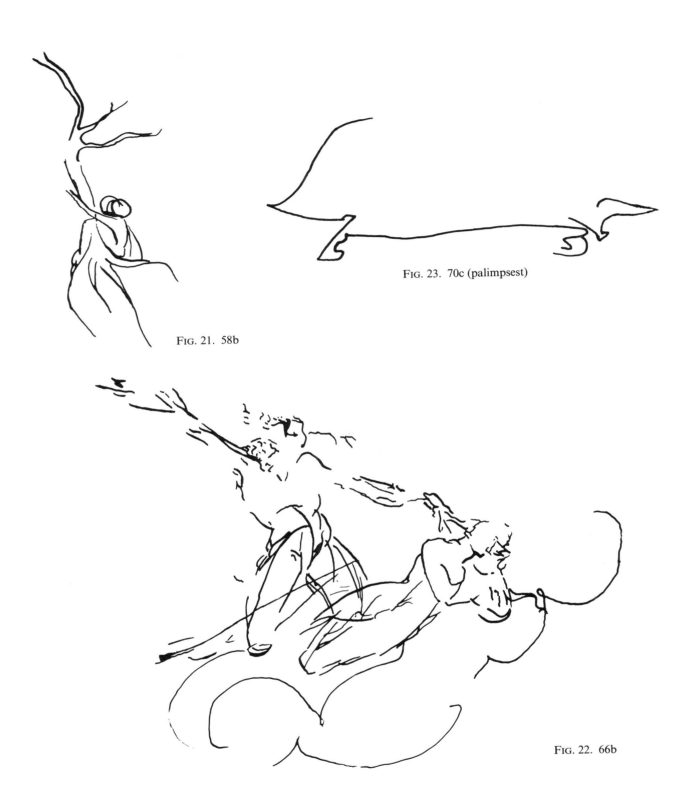

Fig. 21. 58b

Fig. 23. 70c (palimpsest)

Fig. 22. 66b

81

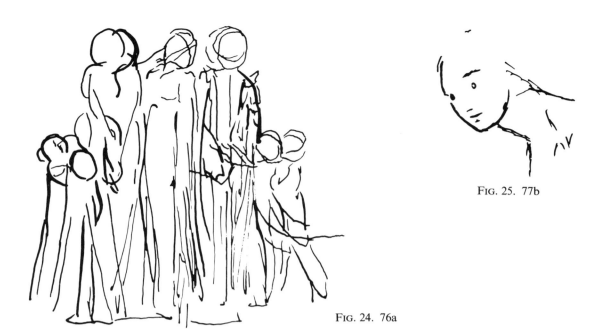

FIG. 25. 77b

FIG. 24. 76a

FIG. 26. 88a (Eve and the serpent)

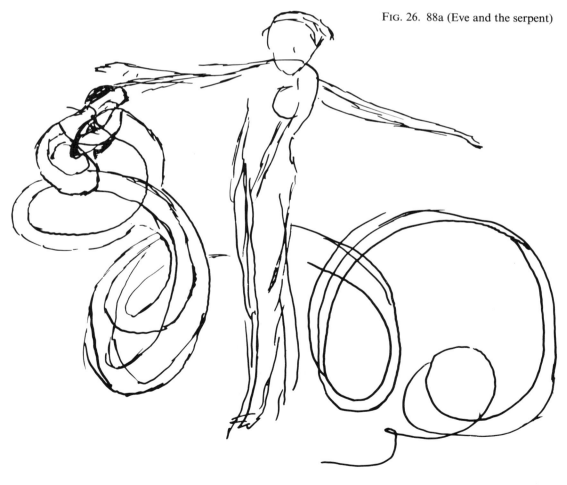

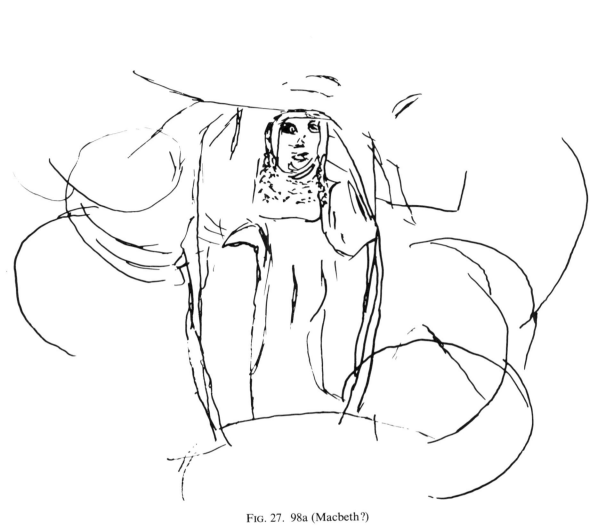

FIG. 27. 98a (Macbeth?)

FIG. 28. 107a

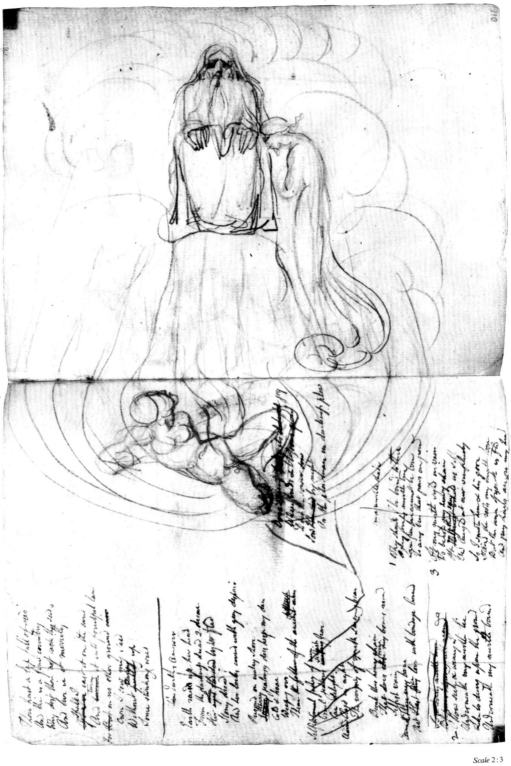

FIG. 29. Composite photograph of pp. 110–11 (God the Father directing the Son to save mankind from Satan—or Sin)

FIG. 30. *Fate*.
Pencil drawing

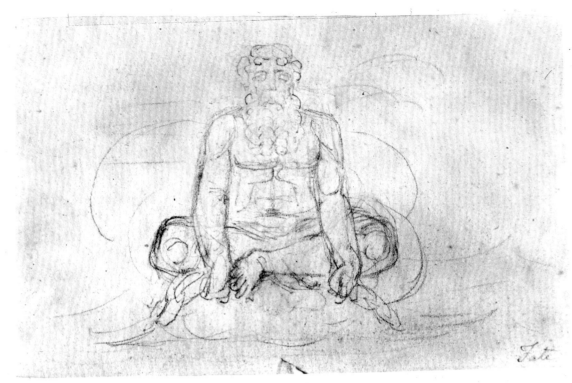

FIG. 31.
*The Evil Demon*.
Pencil drawing (H 3)

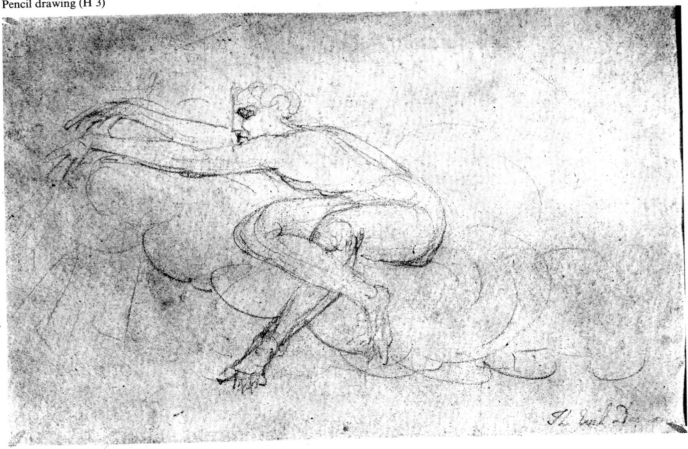

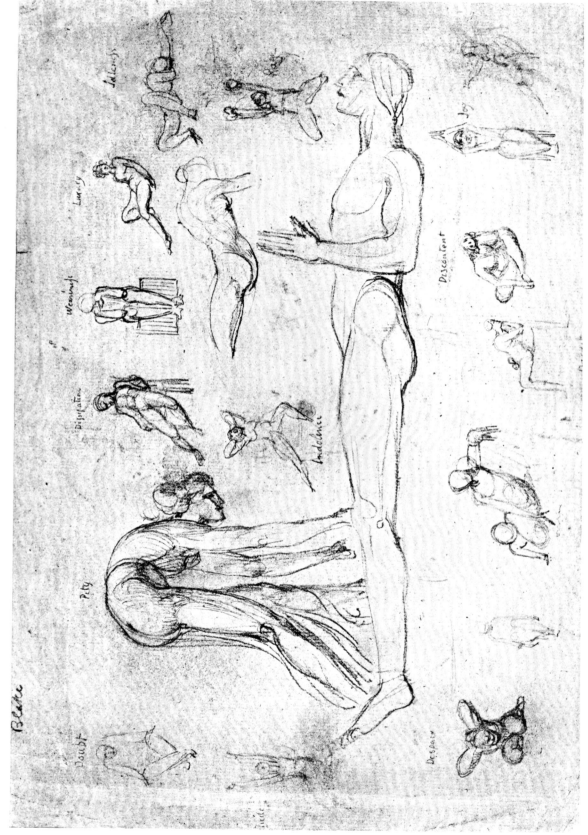

86

Fig. 32. Recto of sheet: copies of *NT* details probably drawn by D. G. Rossetti. (Inscribed 'Blake' in W. M. Rossetti's hand.) The captions, beginning top left, read: (a) 'Doubt', (b) 'Pity', (c) 'Dissipation', (d) 'Weariness', (e) 'Luxury', (f) 'Idleness', (g) 'Suicide', (h) 'Indolence', (i) [no inscription], (j) 'Rage', (k) [no inscription], (l) 'Despair', (m) [no inscription], (n) 'Reason' [uncertain], (o) 'Deceit', (p) 'Discontent', (q) 'Joy', (r) [perhaps also meant to fit the caption 'Joy'], Drawings g, h, j, and r are sketched on top of erased variants. (Sketches i and k are not related to Blake's designs.)

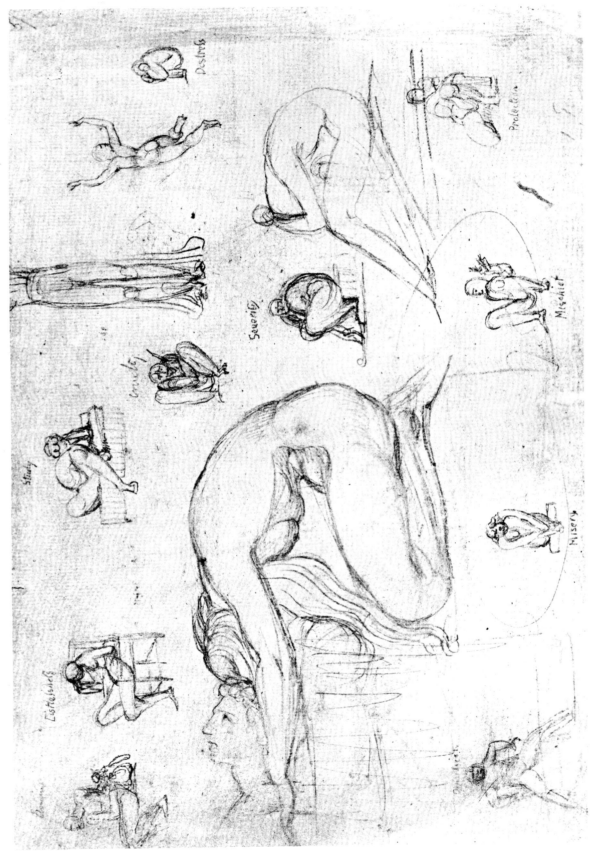

Fɪɢ. 33. Verso of sheet: copies by D. G. Rossetti (H2). The figures, from top left to bottom right, are captioned: (a) 'Avarice', (b) 'Listlessness', (c) 'Study', (d) 'Cruelty', (e) [no inscription], (f), (g) 'Distress', (h) [no inscription], (i) 'Severity', (j) [no inscription], (k) 'Oppression', (l) 'Misery', (m) 'Mischief' (n) 'Protection'. Drawings a, e, j are sketched on top of erased drawings, not related to the final sketches in the case of e and j. In the bottom right corner is an erased word following the numeral '1'. The erased drawing under e was apparently a variant of 'Rage' (H1j). (Sketches h and j are not related to Blake's designs.)

87

FIG. 34. Rejected design for Hayley's Eagle ballad (1802). Pencil drawing

*Scale 3:5*

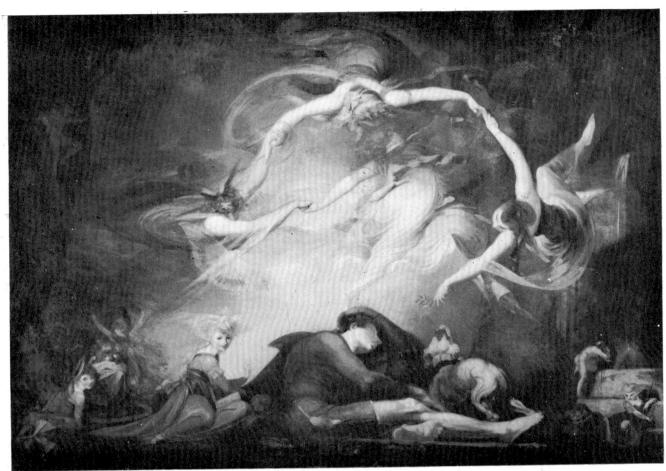

FIG. 35. *The Shepherd's Dream
from 'Paradise Lost'* (1793)

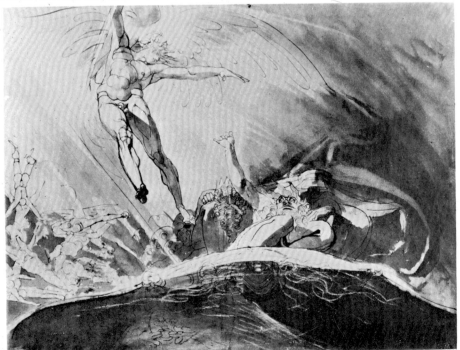

FIG. 36. *Satan Bursts from Chaos*
(Satan fliegt ohne Antwort auf
vom Chaos)

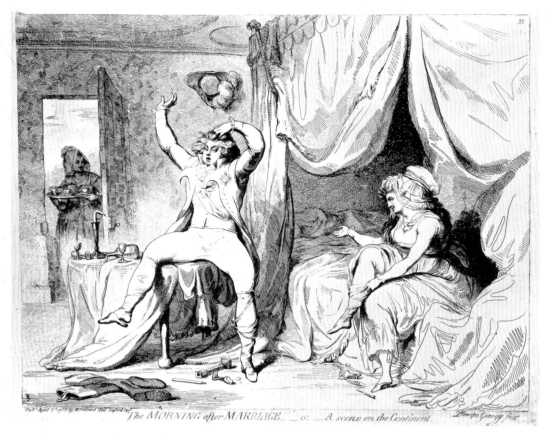

FIG. 37. *The Morning after
Marriage* (5 April 1788)

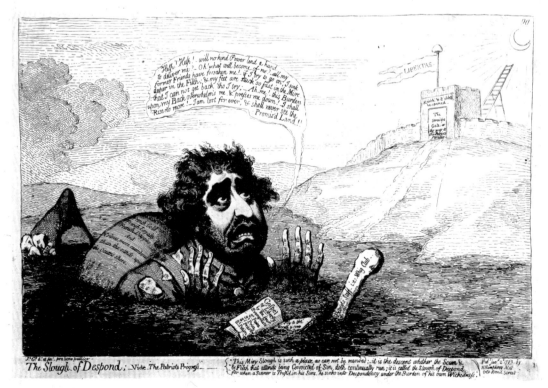

FIG. 38. *The Slough of Despond;
Vide The Patriots Progress*
(2 January 1793)

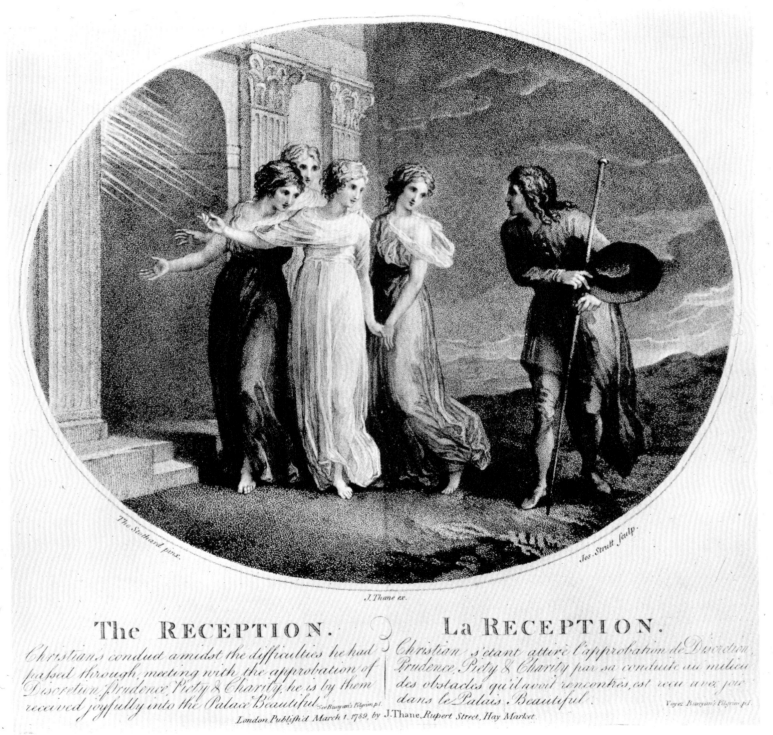

The Stothard pinx.

Jos. Strutt sculp.

J. Thane ex.

The RECEPTION.                    La RECEPTION.

Christian's conduct amidst the difficulties he had        Christian s'etant attiré l'approbation de Discretion
passed through, meeting with the approbation of      Prudence, Piety & Charity par sa conduite au milieu
Discretion, Prudence, Piety & Charity, he is by them    des obstacles qu'il avoit rencontrés, est reçu avec joy
received joyfully into the Palace Beautiful. See Bunyan's Pilgrim p.l.   dans le Palais Beautiful.   Voyez Bunyan's Pilgrim p.l.

London Publish'd March 1. 1789, by J. Thane, Rupert Street, Hay Market.

FIG. 39. *The Reception* (1 March 1789) engr. Jos. Strutt for Bunyan's *Pilgrims Progress*, 1792

91

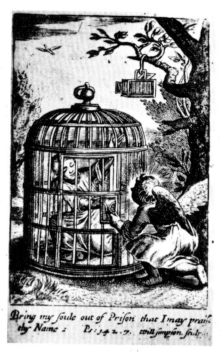

FIG. 40. Francis Quarles, *Emblemes*, 1635,
Bk. 5, Emblem 10 engr. Will Simpson

EMBLEM XXIV.

OF THE USE OF SELF-DENIAL.

WITH hasty steps, at the first dawn of
day,
The chearful traveller pursues his way;
But tired at noon he seeks a shady grove,
Of lofty trees, whose branches meet above:
Conceal'd beneath the grass the Serpent lies,
The swain draws near and by his venom dies.

FIG. 41. John H. Wynne, *Choice Emblems*, 1772,
Emblem 24

EMBLEM XXVII.

OF VAIN PURSUITS.

FROM sultry noon till night's dull
shades descend,
Behold the boy his fruitless chace attend,
To gain the insect's painted wings he flies
And pleas'd at last obtains the gaudy prize;
But whilst its beauties he surveys with joy,
Those hands which seize them fatally destroy.

FIG. 42. John H. Wynne, *Choice Emblems*, 1772,
Emblem 27

# APPENDIX III

## MANUSCRIPT FRAGMENT OF
## 'THE EVERLASTING GOSPEL'

EG j  *There is not one Moral Virtue that*

*Jesus Inculcated but Plato & Cicero*

*did Inculcate before him What then*

*did Christ Inculcate. Forgiveness of*

*Sins This alone is the Gospel & this*

*is the Life & Immortality brought to*

*light by Jesus.  Even the Covenant of*

*Jehovah which is This If you forgive*

*one another your Trespasses so shall*

*Jehovah forgive you That he himself*

*may dwell among you but if you*

*Avenge you Murder the Divine Image*

*& he cannot dwell among you* *by his*

*because you Murder him he arises*

*Again & you Deny that he is Arisen*

*& are blind to Spirit*

P. 1, the recto of the first of two leaves of laid note paper which were once a single folded sheet.  This MS. fragment, now in the museum of the Rosenbach Foundation in Philadelphia, was once bound into some book (probably a notebook of its size) but not into *N*, as comparison of stitch marks in *N* with stitch marks along the center of the inner fold (see left edge of p. 3) makes evident.  Each leaf measures 9.6 x 16.3 cm.; the paper is watermarked '1818' and has vertical chain lines 2.5 cm apart.
The writing on p. 1 is all in pencil (here italics).

What can this $\overset{2}{G}$ospel of Jesus be

What Life & Immortality

What was $\frac{i}{I}$t that he brought to Light

That Plato & Cicero did not write

The Moral Virtues in their Pride

Did o$\frac{er}{ve}$ the World triumphant ride

In Wars & Sacrifice for Sin

And Souls to Hell ran trooping in

The Accuser Holy God of All

This Pharisaic Worldly Ball

Amidst them in his Glory Beams

Upon the Rivers & the Streams

Then Jesus rose & said to $\frac{Me}{men}$

Thy Sins are all forgiven thee

Loud Pilate Howld loud Caiphas Yelld

When they the Gospel Light beheld

~~Jerusalem he said to me~~

The Heathen Deities wrote them all These Moral Virtues great & small

What is the Accusation of Sin But Moral Virtues deadly Gin

**Poem 15**
**(EG 1)**

P. 2, verso of leaf 1.  The writing is all in dark ink.  The numeral '2' at the top is inserted partly over the 'G' of 'Gospel'.

94

**Poem 159**
**(EG 1 contd)**

It was when Jesus said to Me

Thy Sins are all forgiven thee

The Christian trumpets loud proclaim

Thro all the World in Jesus name

Mutual forgiveness of each Vice

And oped the Gates of Paradise

The Moral Virtues in Great fear

Formed the Cross & Nails & Spear

And the Accuser standing by

Cried out Crucify Crucify

Our Moral Virtues neer can be

Nor Warlike pomp & Majesty

For Moral Virtues all begin

In the Accusations of Sin

Am I not Lucifer the Great

And you my daughters in Great State

The fruit of my Mysterous Tree

Of Good & Evil & Misery

all the Heroic
And Moral Virtues all End
In destroying the Sinners Friend

P. 3, recto of leaf 2. All the writing is in dark ink. The words 'Sinners Friend' were written over an illegible erasure.

95

And Death & Hell which now begin

On every one who Forgives Sin

　　　　　1　　This to come first

If Moral Virtue was Christianity

Christs Pretensions were all Vanity

And Caiphas & Pilate Men

Praise Worthy
~~Of Moral~~ & the Lions Den

And not the Sheepfold Allegories

Of God & Heaven & their Glories

The Moral Christian is the Cause

Of the Unbeliever & his Laws

For what is Antichrist but those

Who against Sinners Heaven close

With Iron bars in Virtuous State

And Rhadamanthus at the Gate

The Roman Virtues <u>Warlike Fame</u>

Take Jesus & Jehovahs Name

P. 4, verso of leaf 2. The text is in the same dark ink as on other pages; the inserted numeral and direction are slightly darker, perhaps from a fresh dip of the pen. Note that the spacing is greater at that point, i.e., after line 3, as for a stanza break.

Under 'Warlike Fame' are faint traces of an erasure.

# APPENDIX IV

## ADDENDA

### 1. ANOTHER RELATED DESIGN BY BLAKE

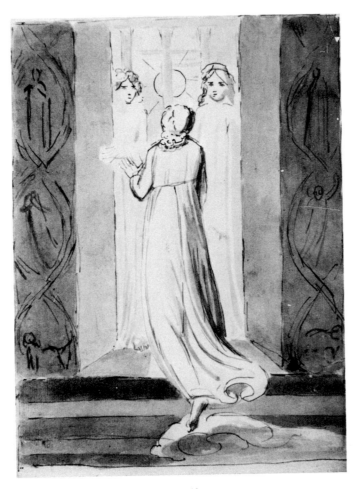

Fig. 43.
A Soul at Heaven's Gate. Wash drawing $10\frac{1}{2}$ by $7\frac{3}{4}$ inches,
executed in the 1780s. Hornby Library, Liverpool City Libraries.

The welcoming angels appear as women; the one at the left is folding the door back with her hand, but three bars of an inner gate stand between the welcomers and the shining sun. God appears as light to the Soul still dwelling in night, according to Blake's symbolism in 'Auguries of Innocence' (a late work; yet compare his early comment on Swedenberg's confusion about the perception of God as a man), but will display a Human Form when the gates of dawning day open. Emblem 13 (p. 31), clearly a variant of the same design, uses the central scene but omits the steps, the bars, and the Tree of Jesse borders. The latter, with more elaborate vignettes in the panels, are used in the 'Introduction' to *Songs of Innocence* (1789) to enclose within heavenly portals the opening poem of child and piper. The moment before even the doors are open is depicted in Blake's later dedicatory drawing 'To the Queen', for Blair's *Grave*: the Soul, rising in a cloud above her sleeping Body, approaches closed portals with a key in each hand; carved angles wait in the arches above the doorway.

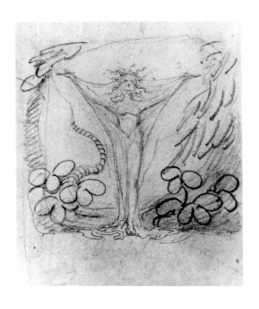

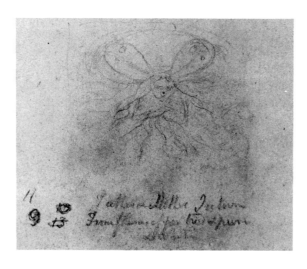

FIG. 44.                                                FIG. 45.

FIG. 44. Earth as Flora, a vegetation goddess? Pencil drawing on a sheet $5\frac{3}{4}$ by $4\frac{1}{2}$ inches (Library of Congress, Rosenwald Collection). Erased caption illegible. The curving tube beside her may be meant to suggest a cornucopia. Is the splitting gown a vegetable sheathe? It seems to match the dividing flame in Emblem 58 (p. 91). Number '3' at right of caption, '13' at left. Blake modified and developed this design for the final plate of *Milton*.

FIG. 45. Flame-tested bee flower? Pencil drawing on verso of the preceding. 'Father & Mother I return/From flames of fire tried & pure/& white'. Compare Fig. 46. Numbers at left of caption written and replaced in the sequence 11, 13, 9, 11.

Note: These sketches, of the same size as many of the Notebook emblems, are on the two sides of a sheet $5\frac{3}{4}$ by $4\frac{1}{2}$ inches in the Library of Congress, Rosenwald Collection (No. NC242.B55A52). Conjecturally dated 1793 in *Blake Newsletter* 35 (Winter 1975–6) p. 76. The numbers on Fig. 44 could mean that this emblem replaced Emblem 5 in the first numbering and was intended for position 13 in the second (see Table V, p. 64). The sequence of numbers on Fig. 45 may have qualified it for position 11 or 13 in the second series and position 9 in the third; the final uncancelled '11' would be accounted for as preceding the choice of Emblem 14 for that position in the third or fourth numbering. (See comment in the Preface.)

FIG. 46.

FIG. 47.

FIG. 46. A human daisy. Emblem added in pencil on the verso of plate 4 of copy C of *For Children: The Gates of Paradise*. (Drawing about 2 by 2½ inches, sketch by J. E. Grant, proportions inexact.) Facing plate 5, 'Fire', an emblem which it seems to echo or balance, this apparently female figure has a head cocked rightward and looking down, flying hair, out-stretched arms like those of *Albion rose* (though paper damage has obscured the position of the hands), a round collar, and about seven petals or scarves; no visible body. This seems a sister to the flower woman of Fig. 45, but compare the hair and arms of the soaring figure that Geoffrey Keynes calls 'the Spirit of Inspiration' in *Drawings of William Blake* (1970), Fig. 33.

FIG. 47. A bearded man working at a press. Emblem added in pencil on the verso of plate 15 of copy C, facing plate 16, the sibyl among decaying bodies. (Drawing about 2¾ by 2 inches; sketch by J. E. Grant, proportions inexact.) The printer's arm is raised to seize the handle of the press which is attached to a spoked wheel. The wall in the background is of stone. Four peculiar objects are in a row near the man's feet. (Compare the printing press in the third panel of the *Songs of Innocence* 'Introduction'.)

Note: From George Cumberland's dated inscription on one of the binder's leaves at the back (reversed)—'Mrs Blake now lives at N 17 Charlton St Fizroy Square at a Bakers. 1830'—we may deduce that Cumberland had just visited Blake's widow and acquired this copy of *The Gates*, hence that it was a copy unsold during Blake's lifetime. Other pencillings in it are some faint diagonal lines on the verso of plate 16, perhaps a sketch, perhaps illegible writing, and a distinct but sketchy pencil drawing of a thigh, calf, and foot, in left profile, along the left side of the emblem on plate 1 ('I found him beneath a Tree').

# INDEXES

## I. INDEX OF POETRY AND PROSE

### (by title and first line)

Numbers refer to Notebook pages

# II. GENERAL INDEX

Emblem motifs are not exhaustively pursued here. Use Table IV (pp. 61–3) and pp. 31–2 as guides to Chapter 2. Table I (pp. 45–53) is a more complete guide to the drawings. Figures in Appendix II, designated 'Fig.', will be found on pp. 77–92. Pagination through 65 precedes the facsimile; pp. 67 ff. follow it. Page numbers preceded by N refer to the facsimile pages and notes; when reference is to note only, not picture, 'n' is used. Specific picture entries are designated 'a', 'b', etc.